THE
POTTER'S
BRUSH

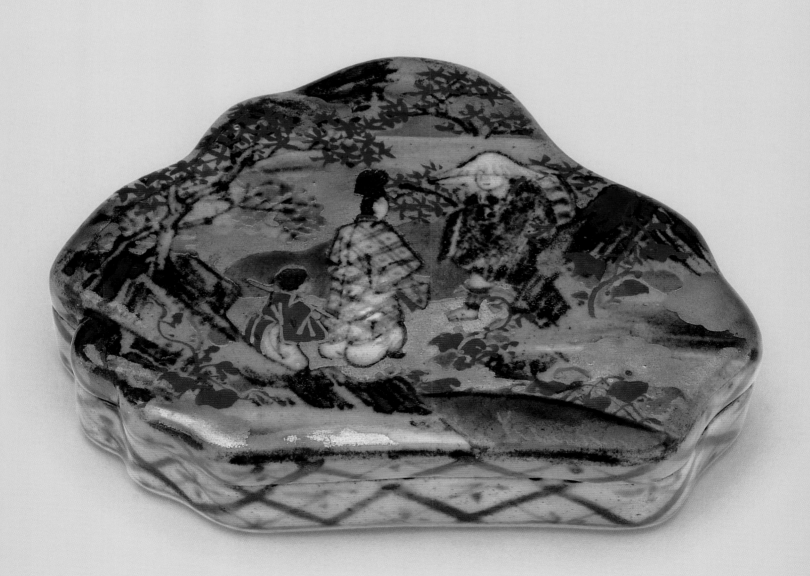

THE POTTER'S BRUSH

THE KENZAN STYLE IN JAPANESE CERAMICS

RICHARD L. WILSON

with contributions by Saeko Ogasawara

Published by the Freer Gallery of Art and Arthur M. Sackler Gallery,
Smithsonian Institution, Washington, D.C.,
in association with Merrell

This book has been produced to accompany the exhibition
The Potter's Brush: The Kenzan Style in Japanese Ceramics
at the Freer Gallery of Art
Arthur M. Sackler Gallery
Smithsonian Institution
1050 Independence Avenue, SW
Washington, D.C. 20560-0707

First published in 2001 by Merrell Publishers Limited

Distributed in the USA and Canada by
Rizzoli International Publications, Inc. through
St. Martin's Press, 175 Fifth Avenue,
New York, New York 10010

Library of Congress Cataloging-in-Publication Data
Wilson, Richard L., 1949–
The potter's brush : the Kenzan style in Japanese ceramics /
Richard L. Wilson ; with contributions by Saeko Ogasawara.
p. cm
Published to accompany an exhibition at the Freer Gallery of
Art, Dec. 9, 2001–Oct. 27, 2002.
Includes bibliographical references and index.
ISBN 1-85894-156-3 (hardcover)
ISBN 1-85894-157-1 (softcover)
1. Pottery, Japanese—Edo period, 1600–1868—Exhibitions.
2. Pottery, Japanese—Expertising—Exhibitions. 3. Ogata,
Kenzan, 1663–1743—Influence—Exhibitions. 4. Pottery—
Washington (D.C.)—Exhibitions. 5. Freer Gallery of
Art—Exhibitions. I. Ogasawara, Saeko– II. Freer Gallery of Art.
III. Title.
NK4167.5 .W55 2001
738'.0952'074753—dc21 2001044859

Produced by Merrell Publishers Limited
42 Southwark Street
London SE1 1UN

Head of Publications: Karen Sagstetter
Editor: Gail Spilsbury
Designer: John and Orna Designs, London
Photography: Neil Greentree
Typeset in Bembo
Printed and bound in Italy

Cover: Water jar or incense burner with design of maple
leaves, by Ogata Kenzan (1663–1743); Edo-Iriya workshop.
Japan, Edo period, ca. 1731–43. Buff clay; white slip, iron
pigment under transparent glaze, enamels over glaze; bronze
cover; 13.9 x 16.1. Freer Gallery of Art, Smithsonian
Institution, Washington, D.C. Gift of Charles Lang Freer,
F1905.24

Frontispiece: Incense container with design of "Narrow Ivy
Road," by Ogata Kenzan (1663–1743); Narutaki workshop.
Japan, Edo period, 1699–1712. White clay; white slip, cobalt
and iron pigments under transparent glaze, enamels over glaze;
2.5 x 10.0. Freer Gallery of Art, Smithsonian Institution,
Washington, D.C. Gift of Charles Lang Freer, F1907.84

Smithsonian
Freer Gallery of Art
Arthur M. Sackler Gallery

TABLE OF CONTENTS

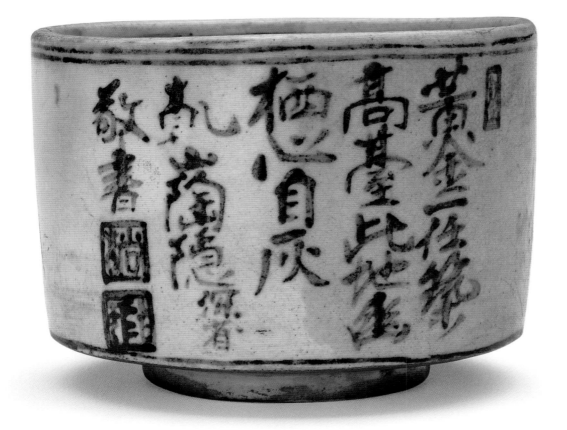

黃金一伍緣
高臺比如鏡
栖月晟
亂崗陰□者
敬書

catalogue no. 1

DIRECTOR'S FOREWORD

This book, and the exhibition that it accompanies, are greatly indebted to the facilities available to scholars at the Smithsonian Institution. A Smithsonian postdoctoral fellowship supported Richard L. Wilson in carrying out his innovative research reinterpreting the identities of the one hundred Kenzan-style ceramics in the Freer Gallery of Art. Dr. Wilson's research also drew extensively on the records relating to the formation of the collection, carefully preserved by Charles Lang Freer (1854–1919) and now housed in the joint archive of the Freer Gallery of Art and the Arthur M. Sackler Gallery, which together form the national museum of Asian art for the United States. He also extensively consulted the books once in Freer's personal collection and now in the Freer and Sackler library.

Dr. Wilson's scientific analysis of some of the Kenzan wares in the Freer—the first such analysis anywhere in the world of a Kenzan ceramic—was carried out in collaboration with the Freer and Sackler galleries' Department of Conservation and Scientific Research. A Smithsonian short-term visitor fellowship provided additional support for a later phase of Dr. Wilson's research at the Freer, as did a grant from the Metropolitan Center for Far Eastern Art Studies.

The revised understanding of the Freer collection that lies at the heart of this activity has in turn transformed the fundamental understanding held by scholars and collectors regarding the nature of Kenzan-style ceramics generally. Credit for this accomplishment belongs to Dr. Wilson, but also to the many staff who activate these institutional programs and facilities. Collaborations of this sort lie at the heart of our goals for the Freer Gallery of Art and the Arthur M. Sackler Gallery and define one strength of the Smithsonian Institution.

Milo Cleveland Beach
FORMER DIRECTOR
FREER GALLERY OF ART, ARTHUR M. SACKLER GALLERY, SMITHSONIAN INSTITUTION

CURATOR'S FOREWORD

As the result of inspired research presented in this book, the Freer Gallery's "Kenzan" ceramics are now seen as diverse representatives of all phases of the enduring tradition of ceramic decoration invented by the Kyoto potter Ogata Kenzan (1663–1743). As Richard L. Wilson was completing his 1985 doctoral dissertation on Kenzan at the University of Kansas, I encouraged him to apply for a Smithsonian postdoctoral fellowship in order to make a close study of the one hundred Kenzan-associated ceramics in the Freer collection. At that time, the Kenzan ceramics (constituting more than 10 percent of the Freer's Japanese ceramics collection) clearly formed a major body of important material, yet their identity and value were ambiguous. Records of comments made by scholarly visitors suggested a focus on the importance of identifying pieces from the hand of Kenzan himself. Those that could not be so identified—the bulk of the collection—were relegated, implicitly, to the shadowy realm of "fakes." It seemed high time to subject this large body of wares to a more subtle and revealing analysis.

Richard spent a year in Washington (1985–86), scrutinizing the Freer's "Kenzan" pieces while also consulting records in the gallery's archives, collaborating with the gallery's conservators to do technical studies, and visiting other collections in North America and Europe. His comprehensive approach involved careful consideration not just of the Kenzan signature (the touchstone for many earlier visitors) or the decoration, but also of the clay, glaze, and pigments, and of the calligraphic mannerisms in the inscriptions. Richard succeeded in dividing the Freer's "Kenzans" into a sequence of categories that reflected continuous production of Kenzan-style ceramics from Kenzan's lifetime to the present day. Of great importance to the field of Japanese art history as a whole was this provocative act of shifting the discussion of "Kenzan ceramics" off the narrow pedestal of the individual artistic personality. Richard's reinterpretation of "Kenzan ware" acknowledges the impact one artist's work could have on the public and on the work of other artists, both contemporaneously and subsequently.

The fruits of Richard's research on the Freer collection were presented to the public in his subsequent publications in English (*The Art of Ogata Kenzan: Persona and Production in Japanese Ceramics*, 1991) and in Japanese, together with Ogasawara Saeko (*Ogata Kenzan: Zen sakuhin to sono keifu*, 1992, and *Kenzan yaki nyūmon*, 1999). The Japanese publications in particular have profoundly transformed interpretations of Kenzan's own work as well as the larger body of ceramics in the Kenzan style. In the course of ongoing research, Richard's understanding of the Freer's Kenzan-style wares has also deepened. It is a pleasure to be able, at long last, to present the Freer pieces in the light of their new identification. I take this opportunity to thank all my colleagues

on the staff of the Freer Gallery of Art who have contributed to the realization of the publication and the exhibition.

Richard has chosen to examine the Freer's Kenzan-style ceramics through the lens of decorative style, since that element, above all, was responsible for the wild popularity of Kenzan's pots in his own lifetime, as well as for the enduring fascination with them on the part of other potters, users, and collectors. Readers of this book and visitors to the exhibition will surely delight anew in Kenzan's brilliant inventions in ceramic decoration and in the work of the many potters who worked in the Kenzan style.

Louise Allison Cort
CURATOR FOR CERAMICS

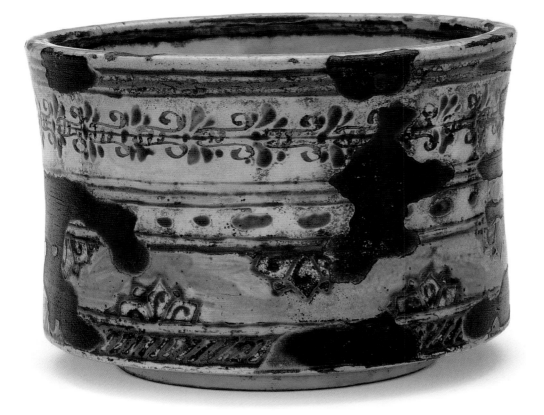

catalogue no. 39

ACKNOWLEDGMENTS

There is no better place than the Freer Gallery of Art to undertake a study of the Kenzan style in Japanese ceramics. The nature of the collection, coupled with the opportunities for multidisciplinary research and the scholarly outlook of the staff, present the ideal platform for research. I am grateful to the Smithsonian Institution for granting me a postdoctoral fellowship in 1985–86 and for supporting return visits in 1997 and 2000. My heartfelt thanks go out to all personnel, most of whom are now part of the expanded facility of the Freer and Sackler galleries. Many of them have become lifelong friends.

The Freer and Sackler galleries' administration has offered every conceivable type of support toward the fulfillment of this long-term study, and benefactors have included the museum's former director, Thomas Lawton, the late associate director, Richard Louie, and of course the just retired director, Milo Beach. Long hours in the library turned into pleasant ones through the help of former head librarian Ellen Nollman, the current head, Lily Kecskes, and staff librarian Kathryn Phillips. Archivist Colleen Hennessey provided extraordinary opportunities to study the Freer papers. Reiko Yoshimura helped me survey the Japanese rare books to find corollary materials for the book and the exhibition.

Art-handling specialists Marty Amt, Rocky Korr, and Jim Smith lent many helping hands during early work in storage; on the 1997 trip Tara Coram and George Rogers gave unstinting assistance.

During my postdoctoral year, the Department of Conservation and Scientific Research was like a second home. Former department head W. T. Chase took time out from a hectic schedule to teach me the basics of database compilation, petrographic analysis, sampling procedures, and various other analytical techniques. Conservation scientist Janet Douglas provided advice and support, and current department head Paul Jett offered much encouragement. Senior conservation scientist John Winter shared his store of knowledge, and conservation scientist Blythe McCarthy has pushed ahead with analytical studies, especially on the Kenzan earthenwares. All of this opened up a new and enduring avenue of research for me.

Among curatorial colleagues at the Freer and Sackler, Fu Shen taught me about Chinese calligraphy. With Ann Yonemura, I had many long and fruitful discussions on issues of material and decoration. Joseph Chang and Stephen D. Allee have opened up innumerable doors to the world of the literatus, and Stephen kindly consented to translate the Chinese poetry that appears on thirteen of the Freer-collection pieces. Jan Stuart's work on inter-art relationships has been a source of inspiration for thinking about similar issues in Kenzan ceramics.

Curator for ceramics Louise Cort is the person who made this project—and these wonderful human connections—possible. She encouraged me to work at the Freer in the first place, served as chief advisor during my residency, and has been a steadfast supporter of the catalogue and exhibition. She supervised all the in-house arrangements for further research, contributed her knowledge and expertise to the book's production, and produced the accompanying exhibition. She read the manuscript and made key suggestions with a level of care that belies her own very busy schedule. It is not possible to recount how much I have benefited from her advice and outlook over these years.

I had numerous occasions to take advantage of the vast array of Smithsonian resources outside the host museum, and among the non-Freer specialists who helped me I am especially indebted to geologist William G. Melson and chemist Joseph Neeland at the National Museum of Natural History, and senior research scientists Edward V. Sayre, Pamela D. Vandiver, and Ronald L. Bishop at the Smithsonian Center for Materials Research and Education. Pamela's insistence on rigorous working assumptions and procedures has been a blessing. Outside the Smithsonian but still within Washington, D.C.'s beltway, reference librarian Thomas Storck at the United States Treasury Department helped me assess the value of Charles Lang Freer's purchases in today's terms.

I feel especially fortunate to have been able to work with the Freer and Sackler galleries' highly skilled yet flexible and compassionate publications staff: senior editor Gail Spilsbury, assistant head of publications Lynne Shaner, and head of publications Karen Sagstetter. Gail's support for the project went far beyond the call of duty. Jane McAllister was helpful as proofreader. I am indebted to Neil Greentree for his exceptional photography of the Kenzan objects and to the museum's head of Imaging and Photographic Services John Tsantes. I also want to thank Merrell Publishers for designing the book.

Andrew Maske, curator at the Peabody Essex Museum in Salem, Massachusetts, joined the team at this stage as a reader well versed in Japanese ceramics, and the book is all the better for his many cogent suggestions. Many thanks, Andy.

It would require many pages to acknowledge all the help I have received elsewhere in America, Europe, and of course Japan. The late Satō Masahiko opened up the Kenzan path for me many years ago, and as time passes, I read his old letters and realize how lucky I was to have had him as a mentor. The monks at the Hōzōji Temple, site of Kenzan's first kiln, have been like family members. Several of my assistants and students at the International Christian University have helped out, and in the former group Kobiki Harunobu did great service as a designer and all-around computer consultant; among the latter, Scott Spears lent his insights to my translations of the Japanese poetry.

Funding for some of the illustrations and additional travel was made possible by the Metropolitan Center for Far Eastern Art Studies. Its benefactor, the late Harry Packard, also took an interest in Kenzan.

Finally, I must underline the extraordinary efforts of my research partner, Ogasawara Saeko. She has set the standards of quality and innovation in all our Kenzan research, and has contributed more than her share of the documentary research. She accompanied me on two surveys of the Freer collection and suggested the thematic structure of the catalogue. The word "contributor" is inadequate to define her part in this project or in Kenzan studies as a whole.

Richard L. Wilson
INTERNATIONAL CHRISTIAN UNIVERSITY, TOKYO
AUGUST I, 2001

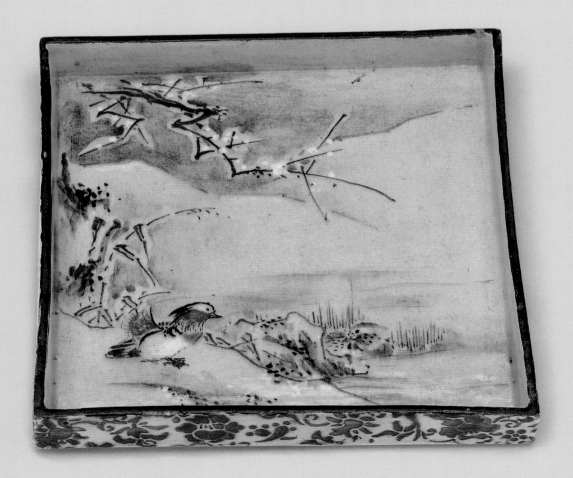

catalogue no. 16

INTRODUCTION: SEEING THROUGH SANO KENZAN

Sensational art finds are both desired and feared: desired because they become a form of pleasure and capital; feared because they displace something or somebody. Japan has had its share of such moments. None, however, rivals the 1962 unveiling of a large group of pots and diaries alleged to have been made by master potter Ogata Kenzan (1663–1743) in Sano, a small village north of Tokyo. Important men saw and blessed these "Sano Kenzan" pieces, and the media, for their part, conspired to turn the tentative into the normative. Those in the know promised even further discoveries. Then, just as the old canon was drenched in doubt, Sano Kenzan crumbled. These were, after all, fakes— not persuasive imitations, but crude, even ridiculous hoaxes, like van Meegeren's implausible Vermeers or the great American fraud, the Cardiff Giant.[1] And light years from Kenzan. But important men had seen and blessed them.

It is no coincidence that by 1962, when the Sano scandal tore through the Japanese art world, Ogata Kenzan was already a cultural hero, fitted seamlessly into the national autobiography. In Kenzan, two modern wishes were fulfilled—romantic life and revolutionary work. Born and raised in one of Kyoto's premier merchant families, Kenzan moved from dabbling dilettante to celebrated production potter, only to die alone and apparently destitute in Edo (present-day Tokyo), far away from his native city. Kenzan the designer remade the meaning of ceramic vessel: suddenly it could have a new range of cultured allusions and material analogues, ranging from poetry to textile design. Above all, the pots were painted rather than simply decorated, and that sense of spontaneity and gesture helped to personalize the products. The surfaces were animated through collaboration with an older brother and stellar artist in his own right, Ogata Kōrin (1658–1716). Against a background of anonymous craftsmanship, the norm for Japanese potters until that moment, these products bore the ultimate personal mark: a handwritten signature reading "Kenzan." For burgeoning numbers of post–World War II culture enthusiasts, this added up to the genesis of the artist-potter. Nor was this lost on twentieth-century pot makers, who were happy to find in Kenzan an ancestor or exemplar. Connections were reinforced in the countless catalogues, books, and exhibitions that were part of the hyperbolic *yakimono būmu* (ceramics boom) propelled by the atavistic postwar culture industry. Each new venue seemed to expand Kenzan's creative repertory.

Such is the context for the debut of "Sano Kenzan." After participating in an exclusive Kyoto viewing in January 1962, an impressive, indeed nearly unassailable, group of curators, professors, and journalists came out in favor of the finds. The Sano diaries clinched the argument: day-to-day events and poetic musings were combined with sketches of pots that matched the very ones that had come to light. All of this was

touted by headlines in Japan's major dailies and art magazines. About four months passed before interested parties realized the discovery would seriously deflate the existing market—the new Kenzan would devalue the old—and then there was a ferocious response, led mainly by Tokyo art dealers. The debate raged back and forth in the media, variously enlivened by panel discussions, televised debates, testimony in National Diet committees, and a parade of self-styled Kenzan authorities ranging from Nobel Prize-winning novelist Kawabata Yasunari (against) to best-selling mystery writer Matsumoto Seichō (equivocal). Scientists and technicians testified pro and con. British potter Bernard Leach, as we shall learn later in the text, was a die-hard advocate and eventually wrote a book in defense of the finds.

And then something happened. The Sano Kenzan pots and diaries were shown to the public. People could actually look at the pieces instead of reading or hearing about them from "authorities." There was, of course, awe—all the hype had to have some impact. But much more was there doubt. There were too many works. The pieces were heavy. The pigments were modern. The writing style was wrong. The diaries were anachronistic. All of these claims were opposed, but not to the satisfaction of *sekken*, the otherwise nameless but powerful social consensus that drives Japanese public life. New Sano Kenzan was quietly, gradually relegated to hinterland dealers and the art magazines that play to wishful but underfunded collectors.[2]

Pronouncements about the authenticity of an object inevitably invoke an authoritative "other scene." The florescence of New Sano Kenzan demonstrates the very fragility of that order, which was (and still is) a mix of popular image, empirical assessment, and political consensus. The weight given to the anecdotal Sano diaries underlines the importance of empathy, and indeed in the postwar era all Kenzans were expected to display a photogenic bravado fitting to Japan's first artist-potter: bold, impromptu execution, masses of color, and preferably a large-size Kenzan signature. The scholarly and scientific debates, on the other hand, exposed modern expectations for the object as a form of material truth, although the standards were invariably based more on personal and institutional loyalties than on sustained, dispassionate examination. Had there been grounding for Kenzan wares in pedigree, the empowering criterion for Japan's tea ceremony wares, much of the debate would have been avoided. Instead, Kenzan was marketed as "art," which foreclosed debate about the collective nature of the artist's enterprise or the enormous industry that he generated. After all, the detractors were not out to bring truth to the Kenzan field; their aim was a return to the status quo.

We are not surprised that a system of interlocking obligations worked against critical scrutiny on either side of the Sano debate. We are constrained, however, when evaluations are limited tacitly to either individual masterpiece or (de facto) fake. Two

centuries of real ceramic production under the Kenzan rubric are effectively denied. The alternative is to suspend the hierarchical urge and consider everything with the Kenzan mark. That is the project of this book. So conceived, "Kenzan" exposes the fundamental paradoxes and ambiguities in the discourse. The "original vs. fake" binary cannot explicate the uneasy boundaries between ceramics and painting, amateur and professional, or distanced delegates and the real-time practitioners. Seen as material culture, "Kenzan" becomes less an authentic form of art and more a brand name invoked in a multigenerational and multidimensional corpus of ceramic products. "Kenzan" exposes a broad band of elite and popular themes, and in so doing presents a text for early modern life, its dreams and deceptions alike. These themes, in turn, become frameworks for the understanding of migrations in "Kenzan taste," affected by everything from technology to mass markets to notions of history itself. Finally, our generic "Kenzan" becomes contemporary critique: we see how, in our own day, the very diversity of "Kenzan" has been erased, an elision carried out in the name of comprehensibility, unity, and canonical taste. Never far from center is the weight of Kenzan's Rimpa school in the modern era: Rimpa is made to stand, rather adroitly, both for Japanese "culturehood" (a timeless native lyricism) and modernity (fashionableness and formalism).

Both then and now, Kenzan is very much a comparative construct. But this is not a colorless relativism. Viewing "Kenzan" as creative matrix, we join the generations of potters, dealers, collectors, scholars, dilettantes, and unnamed folks who have built it. We are engaged participants, not a disinterested, dictated-to audience. The historical Ogata Kenzan reappears, even if prismatically, through this process. There is room for empathy, but with a healthy recognition of complicity: the image contained in the Kenzan pot is also our own.

One could, of course, map out an expanded "Kenzan" in Japan, but it would take a lifetime. Most collections are too small to constitute a sampling; where collections are large they are also new, tainted by post-1950 catholicity. In fact, the only possible domain for a broad, efficient survey is the collection assembled by Charles Lang Freer (1854–1919) in the late nineteenth and early twentieth centuries. It is large, refreshingly heterogeneous, and exceptionally well documented. Moreover, it can be studied and deployed without one's having to kowtow to the old protocols. Sustained examination of the collection and associated records reveals that Freer's activities contributed to a shift in Kenzan perceptions from workshop product to individually conceived artwork. From there the rise in Kenzan's status as "artist-potter," with all the attendant glory and abuse, was but a short distance.

This study of the Kenzan-style ceramics in the Freer Gallery is, of course, a catalogue, but it is also a place to visit and render meaningful the entire panorama of

Kenzan ware as an artistic and cultural text. In keeping with our notion of Kenzan as broad-band design, we invert the conventional life-work-legacy sequence, starting instead with the modern (Freer's) collecting environment, where named art emerges out of generic product. This parallels Japan's Meiji era (1868–1912). Then, in the catalogue proper, we look at the components of that product: we tag the main themes, and use Freer's Kenzan (style) pieces to trace trajectories through two centuries of Japanese life. This begins in the middle of Japan's Edo, or early modern, period (1615–1868). The concluding segments of the book examine texts old and new: biographical materials, pottery techniques, and archaeology.

NOTE TO THE READER

Japanese characters appear next to their romanized equivalents in the index. Proper names follow Japanese usage with the surname preceding the given name. Following Japanese custom, artists are referred to by their studio names. Self-styled transliterations such as (Matsuki) "Bunkio" instead of "Bunkyō" are honored here.

"Kenzan ware" as cited in the manuscript refers to all ceramics with the mark of, or otherwise attributed to, Kenzan. When Kenzan is used as a personal reference, it is to the first Kenzan, the historical Ogata Shinsei (1663–1743).

Diacritical marks are used except for words that are familiar in English, such as Tokyo.

Translations are by the author unless otherwise mentioned in the text or acknowledgments. Special thanks are due to Stephen D. Allee, research specialist in Chinese art at the Freer Gallery of Art and Arthur M. Sackler Gallery for translating the Chinese poetry on the Freer Kenzan pieces. Parts of the chapter on Kenzan's life were adapted, with permission, from my article, "Bernard Leach and the Kenzan School," in *Studio Potter* 27:2 (1999): 9–14. Responsibility for all errors and omissions is mine.

NOTES

1 Between about 1935 and 1943, the Dutch painter Henricus Antonius van Meegeren (1889–1947) created a series of works in the style of Jan Vermeer (1632–1675), which, despite their ghastly appearance, were initially hailed by experts as works of the highest order. The Cardiff Giant, a "fossil" of a giant man "discovered" in 1869 on an upstate New York farm and viewed by thousands, was crafted by cigar manufacturer George Hull.

2 The Sano Kenzan scandal is discussed in detail in Richard L. Wilson, *The Art of Ogata Kenzan: Persona and Production in Japanese Ceramics* (New York: Weatherhill, 1991).

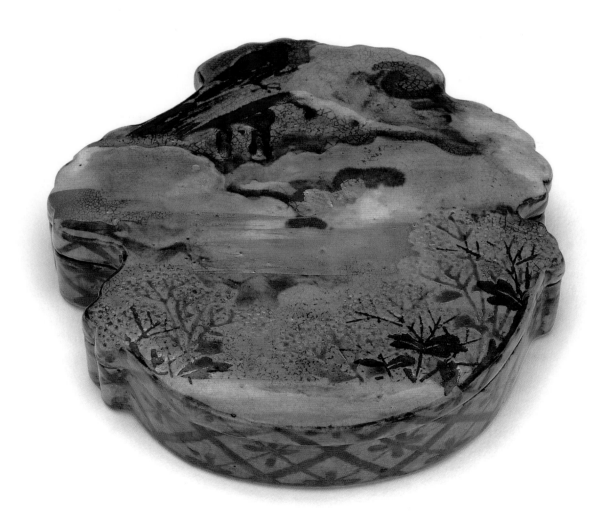

catalogue no. 17

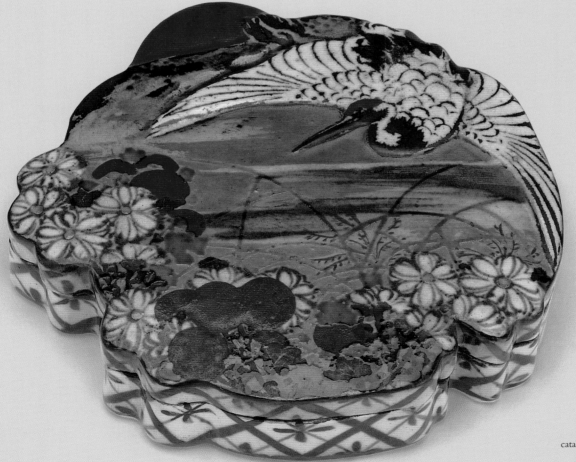

catalogue no. 18

BETWEEN KENZAN AND FREER

As he completed seventeen years of Kenzan collecting in 1911, Charles Lang Freer (1854–1919) looked over a very altered pot-scape, the contours of which he had helped to fashion. In the few decades since the name "Kenzan" had emerged in world markets, its cachet had moved from the industrial to the artistic. Such a complete makeover suggests a certain sleight of hand. The new Kenzan took form in an escalating—and international—chorus of claims about the genius and uniqueness of Japanese art. The transformation of Kenzan into a distinctive Japanese artist required various perspectival shifts, including a new sense of national culture and the appropriation of non-Japanese words and ideas. Therein, Freer's Kenzan collecting emerges as more than just an outreach activity of a Japan-centered art world. Kenzan became a coveted Japanese artist in part because Freer and his milieu pointed out new ways of representing him.

Recent scholarship has facilitated placement of Kenzan in the mid-nineteenth-century "opening" of Japan and the subsequent allure of Japanese culture for European and American audiences. Greater weight is now given to the agendas of the Japanese art bureaucracy and more generally to the visual and ideological structure of Meiji era (1868–1912) nation building. The foreign reception of Kenzan ware now can be understood as a form of appropriation, in which interested parties used art in telling stories about themselves and others. Despite contemporary suspicions about narrating culture as a succession of neatly framed periods, it is difficult to overlook two phases in the late-nineteenth-century dissemination of Japanese arts and crafts. The first stage, broadly framed as 1850 to 1880, is characterized by a pragmatic drive to boost exports of contemporary (and gradually antique) ceramics, lacquer ware, metalwork, and cloisonné. The slogan *shokusan kōgyō* (increase production, promote industry) was used by the Japanese government as an exhortation. On the Western side, demand was concomitant with the industrial revolution; taste was shaped by international expositions, design reform movements, and a general fascination for the exotic. Older rococo or Victorian preferences lingered as undercurrents.

A new phase of acquisition commenced with the 1878 Paris Exposition Universelle and continued into the early twentieth century. The Japanese art leadership—artists, bureaucrats, and critics among its ranks—grew more confident of its own artistic traditions and how they could represent nationhood, as manifested in the new slogan *kokusui hozon* (preservation of the national essence). Accelerated traffic in painting and craft objects in more "traditional" taste was made possible by the migration of Edo-period collections into the art market. One detects a better-informed Western audience that included sophisticated and highly mobile art dealers and collectors. Art producers— the impressionists among them—claimed affiliations with Japan. Received as both a potter and a painter, Kenzan was now viewed as an individual artist, part of a "Kōetsu"

(later called Rimpa) school, which gained international exposure from the late 1880s.[1] All of this came to the attention of Freer. In addition to the extrinsic factors, there are formal qualities in Kenzan ware that Freer found appealing: some of these speak to the times, and some are particular to Freer's gaze.

INDUSTRIAL ART AND ETHNOLOGY

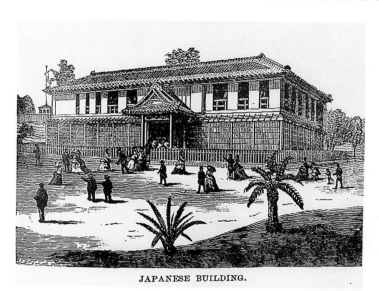

JAPANESE BUILDING.

Fig. 1. Japanese pavilion, Philadelphia Centennial Exposition, 1876. From Thompson Wescott, *Centennial Portfolio* (Philadelphia: T. Hunter, 1876).

The international exposition was the backdrop for Kenzan's overseas debut. Goods from Japan captured attention in these venues after the nation reluctantly concluded treaties with Western powers between 1854 and 1859. Commercial products dominated Japanese submissions to the world's fairs in London (1862) and Paris (1867), but for the 1873 exposition in Vienna the Meiji government, apparently at the urging of technical advisor Gottfried Wagener (1831–1892), established a pavilion that included samples of antique arts. Two years later, anticipating the 1876 international exhibition at Philadelphia (fig. 1), the South Kensington Museum (later the Victoria and Albert Museum) asked Sano Tsunetami (1822–1902), the vice-minister in charge of the Japanese display and later a key figure in the art advocacy group Ryūchi Kai, to assemble a historical collection of Japanese ceramics that would enter the museum after the show. Shioda Shin (1837–1917), another Ryūchi Kai member-to-be, compiled a report to accompany the purchase.

In their review of Meiji era acquisitions at the South Kensington Museum, Victoria and Albert curators Rupert Faulkner and Anna Jackson relate that this 1875 British mandate was for a complete understanding of ceramics through a single acquisition.[2] Such requests surely influenced Japanese thinking about crafts in this nascent "modern" era. The first craft collections for the Tokyo Imperial Museum were formed in the course of preparations for the 1873 Vienna exposition: a pair of representative products from each region was ordered, with one being shipped to Vienna and the other added to the new museum collection.[3] Both literally and figuratively we see the creation of what scholar Robert Rydell, writing about the power of these fairs to organize reality, has called a "cohesive explanatory blueprint:"[4] ideas of "industrial art" and "nation" were replacing the categories of media-specific school and region.

Three Kenzan pieces are listed in the Philadelphia/Kensington purchase catalogue written by museum professional Augustus Franks (1826–1897), and they probably mark Kenzan's American debut.[5] In 1878, Franks used Shioda's notes in compiling a catalogue of his own collection shown at the Bethnal Green branch of the South Kensington, entitled *Catalogue of a Collection of Oriental Porcelain and Pottery Lent for Exhibition by A. W. Franks.* There were seven Kenzan wares featured in this European entree. For the Kensington exhibition of the Philadelphia purchase, which opened in 1879, Franks wrote:

> [Kenzan's] kiln in Narutaki was erected by a brother of the famous painter
> Ogata Korin, named Shinsho, who amused himself in his leisure hours by making
> tea utensils in imitation of Ninsei yaki [Ninsei ware]. The village of Narutaki,
> where was his residence, is situated at the foot of the hill of Atago, to the north-
> west of the Emperor's palace, or in the direction called "ken" in Chinese. On this
> account he was named "Shisui Kenzan," meaning "beautiful blue hill in northwest
> part." He died in 1742, in his eighty-second year, and his work is much esteemed
> by tea drinkers.[6]

Drawn chiefly from Edo period genealogies of tea devotees, these remarks form the basis for comments in another early and substantial British publication, the 1879 *Keramic Art of Japan* by collector James Lord Bowes (1834–1899) and architect George Ashdown Audsley (1838–1925).[7] Likewise, comprehensive culture collecting informs the ceramic purchases made in 1876 to 1877 by French industrialist Emile Guimet (1836–1918), whose acquisitions, ranging from Banko, Seto, Oribe, "Ninsei" (Kyoto ware), Awata, Imari, Satsuma, Bizen, and Kutani suggest, in the words of scholar Ellen Conant, a "didactic program."[8] Japanese compendia continued in the form of *Kōgei shiryō* (Materials on handcrafts), prepared by government official Kurokawa Mayori in 1877 for the Paris world's fair the following year.[9] These projects suggest more than dissem-ination of knowledge: underneath the narration Kenzan is uprooted from the realm of local producers and relocated to the domain of state craft and, in due course, to a Western-conceived world order.

As the early British and French collections were taking shape, other encyclopedic efforts were underway in Japan. British journalist and critic Francis "Frank" Brinkley (1841–1912), whose expertise is best known through his eight-volume series *Japan: Its History, Arts and Literature* (1901–2), formed a large ceramic collection in the 1870s, but owing to its rapid dispersal was overshadowed by that of Edward Sylvester Morse (1838–1925; fig. 2).[10] Hired to teach zoology at in the Imperial University in 1877, Morse encountered shell-shaped ceramics (his specialty was marine brachiopods) in 1878. This inspired a grand taxonomic mission—a four-year frenzy of collecting.[11] The resulting

Fig. 2. Edward Sylvester Morse (1838–1925), early 1900s. Photographer unknown. Courtesy Peabody Essex Museum, Salem, Massachusetts.

Fig. 3. Ninagawa Noritane (1835–1882),
date unknown. Photographer unknown.
Courtesy Peabody Essex Museum,
Salem, Massachusetts.

corpus of more than five thousand specimens is housed in the Museum of Fine Arts, Boston. The collection includes about forty wares with the Kenzan mark and many other Kenzan-style pieces that are useful comparative material. In his quest Morse, like Brinkley, was aided by Japanese antiquarian Ninagawa Noritane (1835–1882; fig. 3). His *Kanko zusetsu* (Illustrated discourse on antiquities), published between 1874 and 1879, forms the basis for Morse's classifications. Freer's correspondence demonstrates that he had met Morse in the late 1890s, received him at his home in Detroit, and helped sponsor Detroit lectures for Morse and market Morse's *Catalogue of the Morse Collection of Japanese Pottery.*[12] Freer obviously valued Morse's pronouncements, inviting Morse to examine the entire Freer collection in 1907. The organization of the Freer Kenzan collection into Yamashiro (Kyoto) and Musashi (Tokyo) categories utilizes the Ninagawa-Morse taxonomy, and the Freer Japanese ceramics as a whole are still organized by this geography-based scheme. In 1921, two years after Freer's death, Morse examined the entire ceramic collection again, and his gruff commentary, preserved in the Freer Gallery object records, is also included in this catalogue.

Such collections and publications predate Freer's purchases by a decade, but precedents they are: Kenzan collecting becomes a legitimate activity, replete with a literature and links to authoritative persons and institutions, foreign as well as Japanese. Freer knew the published work; it can be found in his library together with privately commissioned translations of the foreign-language texts. Freer also was no stranger to the culture of the international exposition from a visit to the 1876 Philadelphia Centennial and later the 1900 Paris fair.[13] And yet Freer's acquisitions diverge from the early ethnological or export-ware approach. He was obviously interested neither in contemporary ceramics nor in assembling Japanese ceramics as some kind of totality. Certain producers and products interested him. One should note, however, that the image of Japanese ceramics as industrial products would linger into the era that followed, there to ambiguously coexist with their new valuation as "art."

THE JAPANESE ART DIASPORA

The 1878 Paris Exposition Universelle was a watershed for things Japanese. Japan was represented by an industrial art display on the rue des Nations and a farmhouse near the Trocadero. The encounter with Asian displays at the Trocadero appears to have convinced powerful art administrator and future Ryūchi Kai leader Kuki Ryūichi (1852–1931) of the merit in protecting Japan's own artistic traditions. That encounter subsequently figured into policy initiatives that placed less emphasis on industrialization and more on the realization of an imperial state. Dealer Wakai Kenzaburō (1834–1908)

and his interpreter Hayashi Tadamasa (1853–1906), working under the aegis of the Kiritsu Kōshō Kaisha (Industrial commerce promotion company), also managed displays of Japanese art from private French collections at the Trocadero; soon the two were to become foremost purveyors of art information and fine collectibles to European enthusiasts. At the same time, Western authorities in Japan began to write and lecture about Japanese art—especially pictorial art. In 1879, British surgeon William Anderson (1842–1900) exhibited his art collection and delivered a lecture to the Asiatic Society in Tokyo; the American scholar and nascent art expert Ernest Fenollosa (1853–1908), who had arrived in Japan the year before to take up a philosophy post in the Imperial University, was in the audience. Finally, there were important changes in the ceramics world itself. The favorable reception of trade goods abroad elevated their status in Japan and contributed toward the formation of craft *(kōgei)* as a discrete genre. The success of named potters, who not only won awards but also were implicitly ranked in "industrial" and "art-craft" groupings at the great exhibitions, contributed to a more hierarchical view of ceramics production, one in which "artistic" values occupied the high ground. Finally, the products themselves changed. From the late 1870s, effusively decorated wares like the "brocade" Satsuma ceramics, once emblematic of Japanese ceramics in the world market, gradually surrendered esteem to porcelains with more sensitive—and painterly—combinations of form and brushwork.[14] All of these developments would, of course, encourage a new treatment of Kenzan.

The groundbreaking text for the new connoisseurs, both in the sense of creating a canon and providing a conceptual framework, was *L'Art japonais* (Japanese art), a survey by collector Louis Gonse (1846–1921) published in 1883. The chapter on ceramics in Gonse's book, written by entrepreneur Siegfried Bing (1838–1905), casts Kenzan in a different light:

Ogata Kenzan, who lived from 1663 to 1743, was the younger brother of the famous lacquer ware designer Ogata Kōrin and, like him, first studied painting. Even though he later moved, his work should be seen to represent the art of Kyoto. Much of his best work was made in Kyoto. Later he traveled to Sano and finally established himself in Edo, where he founded Imado ware which continued under the name Sumidagawa.

Even though he was using the same materials as his predecessors, Kenzan created a style that is completely personal. His designs have a special character, and on first encountering them, their large-scale designs and mastery of execution contrast with the miniaturist style of his predecessors. It is a new school whose influence continues unabated, but unfortunately this has opened up the door to numerous imitations of the master, replete with fraudulent signatures. To steer one's way through these fakes in Japan and in other countries, there is no better criterion

than the perfection of the object in question. Accordingly, the authentic pieces of Kenzan are spared from confusion, as the richness of their enamels and power of design cannot be equaled by any copyist. . . .

This brilliance is especially seen in the early work of the master, which was carried out during his term of work in the [Kyoto] urban potteries. The work at Imado [Edo] is of far less significance, but presents a different order: instead of neutral backgrounds that were meant to make the bold decorations more vibrant, in the new work an inquiry into color in general seems to have predominated as in the glossy glaze that contrasts with the soft tones of the decorations. This result is obtained through the use of an extremely friable and non-refractory clay body which, at low temperature, combines itself with a highly fluxed glaze.[15]

The genealogy quoted by Franks just a few years earlier is glossed over with artistic credentials; instead of ethnographic inclusiveness the concern is with authenticity—which for Bing (and later Freer) was determined by "perfection of the object."[16] Bing, who had lent some six hundred objects to the exhibition that Gonse organized to coincide with the publication,[17] illustrated four Kenzan wares in his essay, and one of them is now in the collection of the Musée Guimet, Paris.

A condensed version of Gonse's *L'Art japonais* published in 1886 has a similar flavor. Here Bing positions the Ogata brothers as emancipators: Kōrin freed Kyoto lacquer ware from the yoke of Tosa design (an ornate painting style associated with the court) and Kenzan liberated the ceramics world of the tyranny of the Chinese manner. Kenzan possessed a freedom of patternmaking with great masses of strong shades, showing "the advantages of simplification." What "seems to be artlessness is really Kenzan's solid talent."[18] Similar sentiments were voiced by British critic and founder of *The Studio* magazine Charles Holme (1848–1923), writing on Kenzan ceramics in *Japan and Its Art,* published in 1889 by British Fine Art Society director Marcus Huish (1845–1921).

Writing and exhibiting are, of course, deeply implicated in the selling of art. We have already mentioned Wakai and Hayashi; the latter remained in Paris to develop a clientele that was a cross section of the culture, business, and aristocratic world of 1880s urban France. In 1888, Bing launched his monthly journal *Le Japon artistique* (Artistic Japan) with concurrent issues in English and German. By no coincidence this paralleled the expansion of Japanese art sales into America and Germany, in which Bing played a major role. New collectors were encouraged by the breakup of the seminal French collections, including the sale of the Philippe Burty estate in 1891 and that of Edmund de Goncourt in 1897. Auctions at the Hôtel Druot in Paris became major events.

One of Bing's best German clients was Justus Brinckmann (1843–1915; fig. 4). Mesmerized by the Japanese goods exhibited in Vienna in 1873, Brinckmann began to assemble a collection that would eventually form part of the Museum für Kunst und Gewerbe in Hamburg. Kenzan appears to have been his greatest passion, and in 1897 he published *Kenzan: Beiträge zur Geschichte der japanischen Töpferkunst* (Kenzan: Commentaries on the history of the Japanese ceramic art). Through a talented assistant, medical student Hara Shinkichi, Brinckmann had access to the Japanese literature, permitting him to compile the broadest and most sophisticated summation on Kenzan until the post–World War II era. Consulting some of the earliest writing on Rimpa, such as Sakai Hōitsu's *Kenzan iboku* (Ink traces of Kenzan; 1823) and "Kōrin-Hōitsu," written for the new painting magazine *Kokka* by Tosa painter Kawasaki Chitora (1835–1902) in 1894, Brinckmann ranged over the tea ceremony, Chinese and Japanese poetry, indigenous Japanese criteria for ceramics connoisseurship, names of Kenzan followers and imitators, and scientific analysis.[19] Kenzan is rendered comprehensible under the gaze of modern art history. Freer possessed a copy of the German original—his scribbled notes on steamship-line stationery mention that he had received it as a gift from the "Hamburg Museum" in 1901. He also had a translated copy made for his private use. Freer had been in Germany in the summer of 1901. His records show that he purchased art from R. Wagner, Berlin, as of July 23 of that year, and presumably he met Brinckmann in Hamburg.

Fig. 4. Portrait of Justus Brinckmann, 1901, by Henriette Hahn-Brinckmann (1862–1934). Woodcut, ink on paper, 54.5 x 37.4 cm. Museum für Kunst und Gewerbe, Hamburg.

To japanophiles or enthusiasts of Japanese ceramics, the name of Frank Brangwyn (1867–1956; fig. 5) is largely known through Bernard Leach (1887–1979), the British potter who studied etching under Brangwyn in 1908. Leach thereafter traveled on to Japan and potter-posterity, but he never acknowledged Brangwyn as a source on Japan. As Ellen Conant mentions in a 1999 article, however, there are elements of Brangwyn's career that Leach "inadvertently may have appropriated or emulated."[20] Conant establishes Brangwyn's connections in a London japanophile community centered around painter Alfred East (1844–1913), Marcus Huish, William Anderson, and Charles Holme. According to Brangwyn's grandnephew Rodney, Brangwyn (like Freer) was an admirer of James McNeill Whistler (1834–1903).[21] Moreover, from 1895, Brangwyn worked closely with Siegfried Bing in decorating what would become the latter's celebrated Maison de l'Art Nouveau; other major commissions followed. By around 1903, Brangwyn appears to have amassed a large collection that included many Japanese objects. And while there is no evidence as to whether or not Leach saw Brangwyn's collection before his departure for Japan in 1909, the fact remains that both men's principal interest in historic Japanese ceramics was none other than Kenzan.

Fig. 5. Frank Brangwyn (1867–1956), 1937. From Rodney Brangwyn, *Brangwyn* (London: Kimber, 1978), 288.

In 1997, at the invitation of Fitzwilliam Museum curator Robin Crighton to see a "very large, and largely undisplayed collection of Edo period earthenware"

in Cambridge,[22] I found thirty-one pieces of Kenzan ware sold to the museum by Brangwyn in 1934—the largest collection in Europe. Brangwyn told biographer William de Belleroche that part of his collection was indirectly or directly acquired through "Yamanaka."[23] This was probably a broad reference to Yamanaka and Company's London office, opened in 1900 and managed by Yamanaka Tokusaburō, but it could also have been the founder Yamanaka Sadajirō (1866–1936), who had been in business in New York from 1895 and made frequent trips to London.[24] Bing must have been a source as well. In Brangwyn's words, "a Japanese pot—when it's the genuine article—such as a piece of Kenzan—well, there's no finer pottery in the world."[25] In terms of the types of Kenzan ware represented, and the percentage of pieces that we would today consider as authentic, the collection is very much like those assembled by Brinckmann and Freer. Unbeknownst to each other, Brangwyn and Freer even purchased pieces of the same set (see cat. no. 50).

Seen in such light, the Kenzan collection of Charles Lang Freer can be situated in an 1890s Japanese art diaspora. The expanded market was driven by a heightened consideration of Japanese goods as fine art, backed by a sophisticated knowledge of the production and meaning of the work. A generation of mobile and savvy antiquities dealers served as the interlocutors. The burgeoning American scene is chronicled by art historian Julia Meech, who cites the presence of import-export firms, professional dealers, and the incorporation of Japanese elements into fashionable style by decorators like Louis Comfort Tiffany (1848–1933). Collectors included the Vanderbilts, the Havemeyers, and especially Tiffany, landscape painter Samuel Colman (1832–1920), and attorney Howard Mansfield (1849–1938).[26] Ernest Fenollosa, who returned from Japan and a worldwide art tour in 1890 to take up a curatorial post at the Museum of Fine Arts, Boston, was soon to be situated as the premier authority on Japanese art. Freer's confidence in Fenollosa is well documented, and below we shall take up their mutual role in heightening international interest in Kenzan's Rimpa school.

FREER COLLECTS KENZAN

Charles Lang Freer (fig. 6) purchased or otherwise acquired Kenzan ceramics from twenty different sources in a period spanning 1894 to 1911. An early group of purchases, spanning 1894 through 1901, originated from New York–based dealers Rufus E. Moore (1840–1918) and Yamanaka and Company. Moore was the first dealer in Asian art patronized by Freer. The two had become acquainted through the above-mentioned Howard Mansfield, a New York lawyer, trustee to the Metropolitan Museum of Art, admirer of Whistler, and fellow member with Freer in the New York–based Grolier

Fig. 6. Charles Lang Freer (1854–1919), 1880s. Photograph by C. M. Hayes, Detroit. Freer Gallery of Art and Arthur M. Sackler Gallery Archives, Smithsonian Institution, Washington, D.C.

Club. Mansfield is mentioned in an 1892 letter from Moore to Freer, which adds that Moore had owned a number of Japanese hanging scrolls for seventeen years.[27] This would establish Moore as an early collector on the American scene. Moore must have been responsible in some way for expanding Freer's interest in ceramics, for his early Kenzan acquisitions from Moore are accompanied by purchases of porcelain, an unusual adventure for Freer at any stage.[28] Nevertheless, as is demonstrated in the catalogue section of this volume, all of the Kenzan wares he supplied to Freer were made in the late nineteenth century; they are also very similar to those furnished by one of Moore's own suppliers, Yamanaka and Company.

Fig. 7. Yamanaka Sadajirō (1866–1936), 1896. From Ko Yamanaka Sadajirō ō Den Hensan Kai, *Yamanaka Sadajirō den* (Tokyo: Ko Yamanaka Sadajirō ō Den Hensan Kai, 1939), facing p. 65.

The Yamanaka enterprise was inaugurated by Osaka-born Yamanaka Sadajirō (fig. 7). Thomas Lawton relates that when the shop opened in New York in 1895, among the earliest customers were Samuel Colman, Henry O. Havemeyer (1847–1907), and Rufus Moore in January and February of that year, followed by Freer in October.[29] Invoices in the Freer archives show that the firm engaged Freer's interest in Japanese ceramics, selling him large numbers of tea-ceremony wares and products of "named" potters like Kōetsu and Kenzan from 1896. From the lists alone, these are "catholic" purchases, not unlike the rosters of important pottery products prepared for the fairs—and, not coincidentally, similar to what one would find in history books today. Included in these lots, however, are lead-glazed earthenwares with "personal signatures"—of Chōjirō, Kōetsu, Kūchū, Kōrin, and Kenzan—which now appear to have been deliberately made for turn-of-the-century collectors. These will be discussed later, but it is difficult to avoid the conclusion that Moore and Yamanaka were knowing purveyors of newly made Kenzans. Yet the Freer-Yamanaka relationship was close: Freer hired a Yamanaka employee referred to as "Sezo Hatashita," who in 1906 created an elaborate hand-drawn catalogue of the pottery collection; Yamanaka also evaluated the contents of lists for Freer's 1906 bequest to the Smithsonian, including a "not good specimens" category—with pieces that look similar (at least by today's standards) to the very ones the firm had sold Freer.

Easily surpassing Moore and Yamanaka as a source of Kenzan wares was Matsuki Bunkio (1867–1941; fig. 8). Matsuki has been the subject of studies by Murakata Akiko, Frederic Sharf, and Grace Hélaine Williams.[30] Born in rural Nagano Prefecture but educated in a Tokyo Buddhist temple, Matsuki journeyed to Salem, Massachusetts, in 1888 and in that year became both ward and employee of Edward S. Morse, who found Matsuki's learning supremely useful in deciphering marks in his pottery collection. With a quick aptitude for merchandising his native culture, Matsuki within a year was homeward bound, commissioned to buy Japanese goods for a Salem department store.

Attending the Third Domestic Industrial Exhibition in Tokyo in that year must have alerted Matsuki to new strategies for selling and representing japanalia. On his next trip, in 1891, Matsuki conducted field research for Morse in addition to trading.

Fig. 8. Matsuki Bunkio (1867–1941), 1898. From frontispiece of *Descriptive Catalogue of an Important Collection of Japanese and Chinese Pottery* (Boston: private publisher, 1898).

In 1892, he was still working for Morse and wrote from Japan of "his hunger for pottery knowledge." In late 1893, Matsuki began to trade independently of his Salem employer, and by 1895 his self-representations were those of a fine art dealer. Over the next three years he consolidated his position in selling art objects rather than curios, and all but severed his ties with Salem.[31]

Charles Freer sought out Matsuki in the latter's Boston shop at 380 Boylston Street in the summer of 1896. The invoice for Freer's first Kenzan purchase from Matsuki remains in the Freer papers; he bought a rectangular dish (cat. no. 49) along with works attributed to late-Edo period woodblock-print artists Katsukawa Shunshō (1726–1792), Torii Kiyonaga (1752–1815), and Katsushika Hokusai (1760–1849).[32] This was the beginning of a close relationship marked by many mutual courtesies. At the end of September, for example, Freer sent a Whistler engraving to Matsuki's American wife, Martha, proffering that there was a great harmony between it and Sōami (1485?–1525), a Muromachi period (1333–1573) landscape painter.[33] The following month Freer acknowledged receiving a Matsuki translation of Ninagawa's *Kanko zusetsu* (Illustrated discourse on antiquities).[34] This was Freer's first sustained relationship with someone closely associated with the world of Japanese antiquities, and in Freer's letters and uncharacteristically lavish cash advances there is eagerness if not infatuation. Certainly one can detect changes in Freer's collecting interests through the Matsuki correspondence, for less than two years after their first meeting Freer had moved from the well-trodden path of late-Edo period woodblock prints to more adventurous fields such as medieval ink painting and Rimpa.[35]

In 1899, just as Matsuki adorned his letterhead with the title "Importer of Japanese Fine Arts," his descriptions of objects became more effusive, with comments about age and provenance. Some of these strain credibility. But more than the embroidery it was the arrival of Ernest Fenollosa (fig. 9) that would spell an end to the Freer-Matsuki relationship. By April of 1901, only three months after his first encounter with Fenollosa, Freer was returning two Kenzan water jars that Matsuki had attributed to the much-touted Ikeda Collection.[36] Habitually vigilant in matters of money, Freer had begun to consult Fenollosa over the fairness of Matsuki's prices and the quality of his merchandise.[37] By 1904, Matsuki's correspondence suggests that Fenollosa was screening all prospective purchases;[38] a 1906 letter from Fenollosa to Freer obliquely accused Matsuki of untrustworthiness.[39] The bond with Matsuki all but dissolved in 1909 as Freer pressed him to repay outstanding debts. Morse's caustic remarks about Matsuki are to be found in his written commentary on the Freer ceramics collection; some of Morse's comments are quoted in this catalogue.

The archival picture of Matsuki is hardly favorable. Undoubtedly Matsuki grew into a wily dealer who understood the rhetoric of the art market. He embellished many

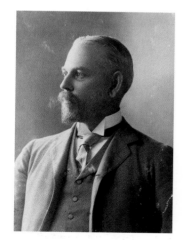

Fig. 9. Ernest Francisco Fenollosa (1853–1908), ca. 1890. Photographer unknown. Freer Gallery of Art and Arthur M. Sackler Gallery Archives, Smithsonian Institution, Washington, D.C.

of his sales with exaggerated if not downright bogus claims about their makers or provenance.[40] In a ploy not uncommon to the antiquities market in Japan today, he also tried to sell objects in groups—of variable quality. Yet by providing both information and many quality pieces, Matsuki is unsurpassed as Freer's "Kenzan" dealer. His Kenzan offerings do include the same type of patent forgeries that Freer and other period collectors purchased elsewhere, but with only one or two exceptions, Matsuki's Kenzan wares (not to mention many other splendid objects in the Freer Gallery's collection) are the finest; even those not attributable to the first Kenzan are by today's standards reasonable approximations. This can only be explained by Matsuki's experience and doggedness in the field.[41] Nevertheless he was maligned by Fenollosa and Morse, both of whom were constructing mythic selfhoods that excluded external—read Japanese—support. The apotheosis continues to the present day. As for Freer, he may have had reason to gripe about Matsuki's indebtedness, but unresolved accounts are typical of good art dealer-client relationships in Japan even today. Freer had in fact written Matsuki at the end of 1898 that, "Whatever there may be still due me can be adjusted any time in the future convenient to you"[42] But this was evidently forgotten, helping us to understand why Matsuki returned to live out his last years in Japan, with little to say about those halcyon days in America.[43]

As Freer's confidence as a collector deepened, he expanded his network of Kenzan providers, variously purchasing from "S. Eida" (Iida Shinshichi) in 1899, Ōshima Kanō in 1900, and "Hayashi" (probably Hayashi Shinsuke) in 1900. Freer's European trip in 1901 included Kenzan purchases from Siegfried Bing in Paris and "R. Wagner" in Berlin. The collection was filled out with purchases from the sale of the estate of Samuel Colman in 1902 and from Tokyo-based dealer Kobayashi Bunshichi (1864–1923) in 1902 to 1905, and with gifts from Honma Kosa in 1904 and British collector Michael Tomkinson in 1904. Several Kenzan wares were purchased from dealers "K. Suzuki" in New York in 1904 to 1905 and from "H. R. Yamamoto," Boston, in 1905. Purchases from the sale of the collection of Washington real estate mogul Thomas E. Waggaman in 1905, from various Japanese sources in the spring of 1907, from a "T. Kita" (Kita Toranosuke) in Kyoto the same year are recorded. On Freer's last trip to Japan, in 1911, he purchased from a dealer named Satō in Nagasaki and a "Y. Fujita in Kyoto."[44] With the exception of an occasional rogue find (the dish from the Waggaman sale [cat. no. 16] is one such example), most of these later acquisitions also represent nineteenth-century production, including wares in a modest Kenzan style and downright forgeries.

Fig. 10. James McNeill Whistler
(1834–1903), ca. 1894. Photograph by
M. Dornac. Freer Gallery of Art and
Arthur M. Sackler Gallery Archives,
Smithsonian Institution,
Washington, D.C.

By 1911, Freer had accumulated more than seventy specimens of Kenzan ware, a group that is clearly the largest outside of Japan and one of the largest anywhere; only the holdings of the Idemitsu Museum of Art in Tokyo and the Miho Museum in Shiga Prefecture are more extensive. Both collections, however, have been assembled in recent decades. In the next chapter we will explore the Freer pieces as a trove of information about early modern Japanese design in general and Kenzan ware in particular.[45] But aside from assembling the collection, Freer's focus on Kenzan can tell us something about the man and his times. What was between Freer and Kenzan?

As was the case with other American artists, collectors, and critics, Freer's initial receptivity to things Japanese was rooted in the Aesthetic Movement, wherein formal considerations such as line, color, contour, and composition became the defining criteria in the arts, irrespective of medium or subject. The appointments of Freer's Detroit house, completed in 1892, demonstrate those beliefs. The gates to Japan were opened, however, by the artist that Freer admired and trusted most, James McNeill Whistler (fig. 10). Whistler used Japanese art as an inspiration in his painting and was an avid collector of Japanese prints and Chinese porcelain. Through Whistler, Freer acquired a critical paradigm: Japanese art embodied an emancipation from realism, detail, and didacticism, a world where many arts, ceramics included, could speak of a universal artistic motive. Whistler also provided a collector's raison d'être: he introduced Freer to Japanese art, not as an end, but in Freer's own words, as a "last gasp of a great tradition," the remains of a far earlier and higher culture.[46]

With their rigorous design sense and artificial juxtapositions of color and texture, Whistler's canvases constituted a real-time model. Thus Fenollosa, describing Freer's collection, could write, "A mural painting by Kanō Yeitoku [Eitoku], a tea bowl by Kenzan, an oil seascape by Whistler, achieve similar delicious tone effects."[47] Considering that from the early 1880s, Kenzan ware was described as a triumph of limited impression, simplicity, and formal effect, Freer's attraction is understandable. In his few recorded comments on Kenzan ware, then, Freer shows a fascination for surface. Freer points out such features as "perfect glaze and strong modeling" (cat. no. 75) and finds fault with "minor details of the landscape and mechanical formation of the writing" (cat. no. 1). Modeling, spacing, painting, and calligraphy (cat. no. 54) are objects of approbation, but aside from a reference to "Shigaraki clay" in catalogue number 65, Freer's Kenzan exists out of time and space.

As part of a mission to recover a "lost tradition" through material evidence, Freer's Kenzan collection is an extension of the ethnographic impulse outlined at the beginning of this chapter. But letters from 1900 and 1901 reveal a growing perception of

Japanese ceramics not simply as pleasing products, but as credentialed masterworks.[48] From January 1901, Freer began to hold forth about pots in a series of letters to New York dealer Rufus Moore. In February of that year, Moore offered a ceramic plaque with the Kenzan mark (cat. no. 8), and upon receipt of the object Freer gushed, "...I am quite content in considering it strictly as a work of art, regardless of its making."[49] But after inspections by Fenollosa and Matsuki, and probably Kyoto dealer Kita Toranosuke, Freer was chary:

> I promised to write you about the Kenzan plaque. Two of the experts who saw
> it declared without hesitation that it is not genuine but it was made by the same
> chap, now living in Kyoto, who created several of the large jars and tea bowls,
> all counterfeits, seen in the country within the last six months. One of them
> told me that he saw at least four or five duplicates of this piece on sale in Kyoto
> last summer.[50]

Letters to Moore later that year show that the new concern with authenticity was matched by a growing affection for big names on ceramics. Freer enthuses that "Kōrin did some wonderful things in pottery" and that a new Kōetsu jar "is a wonder of potting, and the type of thing that would make your back go goose-flesh for a month."[51] The object of fascination is a type of earthenware characterized by chunky shapes derived from lacquer ware and tea-ceremony utensils, decoration that quotes extensively from late-Edo period printed manuals of Rimpa design, glossy lead glazes in black and salmon red, and the interchangeable use of marks of "named" potters/ designers such as Kōetsu, Chōjirō, Kūchū, Kōrin, and Kenzan. This is an art-market confection: the predominance of lacquer-ware forms is generated by the success of Rimpa lacquer ware abroad (Kōrin, for example, was recognized first as a lacquerer); the omnipresent hand-manufacture implies a personalized, individual work, and the signatures are there to spark recognition among collectors who knew the names but little else. These pieces were bought not only by Freer, but also by New York art doyenne Louisine Havemeyer (1855–1929), Justus Brinckmann, and Frank Brangwyn. The period of manufacture is suggested by juxtaposing these pieces with yet another collection, that assembled by Edward S. Morse. The Morse Kenzan pieces, purchased chiefly between 1878 and 1882 under the influence of Ninagawa Noritane, do not display the big signatures and hyperbolic designs—they are conservative workshop products. Morse was duly suspicious, and in his comments on the Freer collections summarily dismissed these named earthenwares as being "fresh from the oven."

The date of production, then, should be the late 1880s or more likely the early 1890s. Fakes, of course, operate in a climate of expectations, and it has been suggested

that these pieces reflect an overseas "cult of Rimpa" that formed around collectors like Freer and Louisine Havemeyer.[52] Writing in 1906, Fenollosa even anointed Freer as the instigator of an entire Rimpa revival: "The national significance of this school as a whole has only recently been understood, since indeed Mr. Freer, of Detroit, has brought together so many striking pieces."[53]

But the record shows that Rimpa publishing and exhibiting had already surged dramatically in Japan in the late 1880s.[54] Behind it was the maneuvering of governmental factions: by this time the state had become the focus of ideological and cultural struggles, and specific types of art furthered political agendas.[55] From the early 1890s, spurred by the translation into Japanese of Anderson's and Gonse's books, Japanese critics built a Rimpa rhetoric around imported keywords such as "original," "unique," "most Japanese of Japanese," "impressionism," and "decorative art."[56] This line, heightened by the burst of national confidence that followed the Sino-Japanese War (1894–95), came to be echoed in a number of turn-of-the-century publications. By the opening years of the new century, Rimpa had taken its place as a cornerstone of national style. Freer's collecting helped to shape these enthusiasms—but it did not inaugurate them as Fenollosa had claimed. There is also evidence that the corpulent "cult" pieces of Kenzan ceramics were sold in Japan as well.[57]

On the other hand, documents and circumstantial evidence suggest that Freer, together with Fenollosa, did make a solid impact on a new generation of collectors in the early years of the twentieth century. Fenollosa's return to Japan in 1897 must have exposed him to the accelerated nationalist fervor, for in his second treatise on Japanese art, published in *Century Illustrated Magazine* in 1898, he positively evaluated the "Kōrin manner" in terms of its ability to "return to native traditions."[58] A March 1901 letter from Fenollosa to Freer hints that paintings attributed to Hon'ami Kōetsu (1558–1637) occupied a prominent place in the latter's collection, and the just cited letters to Moore show the heightened appreciation of Rimpa names in pottery.[59] Freer and Matsuki were exchanging letters about the Rimpa-school lineage in 1902.[60] The burgeoning Western scene came to the attention of newer Japanese collectors after 1904, when art reformer Okakura Kakuzō (Tenshin, 1862–1913) began to travel between Boston and Tokyo.[61] In 1905 to 1906, Freer purchased two stunning sets of screens by Kenzan's Rimpa-school forebear Tawaraya Sōtatsu (active ca. 1600–1640), *Waves at Matsushima* (F1906.231–232) and *Dragons and Clouds* (F1905.229–230). Interest in the art of Kōetsu gained new momentum in Japan the following year, centered around the Daishi Kai tea gatherings sponsored by industrialist-collector Masuda Takashi (Don'ō, 1848–1938) and his employer, the Mitsui Company. This was also the year that Freer, during a visit to Japan, penetrated the circle of these elite collectors (fig. 11). Given this chronology, it is

hardly believable, as the influential scholar Yashirō Yukio once ventured, that Masuda and his fellow collector Hara Tomitarō (Sankei, 1868–1939) were responsible for Freer's interest in Kōetsu.[62]

The rapid exchange of objects, rhetoric, and persons cautions us against identifying any single, dominating agent in this exchange. Indeed, the entire turn-of-the-century craft canon testifies to the malleability of venerable symbols, whether they be industry, art, nationhood, or civilization in the singular. The Ryūchi Kai members who raised alarms about preserving Japan's material legacy were the same men who, less than two decades earlier, had arranged for those goods to be sold in Europe and America. Their growing Rimpa enthusiasms were cribbed from foreigners like Gonse—who had in turn been tutored by two Japanese, Hayashi and Wakai. Masuda Don'ō considered Freer a serious rival and possibly a threat to the national patrimony, but he also celebrated Freer's contribution to the field through the erection of a memorial stone at the Kyoto temple Kōetsuji, where the Kōetsu Kai meetings still take place. The Kōetsu Kai would became a vehicle for incorporating Rimpa objects into the tea ceremony, and also helped to build the Rimpa valuations in place today—price hikes, incidentally, that had discouraged Freer from making further purchases in his late years. Yet in the decades leading up to World War II, the Kōetsu Kai tea records are largely bereft of Kenzans.[63] For tea-ceremony practitioners, the admiration of a pot requires a social history: the vessel is expected to relate demonstrably to certain users, specifically military men and tea masters. There are few, if any, Kenzan wares with such a pedigree. Moreover, the exuberant Kenzan decor was alien to the subdued taste that measured value for tea connoisseurs—and thoroughly alien to the code of self-restraint enforced by militarists of the 1930s. Thus the Kenzan market was dormant in the early decades of the twentieth century, but the ground was nevertheless laid for Kenzan's postwar emergence as an artist-potter.

Freer and his collection are part of that foundation. Through select purchases, writing, and exhibiting, Freer and his contemporaries had placed Kenzan in an elite, internationally recognized group of "uniquely" Japanese "decorative" or even "impressionist" artists whose names ranged over the fields of painting, lacquer ware, and ceramics. Such recognition, further buttressed by the emergence of designer-

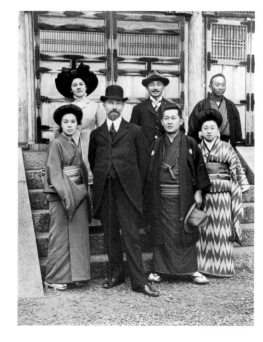

Fig. 11. Freer with Hara Tomitarō (1868–1939) and company, 1907. Freer Gallery of Art and Arthur M. Sackler Gallery Archives, Smithsonian Institution, Washington, D.C.

led craft production in Japan,[64] encouraged a new generation of scholars to write about Kenzan's life. By the 1940s, they had produced a reasonably detailed narrative of Kenzan's youth and productive years. In 1949, Kobayashi Taichirō consolidated the evidence into his romantic *Kyoto Kenzan,* where the artist's life was portrayed as a triumph of spirit and cultivation over ebbing material fortunes. The perceived twists and turns of Kenzan's career played well in the malaise of the 1950s and early 1960s in Japan. These were, after all, the same audiences who were moved by imported films highlighting the sufferings of Toulouse-Lautrec and van Gogh.[65] A tragic autonomy was the real foundation of art. Any objects serving this master narrative, including the ones that surfaced in Sano in 1962, were now represented as genuine examples of the master's work. Art—which Charles Lang Freer duly recognized—and artfulness—which he unknowingly abetted—conjoined in the modern Kenzan drama.

NOTES

1 The name of calligrapher and designer Hon'ami Kōetsu (1558–1637) was applied to the style of painting and craft decoration that came to be called the Rimpa school (school of Kōrin) from the early twentieth century. The relationship of Rimpa, Kenzan, and Freer is taken up at the end of this chapter.

2 Rupert Faulkner and Anna Jackson, "The Meiji Period in South Kensington: The Representation of Japan in the Victoria and Albert Museum, 1852–1912," in *Treasures of Imperial Japan; Selected Essays*, ed. Oliver Impey and Malcolm Fairley (London: Kibo Foundation, 1995), 168.

3 Sato Dōshin, "The Policies of the Meiji Government for the Promotion of the Craft Industries and the Export Trade," in ibid., 62.

4 Robert W. Rydell, *All the World's a Fair: Visions of Empire at American International Expositions, 1876–1916* (Chicago: University of Chicago Press, 1984), 2.

5 Augustus Franks, *Japanese pottery: being a native report with an introduction and catalogue* (London: Chapman and Hall, 1880). Kenzan ware was first displayed outside Japan at the Vienna exposition in 1873.

6 Ibid., 60.

7 For the Franks exhibition, see Augustus Franks, *A Collection of Oriental Porcelain and Pottery, Lent for Collection by A. W. Franks* (London: South Kensington Museum, 1878); the Bethnal Green group is now in the collection of the British Museum. For Audsley-Bowes, see James Bowes and George Ashdown Audsley, *The Keramic Art of Japan* (Liverpool: private publication, 1879). Bowes was a champion of the gaudy export style and had little to say about Kenzan other than repeating some of the comments in the Philadelphia catalogue originally compiled by Shioda Shin. The Bowes collection, which included a few Kenzan wares, was dispersed through auction at Liverpool after his death.

8 Ellen Conant, "The French Connection: Emile Guimet's Mission to Japan, A Cultural Context for Japonisme," in *Japan in Transition: Thought and Action in the Meiji Era, 1868–1912*, ed. Hilary Conroy, Sandra T. W. Davis, and Wayne Patterson (Rutherford: Fairleigh Dickinson University Press, 1984), 133.

9 See Mukai Shikamatsu and Takimoto Seiichi, eds., *Nihon sangyō shiryō taikei* (Compendium of materials on Japanese industry), vol. 5 (Tokyo: Naigai Shogyō Shinpō Sha, 1926–27).

10 See Ellen Conant, "Captain Frank Brinkley Resurrected," in Impey and Fairley, *Treasures of Imperial Japan*, 124–51. Brinkley sold his first and major collection to New York dealer Charles Greey in 1884, who broke it up into pieces.

11 Morse mentions in an "Errata, Addenda and Corrigenda" of 1912 that the bulk of his collection was assembled between 1878 and 1882. Edward S. Morse, *Catalogue of the Morse Collection of Japanese Pottery*, with an introduction to the new edition by Terence Barrow (Rutland, Vermont: C. E. Tuttle, 1979).

12 Edward S. Morse, *Catalogue of the Morse Collection of Japanese Pottery* (Cambridge: Riverside Press, 1901). A Freer letter of 8 November 1897 thanks Morse for his first visit to the former's home in Detroit. A second visit took place on 1 March 1900. A letter from Freer of 29 December 1900 shows that Morse sent Freer promotional literature for his catalogue, which Freer helped market in Detroit. Freer gave Morse some of his own unwanted pieces in 1909, and on 2–3 May 1909, Morse visited Detroit again for another examination of the collection. All correspondence addressed to Freer quoted here is from the Freer Gallery of Art and Arthur M. Sackler Gallery Archives, Smithsonian Institution, Washington, D.C., unless otherwise specified.

13 Thomas Lawton and Linda Merrill, *Freer: A Legacy of Art* (Washington, D.C.: Freer Gallery of Art in association with Harry N. Abrams, 1993), 63, 116, respectively. Freer was also on hand for the Domestic Industrial Exhibition in Kyoto during his first trip to Japan in 1895.

14 This is not to say that cheaper trade goods, including the ornate styles of Satsuma and Kutani, went into a sudden decline in the 1880s; they continued to flourish up to the time of the Russo-Japanese War (1904–5).

15 Siegfried Bing, "La Ceramique" (Ceramics), in Louis Gonse, *L'Art japonais* (Japanese art) (Paris: Quantin, 1883), 286–88.

16 Rydell submits that these more favorable accounts were a form of custodianship, through which Euro-Americans could come to terms with the disquieting realization that superlative material goods were made by a people they considered inferior to themselves. Rydell, *All the World's a Fair*, 29–30.

17 Gabriel Weisberg, *Japonisme: Japanese Influence on French Art, 1854–1910* (Cleveland: Cleveland Museum of Art, 1975), 147.

18 Gonse, quoted in *Kenzan: Commentaries on the History of the Japanese Ceramic Art* (undated translation of Justus Brinckmann, *Kenzan: Beiträge zur Geschichte der japanischen Töpferkunst* in the collection of the Freer Gallery of Art), 3.

19 The first chapter of *Kenzan: Beiträge* was translated in Sakiyama Genkichi, "Kenzan yaki" (Kenzan ware), *Shoga kyōkai zasshi* (Painting and calligraphy society magazine) 3 (1899): 21–23.

20 Ellen Conant, "Bernard Leach, Frank Brangwyn, and Japan," *Studio Potter* 27:2 (1999): 16.

21 Rodney Brangwyn, *Brangwyn* (London: Kimber, 1978), 76.

22 Robin Crighton to the author, private correspondence, 11 November 1997.

23 William de Belleroche, *Brangwyn's Pilgrimage* (London: Chapman and Hall, 1948), 256.

24 See Thomas Lawton, "Yamanaka Sadajirō: Advocate for Asian Art," *Orientations* 26:1 (January 1995): 80–93.

25 de Belleroche, *Brangwyn's Pilgrimage*, 256.

26 Julia Meech-Pekarik, "Collecting Japanese Art in America," in *Japonisme Comes to America*, ed. Julia Meech-Pekarik and Gabriel Weisberg (New York: Harry N. Abrams in association with the Jane Voorhees Zimmerli Art Museum, 1990), 43–44.

27 Rufus Moore to Charles Lang Freer, 3 November 1892.

28 Freer purchased a Kenzan ware desk screen (cat. no. 10) together with two "Imari" dishes from Moore in 1897 (Moore to Freer, 2 July 1897).

29 Lawton and Merrill, *Freer*, 81.

30 See Murakata Akiko, "Nichibi hōshi—Matsuki Bunkyō—no koto" (Matsuki Bunkio: the connoisseur-priest), *Ukiyo-e geijutsu* 66 (1980): 3–17; Frederick A. Scharf et al., *A Pleasing Novelty: Bunkio Matsuki and the Japan Craze in Victorian Salem*, Essex Institute Historical Collections 129:2 (April 1993): 147–59; and Grace Hélaine Williams, "Charles Lang Freer and Matsuki Bunkio: Connoisseur and Dealer in the Era of Japonisme" (master's thesis, Cooper-Hewitt, National Design Museum, Smithsonian Institution, and the Parsons School of Design, 1998).

31 Frederick A. Scharf, "Bunkio Matsuki: 'Salem's Most Prominent Japanese Citizen,'" in Scharf et. al., *A Pleasing Novelty*, 147–60.

32 Matsuki Bunkio to Freer, 8 October 1896. The two men had been exchanging notes about Kenzan, however, from their very first acquaintance as a Freer to Matsuki letter of 1 August 1896 mentions, "I note what you say regarding the Kenzan dish."

33 Freer to Matsuki, 30 September 1896.

34 Freer to Matsuki, 16 October 1896.

35 Matsuki to Freer, 5 April 1898, mentions purchases of paintings attributed to Muromachi ink painter Oguri Sōtan (1413–1481) and Rimpa masters Sōtatsu and Kōrin.

36 Freer to Matsuki, undated letter of April 1901. The so-called Ikeda collection was widely billed as a private collection of a great art connoisseur, but in fact was part of the inventory of Kyoto dealer Ikeda Seisuke (1840–1900). See Patrick J. Maveety, *The Ikeda Collection of Japanese and Chinese Art at Stanford* (Stanford: Leland Stanford Junior Museum of Art, 1987). Freer did acquire at least five Kenzan pieces from the Ikeda collection through Matsuki.

37 Lawton and Merrill, *Freer*, 103–10.

38 Matsuki to Freer, 20 January 1904.

39 Ernest Fenollosa to Freer, 25 September 1906.

40 Sharf et. al., *A Pleasing Novelty*, 159; in correspondence with Freer, for example, Matsuki enhances pieces by claiming, "Following are five important pieces from the sale of the late Mr. Funahashi of Kyoto, a famous silk wholesaler for many generations; the sale was under the management of Mr. Shinsuke Hayashi from whom your great screen came." (The list includes, for example, a Kenzan-ware incense box with design of maple leaves, catalogue number 38, which is clearly the product of a late-nineteenth-century workshop.) Matsuki to Freer, September 1903.

41 Matsuki's better Kenzan purchases must have required a deeper penetration into local markets; Matsuki's older brother Zenemon (1864–1949) had established a shop called Sōkodō in the Shinmonzen area of Kyoto, where many of the best dealers kept their shops.

42 Freer to Matsuki, 29 December 1898.

43 Lawton and Merrill, *Freer*, 110.

44 Further information on the dealers who provided Kenzan wares to Freer:

S. EIDA was probably Iida Shinshichi, a founding member of the connoisseur's group Kōetsu Kai. See Oda Seiichi et al., *Kōetsu Kai no ayumi* (The path of the Kōetsu Kai) (Kyoto: Kōrin-sha, 1981), 51.

ŌSHIMA KANŌ had a gallery whose stationery announced a specialty in "Antique and Modern Works of High Art from the Far East" on 564 and 566 Fifth Avenue (as of Freer to Ōshima, 7 March 1901). He sold Freer a Kenzan bowl along with a lot of seven other Japanese ceramics, including wares marked "Kōetsu" and "Ichinyū" (Ōshima invoice to Freer, 10 December 1900). This is probably the same Ōshima recalled by former Yamato Bunkakan director Ishizawa Masao, who knew New York dealers "Fukushima and Ōshima" during his work at the Metropolitan Museum of Art in the 1930s (Murakata, "Nichibi hōshi," 11).

HAYASHI: It is unclear whether this is Hayashi Tadamasa, centered in Paris, or the prominent Kyoto dealer Hayashi Shinsuke, whose shop was located at 39 Furumonzen, Kyoto. See Helen Nebeker Tomlinson, "Charles Lang Freer: Pioneer Collector of Oriental Art" (Ph.D. diss., Case Western Reserve University, 1979), 321, n. 20. Freer did correspond with the latter. Hayashi appears in Kōetsu Kai records no later than 1920. See Oda et al., *Kōetsu Kai,* 58.

SIEGFRIED BING and Freer met in Paris in July 1901; Freer visited Bing's shop in the company of Whistler. Freer bought Kenzan, Sōtatsu, and Korin-attributed paintings at this time (Lawton and Merrill, *Freer,* 116); presumably the ceramics were purchased then too. It was through Bing in 1903 that Freer tried to buy a screen attributed to Kenzan that, after vigorous bidding, was finally purchased by Yamanaka and Co. for an unprecedented sum (ibid., 117–18).

R. WAGNER'S gallery was located on SW Dessauerstrasse 2, Berlin; the Kenzan acquisition was part of a lot of sixty-four objects, almost all of which were ceramics (Wagner to Freer, 25 July 1901).

SAMUEL COLMAN was a New York landscape painter who had known Henry O. Havemeyer as early as 1875; together they visited the Centennial in Philadelphia in 1876. With Tiffany, Colman became Havemeyer's aesthetic advisor. Colman had visited Japan and had begun to collect ceramics as early as 1880; he also left a collection to the Metropolitan Museum of Art in 1893 (Conant, "Captain Frank Brinkley Resurrected," 148, n. 49).

KOBAYASHI BUNSHICHI sold prints and old books. He inaugurated his Tokyo business in the Asakusa area about 1887, and he had a business relationship with Fenollosa; the latter wrote catalogues for Kobayashi from 1898, and Kobayashi furnished materials for Fenollosa's New York sales. Freer first met Kobayashi in Japan in 1895, and Freer's impressions of him, initially unfavorable, seem to have become more positive from 1903, when the dealer came to terms with Freer's standards (Tomlinson, *Charles Lang Freer,* 340, 371). Kobayashi's role in propagating knowledge of Japanese art through the dissemination of books should not be overlooked; I have found books provided by him in a number of American collections, and the list of printed matter he sold Freer is impressive. For more on Kobayashi's activities see Yamaguchi Seiichi, "Kobayashi Bunshichi jiseki" (Achievements of Kobayashi Bunshichi), *Saitama Daigaku kiyō sōgō hen* (Comprehensive record of Saitama University journals), vol. 6 (February 1998).

HONMA KOSA: Correspondence from Yamanaka to Freer shows the former visiting Honma at his home in Tokyo and buying pieces of his collection (Yamanaka to Freer, 10 September 1904). In the same year Kobayashi Bunshichi offered Freer ukiyo-e paintings from the Honma collection (Tomlinson, *Charles Lang Freer,* 371).

K. SUZUKI appears to have been a Japan-based dealer who brought goods to New York. Freer also purchased a pot marked "Kōetsu" from him.

H. R. YAMAMOTO was Kobayashi Bunshichi's Boston representative, managing the latter's shop on 350 Boylston Street (H. R. Yamamoto to Freer, 21 December 1902).

T. KITA: According to Freer biographer Helen Tomlinson, only one lasting dealer relationship resulted from Freer's first trip to Japan in 1895. This was with Kita Toranosuke, "a curio dealer then associated with Yamanaka and Company" (Tomlinson, *Charles Lang Freer*, 18). Kita also visited the United States in 1900 and Freer introduced him to other collectors (Tomlinson, *Charles Lang Freer,* 338). A letter from Freer to Kita dated 26 August 1902 shows that Kita opened his own Kyoto shop in "19 Sanjō-dori, Kiyamachi" in that year (Freer to Kita, 26 August 1902). Kita wrote Freer from "Sanjō Kobashi," Kyoto, of having visited the Kōetsuji Temple on 18 June, 1912, in the company of Yamanaka's clerk, Ushikubo (Kita to Freer, 21 June 1912).

Y. FUJITA had a gallery in Kyoto, and his name appears in Freer's pocket diary from his 1911 trip. Invoices show that Fujita had a shop in New York before returning to Kyoto, and that Freer bought from both locations.

45 Our judgments about Freer's Kenzan collecting should also take into account pieces that were given away as presents or returned to dealers. See Tomlinson, *Charles Lang Freer,* 327–28.

46 As told by Freer to Agnes Meyer in 1913. See Agnes E. Meyer, *Charles Lang Freer and His Gallery* (Washington, D.C.: Freer Gallery of Art, 1970), 5.

47 Fenollosa, quoted by David Curry in "Charles Freer and American Art," *Apollo* 118:258 (August 1983): 174, 176.

48 Edward Morse jumped on the ceramics-as-art bandwagon as well. In the preface to his 1901 catalogue, written well after the bulk of his collection was formed, Morse wrote, "The proper assignment of Kenzans to their respective families, and the detection of fraudulent Kenzans, will offer another field for study." Edward S. Morse, *Catalogue of the Morse Collection of Japanese Pottery* (Boston: Museum of Fine Arts, 1901), 365.

49 Freer to Moore, 18 February 1901.

50 Freer to Moore, 12 March 1901. The identity of the visiting experts can be inferred by letters in the Freer archives from the winter and spring of 1901.

51 Freer to Moore, 21 October 1901, 13 November 1901, respectively. Tomlinson makes the important point that from his earliest days in the 1880s collecting Dutch graphics, Freer felt most comfortable collecting art by artist (Tomlinson, *Charles Lang Freer*, 332). This carried over into ceramics, with the unintended result of enhancing the named "cult" potters.

52 Julia Meech, "The Other Havemeyer Passion: Collecting Asian Art," in *Splendid Legacy: The Havemeyer Collection,* ed. Alice Cooney Frelinghuysen et al. (New York: Metropolitan Museum of Art, 1993), 145.

53 Ernest Fenollosa, *Epochs of Chinese and Japanese Art* (New York: Dover Publications, 1963; first edition published posthumously in 1912), 126.

54 The Meiji era ascent of Rimpa is embodied in the career of Edo Rimpa painter Nakano (Seisei) Kimei (1834–1892). In 1875, Kimei was in the employ of the Ministry of Home Affairs; in 1882 he received a prize in the first National Painting exhibition; in 1884 he became a member of the Far Eastern Painting Association, received a commission for painting in the Meiji palace, and was awarded another prize in the second National Painting exhibition. He was then instrumental in a series of Rimpa publications: *Ogata ryū hyakuzu* (A hundred pictures of the Ogata school; 1889); reprints of the *Kōrin hyakuzu* (A hundred Kōrin pictures; 1890) and *Kenzan iboku* (Ink traces of Kenzan; 1823); and a reprinted *Ogata ryū ryaku impu* (Abbreviated Ogata school seals; 1891). Kimei was planning a large Rimpa exhibition for 1892, and after his death his son Kigyoku carried on the arrangements. On June 2, the Nippon Bijutsu Kyōkai (Japan Art Society) sponsored an exhibition of Rimpa-school works in Ueno, Tokyo, featuring 350 works by Tawaraya Sōtatsu, his follower Sōsetsu, Kōrin, Kenzan, Watanabe Shikō, Tatebayashi Kagei, Hōitsu, Kiitsu, and various Hōitsu disciples. The *Hyakuzu* was also republished that year. See Ishii Hakutei, "Kenzan tsuizen tenrankai" (Kenzan commemorative exhibition), *Kaiga soshi* 64 (1892): 2–3. This Rimpa revival also coincides with the imperial household's most aggressive patronage of Japan Art Association shows and painters.

55 The faction that championed Rimpa was the Nippon Bijutsu Kyōkai (Japan Art Society), formerly the Ryūchi Kai, led by the same men who had supervised the international exhibition programs and established the national museum and domestic art exhibitions such as the Kanko Bijutsu Kai, which had exhibited Rimpa painting as early as 1882 (Timothy Clark, "The Intuition and the Genius of Decoration: Critical Reactions to Rimpa Art in Europe and the USA during the Late Nineteenth and Early Twentieth Centuries," in *Rimpa Art from the Idemitsu Collection, Tokyo*, ed. Yamane Yūzō, Naitō Masato, and Timothy Clark [London: British Museum, 1998], 76). The name change to Nihon Bijutsu Kyōkai coincided with an accelerated interest in a "national" art, as the group sought to align itself with the Imperial Household (in opposition to a rival faction allied with the Ministry of Education). The background for these struggles was the structuring of a constitutional monarchy to serve as foundation for a modern state. Appropriately, the new governor of the Nihon Bijutsu Kyōkai was an imperial relative, Prince Arisugawa Taruhito (1835–1895). See Sato Dōshin, "The Japan Art Association," in *Nihonga: Transcending the Past*, ed. Ellen Conant et al. (St. Louis: Saint Louis Art Museum, 1995), 80.

56 Clark, "The Intuition," 72.

57 I have seen several pieces in private Japanese collections, and recently I have found that—yes, the Sano Kenzan scandal of 1962—encouraged collectors and critics to dust them off and publish them as originals. They are featured in Aimi Kōu, "Iriya Kenzan no tenbō" (Outlook on Iriya Kenzan), *Hōshun* 102 (1962): 4–11, and moreover in Hiraki Seikō, *Kokutani yaki to Ninsei* (Kokutani ware and Ninsei) (Tokyo: Tokyo Kōetsu Kankō Kai, 1962).

58 Tomlinson, *Charles Lang Freer*, 55.

59 In a letter of thanks following a visit to Freer's home, Fenollosa praised his host, noting, "In your house . . . Koyetsu [Kōetsu] and Whistler and Thayer and Rosetti are spiritual brothers." Fenollosa to Freer, 4 March 1901, quoted in Lawton and Merrill, *Freer*, 134–35. If there is any defining moment in Freer's enhanced interest in Kōetsu, it came during that February 1901 visit when Fenollosa reattributed the folding screen *Coxcombs, Maize, and Morning Glories* (F1901.99) to Kōetsu. By the end of the year Freer was confidently claiming Kōetsu as the founder of the Kōrin (Rimpa) school. The reattribution and Freer's claim are mentioned in Freer to Thomas Wilmer Dewing, 17 December 1901. Fenollosa's new enthusiasm for Rimpa could well have been inherited from Kawasaki Chitora, who was noted in the text to have written an article on Rimpa for *Kokka* as early as 1894. Ellen Conant mentions Kawasaki as a tutor of Fenollosa (Conant et al., *Nihonga,* 16).

60 The content of a Matsuki to Freer letter of 27 October 1902 is written in response to Freer's inquiry about Kōetsu and Sōtatsu.

61 Christine Guth, *Art, Tea, and Industry: Masuda Takashi and the Mitsui Circle* (Princeton: Princeton University Press, 1993), 175. I am indebted to Guth's analysis of Japanese nationalism, Freer, and Fenollosa.

62 As paraphrased in Clark, "The Intuition," n. 28, Freer was buying ceramics with the Kōetsu mark as early as 1896, but the enhanced interest in Kōetsu as a painter, and perhaps in Rimpa as a whole, must derive in good part from Fenollosa; see note 59.

63 This is based on a survey of Kōetsu Kai exhibits in Oda et al., *Kōetsu kai*.

64 Associations such as the Yutōen (literally, Pleasure garden of ceramics; established 1903) and Keishikien (Garden of Kyoto lacquer; established 1906) were founded to inject contemporary designs into flagging industries in Kyoto. Over the next two decades, design departments were opened in art and craft schools nationwide.

65 Henri de Toulouse-Lautrec in *Moulin Rouge* (1952) and Vincent van Gogh in *Lust for Life* (1956). Bernard Leach, in a record of his visit to Japan (1953–54), mentions the shared impact when he, folkcraft leader Yanagi Sōetsu, and potter Kawai Kanjirō went to see the former. "We were all stirred by the moving rendering of the tragedy of one of the great artists of our time, as great a tragedy as that of his friend, Vincent Van [sic] Gogh. Such is the price we pay for genuine, if tortured, art which is the work of recluses and reactionaries." Bernard Leach, *A Potter in Japan* (London: Transatlantic Arts, 1956), 138, 140.

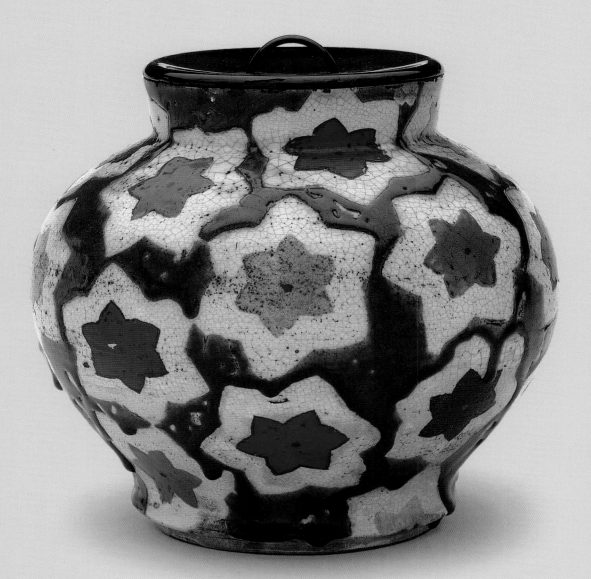

catalogue no. 40

CATALOGUE

CATALOGUE

Underlying the regimes of knowledge and taste that drove Charles Lang Freer and his milieu to collect Kenzan was a conviction—one not unfamiliar to today's art world—that form itself was constitutive of meaning. And it was Rimpa objects, including Kenzan ware, that were declared the acme of form, specifically those pleasing juxtapositions of line, plane, and color that had been consecrated as the "decorative." Everyone stood to benefit: the nationalists of the Meiji era (1868–1912) had ammunition for their claims to uniqueness; European and American collectors and artists gained further tangible evidence for their ecumenical order of art. These passions are understandable enough, but they elide the real factor behind the success—the staying power of the Kenzan mark. As the Freer collection itself demonstrates, for potters of the Kenzan school the world was a great treasury of images to be plundered and packed into fictile objects. This began with the first Kenzan, himself a passionate collector and disseminator of literary and visual symbols, and continued over the next two centuries until Freer. And again, as the Freer collection so clearly shows, even among designated heirs the Kenzan style was never closed: "Kenzan" was less a transmitted body of practice than an object of veneration and prey, a mode of ceaseless reinvention by industrial and antiquarian parties. The Freer collection, then, provides an opportunity to set aside the old narratives and view the kaleidoscope of Kenzan style. Our vehicle is the master themes and tropes bundled under the name "Kenzan."

The catalogue consists of an introduction and six thematic units. The former begins with an overview of decorated ceramics in the Japanese home islands in the seventeenth century, with special attention given to the emergence of Kyoto products. The focus then moves to four general episodes of Kenzan-ware production, beginning with the historic founder and ending with the art-market imitations of the late nineteenth century. The purpose is to provide grounding for attributions in the catalogue entries. The preliminary notes conclude with an explanation of the organization and terminology of individual entries.

The six thematic units applicable to the Freer Kenzan wares include: the Scholar-Recluse, Native Poetics, Utsushi (creative copies), the Kōrin Mode, the Kenzan Mode, and the Raku Mode. Each unit begins with an illustrated essay describing the importance of that theme in the Edo period (1615–1868), and proceeds to the individual entries. The entries approximate a chronological sequence, although exceptions are made for certain subgroupings (for example, landscape subjects are bundled together). The reader will quickly note that many of the Freer pieces could be situated in more than one group—testimony to the heterogeneous demands of generations of Kenzan-ware consumers, but also part of the first Kenzan's ability to pack so much into a single vessel.

Ogata Shinsei Kenzan (1663–1743) appeared on the scene just as fine (decorated) ceramics production had matured, both as technique and sanctioned style. This was facilitated by changes wrought by the Tokugawa regime, which ruled Japan from 1600 to 1868. This was an era of peace, and the ruling warrior estate transformed itself into a class of consuming bureaucrats. In addition to maintaining their respective fiefs, regional lords were compelled by the central government to support large and unproductive households in Edo, the capital. Their fixed rice income forced the warriors to depend on the merchant class, who could turn crops into specie and provide the requisite leisure and ceremonial goods. The merchants grew wealthy and the warriors, whose domains could never produce enough to meet spiraling consumption, were perpetually in debt. Cropland expansion and diversification were undertaken to produce further revenue, and the resulting surpluses contributed to the development of broad transportation systems and markets, and, within a century, a national economy with convertible currencies and standard weights and measures. Far-flung towns developed specialized products, and the major cities assumed mercantile (Osaka), productive (Kyoto), or consuming (Edo) roles.

Ceramics production was another way to enhance domain income, and this both coincided with and further propelled technical developments, specifically a transition from folk stonewares to urbane porcelains. The undisputed technical center was the Arita porcelain complex in Hizen Province which, upon the discovery of the appropriate raw material in the second decade of the seventeenth century, began to switch from stoneware to porcelain making. Porcelain is fine textured, white, and resonant, and its receptivity to painted decoration encouraged various types of value-adding. As the archaeology of urban resident sites demonstrates, by the end of the century native porcelain had permeated not only the ruling estate but also the homes of upper-class merchants. Other ceramic producing centers rushed to develop specialty stoneware products, most of them decorated. Makers of Karatsu stoneware ceded much of the small-ware trade to nearby Arita and increasingly focused on large platters and mixing bowls. Seto and Mino workshops, using their location in the middle of the main Honshu island to dominate Edo sales, employed their staple iron and ash glazes in ever-changing lines that included small dishes, bowls, and sake bottles. On the other hand, traditional producers of unglazed ware, such as Tokoname and Bizen, maintained monopolies on large jars and vats. Smaller, super-specialized producers also emerged such as the kilns of Shidoro in Tōtōmi Province (modern Shizuoka Prefecture), which produced iron-glazed sake bottles, and the port city of Sakai, south of Osaka, which made unglazed kitchen mortars.

The other key participant in the early modern polity was the merchant class, whose real and symbolic needs played into pottery conceptions. In the first half of the early modern period the Kansai region was the crucible of merchant-class identity formation, and Kyoto took the lead in producing goods that reflected it. Kyoto merchants prided themselves on reconstructing the city after the devastating civil wars of the fifteenth century. They also had acquired polish and prestige through simultaneously supporting and learning from the court and religious elites. Merchant preeminence in the city was threatened by the ascent of the Tokugawa and removal of the capital to Edo after 1600, but the pacification, which sent large grants to Kyoto along with a Tokugawa bride for the emperor, effected a degree of stability and wealth hitherto unimagined. A new social formation, sometimes called the "Kan'ei salon" after the era in which it flourished (1624–44), brought together military and merchant power brokers, intellectuals, performers, and producers of things. In tea ceremonies, flower-arranging galas, Nō performances, and poetic outings, contemporary objects were infused with both political power and courtly aura. In an atmosphere of relative freedom and self-administration, Kyoto learned to market itself, and prospered.

Kyoto workshops were late to join the decorated ceramics trend, for aside from its reliance on local earthenware products, the city was a habitual consumer of imported pots. Stonewares were obtained as tribute from the provinces, and porcelains were imported from China. Glazed earthenware workshops like Raku and Oshikōji did appear in the late sixteenth century to fill small market niches, but the accelerated demand and new imagery generated by the Kan'ei salon demonstrated a higher order of commercial feasibility. A new kiln infrastructure was built on the salon core—Tokugawa-funded monasteries headed by imperial princes. Syndicates of merchants and temple functionaries opened workshops in the hills around the city—Awata, Yasaka, Kiyomizu, and Otowa in the east, Mizorogaike in the north, and Omuro/Ninsei in the west. The early products were conservative interpretations of monochromatic Chinese and Korean stonewares popular in the tea ceremony, but in mid-century diaries and especially in the products of Kyoto's first stellar potter, Nonomura Ninsei (active 2d half 17th century), we witness a transfer of imagery from longer-standing Kyoto crafts such as musical instruments, folding fans, patterned stationery, Buddhist altar fixtures, and imperial regalia into ceramic forms and surface decoration. The incorporation of this "courtly" taste into new objects was referred to as *kirei* or *hime,* variously connoting an elegant or courtly beauty. The cross-referencing itself resonated with an older custom of playful display known as *mitate* or *tsukurimono,* first developed at court but gradually practiced by warlords and merchants alike.[1] The ceramic quotations gained immeasurably from Ninsei's successful management of an overglaze-enamels palette.

The emergence of a Kyoto-ware market niche in the second half of the seventeenth century has parallels in products made elsewhere. Both Hizen and to some extent Seto and Mino workshops shifted from simple, robust decor schemes to representations that were either delicately poetic or explicitly pictorial: shapes and motifs were derived from native sources and occasionally from imported Chinese woodblock-printed manuals. These refinements are manifested in the Kutani, Kakiemon, and Nabeshima modes of Hizen porcelain, and the later Ofuke style at Seto and Mino. Thus, by the end of the 1600s, Japanese tableware had developed a complex network of producers and, at the high end of the market, a variety of decorations that resonated with elegance and "tradition." It is not uncommon to encounter them as treasured heirlooms or as models for later work. And yet, like official decor everywhere, the refined mode exhibited a dull-witted sanctimony, one ill-suited to the world into which Ogata Kenzan was born—a world that was fast moving, well informed, and subtly self-deprecating.

EPISODES OF KENZAN-WARE PRODUCTION

Art-historical and archaeological evidence can be combined to chart the workshops, stylistic sensibilities, and markets associated with the Kenzan style (see fig. 12). The episodes that follow are not intended as an a priori overview to research on the Freer collection; indeed, these assumptions could not have been developed without study of the Freer collection and its records. An initial summary, however, serves as a guide to the stylistic trajectories and attributions presented in the catalogue.

A STOREHOUSE OF STYLE: OGATA SHINSEI KENZAN (ACTIVE 1699–1743): There is nature and nurture behind the triumph of the Kenzan mark. The first Ogata Kenzan (1663–1743), whose biography is considered in the next chapter, was afforded every variety of cultivation that money could buy, and he responded with a commitment to the arts and letters. After his father's death in 1687, he lived as a recluse on the outskirts of Kyoto, his home city, immersed in literati pastimes. When he opened his first workshop at Narutaki in 1699, he approached pottery not as an artisan but as an amateur, and that element—a sense of clumsy enthusiasm and naive iconoclasm—endeared Kenzan wares to consumers interested in something beyond refined orthodoxy. Kenzan was also something of an information collector, obsessed with rationalizing all of his world into new pottery products. The stylistic repertory included images of the Chinese-inspired scholar-recluse, native *waka* poetry and Nō drama, ceramic modes for the tea ceremony, and in due course more up-to-date designs by both Kenzan and his older brother Kōrin. The breadth of representation reveals an acquisitive, positivistic spirit that surfaces elsewhere in the imagery of the day. Novelist Ihara Saikaku (1642–1693)

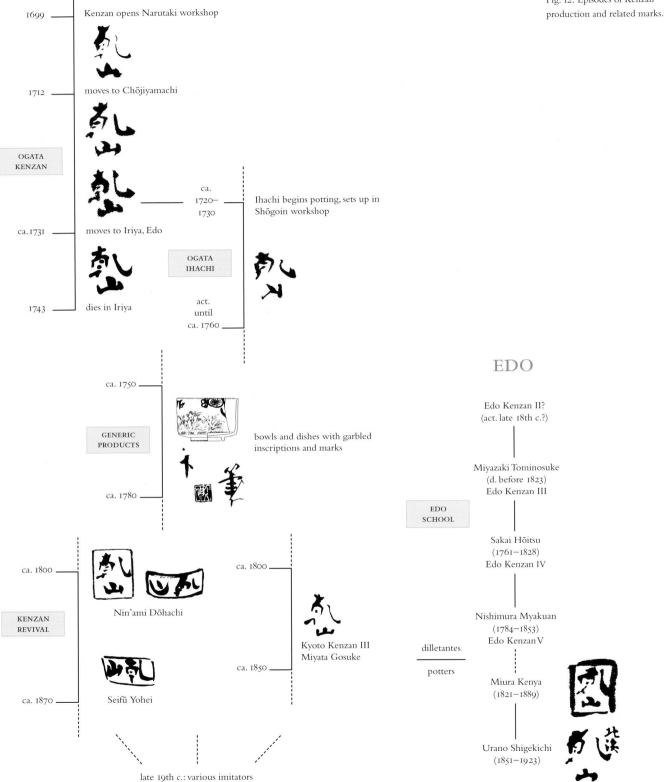

KYOTO

1699 — Kenzan opens Narutaki workshop

1712 — moves to Chōjiyamachi

OGATA
KENZAN

ca.
1720–
1730 — Ihachi begins potting, sets up in Shōgoin workshop

ca.1731 — moves to Iriya, Edo

OGATA
IHACHI

1743 — dies in Iriya

act.
until
ca. 1760

ca. 1750

GENERIC
PRODUCTS

bowls and dishes with garbled
inscriptions and marks

ca. 1780

ca. 1800

KENZAN
REVIVAL

Nin'ami Dōhachi

ca. 1800

Kyoto Kenzan III
Miyata Gosuke

ca. 1850

ca. 1870 — Seifū Yohei

late 19th c.: various imitators

EDO

Edo Kenzan II?
(act. late 18th c.?)

Miyazaki Tominosuke
(d. before 1823)
Edo Kenzan III

EDO
SCHOOL

Sakai Hōitsu
(1761–1828)
Edo Kenzan IV

Nishimura Myakuan
(1784–1853)
Edo Kenzan V

dilletantes

potters

Miura Kenya
(1821–1889)

Urano Shigekichi
(1851–1923)

Fig. 12. Episodes of Kenzan
production and related marks.

characterized it with the word *kura*, or storehouse, and his pages, as well as nonfiction works such as the encyclopedia *Wakan sansai zue* (Illustrated products of China and Japan; 1713), are sheer repositories of information. Merchant-class culture roamed over this spatial and temporal topography, digesting and reproducing it in an increasingly unbounded public space. Anticipation of how that would be packed into clay containers must have been part of the thrill of using Kenzan pots.

Those proclivities could not have been built into a pottery business without some fundamental structural changes in the ceramic trade itself. And a successful business it was: after a little over a decade Kenzan ware was listed as one of Kyoto's prominent souvenirs in the just-mentioned *Wakan sansai zue,* and a reference to Kenzan ware in *Ikutama shinjū* (Love suicide at Ikutama), a drama for the puppet theater written in 1715 by Chikamatsu Monzaemon (1653–1724), demonstrates that Kenzan ware was stocked by Osaka merchants. This points to a very different distribution system from that of Ninsei ware, which was marketed through personal networks of antique dealers called *karamonoya* and tea masters. Throughout the country an older class of privileged purveyors was giving way to a system of wholesalers and forwarding agents who gathered and redistributed goods at specific nodes (like Osaka) in a nationwide commercial economy. Kenzan ware may have been initially conceived as a series of one-of-a-kind works for privileged clients, but it was rapidly transformed into a commodity for mass distribution—from couture to prêt-a-porter, with all the trade-offs that entailed (rapid turnover, less individual participation, more standardization).

The accelerated trade is associated with Kenzan's 1712 move to Chōjiyamachi in downtown Kyoto. His workshop was hard by the canal that carried goods to Osaka, and he rented kiln space in the industrial quarters. Demand for Kenzan ware was also bundled with the success of his by-then-deceased brother Kōrin, materialized in many "Kōrin" pattern books published in the 1720s and 1730s. Thus there are at least two vectors in the ascendancy of Kenzan ware: the diverse and idiosyncratic creative energies that issued from the man, and the images that accrued to a brand name operating in mass markets.

OGATA IHACHI (ACTIVE CA. 1720–1760): It was probably during his Chōjiyamachi years that Kenzan took on one Ihachi, the grandson of Nonomura Ninsei and son of his Narutaki helper Nonomura Seiemon (active late 17th to early 18th century). Before Kenzan moved to Edo around 1731, he established Ihachi in a new workshop in the Shōgoin Temple east of the Kamo River, where the younger man produced a high volume of wares with the Kenzan mark. Ihachi continued the styles and subjects developed by his adoptive father but also made Raku wares, Kōchi-style wares, copies of European Delft ware, and an underglaze blue product called *ai-e*. These are represented

in the Freer collection. Kenzan did not seem to regard Ihachi as any kind of artistic or spiritual heir, rather the successor of the Kenzan workshop, and thus we are historically accurate in evaluating Ihachi's work as "authentic" Kenzan ware. Ihachi appears to have been active until the 1760s, and the large number of pots bearing his signature testify to the sustained popularity of the Kenzan brand.

"KENZAN-STYLE" GENERIC PRODUCTS (CA. 1750–1800): Prior to the advent of urban archaeology in the 1980s, virtually nothing was known about developments in the Kyoto ceramic industry between the time of Kenzan and the late-eighteenth-century Kyoto porcelain pioneer Okuda Eisen (1753–1811). The period is conventionally viewed as a ceramic dark age where, under the corrupt regime of administrator Tanuma Okitsugu (1719–1788), patronage was stifled owing to the collapse of government finance and samurai morale. In the countryside there was famine and revolt. No named successor arose to manage the Kenzan workshop, and indeed, with the exception of several brief and ambiguous references in tea-ceremony literature, there is no mention of Ogata Shinsei or Kenzan ware through the end of the century.

Such is the view from above, but excavations of what are called user sites— residential and other sites whose artifacts provide clues to consumption—demonstrate that the second half of the eighteenth century was one of great development of ceramics for the mass market. For example, it is not uncommon to find porcelain bowls and dishes from Arita in the remains of lower-class urban dwellings of this era. Likewise, the Kyoto workshops, in tandem with a burgeoning small-ware industry in neighboring Shigaraki, filled markets near and far with distinctive small bowls in rounded, conical, and cylindrical shapes. Kenzan-style designs are among them. The large repertory of the first generation is condensed into two products, a cylindrical tea bowl and a flat, rectilinear dish, both decorated with an equally limited repertory of flowers and grasses. Nearly all of these works have short and sometimes garbled poetic inscriptions, but very few have any Kenzan mark save a facsimile seal in which the "ken" of Kenzan is chronically miswritten. Coupled with the absence of documentary references, such "Kenzan-style" wares show how "Kenzan" was assimilated and finally swallowed up by the mass market. As part of the regional spread of production that marks this period, these wares came to be made in Seto and Mino workshops as well. The disappearance of all such pieces from user sites at the turn of the century, however, also serves to dispel any notion of production by an unbroken chain of successors. Kenzan was forgotten.

KENZAN REVIVAL (1800–1850): The Bunka and Bunsei eras (1804–30) marked a new flowering in urban arts and letters. Plentiful harvests and a respite from the harsh policies of Tanuma's successor, Matsudaira Sadanobu (1758–1829), reignited cultural

confidence, and with it sponsorship for elite ceramic production. In the Kyoto ceramic industry, a series of new individual leaders emerged, among them Nin'ami Dōhachi (1783–1855), Ogata Shūhei (1788–1839), Kiyomizu Rokubei (1790–1860), and Seifū Yohei (1803–1861), and they reproduced Kenzan wares with and without their own workshop marks. A self-designated Kyoto Kenzan "successor" named Miyata Gosuke (active early 19th century) appeared as well. The addition of personal signatures or seals facilitates dating and, more important, provides a picture of how Kenzan was imagined in the early decades of the nineteenth century.

But Kyoto was no longer the center: Kenzan had now become a legacy, and it was administered from Edo. At the edges of the circle of intellectuals and artists associated with the aforementioned Matsudaira Sadanobu were several individuals with an interest in creating, from an Edo vantage point, a bounded Japanese tradition.[2] Under Sadanobu's imprimatur, painter Tani Bunchō (1763–1840) participated in ambitious surveys of temple properties and coastal vistas in the 1790s. His custodial urges are reflected in his self-styled Nanboku Combined School, which in effect claimed to synthesize all known Japanese painting styles. Thus situated, Bunchō recommended to his friend, Sakai Hōitsu (1761–1828), that he restore the Rimpa school to its proper station. Hōitsu is well known for his multifaceted Kōrin revival and his own Rimpa-style painting, but he meddled with Kenzan as well. He published a book of Kenzan painting and ceramics called *Kenzan iboku* (Ink traces of Kenzan; 1823) and compiled and subsequently "inherited" credentials for an "Edo Kenzan" school. Moreover, Hōitsu's occasional agent, an antiquarian named Sahara Kikuu (1762–1832), was sent to Kyoto to collect material and there spread Kenzan enthusiasm to Shūhei, who adopted the Ogata name and Kenzan style. Kikuu patronized Rokubei and an Eisen disciple named Kinkodō Kamesuke (1764–1837) as well. From Hōitsu's day the "Kenzan" discourse would bifurcate into a professional/productive Kyoto center and an amateur/custodial Edo center. Edo had rights to sanction, but Kyoto potters had license to send imitation wares to Edo (later Tokyo), there to be consumed as originals.[3]

Aside from Hōitsu's printing of Kōrin and Kenzan material, which was of course appropriated in ceramic decor, there is an unmistakable element of humor and exaggeration in the revived Kenzan. The physical manifestations include a disinterest in compositional unity, a preference for large, even crude motifs, and often an outsized, patently ersatz Kenzan signature. The objects themselves are larger than earlier wares, and speak of an unembarrassed gusto for the pleasures of eating and drinking. Searching for parallels in literature, painting, and the woodblock print, one finds an early nineteenth-century cult of eccentricity and play which, in disgust or disillusionment with a morally and fiscally bankrupt government, focuses upon the surface, the ordinary, and the fragmented.[4]

CERAMICS INTO ART (LATE 19TH CENTURY): The first chapter of this book surveyed the developments and dislocations that occasioned Kenzan's debut as a global artist. The collapse of the feudal system, the removal of the capital to Edo (renamed Tokyo), and the intrusion of Westerners had reverberations in material culture. The creation of a new and internationalized public sphere mediated by recently risen bureaucrats, trading companies, and foreign critics would affect Kenzan production in at least two ways. Appropriate to the rising nationalism (and the expanded market) of the late 1880s and 1890s, Kenzan was located in a Rimpa-centered pantheon of indigenous artist-craftsmen, and a series of deliberate forgeries were so conceived. Until this point, all Kenzan wares, regardless of whether or not they were made by the first Kenzan, were conceived as functional ware for the table and other private deployments. The specifics of the system changed with the times, but the functional concept stayed intact. But for the new Meiji markets, makers had to build in historicity. How the appearance and names of things resonated with widely circulated printed matter was important, especially for foreigners ignorant of the contexts in which traditional vessels were used and appraised. Hence the ebulliently styled and flagrantly signed and sealed wares of the "Rimpa cult."

A second type of modern forgery, which reflects both traditional Japanese notions of the homage piece and Western notions of the genuine, attempted to reproduce the specific topography of works thought to be original.

At the popular level, there was fun and nonsensical thievery. Certain vigorously decorated teapots excavated from mid-nineteenth-century contexts have names like "Kenzan," "Ninsei," and "Dōhachi" interchangeably brandished on the median. Names and styles could be detached, and they were detached with impunity.

It is revealing that in the late Edo and Meiji eras the potters who laid claim to the Kenzan lineage, such as Ida Kichiroku (1793–1861), Miura Kenya (1821–1889), and Urano Shigekichi (1851–1923), all lived a hand-to-mouth existence. Fantasy overwhelmed all such credentials.

If "Kenzan" was a valise of images from its very inception, how much more so after 1890, when many old notions of authority were dysfunctional and the market was awash with names, styles, and new arbiters. When artistic originality and authenticity become a central issue, various types of heresy abound. "Kenzan" has survived by refashioning from without—by the popular markets, Edo pundits, and even by non-Japanese.

DATA: Catalogue entries begin with the author's attribution, which is explained at the end of each entry. Earlier attributions include the original attribution by the dealer who supplied the piece to Freer, occasionally modified by Freer, followed by the opinion of pioneering Japanese ceramics researcher Edward S. Morse (1838–1925), who examined the collection. Acquisition information includes the source(s) of the object and the purchase price, as recorded in the Freer object record and archives. Names and locations of dealers and donors are given as they appear in the object record except when more complete citations are possible. Dimensions are provided in centimeters. In acquisition numbers, "F" signifies the object is in the Freer Gallery of Art. The first four digits represent the year of acquisition, and the digits after the decimal point represent the order of acquisition in that given year.

MANUFACTURE: The description follows, as closely as possible, workshop procedure. Clay is identified in terms of texture and color. Grain size estimates are based on microscopic studies, tactile sensation, as well as examination by the naked eye. "Fine-grained" clay refers to a body whose largest inclusions average approximately twenty microns in maximum diameter; "medium-grained" clay refers to a body whose largest inclusions average approximately fifty microns in maximum diameter; and "coarse clay" refers to a body whose largest inclusions average approximately fifty microns in maximum diameter but with a much higher density of those inclusions. Clay color description, while not always a reliable indicator of chemical composition, generally indicates levels of mineral colorants, especially iron. Evidence for forming is based on the shape of vessels and marks made in the course of manufacture. Pigment and enamel descriptions are based on physical inspection, laboratory analysis, and recorded comments by Kenzan and other Edo period potters.

Signatures and seals are listed in Japanese, with English translations appended.

Descriptions of firing temperature are determined by hardness, backed up by diagnostic studies using the microscope. Although degree estimates of firing temperatures are notoriously unreliable, what I have described as low-temperature firing (earthenware) peaked between about 800 to 900 degrees Centigrade, and high-temperature firing (stoneware and porcelain) between about 1200 to 1280 degrees Centigrade. Characterization of glazes—in the case of Kenzan ware either lead-silicate (applied to earthenware) or feldspathic ash glazes (applied to stoneware and porcelain)—derives from visual inspection of luster and crazing, backed up by major-element analysis using the electron beam microprobe.

The "Potters' Perspectives" chapter is devoted exclusively to technical matters.

THEME: Each entry includes an interpretive statement about the historical, literary, and artistic associations that the shape, decoration, inscription, or materials may evoke. Here it will be useful to compare the specific representations in any given piece to the general comments at the beginning of the respective section. Needless to say, there is considerable license in the rendering of any motif, reflecting both unconscious and deliberate distance from classic or orthodox referents.

DATING AND ATTRIBUTION: In addition to lessons learned from the thematic grouping employed here, attributions (maker, region, date) are anchored in studies the author has made with collaborator Ogasawara Saeko over the last two decades. We have surveyed about three thousand pieces with the Kenzan mark, dividing them according to criteria such as shape, technique, decor style, border patterns, inscription style and content, signature style and content, seals, and ciphers. These characteristics fell into clusters that we consider as workshop styles. Within these clusters, dated and datable pieces were identified; external dating evidence such as the formation of a certain collection (like those of Morse or Freer) or the publication of a certain influential design book (such as *Kōrin hyakuzu* [A hundred Kōrin pictures; 1815], or *Kenzan iboku* [Ink traces of Kenzan; 1823]) was also consulted. Based on those criteria, the clusters were arranged in chronological order. For the full scheme organized as catalogue raisonné, see Richard L. Wilson and Ogasawara Saeko, *Ogata Kenzan: Zen sakuhin to sono keifu* (Ogata Kenzan: his complete work and lineage), vol. 2 (Tokyo: Yūzankaku, 1992); hereafter referred to as OKZS II. For a more concise, updated presentation, with archaeological evidence appended, see Richard L. Wilson and Ogasawara Saeko, *Kenzan yaki nyūmon* (Introduction to Kenzan ware) (Tokyo: Yūzankaku, 1999).

Some attributions include names and, for lack of a better word, schools, although no academic mechanism is implied:

Ogata Kenzan (1663–1743): made at one of Kenzan's workshops under the direct supervision of and with occasional personal participation by Kenzan himself. These workshops include: Narutaki, 1699–1712; Chōjiyamachi, 1712–ca. 1731; and Iriya (Edo), ca. 1731–43.

Ogata Ihachi (Kyoto Kenzan II; active ca. 1720–1760): made at Ihachi's workshop at Shōgoin, Kyoto, under the direct supervision of and with occasional personal participation by Ihachi himself.

Kyoto workshop, Kenzan style: made in a Kyoto workshop not connected to Kenzan himself or any of his named followers; a vernacular production unconnected to the antiquities market.

Kyoto workshop, imitation: made in a Kyoto workshop for the antiquities market.

Edo Kenzan school: made at the small workshops of Kenzan's followers in Edo, present-day Tokyo. The term "school" is applied as the workshops clustered around a single area, Ueno-Asakusa, and were under the influence of Sakai Hōitsu (1761–1828), Nishimura Myakuan (1784–1853), and their designated followers.

Other "named" Kenzan followers such as Ida Kichiroku (1793–1861) and Miura Kenya (1821–1889), both active in Edo.

A traditional criterion in dating and attribution of ceramics from Japan's early modern era (Edo period, 1615–1868) is inscriptions on wooden boxes made to accompany the pieces; with two exceptions (the box lids of cat. nos. 35 and 76) these have not been preserved in the Freer group.

THE SCHOLAR-RECLUSE

The expression of human nobility through nature is central to East Asian literary and artistic sensibilities. Virtue is expressed in the lonely but lofty mountain retreat, or the flowers and trees that evoke the upright, unyielding, and ever-renewing heart. Pictures so painted, and poems so written, express a delight in an untainted world, or provide vicarious pleasure to others unwilling or unable to escape the banality of this one. These subjects have extensive roots in Chinese literature and became prominent in Chinese painting from the fourteenth century. Poetic and painted images of the scholar-recluse were also nurtured in medieval Japan in the institution called Gozan, a group of Zen monastic centers. This is less an unbroken transmission than a form of intermingling, as bodies of knowledge and practice were reshaped by local needs. In Kenzan's time, official support for Confucian studies (the shogun Tsunayoshi, who ruled from 1680 to 1709, was a particular devotee) coupled with peacetime affluence to ensure a swell of sinophilia, affecting the production of texts, rituals, leisure, and of course, goods.

Ogata Kenzan's commitment to an introspective life is assumed to have begun with the death of his father in 1687: the boyhood name Gonpei was discarded in favor of Shinsei, meaning "deep meditation." As the "The First and Last Kenzan" chapter of this volume will demonstrate, his immersion in Chinese-inspired scholarly pastimes, some of them long nurtured in Japan and some recently arrived, is amply documented. An early penchant for cultivation is revealed in his 1682 visit to Kogidō, the Confucian academy of his relative Itō Jinsai. He built a retreat called the Shūseidō (fig. 13) in the hills outside of Kyoto in 1688; he studied under monks of the Ōbaku sect, itself a recent arrival from China; and he made a pilgrimage to the retreat of the doyen of Japanese recluses, Ishikawa Jōzan (1583–1672), in 1692. Recent discoveries show Kenzan pursuing literati amusements with wealthy culture-loving merchants of the Naba family, Gizan and Yūei. Even after opening his kiln in the northwestern hills of Kyoto in 1699, Kenzan styled himself as a recluse-potter, using names such as Tōin (Hermit Potter).[5]

There is little reason to doubt Kenzan's pursuit of the scholar-recluse ideal and its impact on his work. Traditional biographies tout this as a rejection of the world, and cast Kenzan as a serious intellectual who retreats into the countryside in disgust at the profligacy of his older brother Kōrin. But in Kenzan's day eremitism had become a popular pastime. This is taken up in vernacular literature, notably *Fusō kindai yasa inja* (Recent stylish recluses), published in 1686 by Seiroken Kyōsen, a disciple of the popular novelist Ihara Saikaku (fig. 14). Underlying its

Fig. 13. Reconstruction of Kenzan's Shūseidō villa, built ca. 1688.

Fig. 14. "Hermit" playing a *shō*, a Japanese panpipe, from Seiroken Kyōsen, *Fusō Kindai yasa inja* (Recent stylish recluses) (Osaka: Kawachiya Kihei, 1686). Private collection, Japan.

Fig. 15. Landscape paired with a poem, "Mt. Dai," by Wang Jian (d. ca. 830). From a volume of the *Hasshu gafu* (Eight varieties of painting manual), recarved in Japan from a work originally published as Huang Fengchi, ed. *Bazhong huapu* (location unknown: Jiyazhai and Qinghuizai, 1620–44) Freer Gallery of Art and Arthur M. Sackler Gallery Library, Smithsonian Institution, Washington, D.C.

didactic prose, *Yasa inja* suggests a fascination for a "stylish" reclusion, which is not a rejection of anything, but rather one of many cultural poses that wealthy townsmen could adopt. The other deficiency in the standard account is that it locates Kenzan's scholarly tendencies in local social networks—growing out of Kyoto personages such as Gensei Shōnin (1623–1668) and Jōzan. But human exchange was only a part of the picture: the entire notion of reclusion as a lifestyle choice, which had matured in late-Ming dynasty (1368–1644) China, was available to Kenzan not only through his Japanese mentors, but also via the printed book and representative products (fig. 15). Life as a scholar-recluse, in other words, was a worthy pursuit but also a form of consumption. As will be discussed in the chapter "The First and Last Kenzan," an episode of Kenzan's literati life even found its way onto the public page.

Print culture centers on acceleration and dissemination of knowledge—and that facilitates new world views and social relations. The breadth of published material held out the possibility that with money and information, the world—perhaps we should say many worlds—were within one's grasp. These roles were understood in material terms. For the late-Ming reader the role of the amateur scholar was spelled out in exquisite detail in volumes such as Wen Zhenheng's (1585–1645) *Zhang wu zhi* (Treatise on superfluous things; 1615–20), a manual that describes to a fault the material environment of the gentleman and how these items were most effectively deployed. Meaningful events, places, and objects are inserted into a map of consumption that put the good life within range. Although we cannot be certain that Kenzan read these manuals, he knew the template, for his life, as described by friends in the early 1690s, is unmistakably "correct" in its appointments.[6]

A related point about the late-Ming culture of information is the performative aspect of things. In his study of the visual environment of that era, Craig Clunas asserts that in an urban world awash in goods and images, sheer ownership was less important than how these things were appraised, used, and shared.[7] Clunas is concerned with pictures and hence addresses the field of looking, but his point about the inevitably collective aspect of beholding fine goods is applicable to the fictile arts. For traditional ceramics, real deployment is of course a given, but vessel shapes and their pictorial decorations also operate in an environment of "social empathy," which in early modern times was driven by the mass circulation of artistic and literary tropes.[8] Literary personages such as the plum-loving recluse Lin Bu (967–1028) and the outcast scholar-official Su Dongpo (1037–1101), imaginary mountain hermitages, and botanical "friends of

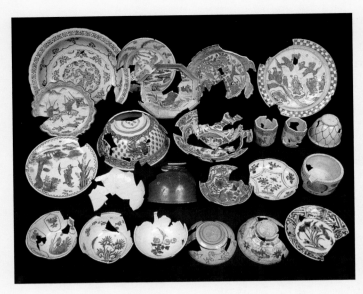

Fig. 16. Chinese porcelains excavated from the Mukogaoka site, Bunkyō Ward, Tokyo. Late 16th–early 17th century (buried 1st quarter 18th century). Porcelain with various underglaze and overglaze designs. Tokyo Metropolitan Government.

Fig. 17. Dish with mountain hermitage design, late 17th century. Uchinoyama kiln, Saga Prefecture, Kyushu. Excavated at the Iidamachi site, Chiyoda Ward, Tokyo. Stoneware, underglaze iron, ht. 5.2 x diam. 13.7. Tokyo Metropolitan Government.

the scholar" fit into what Clunas calls the "iconic circuit"; these are also the stuff of Kenzan decoration. Can this, then, reflect simple exoticism, a longing for Chinese images in an isolated Japan? It appears unlikely, for these personages were already appropriated in popular literature, and in a panoply of poses.[9] With such a density of information, coupled with a mood of spontaneity, Kenzan's products were not mute props in the game of culture; they gave direction and coherence to social intercourse. The consumption of food and drink was the foundation, but activities ranged over incense and poetry guessing, viewing of Nō performances, literary activity in the scholar's study, and gift giving. The tea ceremony was a model, of course, for an enhanced role of ceramics, but with the sedimentation of the ritual and its equipment in Kenzan's day, it could no longer be seen as a stage for innovations. Kenzan's overturning of the usual relationship between social relations and objects could only have been realized in an information-rich culture, but we should not forget that the primary agent was Kenzan himself.

There is also the view from below: Kenzan ware was circulating in a mass ceramics market that demanded painted imagery, and some of it buttressed the scholarly mode. Urban salvage archaeology, made possible by the rapid economic growth of the 1980s and 1990s, has recovered millions of shards, many of them understandable as whole pots. Datable assemblages now permit major ceramic products to be dated to within a quarter century.[10] A grassroots view of the vessel environment is thus possible. Dealers' stocks, discarded (owing to fire or other calamities) in Kenzan's day, include imported porcelains, especially types called *kosometsuke* (with cobalt decoration) or *gosu aka-e* (cobalt and enamels), that evoke, at various levels, this scholarly mode (fig. 16). Domestic production included bowls, dishes, and other vessels, with decoration that ranged from bird-and-flower compositions on Arita porcelains to monochrome landscape depictions on ubiquitous stonewares produced in the Imari region of Hizen (fig. 17). The vernacular production empowered Kenzan ware just as Kenzan ware eventually empowered it.

Later potters appropriated Kenzan's literati style. And since these reproducers were, unlike most of us, free from any scientific or art-historical notion of authenticity, the recombinant Kenzan of the late eighteenth and nineteenth centuries has its own life, its own panoply of sources. Yet among all Kenzan prototypes, the "scholarly mode," which demanded a certain density of information, was not easily duplicated. The slippage is evident in a type of cylindrical tea bowl widely excavated from late-eighteenth-century urban sites (fig. 18). Those vessels feature Kenzan-derived poetic phrases, but often with

mistaken characters or incongruous painted decor; the Chinese-style poems are even "scattered" over the surface in a manner appropriate to native verse. At this point there is little difference between word and picture, although this haphazard synthesis is not what the great Chinese critics had in mind in their epistles on the integral nature of the gentleman's arts.

Fig. 18. Kenzan-style tea bowls, excavated from the Owari Tokugawa clan headquarters in Edo, late 18th century. Kyoto ware. Stoneware with various underglaze and overglaze designs. Tokyo Metropolitan Government.

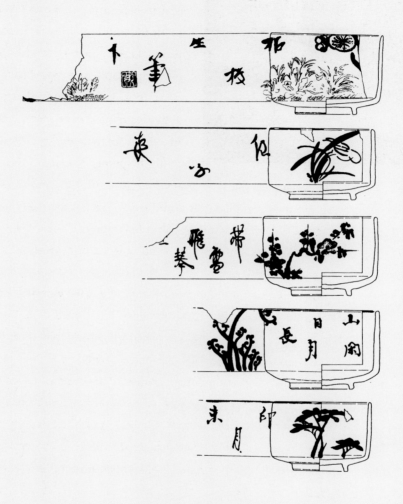

BY OGATA KENZAN (1663–1743)

(CHŌJIYAMACHI WORKSHOP, 1712–CA. 1731)

Japan, Edo period, early 18th century

Acquired from Matsuki Bunkio ($40); original attribution: "Kenzan."

Morse attribution: "One of the generations of Kenzans in Tokyo."

6.1 x 8.0

Freer Gallery of Art, Smithsonian Institution, Washington, D.C.

Gift of Charles Lang Freer, F1898.440

Fine-grained, buff-white clay. Wheel thrown and trimmed. Decoration in an impure underglaze cobalt includes double band on inside and outside rim, single band around base, motif of mountain hermitage *(sango)*, and inscription, signature, and painted seals. Signature reads "Kenzan Tōin Shinsei kei sho" (Respectfully written by Shinsei, Hermit Potter of Northwest Mountains). Seals read "Shōko" (Veneration of Antiquity) and "Tōin" (Hermit Potter). Transparent stoneware glaze on exterior, with partial glazing on upper part of inside wall. High-temperature firing. Gold lacquer repairs.

A ceramic referent for the decoration may be found in a type of underglaze cobalt-decorated porcelain bowl imported from late-Ming dynasty (1368–1644) China; Japanese connoisseurs called these *undō-de* (literally, cloud-pavilion style). The Kenzan version, however, has a more painterly approach, reflecting the first Kenzan's proximity to high-culture sources and skills. The brushwork makes use of the splashed ink or *haboku* style, discussed in more detail in the next entry.

The overall composition suggests a handscroll wrapped around the vessel. The poem, appropriate to the high-minded flavor of the mountain retreat, may be paraphrased thus:

Indifferent to expense, they built a lofty golden terrace,
Settled here in seclusion, my mind has turned to ashes.

The poem alludes to a well-known series of linked verses called *Jingqiu langu* (Reflections on Jingqiu), composed by Chen Ziang (661–702). They portray a journey on horseback to the ruins of the former Warring States kingdom of Yan; there, a Camelot-like "golden terrace" was built by the Yan emperor Zhao as a gathering place for the ablest persons in the realm, but was destroyed in warfare. The point is evanescence: the grand ambitions of humans come to naught.[11]

The absence of glaze on the interior shows the vessel was made not as a tea bowl but as an incense burner. It has been suggested that the use of the character "ash," connoting "extinction," at the end of the poem relates to the use of this piece as an incense burner (the incense is laid over a bed of ash).[12] The harmonization of visual and literary imagery with actual deployment is a fitting example of the first Kenzan's total approach.

The "kei" character in the "Kenzan" signature conveys that the poem was "brushed in humility." Other inscribed Kenzan wares from this period have similar additions.

With its speed and attempt to depict tonal variation, the brushwork shows the hand of a trained artist; it may be assigned to Watanabe Soshin (possibly the same person as Watanabe Shikō [1682–1755]), a painter who occasionally served the Kenzan workshop.[13] The calligraphy and signature are closest to a type seen on pieces of Kenzan ware dated between 1712 and 1715—the early phase of Kenzan's Chōjiyamachi workshop.

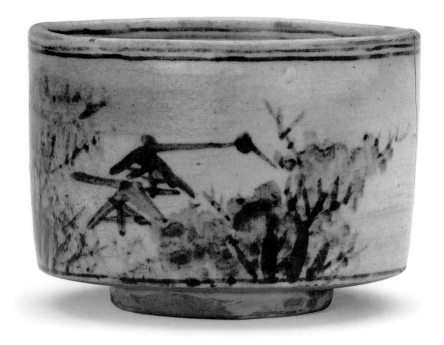

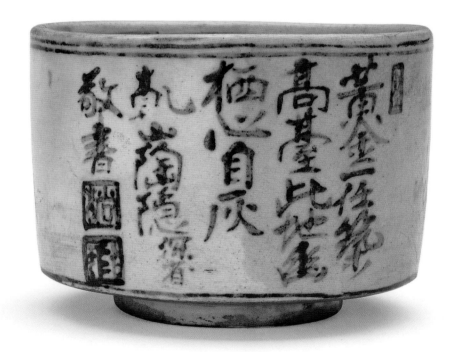

KYOTO WORKSHOP, KENZAN STYLE
Japan, Edo period, early 18th century
Acquired from Matsuki Bunkio ($60); original attribution: "Kenzan."
Morse attribution: "Tokyo—Kenzan—genuine."
3.0 x 21.7 x 21.9
Freer Gallery of Art, Smithsonian Institution, Washington, D.C.
Gift of Charles Lang Freer, F1906.260

Fine-grained buff clay. Decoration on front: water-landscape vignette with boats, surrounded with double-line frame, in underglaze iron. Edge patterns in underglaze iron: inside pattern is castanet and *ruyi*, or *reishi* (fungus of immortality), with tendrils, single-line frame; outside is cloud scrolls with central floral pattern, single-line frame. Inscription and signature in underglaze iron. Inscription reads "Kenzan Tōin sho" (Inscribed by Kenzan Hermit Potter). The seals are hand painted in ochre; the seal at the start of the inscription reads "Kenzan" and the relief-style seal at the end reads "Shōko." Totally covered with a transparent lead glaze. Low-temperature firing. Scars from stacking on base.

This is a *kakuzara*, a flat rectilinear dish with low, vertical edges. It is one of the trademark shapes of the Kenzan workshop. It was probably used for serving sweets or multiple portions of food. The painting subject is a lone fisherman, and the poem reads:

His little leaf of a skiff moors in the emerald cove,
Unconcerned with the back and forth of human affairs.

The painting style, characterized by diffuse, washy strokes punctuated by dark accents, is known in Japan as "splashed ink" *(haboku)*. Based on Chinese paintings imported into Japan, especially those by Southern Song dynasty master Yuqian (active 13th century), the style was firmly established by the Muromachi period painter Sesshū (1420–1506). Kanō-school masters further codified *haboku* from the seventeenth century on. While not attaining enduring respect in China—it was held to be a little too haphazard—for the Japanese the *haboku* style had an impeccable academic lineage and lofty poetic nuance.

The edge patterns are an important part of the design scheme in Kenzan-ware dishes. Here auspicious symbols are added to enhance the generally "Chinese" feeling of the work. The castanets are associated with Daoist immortals, and the fungus of immortality augurs for long life. The tendril-like lines that radiate from these symbols are, by Chinese convention, the red ribbons tied around things thought to be auspicious. The cloud and floral patterns derive from Chinese lacquer ware or ceramics.

The same subject and poem are depicted on two other well-known Kenzan works, a square dish in the Nezu Institute of Fine Arts in Tokyo, and a rectangular tray in a private collection in Japan. The latter bears a date "Honchō Hōei nen sei" (made in this dynasty in the Hōei era [1704–11]).[14] Such evidence affirms that *haboku*-style decoration is part of Kenzan's early production of rectilinear painted dishes, all of which make use of detailed, "academic" painting styles. The painter seems to have been Watanabe Soshin, whose seal appears on the rectangular tray just mentioned.

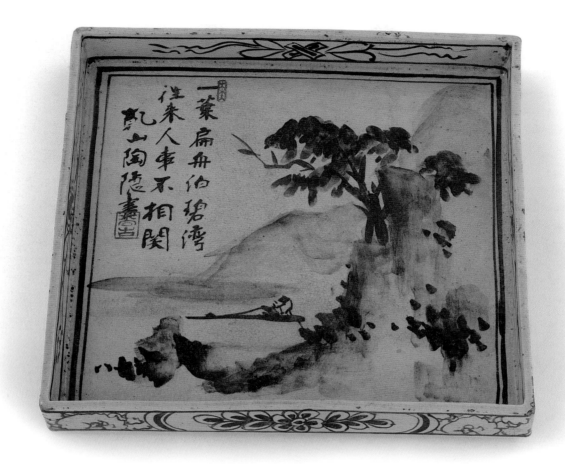

In the Freer dish, however, this mode is combined with a later one, specifically, the lighter and more diverting square dishes decorated jointly by Kōrin and Kenzan (see cat. no. 48); the size of the dish and edge decoration clearly belong to this latter genre.

The calligraphy on the Freer piece follows the Kenzan manner, but without the characteristic rhythm and confidence. Moreover, there is a key difference from the two comparable pieces just mentioned: the word "cove" has been substituted for "current." This is inconsistent with the nuance of the poem, which contrasts the movement of the "worldly" water with the stillness of the "anchored" boat. The style of the seals, especially the "Shōko" seal at the end of the inscription, is without parallel in other known works. Furthermore, as it is painted over rather than under the writing, the seal execution is unusual for Kenzan ceramics (although in writer's practice the seal is impressed after the signature). The dish is extraordinarily heavy owing to the thickness of the walls: 0.5 to 0.6 centimeters as opposed to 0.4 to 0.5

for established Kenzan *kakuzara*. Otherwise, the likeness of the painting and inscription style to the Nezu and other *haboku* specimens suggests that it is an early piece; later Kenzan imitators rarely attempted such large inscribed *kakuzara*. The piece may be an imitation from a contemporaneous Kyoto workshop.

KYOTO WORKSHOP, KENZAN STYLE

Japan, Edo period, 18th century

Acquired from R. Wagner, Berlin ($100); original

attribution: "Kenzan."

Morse attribution (1921): "My gracious, what the devil is this thing!
None but a fool would make an oval jar for a tea ceremony. Tokyo—
Kenzan—if genuine—but looks suspicious."

17.3 x 24.7

Freer Gallery of Art, Smithsonian Institution, Washington, D.C.

Gift of Charles Lang Freer, F1901.52

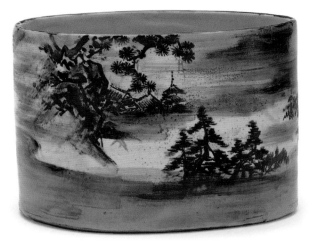

Fine-grained buff clay. Wheel thrown, deformed, applied to oviform slab base. Partial application of white slip, painting in underglaze iron and cobalt. "Kenzan" signature in iron pigment on base. Overall application of transparent stoneware glaze, with bottom in reserve. High-temperature firing. Additional details in green, red, blue, yellow, and gold overglaze enamels. Base crack covered by blue enamel.

The shape and size of the piece suggest it was intended for use as a water jar for the tea ceremony. It was probably fitted with a black lacquer lid. The meaning of the shape is unclear, but an allusion to a courtier's hat *(eboshi)* box is possible. American viewers will be reminded of Shaker bentwood boxes. The decoration of a mountain temple is a stock image from the "Chinese"-derived landscape painting tradition.

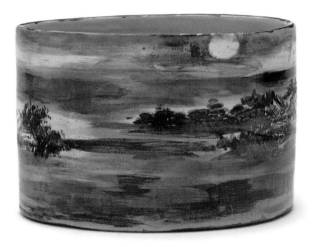

The decor is uninspired for original Kenzan production, although it clearly refers to Kenzan's early style, which featured landscape depictions in a detailed academic manner. The signature type also takes after the Narutaki mode. The jar may be an imitation from a workshop operating during Kenzan's own lifetime; covering cracks with enamel is a device that appears in Kyoto wares from about the 1740s. Later imitators, as will be demonstrated below, tended to follow the more flamboyant Rimpa style of Kenzan.

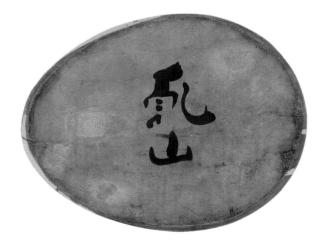

BY OGATA IHACHI (KYOTO KENZAN II, ACT. CA. 1720–1760)
Japan, Edo period, mid–18th century
Acquired from Yamanaka and Company ($8); original
attribution: "Kenzan."
Morse attribution: "Imitation Kenzan."
7.3 x 10.0
Freer Gallery of Art, Smithsonian Institution, Washington, D.C.
Gift of Charles Lang Freer, F1896.99

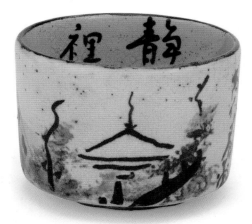

Fine-grained buff clay. Wheel thrown and trimmed with the wheel
turning clockwise. Foot ring bears a series of finger impressions
around perimeter. Partial application of white slip, applied by dipping
inside and modified by brush outside. Single band of iron at mouth
rim. Underglaze decoration of mountain hermitage, poetic inscrip-
tion, signature and cipher in iron and cobalt. Signature reads "Kenzan
Sei sho" (written by Kenzan Sei) with cipher added. Overall appli-
cation of transparent stoneware glaze. High-temperature firing. Gold
lacquer repairs.

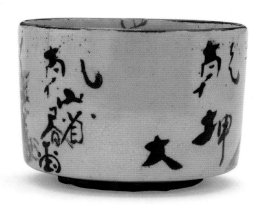

The poem reads: "In tranquility, the universe is great." The conflation
of a vast entity with a small bounded space is a common theme in Zen
poetry, and ultimately derives from the early and influential Daoist
text *Zhuangzi* (ca. 3d century B.C.)[15] A ceramic prototype with this
expression can be seen in *kosometsuke*, the late-Ming cobalt-decorated
porcelains imported into Japan in the early-Edo period.[16] Here, since
half the poem is on the outside and half on the inside, the full measure
of the verse—and its relation to the enclosed space of the vessel, which
"becomes" the universe in metaphor—is revealed either through
drinking or otherwise handling the bowl. Serious poetic appreciation
thus merges into mischievous "parlor" humor, with parallels in painted
sake cups that reveal comical faces or other figures as they are tipped.

A lived experience—the first Kenzan's construction of a vast universe
inside ceramics—became a form of decoration for his successors.
Cylindrical tea bowls with the mountain hermitage motif remain in
large numbers in Japanese and Western collections.[17] The signature
type, close if uninspired adherence to Kenzan's script style, and use of a
cipher in the shape of the character "ji" all point to the workshop of
Ihachi, heir to Kenzan's Kyoto workshop.

BY OGATA IHACHI (KYOTO KENZAN II, ACT. CA. 1720–1760)

Japan, Edo period, mid–18th century

Acquired from Siegfried Bing, Paris ($100); original attribution: "Kenzan."

Morse attribution: "I think that's a Tokyo Kenzan."

27.8 x 40.8 x2.0

Freer Gallery of Art, Smithsonian Institution, Washington, D.C.

Gift of Charles Lang Freer, F1901.77

Fine-grained buff clay. Slab constructed, with modeled edge and attached stand. White slip applied to both sides. Rim and stand painted in underglaze iron. Landscape depiction on each side, in summer and winter themes, in underglaze iron. "Kenzan" signature in underglaze iron on one side. Seals reading "Kenzan" and "Shinsei" applied through a stencil in ochre over signature. Overall coat of transparent lead glaze; low-temperature firing. Five spur marks on the bases of the stand. Stylized chrysanthemum pattern in gold lacquer on frame.

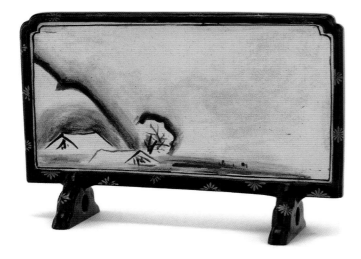

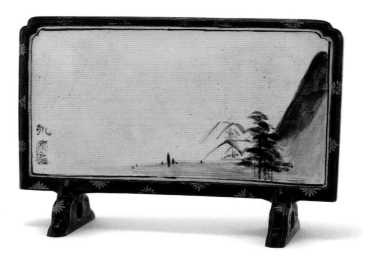

The *kenbyō* (also read *kenpei*), literally an "inkstone protector," is an intimate part of the scholar's desk ensemble. It is set on the far side of the writing equipment, and is considered to slow the evaporation of the ink, which the writer or painter grinds into a solution in a special stone prior to work. The *kenbyō* is also an object of appreciation in its own right. First becoming popular in Song dynasty China, *kenbyō* were made from materials such as ceramics, brass, jade, and wood, generally in the shape of the single- or multiple-panel screen used for mounting painting and calligraphy. In Japan, ceramic versions were among the late-Ming imports known as *kosometsuke*; these may have

instigated the first local versions, apparently made in the Mino kilns.[18] They also may be found among seventeenth-century Arita products, specifically *kenbyō* attributed to the early Kakiemon workshop (1670s).[19]

The style of the decoration, signature, and facsimile seals is that of the first Kenzan's Kyoto successor Ogata Ihachi. A very similar piece, once in the collection of Freer's friend and rival collector Howard Mansfield, is now in the collection of the Metropolitan Museum of Art, New York (36.120.655).[20]

BY OGATA IHACHI (KYOTO KENZAN II, ACT. CA. 1720–1760)
Japan, Edo period, mid–18th century
Acquired from Siegfried Bing, Paris ($60); original
attribution: "Kenzan."
Morse attribution: "Tokyo Kenzan. Genuine—a good one."
2.0 x 15.0 x 15.0
Freer Gallery of Art, Smithsonian Institution, Washington, D.C.
Gift of Charles Lang Freer, F1901.76

Fine-grained buff clay. Slab, formed on a drape mold and trimmed,
with some spatula marks apparent. Decoration of hut and trees in
underglaze iron, and red, blue, green, and yellow enamels. Motifs of
reeds in underglaze iron over green background on outer edge.
"Kenzan" mark on verso in underglaze iron. Overall application of
transparent lead glaze, with application marks from a flat brush visible.
Low-temperature firing.

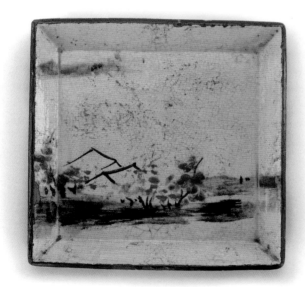

The Kenzan rectilinear dish with everted edges is known as a
gakuzara, or "plaque-dish," based on the resemblance to a framed wall
plaque *(gaku)*. The size and shape of this piece, however, suggest that it
was used as a *mukōzuke*, a dish (usually containing seafood) that
accompanied portions of rice and soup in lacquer-ware bowls. The
ensemble was served to each guest on a square tray.[21] The migration of
mountain hermitage decor from incense and writing utensils into the
dining area also tells of a change in referents. Here it becomes as much
a "Kenzan" motif—one of dozens of "vocabularized" signs—as it is an
evocation of the scholar's lair.

Several features of the dish distance it from first-generation Kenzan
production. In keeping with its origins in Chinese ink painting,
the mountain hermitage theme was conventionally executed in
monochrome. With its soft coloration, this piece has in effect confused
the Chinese tradition with the softer, lyrical style identified as
indigenous Japanese painting, or *yamato-e*. The brush strokes on this
dish also lack the sureness associated with the first Kenzan workshop.
The signature style is that of Ogata Ihachi (Kyoto Kenzan II), who
produced a number of food dishes in this general size.

KYOTO WORKSHOP, IMITATION

Japan, Meiji era, late 19th century

Acquired from Iida Shinshichi ($5); original attribution: "Kenzan."

Morse attribution: "Brand new—Kenzan."

7.9 x 10.2

Freer Gallery of Art, Smithsonian Institution, Washington, D.C.

Gift of Charles Lang Freer, F1899.99

Fine-grained buff clay. Wheel thrown and trimmed; indentation to median in soft stage. Partial application of white slip; painted decoration of huts and trees in underglaze iron. "Kenzan" signature in underglaze iron inside of foot ring. Transparent stoneware glaze applied to entire vessel, with glaze trimmed away from the bottom of foot ring after application. High-temperature firing.

The slightly inverted cylinder recalls late-Ming, Chinese porcelain bowls known in Japan as *undō-de*, but the overall decorative concept takes after the Kenzan model. The manner in which the background tree line curves over the dipped area of white slip is clever, providing a sense of three-dimensional form. This, however, suggests a more empirical gaze than one would encounter in Ogata Kenzan's own day.

The indentation of the median is a rustication common to many nineteenth-century products. The treatment of the foot ring, the slip pitting, and the signature are all atypical of early Kenzan production. The glaze has the hard, industrial look of a limestone (rather than ash) glaze; that would be a Meiji era feature.

The Kenzan mark employed here is encountered on a number of wares in Japanese collections; ones in Europe and North America formed after 1890 display it as well.[22] No marks of this type appear in the Morse collection formed in the late 1870s to early 1880s, prompting a very late-nineteenth-century assignment. Recent manufacture is implicit in the low price.

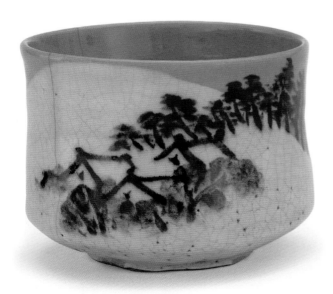

KYOTO WORKSHOP, IMITATION
Japan, Meiji era, late 19th century
Acquired from Rufus E. Moore ($20); original attribution: "Kenzan."
Morse attribution: "Put it in Kyoto—it isn't old."
1.9 x 25.7
Freer Gallery of Art, Smithsonian Institution, Washington, D.C.
Gift of Charles Lang Freer, F1901.194

Medium-grained brown clay. Slab formed, with trimming marks visible. Spatula-carved grooves on underside. Decoration of winter landscape in white slip and underglaze iron and cobalt on front. "Kenzan" signature and painted "Shōko" facsimile seal, both in underglaze iron, in lower-left part of composition. Front and edge covered with transparent stoneware glaze. High-temperature firing.

Winter landscape was a popular theme in Kenzan-ware imitations in the nineteenth century. There may be an undiscovered source in earlier Kenzan designs, but some of these later issues resemble a popular type of winter landscape dish made in late-Ming China and reproduced at the Nabeshima workshops in Kyushu in the late seventeenth or early eighteenth century.[23]

The attached cord, surely an addition to make the piece comprehensible to an overseas clientele, suggests a plaque; otherwise, the dimensions and shape point to a *shiki-ita,* a tile that insulates floor matting from the heat of a charcoal brazier. The clay appears to be industrially processed; the painting style, signature, and seal are common to collections formed in the late-Meiji era or thereafter. In fact, after receiving this piece from New York dealer Rufus E. Moore (1840–1918), Freer was informed, probably by Kyoto dealer Kita Toranosuke, that it was made by a Kyoto potter who created many of the imitations circulating in the American market.[24]

A similar piece, minus cord, is in the collection of the Risshō Kōsei Kai, Tokyo (ex–Kushi Takushin collection).[25]

KYOTO WORKSHOP, IMITATION
Japan, Meiji era, late 19th century
Acquired from Rufus E. Moore ($12); original attribution: "Kenzan."
Morse attribution: "Made by Kiyomizu potter, decorated by Kenzan."
4.8 x 12.9
Freer Gallery of Art, Smithsonian Institution, Washington, D.C.
Gift of Charles Lang Freer, F1896.97

Clay not visible. Hand carved. Painting of a mountain hermitage on the outer surface in underglaze iron. Signature reading "Shisui Shinsei saku" (made by Shisui Shinsei) and facsimile seal reading "Shōko," both in underglaze iron. Overall application of an opaque stoneware glaze that has "crawled" in the firing. Five spur marks on foot ring.

The glaze texture is loosely inspired by Shino ware, while the shape echoes that of the broad, shallow "summer" tea bowls carved by Raku and amateur potters. The mountain hermitage is, as we have seen, a stock Kenzan-ware subject.

This piece is a pastiche of techniques and styles, whose appeal relies more on an overall sense of amateurism rather than any historic fidelity. Early Kenzans did not prefer hand carving since the irregular surface was difficult to paint on; this low, flaring, summer tea-bowl shape was avoided because there was no clearly visible decorating space on the exterior. For similar reasons, there was little interest in thick, rather textured glazes like Shino. The name "Shisui Shinsei" was reserved for use as a signature on painting proper by the first Kenzan and never used on his ceramics.

While the first Kenzan did use a small-sized seal reading "Shōko," this large one calls attention to itself. Wares with prominent "Shōko" seals appear on a variety of pieces in European collections begun in the 1890s.[26] This piece is assigned to the late nineteenth century and is probably the work of Kyoto potters catering to the antique trade. Another "Shōko" work in the Freer collection is a tea container with a design of cranes (cat. no. 55).

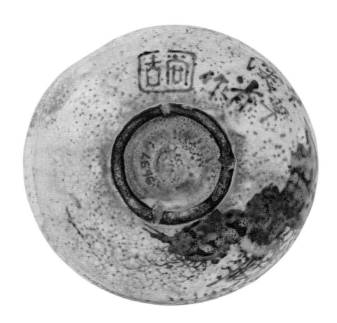

KYOTO WORKSHOP, IMITATION

Japan, Meiji era, late 19th century

Acquired from Rufus E. Moore ($65); original attribution: "Kenzan."

Morse attribution: "Kenzan—Tokyo—Musashi."

27.6 x 38.2 x 2.6

Freer Gallery of Art, Smithsonian Institution, Washington, D.C.

Gift of Charles Lang Freer, F1897.20

Fine- to medium-grained buff clay. Assembled from slabs and molded parts. Front: underglaze iron decoration of landscape, "Kenzan Shinsei utsusu" (copied by Kenzan) signature and painted facsimile "Shōko" seal, all in underglaze iron. Edge diaper pattern in yellow, green, and red underglaze enamels and iron. Back: poem in wax resist with green enamel fill. Edge pattern of vine scrolls in yellow, green, and red underglaze enamels and iron. Overall application of transparent lead glaze. Low-temperature firing. Left panel reattached; wheel support cracked and bonded.

The desk screen, described in detail in the entry for catalogue number 5, is part of the scholar's writing equipment and thus poetic themes such as this one are quite appropriate. Here the poem and poet are named, a rare instance in any Kenzan ware: "Fisher's Hut," by Li Dongyang (1447–1516). Li was a powerful scholar and bureaucrat known to have insisted on the correctness of Tang dynasty (618–907) models in poetry and prose.[27]

Living off of fish and shrimp, passing the bloom of their lives,
In this region of clouds and waters, just a few families dwell.
Springtime kitchens, wrapped in smoke, burn the leaves of rushes,
For winter robes, white as snow, they twist the flowers of reeds.
In the verdant weeds, round and round, losing the path to follow,
Under green willows, wide and deep, his fishing craft disappears.
The dreaming gulls are undisturbed, doors are left half open,
On a bank of shimmering moonlight, glimmers the silvery sand.

The signature type, coupled with the modern techniques of wax resist and chrome-pigmented green, place this in late-Meiji production. Our survey of the sources for the Chinese poetry inscribed on Kenzan ware suggests that poems inscribed by the first Kenzan are synthetic, "composed" by the man himself, and that imitators, when they dared to include poetry, often copied verbatim the work of famous masters. This is a case of the latter.

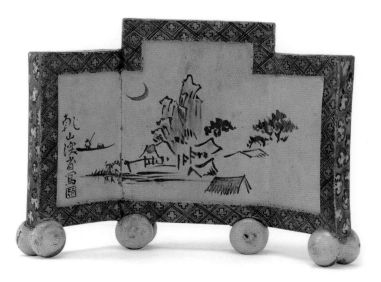

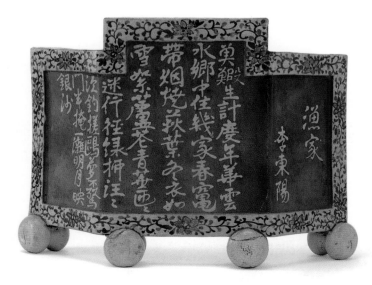

KYOTO WORKSHOP, KENZAN STYLE

Japan, Edo period, mid–18th century

Acquired from Matsuki Bunkio ($60); original attribution: "Kenzan."

Morse attribution: "Yes, that's a good Kenzan. Fair age—good

signature. A hibachi, well used."

9.2 x 10.6

Freer Gallery of Art, Smithsonian Institution, Washington, D.C.

Gift of Charles Lang Freer, F1902.218

Fine-grained buff clay. Assembled from five slabs. White slip applied to outside, upper one-third of inside, and bottom. Pine painting, edge bands, poetic inscription, signature and seals in underglaze iron and cobalt. The intaglio seal is executed in sgraffito (incised through the pigment) and the relief seal is painted. The signature reads "Kenzan Shinsei sho" (written by Kenzan Shinsei) and the seals read "Tōin" and "Shōko." Transparent stoneware glaze applied to outside, upper half of inside. Base unglazed. High-temperature firing. Four setting wad marks on base. Later wire-clamp repairs to vertical cracks.

Absence of glaze inside suggests use as a *hiire,* a pot that holds embers, embedded in ash, for lighting pipes. Laboratory analysis revealed calcite ($CaCO_2$) at the bottom of the pot, which was probably residue from the ash bed. The Chinese-style poem, employing the Confucian preference for expressing human virtue through nature, reads:

Straight trunks a thousand feet, green the winter through,
An acre wide, their dense shadows bring coldness to July.[28]

The upright and long-enduring nature of the pine is analogous to the character of the gentleman.

The general design of the piece, a poem-painting that is wrapped, handscroll-like, around the vessel, follows an original Kenzan concept. The highly stylized pine painting and the formalistic calligraphy suggest a later date. The signature style is closest to that of Ihachi, second-generation Kenzan in Kyoto. But Ihachi was a faithful follower of first Kenzan conventions, and the archaic form of the "shin" character in "Shinsei" is unusual, as is the seal sequence, which is reversed from the usual order. The piece is part of a burgeoning mid-eighteenth-century production keyed on Kenzan and Ihachi models.

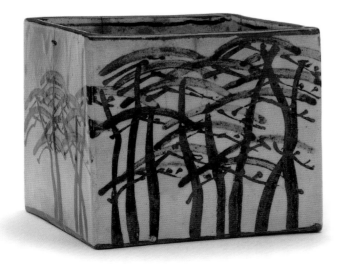
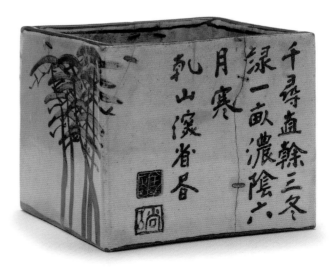

KYOTO WORKSHOP, KENZAN STYLE

Japan, Edo period, mid to late 18th century

Acquired from "Hayashi" ($115); original attribution: "Kenzan."

Morse attribution: "Kyoto Kenzan. Old family of Kenzan—one hundred years at least."

7.3 x 9.8

Freer Gallery of Art, Smithsonian Institution, Washington, D.C.

Gift of Charles Lang Freer, F1900.50

Fine-grained buff clay. Thrown and trimmed on potter's wheel; chatter marks from the trimming. Partial application of white slip, fissured from excess shrinkage. Bands around rim and base in underglaze iron; painting of polyanthus narcissus in underglaze iron and cobalt; poem, "Kenzan Sei sho" signature, and "Tōin" facsimile seal in underglaze iron, with seal frame and characters incised through pigment. Transparent stoneware glaze applied to entire vessel, with foot ring and base in reserve. Three stacking spur marks in cavetto. High-temperature firing. Vertical crack in median.

The cylindrical tea bowl with painting and inscription is a staple design of Kenzan ware. The line reads: "Emerald sleeves, yellow cap." The phrase is found on at least seven other pieces bearing the Kenzan signature.[29]

The Freer invoice file shows that this was "bought of Hayashi" together with two jars attributed to the Shidoro kilns. This Hayashi may have been interpreter and Paris art dealer Hayashi Tadamasa (1853–1906)—the price seems to be in line with the European market—although another possibility is Kyoto dealer Hayashi Shinsuke. Freer purchased a Kenzan painting (F1902.36) from entrepreneur Siegfried Bing (1838–1905) that was originally in the Hayashi collection.

The comparatively high firing, the intensity of the cobalt pigment, the exaggerated calligraphy of the poem, and the tentative signature are at variance with the work of the first Kenzan. The use of the cylindrical tea-bowl shape, and absence of a major reinterpretation of the genre, suggest that it is part of the conservative Kenzan-style production that continued in Kyoto in the decades after the original Kenzan's death. Archaeology of consumer sites in Edo reveals a peak of Kenzan-style cylindrical tea-bowl production between about 1740 and 1780, and this piece may be situated therein.

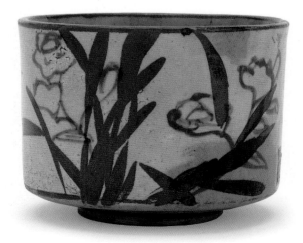

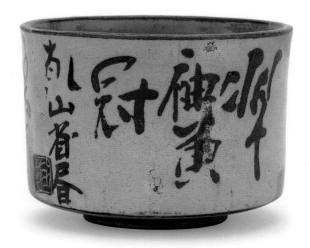

KYOTO WORKSHOP, KENZAN STYLE
Japan, Edo period, mid to late 18th century
Acquired from Matsuki Bunkio ($40); original attribution: "Kenzan."
Morse attribution: "Tokyo Kenzan."
13.1 x 10.3
Freer Gallery of Art, Smithsonian Institution, Washington, D.C.
Gift of Charles Lang Freer, F1901.160

Fine-grained buff clay. Thrown on potter's wheel and paddled into hexagonal shape. Foot ring applied as coil and trimmed by spatula. Rim decoration of cloud scroll in underglaze iron, with interior lines incised through pigment; decoration of camellia in underglaze iron and cobalt with veins in leaf incised through pigment. Inscription, "Kenzan Shinsei" signature, and cipher in the shape of the character "ji" in underglaze iron. Exterior and interior surfaces covered with transparent stoneware glaze; foot ring in reserve. High-temperature firing. Gold lacquer repairs.

The subject of the decoration is the camellia. The Chinese-style inscription reads: "All made-up with palace powder, blossoms in the snow."

According to a note left by Matsuki Bunkio and preserved in the Freer record, this was one stanza out of a set of four on the camellia.[30] The other lines are not recorded. The first two characters in the stanza connote white "pancake" makeup emblematic of courtesans.

The faceted shape, which appears in Hizen porcelains in the second half of the seventeenth century,[31] is an uncommon one in Kenzan ware, although one other piece, with a hollyhock design, is known.[32] The calligraphy and signature style, however, are similar to those on

the large number of inscribed pieces made in Kyoto workshops from the second quarter of the eighteenth century.

The Freer Gallery object record quotes dealer Matsuki Bunkio's statement that the piece was "purchased from Fukuta [sic] of Kyoto in 1898 and left at Shozan (great painter of Kyoto) at his request." "Fukuta" may have been the Kyoto dealer Fukuda Zenjirō.[33] "Shozan" was Okumura Shōzan (1842–1905), who was trained in the Kotō-ware tradition of the Hikone domain but later moved to Gojōzaka, Kyoto, where he made imitations of Ninsei and Kenzan as well as his own painted wares, which received prizes at the large industrial fairs.[34]

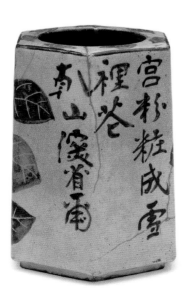
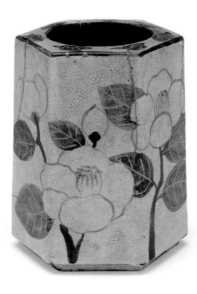
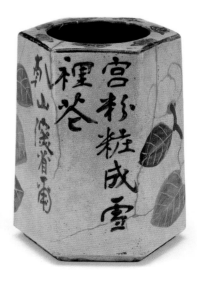

KYOTO WORKSHOP, KENZAN STYLE

Japan, Edo period, late 18th to early 19th century

Acquired from Y. Fujita, Kyoto ($60); original attribution: "Kenzan."

Morse attribution: "If that's a true Kenzan, it's Tokyo Kenzan. Pretty new—glistening glaze—modern."

8.9 x 9.7 x 10.0

Freer Gallery of Art, Smithsonian Institution, Washington, D.C.

Gift of Charles Lang Freer, F1911.401

Fine-grained buff clay. Formed from five slabs, with the wall slabs pressed into intaglio molds. Facets on the edges of the base form feet. Relief panels on two sides feature pine and plum; other panels bear inscription and signature. Signature reads "Kenzan Sei sho" and seal reads "Tōin." Decoration of plum blossoms in underglaze iron and cobalt on the raised area surrounding the panels. Transparent stoneware glaze on surround and upper one-third of inside wall. High-temperature firing.

Absence of glaze on the inside suggests function as a *hiire*, and the inclusion in the decor of two of the "winter friends," pine and plum, are appropriate to the scholar-recluse mode. The pine inscription reads: "Through all four seasons, it casts a cooling shade." The plum poem, which has an additional line, reads:

A subtle fragrance off and on comes in upon the wind,
Scattered shadows cross and slant along the riverbank.

The plum poem is an adaptation of one of the most famous of all plum verses, "Small Flowering Plum in the Garden on the Hill," by Song dynasty poet Lin Bu (967–1028), characterized by scholar Maggie Bickford as the patriarch of plum-blossom poetry.[35] Despite Lin Bu's lofty pedigree, the inscriber of this pot decided to alter the model; the pine inscription, moreover, is a fragment of a longer poem that appears on other Kenzan ware.[36]

The unglazed relief panels in this piece are unusual for Kenzan production, which is invariably smooth surfaced. The idea of having characters and decoration in relief, while not without precedent in earlier Japanese ceramics, seems more in keeping with the sinified tastes that developed with the growing popularity of steeped tea, or *sencha*, in the late eighteenth century. Two pieces similar to the Freer piece exist, one in a private collection in Kyoto and one in the collection of Risshō Kōsei Kai, Tokyo (ex–Kushi Takushin collection).[37] They seem to be made out of the same mold, although there are differences in the painted surround.

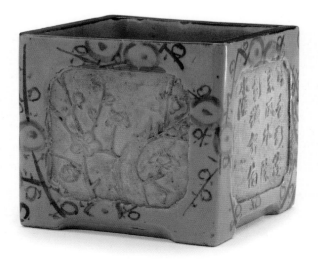
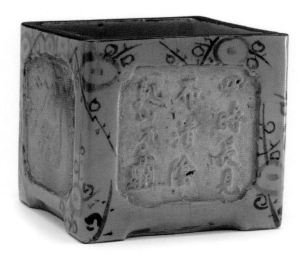

KYOTO WORKSHOP, IMITATION
Japan, Meiji era, late 19th century
Acquired from Matsuki Bunkio ($37); formerly in the collection of
Ikeda Seisuke, Kyoto; original attribution: "Kenzan."
Morse attribution: "Doesn't amount to much—signature wrongly
written—smash it!"
31.3 x 5.7
Freer Gallery of Art, Smithsonian Institution, Washington, D.C.
Gift of Charles Lang Freer, F1900.73

Fine-grained buff clay. Thrown on the potter's wheel and separated
using a cord, leaving a characteristic spiral cut-mark on base.
Cylindrical lugs attached at rim. Decoration of bamboo, in two tones,
and inscription/signature "Keichō Shisui hachijūsai utsusu" (Copied
at age eighty-one by Keichō Shisui) in underglaze iron. "Kenzan"
mark, in a seal-style script, in underglaze iron with single line
surround. Overall application of transparent stoneware glaze. High-
temperature firing.

The lugs, of a type called *kuda-mimi*, echo those attached to bronze
and celadon flower vases used in the tea ceremony. The overall shape,
on the other hand, suggests bamboo. The poem, evoking the refreshing
sound of wind blowing through bamboo, reads: "When the wind
blows, bamboo plays beautiful music." The same five-character poem
appears on a bamboo-decorated dish with a Kenzan mark.[38]

This piece "plays" on the image of Kenzan as a scholar-recluse,
without any reference to the mainstream style. Incorporation of pseu-
donyms like "Keichō Shisui," used by Kenzan only in his late painting,
are derived from late-Edo and Meiji era histories of the Rimpa
school, which made these names widely known and accessible for
reproduction.

Dishes with an identical Kenzan mark are known.[39] Irrespective of
the maker, flower vases with the Kenzan mark are exceedingly few
in number.

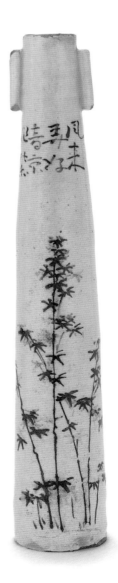
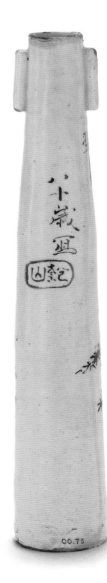

NATIVE POETICS

In the large group of documents preserved by the Konishi, descendants of the Ogata, is a sketch of Kakinomoto Hitomaro (active ca. 685–705), an early and preeminent practitioner of Japanese verse (fig. 19). Aside from its kinship to older renditions, the figure is identifiable by the attached inscription, a copy of one of Hitomaro's most quoted works:

Dimly through morning
mists over Akashi Bay,
My longings trace the ship
Vanishing from sight,
Floating silently behind the isle.[40]

The pairing of Japanese poet and poem is part of a long tradition called *kasen-e:* an imaginary "portrait" of an esteemed poet is joined with a skillfully brushed sample of his or her work. Here, the fine but otherwise unattributed handwriting has invited further analysis. After comparison with widely accepted documents and signed inscriptions on paintings and pots, we have concluded that the writer is none other than Ogata Kenzan himself. Inasmuch as the painting is widely agreed to be from the hand of Kenzan's brother Kōrin, and as it reflects an initial, eclectic stage of Kōrin's work, the Hitomaro becomes an early—and unparalleled—joint work on paper by the two brothers (their celebrated ceramic collaborations will be visited in "The Kōrin Mode" section of the catalogue). It may well have been created before Kenzan opened his first ceramic workshop in 1699.

Kenzan's sure hand (fig. 20) is generous with ink, imaginative in its deployment of script types, and confident in linking individual characters. This demonstrates a mastery of *wayō*, the native handwriting tradition. Such aptitude ran in the family. Kenzan's great-uncle Kōetsu was

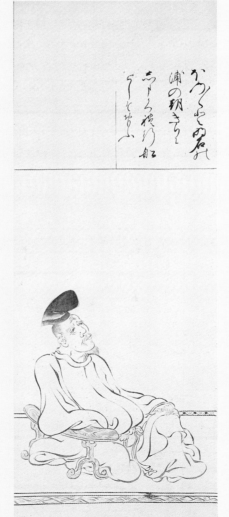

Fig. 19. Portrait of Hitomaro, late 17th century, by Ogata Kōrin (1658–1716) with inscription by Ogata Kenzan (1663–1743). Hanging scroll, ink on paper, 96.1 x 34.2. Osaka Municipal Museum of Art.

Fig. 20. Detail of inscription on the portrait.

a key figure in a classical-verse revival of a century earlier, and successive heads of the Ogata house achieved fame as Kōetsu-style calligraphers.

The deft hand also connects to the literary heart. In copying out such a verse, Kenzan was reproducing images and metaphors central to the indigenous tradition. Already in Hitomaro's day, feelings of longing, love, and loss were conflated with natural beauty and frequently linked to real places—mountains, waterways, seacoasts, and moors. Later poets would assign to some of those places fixed lyrical identities. It was this very particularity that would facilitate the transfusion of poem into pot, a mode in which Kenzan potters excelled.

In Kenzan's early modern period, native literary practice moved from a guarded, privileged tradition to popular hobby. Political stability guaranteed prosperity and leisure, and the ruling warrior class was required to cultivate skills in the arts and letters. Chinese classics were given priority but the Japanese tradition was not excluded. The didactic manual *Shison kagami* (Mirror of posterity; 1673) prescribes, among other things, familiarity with the Four Confucian Books, Nō recitation, and composition of continental and native verse. In addition to moral cultivation and personal pleasure, knowledge of Japanese poetry was a practical asset—"spontaneous" recitation of poetry was useful in official audiences and all kinds of private engagements. The upper merchant class, with its general aspiration to an aristocratic lifestyle, followed suit, but in Kenzan's Kyoto this had a particular urgency. In defeating the Toyotomi faction and moving the political center to Edo, the Tokugawa had stripped Kyoto of all but the vestiges of power; celebrating the city's classical heritage—the bygone days of the Heian period (794–1185) when emperors actually ruled and great poetry was in the air—was a political as well as aesthetic act. For those with the requisite means, the classics were accessible through printed anthologies, instruction manuals, and teachers. The city guidebook *Kyō habutae* (Weave of Kyoto), published in 1685, lists dozens of teachers in verse and Nō recitation. Poetry societies blossomed, focusing on the ancient *waka* verse and on the more up-to-date *haikai*.

Fig. 21. Illustrated poem of the twelfth month, from Fujiwara Teika's poems of birds and flowers of the twelve months, in *Shigi no hanegaki*, 1691.

Classical literature here may be understood as the ancient texts written in the classical Japanese language: prose-poetry works such as the *Tales of Ise* (compiled 10th century) and *Tale of Genji* (written 11th century) and imperially authorized verse anthologies like *Kokinshū* (Collection of poems ancient and

modern; compiled early 10th century) and *Shinkokinshū* (New collection of poems ancient and modern; compiled early 13th century). The Nō drama, which transforms the early court-based narratives into staged moments of intense human feeling—sadness, rage, and jealousy—is also associated with these indigenous "classics." In Kenzan's day certain poets and verse collections enjoyed great prestige. In the world of *waka*, especially the thirty-one syllable verse form called *tanka*, a particular locus of authority was the Kamakura-era poet and critic Fujiwara Teika (1162–1241). Teika's aesthetics had been central to the coveted medieval poetry tradition called *Kokin denju* (Transmission of the ancient and modern), and sixteenth-century merchant tea enthusiasts admired qualities of mystery, loneliness, and desiccated beauty attributed to Teika and his milieu. By the seventeenth century, the increased popularity of the tea ceremony and accessibility to copybooks and court poetry teachers had enshrined Teika as a paragon of poetic mood, calligraphy style, and verse. This is evident in a popular illustrated anthology called *Shigi no hanegaki* (Fluttering of snipe's wings; 1691 [fig. 21]), which featured Teika poem-pictures together with illustrated permutations of other classical verses. Here is a source for Kenzan's materialization of the classical tradition. Moreover, the social intercourse in events such as *kaiseki*, the tea-ceremony meal, provided the tissue that connected Teika imagery with ceramic vessels (figs. 22 and 23).

Nō drama, although institutionalized as an official entertainment of the warrior class, was another area of cultural trespass: it began to boom among cultured townsmen during Kenzan's youth. Nō libretti, or *utai-bon,* were published in large numbers in the late seventeenth century, and their titles figure prominently in late-seventeenth-century booksellers' lists. Kenzan's father, Sōken (1621–1687), and older brother Kōrin were enthusiasts; their study under townsman teacher Shibuya Shichirōemon is mentioned in the family archive. The names of Nō players also appear in the salon of court noble Nijō Tsunahira (1670–1732), which Kenzan and his brothers frequented in the 1690s

Fig. 22. Dish illustrating the twelfth month, from a set of dishes with designs of Fujiwara Teika's poems of birds and flowers of the twelve months, 1702, by Ogata Kenzan (1663–1743). Lead-glazed earthenware. 2.2 x 16.8 x 16.8. MOA Museum, Atami.

Fig. 23. Underside of fig. 22.

and thereafter.[41] As with *waka*, Nō imagery was adopted in salable goods. Kenzan's productive urges are manifested in sets of rectangular dishes with designs after well-known Nō drama themes (figs. 24 and 25). Programmed dining was part of an increasingly rationalized Nō performance.

It is difficult to believe that poetic quotations, however rooted in a revered classical age, represented a stable set of values or elicited fixed readings. For sixteenth-century tea masters, poem fragments became material tokens of an imagined literary pedigree. Ninsei wares partook of the late-seventeenth-century fashion (especially evident in elite textiles) for mixing elegant materials with classically grounded rebuses and allusions. Ninsei wares also made a subject of famous places *(meisho),* which figure in the classical corpus as poignant backdrops for love, loss, and longing. *Meisho* constituted a spatial template that could be coopted by the increasingly mobile populace, with its tourism, group pilgrimages, and away-from-home hedonism. *Meisho* thus blur into famous things: *meisan.* Kenzan's pots themselves were identified as Kyoto *meisan,* and although further evidence is lacking, we may assume that later Kenzan goods were part of the souvenir-and-guidebook culture of mass tourism.

Fig. 24. Rectangular dish with design inspired by Nō drama *Ataka* (The barrier station at Ataka; early 18th century), by Ogata Kenzan (1663–1743). Lead-glazed earthenware. 2.6 x 10.8 x 19.0. Courtesy Peabody Essex Museum, Salem, Massachusetts.

Fig. 25. Underside of fig. 24.

BY OGATA KENZAN (1663–1743) (NARUTAKI WORKSHOP, 1699–1712)
Japan, Edo period, early 18th century
Acquired from Waggaman Collection, American Art Association Sale
($25); original attribution: "Kenzan."
Morse attribution: "A *good* one—good decoration."
2.1 x 16.6 x 16.8
Freer Gallery of Art, Smithsonian Institution, Washington, D.C.
Gift of Charles Lang Freer, F1905.58

Fine-grained buff clay. Slab, draped over mold and trimmed. Some evidence of trimming marks on bottom. Decoration on front: birds, rocks, trees, and grasses in blue, green, yellow, red, and purple underglaze enamels. White slip used as pigment for buds, bird details, and snow. Underglaze iron pigment on rim and on the bevel on base. On outside edge: camellias, pomegranate blossoms, cloves, flowers, and scrolls in underglaze blue enamel. On underside: "cloud" bands in underglaze blue enamel; poem in underglaze iron; "Kenzan Shōko Shinsei" signature, followed by the *kinchaku* (moneybag) style of cipher in underglaze iron. Coated with a transparent lead glaze; horizontal brush strokes of glaze application visible. Low-temperature firing. Some chips on rim, but interior shows no signs of wear.

The size, the underlying decoration of colored swatches on the back simulating the traditional cloud-patterned paper *(kumogami)*, and the composition of the poetry all suggest the format of the poem card, or *shikishi*, a heavy-paper card used for inscribing poetry. The theme of the painting is one of twelve vignettes of birds and flowers of the twelve months based on paired poems by Fujiwara Teika. The Freer dish illustrates the twelfth month, and the poems to accompany the paired mandarin ducks and blossoming plum read thus:

Plum blossoms:
It is that time when snow buries the colors of the hedge,
Yet a branch of plum is blooming, on "this side" of the New Year.
Mandarin duck:
The snow falls on the ice of the pond on which I gaze,
piling up as does this passing year on all years past,
And on the feathered coat of the mandarin duck, the "bird of regret." [42]

The plum "takes sides" in one of its time-honored roles as the flower that recognizes the new year. In Tang dynasty China, mandarin ducks *(oshidori)* were paired on marriage mirrors as symbols of human devotion; they were believed to mate for life and if one should die, the other, becoming the "bird *(tori)* of regret *(oshi)*," would pine away. The verse pair, then, is a lament over time irrevocably passed; the poignancy of lost love is reinforced by another traditional plum image, separation.

The poems were composed by Fujiwara Teika in 1214 for Prince Dōjo (died 1249), then abbot of the Ninnaji Temple in northwest Kyoto. From the seventeenth century, this set of Teika bird-and-flower poems became a favorite subject for painters such as Karasumaru Mitsuhiro (1579–1638), Kanō Tan'yū (1602–1674), Tosa Mitsuoki (1617–1691), and Yamamoto Soken (died 1706). [43] According to Kobayashi Taichirō, a scholar active in Kenzan studies in the period immediately after the World War II, Kenzan's dishes were inspired by a set of illustrated poems in the aforementioned *Shigi no hanegaki*, published in 1691. Close inspection of the pottery versions, however, reveals a stylistic debt to the Kanō school, and indeed these compositions are nearly identical to those in an album of Teika poem-pairs and pictures signed by Tan'yū, now in the Idemitsu Museum of Art, Tokyo. [44] A recent exhibition of official painters *(goyō eshi)* of Kenzan's day also revealed that Teika themes were inserted into a great diversity of small-painting formats. [45] This too would have encouraged experiments in three-dimensional objects.

At least seven whole sets of such dishes remain. [46] The most frequently published set, preserved at the MOA Museum, Atami, bears the date Genroku era, fifteenth year, or 1702. After comparing the defining criteria of all versions with the Freer piece, [47] it may be observed that the Freer piece shares stylistic kinships with a set in the Idemitsu Museum of Art, Tokyo. [48] Six of the dishes in the latter set have Rimpa rather than the usual Kanō-style designs. It is unlikely that an imitator would engage in such variation (it is possible that one half of the Idemitsu set is a later substitution, but the size, warping, and glaze defects of both halves are comparable). If genuine, the Idemitsu set (and hence the allied Freer piece) represents a diversification from the academic Kanō prototype seen in the 1702 MOA set. Considering that Kenzan's Rimpa style developed slightly later than his academic designs, this dish would have been made closer to his period at Chōjiyamachi, 1712 to about 1731. It was obviously a popular item and long seller, and one suspects there were minor variations with each new "edition."

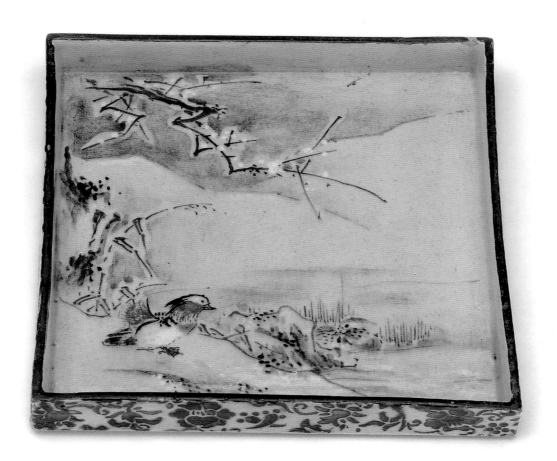

BY OGATA KENZAN (1663–1743) (NARUTAKI WORKSHOP, 1699–1712)
Japan, Edo period, early 18th century
Acquired from Matsuki Bunkio ($115); original attribution: "Kenzan."
Morse attribution: "Kyoto—Kenzan. A ripper—a fine one."
3.0 x 11.4
Freer Gallery of Art, Smithsonian Institution, Washington, D.C.
Gift of Charles Lang Freer, F1903.117

Drape-molded white clay. Lid and base details hand carved. White slip
application to cloud details on cover, sides, inside of cover and body,
and base. Underglaze cobalt decoration of cloud edges on cover,
border pattern of lozenges on side, and "cloud" bands on interior.
Magpie, bridge, and flower details in underglaze iron; "Kenzan" mark
on base in same. Transparent stoneware glaze applied to entire vessel,
with contact areas between cover and base reserved. High-temperature
firing; three scars from setting pins visible on base. Painting of maiden-
flower blossoms in two shades of green overglaze enamels. Enamels
fused in low-temperature firing. Application of overglaze gold enamel
to cover and interior. Possible second low-temperature firing to fuse
the gold. Discoloration probably caused by washing.

The piece is conventionally identified as a container for pellets of
incense, for use either in an incense-guessing contest or in the tea
ceremony. My suspicion that the piece was used as a container for the
red, pasty ink used for writers' and painters' seals was confirmed by
Freer conservation scientist Blythe McCarthy, who detected traces of
mercury sulphide (cinnabar) on the inside. The large size also suggests
a use other than holding incense.[49]

In keeping with its role as a writer's accessory, the decoration for this
box has a literary theme. A comparison with a well-known Kenzan
design, the set of twelve dishes based on Fujiwara Teika's poems of
birds and flowers of the twelve months (see cat. nos. 16 and 18), reveals
that this pairing of maidenflower (ominaeshi) and magpie (kasasagi) is
intended to represent the seventh month. A knowing audience would
link the image to this poem from the Teika series:

Maidenflower:
Maidenflower, not seen except in autumn:
Have you made a pledge to greet the sky in which the lover-stars emerge?
Magpie:
Having promised to join your wings with others through the whole night,
magpies,
Have you waited all this time for autumn's coming
to make the bridge for the lover's crossing?[50]

The reference in the poem is to Tanabata, a Japanese festival held on
the seventh night of the seventh lunar month. It is derived from a
Chinese Daoist legend: the Lord of Heaven, the father of the female
"Weaver" Star (Vega), forbade her to join her mate, the "Herdsman"
Star (Altair), for more than one night each year. In Japan this spinning
maiden is called Princess Tanabata: she crosses the "bridge" of magpies
over the Milky Way on the seventh night of the seventh month to
meet her estranged lover.

In terms of design, the piece has several notable features: first, the use
of a fine white clay with an overall glaze coat; second, the clever way
in which the shape of the cover is orchestrated with the painting; and
third, the remarkable orchestration of slip application, underglaze
pigment, overglaze enamel, and overglaze gold painting (suggesting
that the decorator was on hand during each phase of production).

In recent years about a dozen of these incense-shaped boxes have
come to light, and the finest ones seem to have been part of a single
set with the twelve months theme.[51] In addition, there are several
pieces that display the same exacting technique, but different themes
(cat. no. 20), and also some that are clearly later imitations (cat. no. 27).
Kenzan-ware shaped incense cases enjoyed great popularity in the
late-Edo period and Meiji era. (A fragment of one was excavated from
a disposal pit at the Tameike site in Chiyoda Ward, Tokyo, together

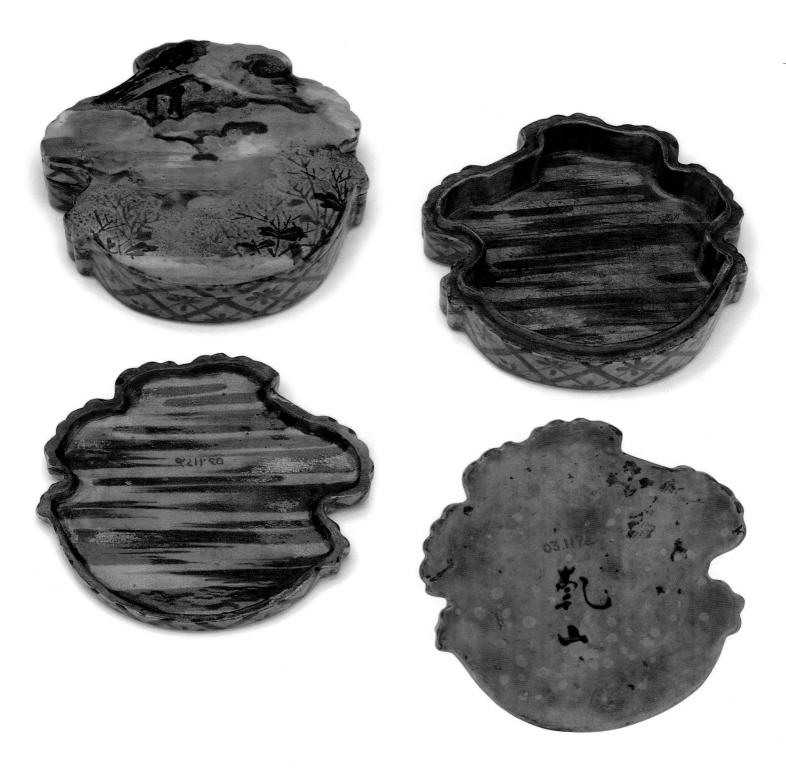

with bowls and dishes from the late eighteenth and early nineteenth centuries.[52]) As Freer's records suggest, they were among the most-prized Kenzan wares during the period he was collecting.[53] But in the post–World War II years, when interest in Kenzan revived, these pieces were largely ignored in Japan. They may have seemed a little too ornate in contrast with the bolder standard for Kenzan wares then in fashion. Yet when considered together with the aforementioned

square dishes, the earliest set of which is dated 1702, they may be located in a transition between the ornate style of Ninsei and the abbreviated Rimpa style of Kenzan. One problem here is the signature; it does not match the style of signature used by Kenzan in his early career. This can be explained by assigning the signature to the anonymous decorator of this piece—someone whose skill in painting far surpassed that of Kenzan himself.

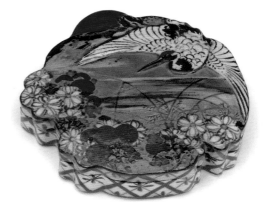

BY OGATA KENZAN (1663–1743) (NARUTAKI WORKSHOP, 1699–1712)
Japan, Edo period, early 18th century
Acquired from Matsuki Bunkio ($120); formerly in the collection of
Ikeda Seisuke, Kyoto; original attribution: "Kenzan."
Morse attribution: "A ripper! Kyoto Kenzan—rare.
That's the old type, all right."
2.6 x 11.0 x 12.0
Freer Gallery of Art, Smithsonian Institution, Washington, D.C.
Gift of Charles Lang Freer, F1900.72

Drape-molded from fine white clay. Lid and base details hand carved.
White slip application to cover details, sides, inside of cover and body,
and base. Underglaze cobalt (and iron) decoration of clouds, chrysanthe-
mums, crane, and floral details on lid, border pattern of lozenges on side,
and "cloud" bands on interior. "Kenzan" mark on base in underglaze
cobalt. Transparent stoneware glaze applied to entire vessel except for
contact areas between lid and base. High-temperature firing; four scars
from setting spurs visible on base. Painting of sun, crane crest, pampas-
grass tassels, and chrysanthemums in red overglaze enamels; floral details
in yellow overglaze enamels; pampas grass and chrysanthemum leaves
in green overglaze enamels. Low-temperature firing to fuse the enamels.
Application of gold overglaze enamel to parts of cover and interior.

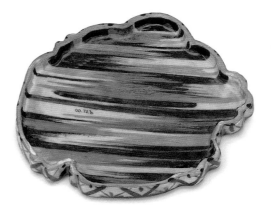

The vessel is conventionally described as an incense container, but
the large size and scientific confirmation of seal ink in the afore-
mentioned catalogue number 17 suggest that the intended use was as a
seal ink container. The theme of the decoration is both auspicious and
literary, deriving from Fujiwara Teika's poems of birds and flowers of
the twelve months (see cat. no. 16). In this set, the chrysanthemum-
crane pairing is intended to represent the tenth month:

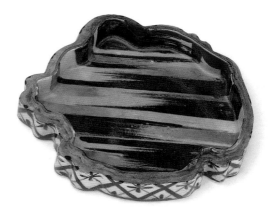

Chrysanthemum:
If the chrysanthemum did not give off this scent on this frosty night
In the "month of no gods," what then would serve as our keepsake of
autumn?
Cranes:
Though the rays of the evening sun are falling on the huddled cranes,
The rain clouds are moving from peak to peak.[54]

The container is part of the same set as catalogue number 17; refer
to those notes. Matsuki Bunkio, who provided this piece, noted:
"One of the most costly specimens of Kenzan in Japan. Used to hold
incense to burn. It is very much like Ninagawa's type of Kenzan in
Morse collection."

POSSIBLY BY OGATA KENZAN (1663–1743)
(NARUTAKI OR A CONTEMPORARY KYOTO WORKSHOP, CA. 1700–1720)
Japan, Edo period, early 18th century
Acquired from Iida Shinshichi ($25); original attribution: "Kenzan."
Morse attribution: "Kyoto—Kenzan."
7.2 x 10.4
Freer Gallery of Art, Smithsonian Institution, Washington, D.C.
Gift of Charles Lang Freer, F1899.98

Coarse buff clay. Wheel thrown and trimmed. Partial application of white slip using a flat brush. Decoration of cranes and chrysanthemums in underglaze iron and cobalt pigments. "Kenzan" signature in underglaze iron on base, outside of foot ring. Transparent stoneware glaze; base area unglazed.

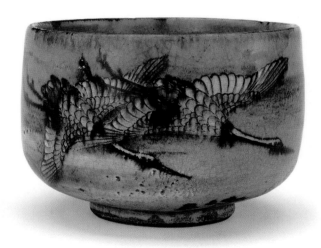

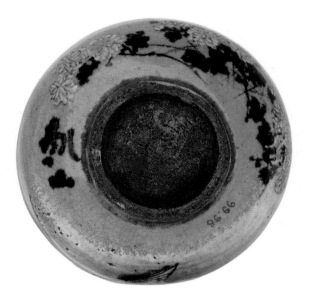

The combination of crane and chrysanthemum has two possible but interrelated nuances. First, it is an auspicious combination, since both bird and flower symbolize longevity. Second, the painting may refer to poems of birds and flowers of the twelve months by Kamakura period poet Fujiwara Teika, demonstrated above as a favorite theme in Kenzan ware; the crane and chrysanthemum pairing are used for the tenth month. An incense container in the Freer collection, once part of a set of twelve corresponding to those poems, has the same pairing and similar design elements (see cat. no. 18).

This piece shows a signature style similar to that used in Kenzan's first decade at Narutaki; the careful brushwork, suggestive of a trained decorator, is also a Narutaki trait. The anomalous feature is the gritty clay, more typical of late-eighteenth- or early-nineteenth-century work when Kyoto potters began to use clays of varying colors and textures.

BY OGATA KENZAN (1663–1743) (NARUTAKI WORKSHOP, 1699–1712)

Japan, Edo period, early 18th century

Acquired in Japan in spring 1907 ($75); original attribution: "Kenzan."

Morse attribution: "May be Tokyo—Kenzan (?). After the style of
Kenzan. Oh, damn these things!"

2.5 x 10.0

Freer Gallery of Art, Smithsonian Institution, Washington, D.C.

Gift of Charles Lang Freer, F1907.84

Lid and base hand carved from a fine-grained, white-buff clay;
lid contours carved in to match painting scheme. White slip applied
to select areas of cover and interior. Underglaze cobalt and iron
decoration of figures in an abbreviated landscape setting on lid. Border
pattern of lozenges on side and "cloud" bands on interior in under-
glaze cobalt. "Kenzan" mark on base in underglaze cobalt. Transparent
stoneware glaze applied all over vessel with contact areas between lid
and base reserved. High-temperature firing; three setting spur marks
visible on base. Accents to cover design in red and green overglaze
enamels. Low-temperature firing. Application of gold to cover details
and interior clouds. Second firing at low temperature.

In the ninth chapter of the classical work *Tales of Ise*, a party of
exiles that includes the central figure, customarily identified as
courtier Ariwara no Narihira (825–880), comes to a mountain pass
called Utsutōge (in Suruga Province, present Shizuoka Prefecture).
The gloomy, ivy-overhung path they were to take into the hills
plunged the group into melancholy. Just then they came upon a
wandering ascetic whom they had known back in the capital, and
Narihira wrote out a letter (presumably to a lover) for the monk to
deliver upon returning home:

Beside Mount Utsu
In Suruga,
I can see you
Neither waking
Nor, alas, even in my dreams.[55]

This episode, under the name "Utsunoyama" (Utsu mountain) or
"Tsuta no Hosomichi" (Narrow Ivy Road), came to express
desolation and longing for home and one's lover. From the Kamakura
period there appeared scroll paintings and lacquer ware with the
"Tsuta no Hosomichi" theme, often marked by the *oi* (the backpack
carried by Narihira's emissary) and *fushi bumi* (rolled letter). Rimpa
artist Tawaraya Sōtatsu and his atelier further disembodied the motif,
using simple ivy-road compositions in painting, lacquer ware, and
publishing. Kenzan's brother Kōrin was obviously inspired by the
motif, and his sketchbooks show a number of reductive variations.[56]

One characteristic of the Rimpa design is to progressively
"deliteralize" favorite themes; Kōrin, for example, is celebrated for the
way he reduced the "eight bridges" passage from the classic *Tales of Ise*
into the simple motif of irises. Here, the popular ivy-road vignette is
represented in picture alone. Presumably the user would be required
to "complete" the poem-painting pair—a ceramic permutation of
traditional verse-guessing, which required visualization of written
material or, conversely, recitation based on a picture.

This piece varies slightly from catalogue numbers 17 and 18 with
regard to size, manner of decoration, and signature, and hence belongs
to another production episode, albeit from the first Kenzan workshop.
A very similar piece (width 10.0 cm), with an illustration from
"Yomogiu" (The wormwood patch) chapter of the *Tale of Genji*, has
recently come to light in Kyoto.[57]

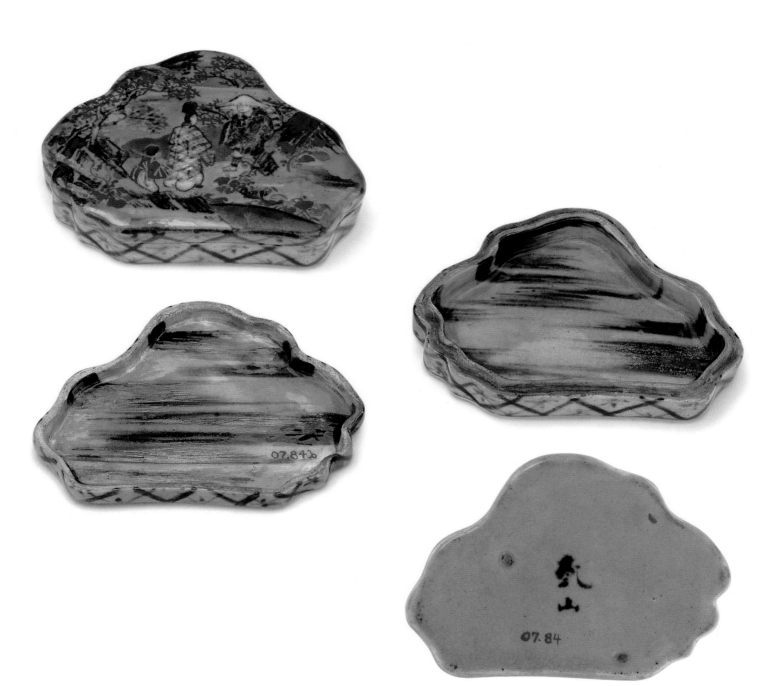

BY EDO KENZAN III

Japan, Edo period, early 19th century

Acquired from Samuel Colman Collection sale ($21); original
attribution: "Kenzan."

Morse attribution: "Good little piece—very nice one."

8.7 x 13.8

Freer Gallery of Art, Smithsonian Institution, Washington, D.C.

Gift of Charles Lang Freer, F1902.82

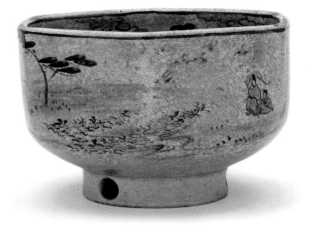

Fine-grained red clay; flecks of mica visible. Wheel thrown and
trimmed; body section paddled into hexagonal shape. Three
circular perforations in pedestal foot. White slip applied to inside wall and
entire exterior. Decoration of river, plovers, chrysanthemums, pines,
figures engaged in cloth processing, and bush clover in underglaze
iron pigment and enamels; band of clouds on inside rim in underglaze
iron pigment and enamels. "Kenzan" mark in underglaze iron on base
inside foot. Application of transparent lead glaze, with cavetto and
foot ring reserved. Low-temperature firing. Three stacking spur marks
in cavetto.

The unglazed interior and the shape suggest a pot to hold live embers
for lighting pipes. The faceting resembles the folds of a screen.

Six "Tama" (Jeweled) rivers are employed poetically in Japan.[58] This
one, identifiable by the cloth-processing vignettes, is the Tama River in
Musashino, present-day Tokyo. Place-names in western Tokyo along
the Tama River such as Chōfu (cloth preparation), Fuda (cloth field),
and Somechi (dyeing place) link the area to textile production. This
can be seen in a poem in the eighth-century anthology *Manyōshū*
("Azuma uta" [Eastland poems] section), which reads:

Though not the famed cloth
Washed in the Tama River,
More and more
How this young thing
Makes me adore her![59]

The red earthenware body is in keeping with Edo rather than Kyoto
production. Other pieces with the same signature style bear the
additional mark "Sandai" (third generation).[60] Some of them also are
inscribed with Bunka, Bunsei, and Tempō-era marks (1804–44
inclusive). Like the Freer piece, most of these "third-generation
Kenzan" pieces are low fired. Since few such pieces remain, the Freer
piece provides important information for the production of this
workshop.

[22] MEDICINE CASE WITH DESIGN OF "EIGHT BRIDGES"
(YATSUHASHI)

BY MIURA KENYA (1821–1889)

Japan, Edo period, mid–19th century

1.2 x 9.0 x 6.6

Freer Gallery of Art, Smithsonian Institution, Washington, D.C.
Gift of Stanley D. Fishman, F1984.45

Fine-grained, reddish buff clay. *Inrō* body pieces, *ojime* and *netsuke* are
hand carved. Vignette of iris bog in blue, white, brown, purple, yellow,
and green underglaze pigments and enamels. "Kenzan" signature on
base in single-line enclosure, and "Tenrokudō" signature on *netsuke*,
both in underglaze iron. Overall application of transparent lead glaze,
with contact areas reserved. Low-temperature firing.

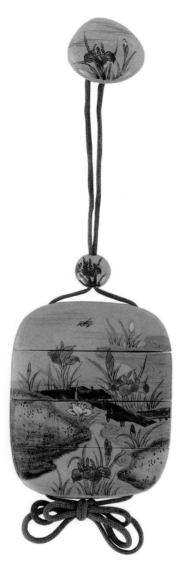

The subject is the "eight bridges" episode of the *Tales of Ise*, a favorite
motif in the Rimpa school, especially in Kōrin painting and Kenzan
ceramics (see cat. no. 48). This version suggests the participation of a
professional decorator. The bold distortion characteristic of Rimpa is
absent; something of late-Edo period naturalism is hinted in the
perspective, tonal variations, and flying insects. This manner may have
been absorbed from the school of painter Tani Bunchō (1764–1840),
with whom Kenya is occasionally associated.

The signatures confirm that this piece was made by Miura Kenya
(1821–1889), an Edo potter and inventor who inherited a Kenzan title

from fourth-generation Edo Kenzan Nishimura Myakuan (1784–1853)
in 1836.[61] Since there are few dated Kenya works, it is not possible to
reconstruct a stylistic development, but early in his career in Asakusa
and Fukagawa (1832–53), fresh from training in the precision
technique of Ritsuō-style lacquer, would be an occasion for Kenya to
make exacting pieces in non-Kenzan styles like this one. Consistent
with the craftsmanship is the execution of the "Kenya" signature,
written in a fine line without the mannerism of the later mark. Later
Kenya works, made chiefly at Mukōjima on the far side of the Sumida
River in Edo, have a gravelly clay and a painting manner in a grossly
simplified Kenzan mode.

EDO KENZAN SCHOOL

Japan, Edo period, early to mid–19th century

Acquired from Matsuki Bunkio ($160);

original attribution: "Kenzan."

Morse attribution: "Imitation Kenzan."

8.3 x 11.3

Freer Gallery of Art, Smithsonian Institution, Washington, D.C.

Gift of Charles Lang Freer, F1906.284

Medium- to coarse-grained buff clay. Wheel thrown and trimmed, with scars from trimming on median. Decoration of cherry trees and clouds in white slip, underglaze iron, and red, blue, and green underglaze enamels. Possibly an underglaze iron band on rim. "Kenzan" mark in underglaze iron inside foot ring. Overall application of lead glaze with pale green tint. Low-temperature firing. Glaze loss on interior surfaces. Gold lacquer repairs.

The oversized blue clouds seem to block access to any poetic allusion but in fact refer to a literary convention: abundant cherry blossoms are elegantly confused for clouds, usually hovering over Mt. Yoshino in Nara:

Now it seems that the
Cherry blossoms have burst forth—
At last from here I
See white clouds floating between
The rugged far-off mountain slopes.[62]

Cherry blossoms are rarely used in early Kenzan-ware decor, but in the nineteenth century they appeared in legion in the "Edo Rimpa" painting of Sakai Hōitsu (1756–1828) and his disciples. This, coupled with the rough clay body, soft glaze, and signature style, hints at production in Edo of the first half of the nineteenth century. A number of Kenzan-style workshops seem to have been operating at that time in or around a part of the city called Iriya (present-day Taitō Ward, Tokyo).

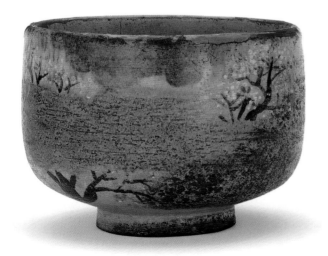

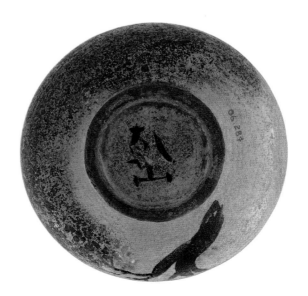

EDO KENZAN SCHOOL

Japan, Edo period, early 19th century

Acquired from Matsuki Bunkio ($40); formerly in the collection of
Ikeda Seisuke, Kyoto; original attribution: "Kenzan."

Morse attribution: "Very poor signature. A poor thing—a rotten
thing—none of the family of Kenzan guilty of that. Imitation—
cheap, dirty, chaotic, inchoate fragment."

5.0 x 5.6

Freer Gallery of Art, Smithsonian Institution, Washington, D.C.

Gift of Charles Lang Freer, F1900.77

Medium-grained, light-brown clay. Cover and base formed by
carving, with cover modeled in a mountain form. White slip applied
to exterior and base. Decoration of deer, grasses, pine, maples, and
chrysanthemums in underglaze and overglaze enamels. "Kenzan"
signature on base in underglaze iron. Interior and exterior brush
coating of transparent lead glaze with contact points reserved. Low-
temperature firing. Gold lacquer repairs.

Matsuki Bunkio left a note that this piece was "representing Mountain
[sic] near Nara." Matsuki was referring to Nara's Mt. Kasuga. The deer
is the tutelary deity of the Kasuga Shrine, worshiped as a sacred
animal. Also, the plaintive cry of the deer in autumn, specifically the
lone stag seeking a mate, became a symbol for a disconsolate lover. A
prominent example appears in the classical anthology *Kokinshū*
(compiled ca. 905):

Treading through the autumn leaves
In the deepest mountains,
I hear the belling of the lonely deer;
Then it is
That autumn is sad.[63]

The form, on the other hand, has a Chinese origin; mountain-shaped
seals of semiprecious stone and of similar size and shape, dated to as
early as the seventeenth century, can be seen in many collections.[64]

Morse's comments show an extraordinary animus for this piece—as
if words could make it go away—but it is not entirely new. A similar
incense container is illustrated in *Kenzan iboku* (Ink traces of Kenzan),
published in 1823 by Edo Rimpa painter Sakai Hōitsu; such vessels
were clearly in circulation in Edo in the early nineteenth century. The
low-fired technique, the signature style, and the overwrought packing
of information is common to the Edo Kenzan school of Hōitsu's day.

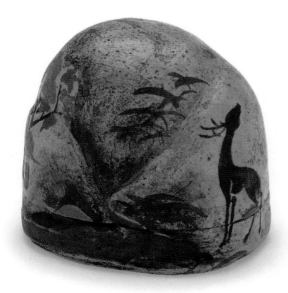

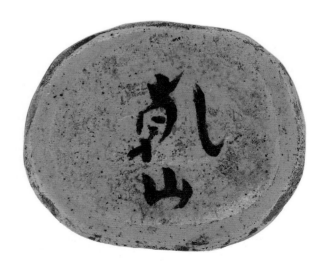

KYOTO WORKSHOP, KENZAN STYLE
Japan, late Edo period or Meiji era, mid–19th century
Acquired from Matsuki Bunkio ($20); original attribution: "Kenzan."
Morse attribution: "Kenzan, all right—Tokyo Kenzan."
2.5 x 7.2
Freer Gallery of Art, Smithsonian Institution, Washington, D.C.
Gift of Charles Lang Freer, F1901.115

Medium-grained, light-brown clay. Lid and base carved by hand.
Decoration of oxcart, figure, boats, pines, *torii* (shrine gate), and clouds
in white slip, underglaze iron and cobalt. Edge pattern of lozenges in
underglaze iron. "Kenzan" mark, in single rectangular frame, on base.
Transparent stoneware glaze applied to exterior and interior, with base
and rim contact surfaces in reserve. High-temperature firing.

The ensemble of oxcart, offshore boats, and shrine gate refers to
Sumiyoshi Shrine in present-day Osaka Prefecture. The Sumiyoshi
(also called Suminoe) god protected seafarers, and from the late Heian
period became the god of native poetry as well. The ocean waves and
pines surrounding the shrine are frequent markers in native verse:

Through the ancient pines
That line Suminoe bay
Blows the autumn wind—
Its soughing carrying the
Clapping of white waves off shore.[65]

The original Kenzan did create incense boxes with classical literary
themes; catalogue numbers 17, 18, and 20 are some of the most elegant
specimens extant. But the clay, decorative techniques, and signature in
the Sumiyoshi box are at variance with the above. The high-fire
manufacture points to Kyoto, and the style of signature, especially the
manner of abbreviation and painted frame, relates in a general way to
Kenzan reproductions from mid-nineteenth-century Kyoto.

An original note left by Charles Freer attributes this piece to 1790,
probably based on advice that the piece was about 110 years old.

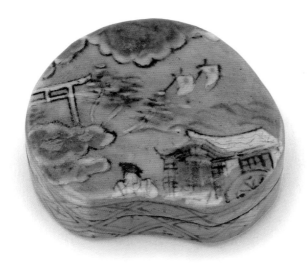

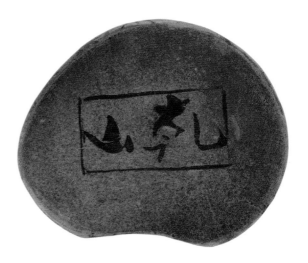

KYOTO WORKSHOP, KENZAN STYLE
Japan, late Edo period or Meiji era, mid–19th century
Acquired from Matsuki Bunkio ($30); original attribution: "Kenzan."
Morse attribution: "Nice little thing—sweet little piece—late though.
Tokyo—Kenzan."
1.4 x 8.1
Freer Gallery of Art, Smithsonian Institution, Washington, D.C.
Gift of Charles Lang Freer, F1902.219

Fine-grained, gray-buff clay. Pressed in an intaglio mold. Decoration
of trees, blossoms, and water in white slip, underglaze iron, and
underglaze cobalt; edge band and "Kenzan" mark on back of cover in
frame in underglaze iron. Overall coat of transparent stoneware glaze
and high-temperature firing. Addition of details in red and gold
overglaze enamel, fused in one or more low-temperature firings. Base
missing; replaced by wood facsimile.

The decoration may be intended to suggest the Nō drama *Sakuragawa*
(Cherry River) by Zeami Motokiyo (1364–1443). An impoverished
maiden of Hyūga Province (Miyazaki Prefecture), Sakurako, sells
herself into servitude. Driven mad with grief, her mother searches the
country, finally locating her child on the banks of the Sakuragawa in
faraway Hitachi (Ibaraki Prefecture). The folding fan shape is also
suggestive of Nō as it is a key stage property.

Encapsulating an entire Nō drama into a single motif was a concept
explored by the first Kenzan; sets of rectangular dishes decorated with

Nō themes remain in the Osaka Municipal Museum and the Idemitsu
Museum of Art, Tokyo, and individual pieces can be found in the West
at the Peabody Essex Museum, Salem, Massachusetts, and the Art
Institute of Chicago.[66] It should be noted that these rectangular dishes
are inscribed with relevant verses on the back, where this box (at least
the cover that remains) is not.

The signature style of this piece, with its frame and exaggerated but
poorly executed strokes, is typical of imitations from the mid-
nineteenth century. The clay body and high-temperature firing point
to a Kyoto workshop.

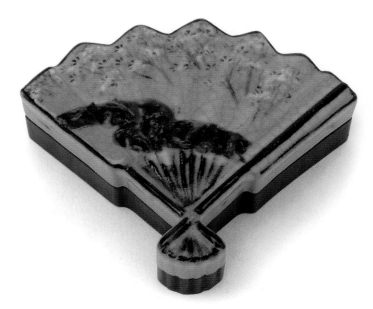

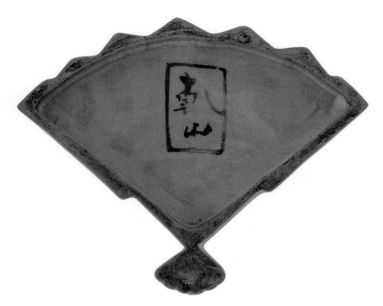

KYOTO WORKSHOP, IMITATION

Japan, Meiji era, late 19th century

Acquired from Matsuki Bunkio ($35); original attribution: "Kenzan."

Morse attribution: "Tokyo Kenzan."

1.9 x 6.5

Freer Gallery of Art, Smithsonian Institution, Washington, D.C.

Gift of Charles Lang Freer, F1900.75

Base and lid hand carved in fine-grained reddish clay. Cover decoration of bush clover and flowing water in white slip, underglaze iron, and green and blue underglaze enamels; edge pattern of lozenges in white slip and underglaze iron; interior decoration of cloud bands in white slip, underglaze iron, and green underglaze enamel. "Kenzan" mark on base in white-slip patch, with mark and frame in underglaze iron. Overall coat of lead glaze, with base and lid contact points in reserve. Low-temperature firing.

The bush clover *(hagi; Lespedeza acutifolia)* has been a popular autumnal plant since at least the eighth century, and came to occupy a prominent place in the classical literary canon. When bush clover is combined with flowing water, it refers to the theme of the Tama River at Yaji, located in Shiga Prefecture, present-day Kusatsu City. The stream begins at a hill called Ogamiyama and flows into Japan's largest inland water body, Lake Biwa. The spot was made famous in a poem by Minamoto no Toshiyori (1055–1129) published in an anthology called *Senzaishū* (Collected poems of the ages):

Let's come again tomorrow
To the Tama River at Yaji—
Rising over the flowering bush
Are colored waves where
The moon has its abode.[67]

This particular piece does not have the coherence of design seen, for example, in catalogue numbers 17 and 18; the painting and vessel contours do not match well. The use of a red clay for ware with painted decoration is discordant. The style of signature can be seen on a number of pieces in Japanese and overseas collections.[68] Since those pieces are common to collections made after 1890, and many are found in overseas collections, it is suspected that such works are imitations for the late Meiji era international market. It is likely that the same workshop produced catalogue numbers. 9, 38, and 55.

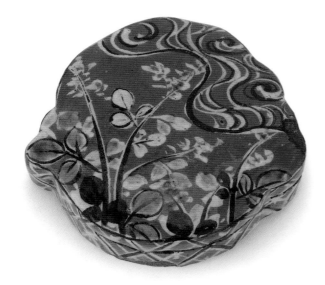

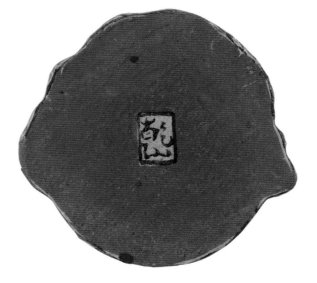

UTSUSHI: COPIES WITH A DIFFERENCE

Descriptions of Kenzan's work typically foreground painting and design. But our broad study shows that Ogata Kenzan and his immediate followers attempted to survey nearly all of the ceramics production known to them. Kenzan the first imitated ceramics from China, Vietnam, Thailand, and Holland and the Japanese wares known as Karatsu and Oribe (figs. 26 and 27). Such an encompassing review of both domestic and local production reveals access to exotic material and informational resources. There is also the suggestion of a lofty perspective—contemporary critics call it the panoptic. Seeing all is not only knowing, but is also a form of ambition and command. Kenzan, who came to ceramics from a position of privilege, endorsed a body of "classical" work.

Ogata Kenzan was not the first potter to reproduce earlier or external models. Starting with the fifth century, much of Japanese ceramics history can be so described. But from the mid–seventeenth century a certain kind of copy, bearing the imprint not only of makers but also of patrons, became fashionable in Kyoto. This is called *utsushi*—copying with a difference. The difference lies in a paradox: through various forms of stylization, such as technical refinement or a bland clumsiness, the *utsushi* creates or maintains the very difference that the copy proposes to obliterate. Intentions are meant to intrude.

The first attempts, known chiefly through early-seventeenth-century diary references, are derivatives of Chinese and Korean tea bowls and tea caddies popular among practitioners in the cult. Local input is evidenced in the form of *kirigata*, paper cutout designs provided by tea masters and other persons of taste. Much better known, in word and deed, are the *utsushi* of the celebrated potter Nonomura Ninsei (active 2d half 17th century). Apparently at the behest of his patrons, Ninsei applied his formidable manual skills to models domestic and foreign; heirloom pieces as well as shards from his Kyoto kiln site show crisp tailoring to the requirements of the tea ceremony, which at that time stressed refinement and orthodoxy.

Ninsei's full repertory of *utsushi* recipes—for clays and glazes—is known through a compendium of pottery techniques copied into Kenzan's own pottery manual, *Tōkō hitsuyō* (Potter's essentials; 1737). And yet Kenzan chose not to employ any of those formulas or effects. What, then, was *utsushi* for Kenzan and the aspirants to his tradition? Elsewhere I have argued that, as a result of his interest in surface decoration and contemporary demands for diverting vessels, Kenzan experimented with all classic ceramics that had painted effects instead of staid monochromes.[69] But intentions are difficult to recover; pot shards are not. Ceramic archaeology provides a baseline for locating shifts in notions of distinctiveness. Excavated wares from urban sites show that in the first half of the seventeenth century,

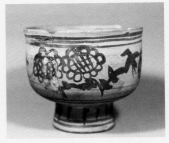

Fig. 26. Annam (Vietnamese) *utsushi* tea bowl, by Ogata Kenzan (1663–1743), excavated from the Narutaki kiln site (act. 1699–1712). Bisque ware with cobalt decoration, 11.2 x 12.9. Hōzōji, Kyoto.

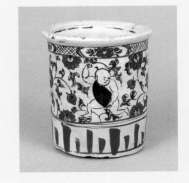

Fig. 27. *Aka-e* (Ming dynasty common-ware porcelain) *utsushi* brush holder, by Ogata Kenzan, (1663–1743), dated Hōei era (1704–11). Porcelain with overglaze enamel decoration, 11.8 x 10.4. Hosomi Museum, Kyoto.

glazed ceramics as a whole continued the robust mode begun in the heyday of the tea ceremony. Hizen (including Arita and Karatsu) and Seto and Mino were the major manufacturers. Karatsu and Mino, which manufactured Japan's first feldspathic-glazed tableware, surged forward in the 1590s, variously issuing painted Karatsu, painted Shino, and Oribe wares. After about two decades, decorated Arita porcelain appeared, with vigorous decoration inspired by Karatsu sources but moreover by Chinese wares. Decorated ceramics—especially tableware—had begun to capture demand nationwide.

A pronounced move toward elegance and elaboration from mid century reflects both technical advances and the expanding role of domestic ceramics in formal etiquette and gift presentation. Hizen porcelains, especially the Kutani, Kakiemon, and Nabeshima styles, developed complicated shapes and extravagant decoration. Some of the latter is taken from printed literature. Ninsei, as we have seen, appeared on the Kyoto stage at this time, providing high style to the local stoneware industry. This in turn spawned a whole "Kyoto-ware *utsushi*" stoneware output emanating from the Imari area of Hizen in the mid–seventeenth century and continuing for almost a century. In Seto, another Kyoto-ware *utsushi* product called "Omuro chawan" (Ninsei tea bowl) appeared in the early 1700s. Seto and Mino wares as a whole became more elegant, and the old iron-painted and copper-splashed Oribe models fell out of favor.

By the onset of the eighteenth century, however, this elegant mode had become mainstream; user sites show that fine-painted ceramics, especially porcelains, were commonly used by the upper stratum of warriors and townsmen, even replacing lacquer ware in daily meals. Refinement alone could not constitute value. What were the possibilities for limited-edition utensils at this point? Kenzan's solution seems to have been to reach back, beyond the period of elegance, to the rustic mode. This was not mere nostalgia but adherence to a precept that the young Kenzan had absorbed under literati such as Itō Jinsai: that a true scholar must renounce his ties with the present and seek out "an initial [read: past] creative formulation."[70]

This belief in historical norms also parallels developments in the world of tea, texts of which were casting the sixteenth to early seventeenth century as a golden age.

Chadō benmōshū (Handy guide for learning tea; 1680) established a system of values and nomenclature for ceramic classics such as Oribe ware. *Nanpōroku* (Record of [Priest] Nanpō), a 1691 tea document, memorialized the Momoyama era master Sen Rikyū (1522–1591) for the merchant-class tea schools that took him as saint and ancestor. A guide to classic pots, the 1694 *Wakan sho dōgu* (Compendium of domestic and foreign utensils; fig. 28), illustrated some forty-seven approved varieties of ware, all of them intended for use in the tearoom. The booklet's

Fig. 28. Illustration of an Annam-style tea bowl in *Wakan sho dōgu*, 1694.

woodblock printing with phonetic glosses indicates that it was intended for widespread consumption. Copies and takeoffs of golden-age Raku ware were produced by Kenzan's cousin Sōnyū and his successor Sanyū (to be discussed further in the last section of the catalogue, "The Raku Mode").

The circulation of information, then, hints at an accelerated demand, one that real antiques could not satisfy. Imports were increasingly inaccessible—in urban sites they all but disappeared after 1700—and the hiatus lasted throughout the next one hundred years. Facsimiles were thus created by Kenzan, and his rubric was the revival of the past. Kenzan coupled the longing for the rustic with his amateur instincts, making versions of Oribe, Karatsu, Chinese, Vietnamese, Thai, and Dutch wares, all with considerable imagination. The marketing aspects are submerged in personalization: self-conscious signatures like "Shōko" (Veneration of antiquity) and inscriptions such as "I copied a rare vessel from Korea" draw the user into a world of antiquarian pleasure (figs. 29–30), privileging spectatorship as much as the viewed object. In surveying the world of ceramic antiquity through actual manufacture, Kenzan anticipates the individual *utsushi* masters of a century later, Okuda Eisen, Aoki Mokubei (1767–1833), Kinkodō Kamesuke, and Nin'ami Dōhachi.

Utsushi with the Kenzan mark themselves reflect changes in the domestic market. The 1720 relaxation of import restrictions must have invigorated interest in *utsushi* products: judging by extant wares, Kenzan's Kyoto successor, Ihachi, made far more Chinese and Dutch copies than did Kenzan himself. Ihachi's imitations seem to have influenced the founding of the Banko pottery in Mie Prefecture, where early works were also takeoffs on late-Ming enameled ware. The third-generation Edo Kenzan experimented with foreign decoration as well.

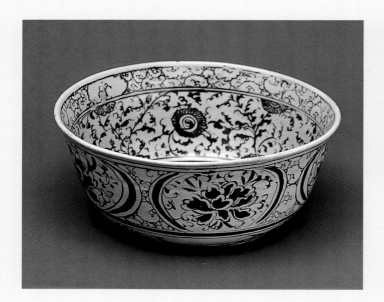

Fig. 29. *Egorai* (Cizhou) *utsushi* bowl, by Ogata Kenzan (1663–1743), 1706. Stoneware with underglaze iron decoration, 14.6 x 34.8. Hamamatsu Municipal Museum.

Fig. 30. Underside of fig. 29.

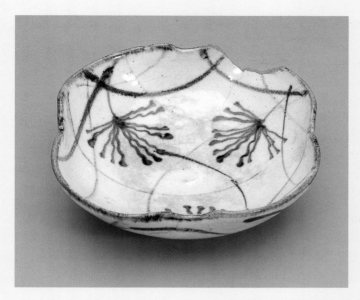

Fig. 31. Kenzan *utsushi* food dish with design of pampas grass, by Ogata Shūhei (1788–1839), early 19th century. Excavated from the Hikage-chō site, Bunkyō Ward, Tokyo. Stoneware with underglaze iron and cobalt decoration, 5.7 x 14.9. Tokyo Metropolitan Government.

Over the decades Kenzan *utsushi* changed to meet new demands: the popularity of large tea gatherings and communal feasting from the late eighteenth century encouraged the manufacture of larger, multiportion bowls, many of which bear a Kenzan mark. The enthusiasm for these bowls is documented in an 1832 collection of observations called *Nen-nen todome* (Yearly jottings); the sale price of a large Kenzan bowl *(Kenzan ōdonburi)* is compared with other items.[71] The popularity of Chinese-style steeped tea, or *sencha*, also fed a new spate of antiquarianism and instigated the reproduction of hitherto unfamiliar vessels. Some *sencha* wares bear the mark of Kenzan or his successors.

By the early nineteenth century, Kenzan ware itself had achieved classic status, and became a focus of *utsushi* production in Kyoto and elsewhere. This was part of an overall reappraisal of Japanese cultural history by statesmen, antiquarians, and potters. In the forefront of this regeneration were Nin'ami Dōhachi, Ogata Shūhei (fig. 31), and Seifū Yohei (1803–1861). Kenzan copying is mentioned anecdotally in the Freer object records: catalogue number 13 had been left at the workshop for study (presumably as a copy model) by the potter Okumura Shōzan (1842–1905), renowned for his imitations of Ninsei and Kenzan. When I lived in the Kyoto potters' quarters, many of my neighbors specialized in these Kenzan copies, which were marketed as high-quality tableware.

BY OGATA KENZAN (1663–1743)

(EDO-IRIYA WORKSHOP, CA. 1731–1743)

Japan, Edo period, early 18th century

Acquired from Matsuki Bunkio ($50); formerly Matsumoto
collection, Kyoto; original attribution: "Kenzan."

Morse attribution: "A late Kenzan."

5.4 x 9.6

Freer Gallery of Art, Smithsonian Institution, Washington, D.C.

Gift of Charles Lang Freer, F1900.76

The thick glaze obscures most of the forming details, but the clay
body appears to be brownish, medium-grained. Cover and base
apparently thrown and trimmed on wheel, although some irregularity
inside of foot ring points to modeling with a spatula. White slip on
outside cover. Exterior decoration consists of bands in black, blue, red,
purple, green, and yellow underglaze enamel. Inscription and signature
in underglaze iron on base reads, "Nagasaki gūkyo ni oite, Keichō
Kenzan Shinsei kore o tsukuru" (Made by Keichō Kenzan Shinsei in
temporary residence in Nagasaki). Lead glaze applied to entire interior
and exterior; overglaze green enamel applied to interior of cover and
base. Low-temperature firing. Setting spur marks on rim of cover and
on base; scars on top of cover from tongs used to extract the piece
from a hot kiln.

The closest analogue that this piece has in the craft world is round
lacquer incense containers with concentric bands known as *dokuraku*
(toy top). These were manufactured in Ming China and became
popular among aficionados of the tea ceremony.[72] As a toy, the top is
popularly used during New Year celebrations. Since it spins on, it
suggests enduring good fortune. *Dokuraku* additionally connotes the
self-contentment of the true scholar—the top that keeps revolving
without urging.

A note left by Matsuki Bunkio mentioned: "Name of this box was
'tama' or 'marble.' . . . This piece was formerly in the possession of the
famous Japanese connoisseur, Mr. Matsumoto of Kyoto."

Noteworthy is the internal evidence for a "Nagasaki" manufacture.
The immediate association is with the city of Nagasaki, which in
Kenzan's day served as Japan's sole foreign trade port and locus of
exotica. An incense container similar to the Freer piece was illustrated
in 1973 by the late ceramics historian Mitsuoka Chūsei, who posited
that Kenzan may have accompanied Ogiwara Shigehide (1658–1713),
superintendent of finance and crony of the Kyoto mint officials with
whom Kenzan's brother Kōrin was on good terms, on an official trip
to that city in 1697. Mitsuoka also mentioned that the cover of the box
he illustrated was not an original; it was a replacement made by Eiraku
Hōzen (1795–1854).[73]

The piece illustrated by Mitsuoka, however, appears to be a copy of
the Freer piece; the handwriting, while superficially similar, lacks the
rhythm and spacing of this one. Furthermore, several aspects about the
Freer piece contradict Mitsuoka's travel-to-Nagasaki thesis. First,
Kenzan never mentioned a visit to Nagasaki in his otherwise detailed
pottery notes; second, the strong but unaffected writing style seems to
accord not with Kenzan's early career but with his late years in Edo;
third, the use of the archaic form of the character for *shin* in "Shinsei"
is a sign of late manufacture; fourth, the use of "Keichō" (refugee from
Kyoto) appears only on pottery and painting from the master's late
years; and fifth, the expression *gūkyo* (temporary abode) appears on
other Kenzan pots attributable to the Edo years, some of them dated.[74]
Thus Kenzan either made a trip to faraway Nagasaki at the end of his
career (implausible) or there may be another Nagasaki. Edo period
maps show a Nagasaki-chō several blocks northeast of Rokkenbori,
where Kenzan is reported to have stayed during his Edo years. This
area east of the Sumida River was dotted with small earthenware
potteries, some of which continued into the twentieth century.

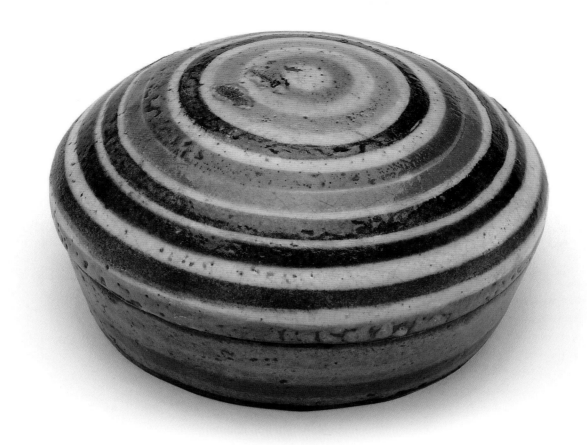

BY OGATA IHACHI (KYOTO KENZAN II, ACT. CA. 1720–1760)
Japan, Edo period, mid–18th century
Acquired from Y. Fujita, Kyoto ($75); original attribution: "Kenzan."
Morse attribution: "Tokyo—but a genuine Kenzan. A hibachi.
Interesting thing."
12.0 x 13.7
Freer Gallery of Art, Smithsonian Institution, Washington, D.C.
Gift of Charles Lang Freer, F1911.400

Fine-grained buff clay. Assembled from seven slabs; marks from cloth used in the molding process visible in the interior. Application of white slip to exterior and upper part of interior. "Kenzan" signature in underglaze iron on base. Application of transparent stoneware glaze to exterior and upper half of interior, with foot in reserve. High-temperature firing. Bounding lines and interior squiggle pattern in red overglaze enamel; flowers and vines, including chrysanthemum, pomegranate, and palmette, in green, yellow, blue, and purple overglaze enamels. Low-temperature firing to fuse enamels. Fitted with brass rim; cover added.

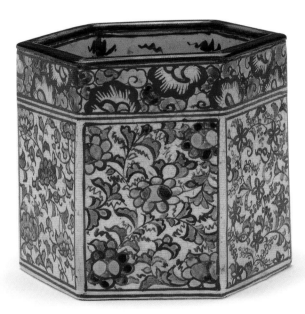

The general proportions and metal fitting suggest function as a small handwarmer; it would have been filled with ash, with live embers set inside. The rectilinear form in general borrows from Kenzan-ware precedents, although this six-sided shape has a more distant ancestry in Ming dynasty incense burners; mass-produced connoisseur's manuals bestowed approval on the six-sided shape.

The painted surface is a mix of elements taken from late-Ming, common-ware porcelains imported into Japan in the early seventeenth century. The cloud band at the top appears, for example, in the underglaze blue porcelains called *undō-de* in Japan. There is also a good dose of the Kenzanesque, such as the flatly rendered flowers.

The style of signature is characteristic of Kenzan's adopted son and Kyoto successor, Ogata Ihachi. Judging from his oeuvre, Ihachi was an avid producer of exotic ceramics and reworked many of these schemes to fit local taste.

BY KENSAI (IDA KICHIROKU; 1793–1861)
Japan, Edo period, mid–19th century
Acquired from Siegfried Bing, Paris ($55); original
attribution: "Kensai."
Morse attribution: "May be Kensai."
8.1 x 6.2
Freer Gallery of Art, Smithsonian Institution, Washington, D.C.
Gift of Charles Lang Freer, F1901.75

Medium-grained brown clay, thrown on the potter's wheel. White slip
applied to outside and bottom. Decoration of phoenix and cloud
scrolls in red, yellow, green, and black underglaze enamels. "Kensai"
mark in underglaze iron on base. Totally covered with transparent lead
glaze. Low-temperature firing. Outfitted with ivory cover.

Shape, size, and the type of cover suggest use as a tea container *(chaki)*.
This is basically a relaxed version of the hieratically conceived tea
caddy *(chaire)*, which is employed in more formal tea service.

The phoenix *(hō-ō)* is traditionally seen as an emblem of female rule,
ruler of the birds, harbinger of peace, prosperity, and sage rule, and sign
of the southern quadrant of heaven. In Chinese popular culture the
phoenix was depicted on wedding gifts and trousseaux, for the bride
was an "empress for a day."[75] This auspicious grammar came to be
embodied in Japanese things as well.

"Kensai" was a pseudonym of Kenzan-style potter Ida Kichiroku. In
1836, Kichiroku received the art name "Kensai" together with

instruction in Kenzan-style pottery techniques from fifth-generation
Edo Kenzan Nishimura Myakuan. Kichiroku thereafter worked at far-
flung kilns such as Kameyama (Nagasaki Prefecture), Izawa (Mie
Prefecture), Hanno (Saitama Prefecture), and Sano (yes, Sano!), Tochigi
Prefecture. The "Kensai" signature on this piece may suggest relatively
early production, for the names "Kichiroku" and "Kitsuroku" appear
on his later works. Aside from the signature, the chromatics of this
piece are similar to a tiered box in the Morse collection, also bearing a
"Kensai" signature. Kichiroku's ceramics range from finely crafted
glazed earthenware figurines and incense boxes to rather dull
stonewares, many of them in a Kenzan style.

KYOTO WORKSHOP, KENZAN STYLE
Japan, Edo period, early to mid–19th century
Acquired from Matsuki Bunkio ($18); original attribution: "Kenzan."
Morse attribution: "Tokyo Kenzan—a beauty—a good one."
11.0 x 22.8
Freer Gallery of Art, Smithsonian Institution, Washington, D.C.
Gift of Charles Lang Freer, F1898.445

Fine-grained, brown-gray clay. Thrown and trimmed on the potter's wheel. White slip applied to entire vessel; pinholes in slip indicate that vessel was quite dry at the time of application. Decoration of rim and base bands, vining peonies, and mythical Chinese lion-dog (shishi) in underglaze iron. "Kenzan" mark in underglaze iron on base. Transparent stoneware glaze applied to entire vessel. High-temperature firing; five stacking spur marks in cavetto. Gold lacquer repairs. Moisture stains from washing on interior.

Size and shape suggest use as a bowl for sweets or possibly for grilled food. The overall decorative scheme, marked by the contrast between white slip and iron decoration, is inspired by Cizhou ware, a northern Chinese folkware. The pairing of peonies with shishi comes from Chinese mythology: the peony is the queen of flowers and the shishi is the king of animals.

The first Kenzan took an express interest in Cizhou ware. An oft-cited example is a bowl, bearing a date of 1706, in the collection of the Hamamatsu Municipal Museum (see figs. 29 and 30); its decoration draws from Cizhou models of the sixteenth century.

Based on its signature style and the bombast of the decoration, the Freer piece comes from a Kenzan revival in Kyoto in the early to mid–nineteenth century. A Cizhou-style food dish with a similar Kenzan mark was excavated from the Doshisha University Ikushinkan site in 1993; the accompanying artifacts were datable to the third quarter of the nineteenth century. The Freer dish shares similar design and technical characteristics.

Matsuki Bunkio, who sold this piece to Freer, mentioned that "this bowl was formerly in the Tokyo Museum and was used as a model by the students." Matsuki may have been referring to the Tokyo School of Fine Arts (Tokyo Bijutsu Gakkō), which was founded in 1889. Since the school was originally housed in the Educational Museum (Kyōiku Hakubutsukan), Matsuki's reference is coherent.

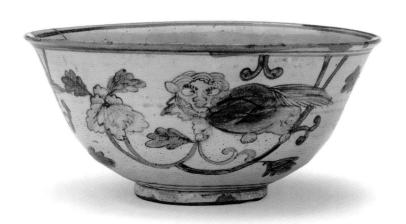

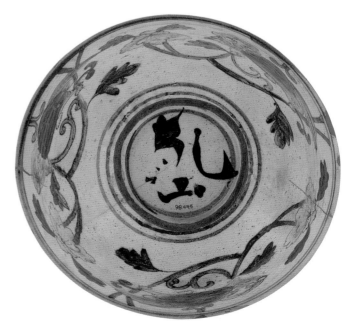

KYOTO WORKSHOP, KENZAN STYLE

Japan, Edo period, early to mid–19th century

Acquired from K. Suzuki ($25); original attribution: "Kenzan School."
Morse attribution: "Questionable—dreary, damn thing!"

6.7 x 14.4

Freer Gallery of Art, Smithsonian Institution, Washington, D.C.

Gift of Charles Lang Freer, F1905.22

Fine-grained buff clay. Wheel thrown and trimmed. White slip applied inside and out; some marks from wiping on base. Rim band, band of dots inside rim, cloud motifs, and character in a double-banded reserve circle all in underglaze iron. Stylized chrysanthemums on outside wall in underglaze iron. "Kenzan" mark inside foot ring, inside single-line frame, in underglaze iron. Transparent stoneware glaze applied inside and out. High-temperature firing. Green leaves and red surround in overglaze enamels. Rim repair and subsequent retouching.

Auspicious character decoration probably came to the attention of Japanese audiences through late-Ming dynasty Chinese imports, such as wares from the recently excavated Zhangzhou kilns in Fujian Province.[76] These were quickly copied in Japan, first in Mino wares and later in Arita porcelains. The domestic zenith of pots with the single-character inscription occurs in Arita porcelains of the so-called brocade *(kinran-de)* style; they were produced chiefly between about 1690 and 1730, which coincides with Kenzan's career.

In Chinese lore, dew dripping from the chrysanthemum was considered an elixir of immortality; in the chrysanthemum festival on the ninth day of the ninth lunar month participants admired the blossoms, drank a "chrysanthemum" wine, and composed poetry. Auspicious tidings, seasonality, and banqueting thus intersect.

The historical Kenzan and his successors employed this motif, mainly in the form of medium-sized serving bowls. A star-shaped bowl inscribed with the character *kei* (congratulate; rejoice) in the cavetto can be attributed confidently to the first generation.[77] In the Freer piece, the slapdash signature (the bottom part of the *ken* is actually miscopied) and design bravura are early- to mid–nineteenth-century enthusiasms. A dish nearly identical to the Freer piece is in a private collection in Japan.[78]

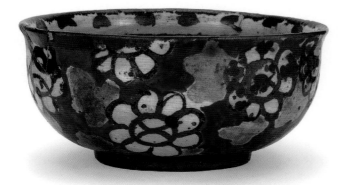

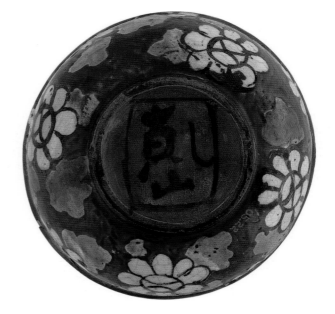

KYOTO WORKSHOP, IMITATION
Japan, Edo period, 19th century
Acquired from Yamanaka and Company ($200); original
attribution: "Kenzan."
Morse attribution: "Signed Genroku. Inscription no good. Modern
imitation."
21.4 x 15.6
Freer Gallery of Art, Smithsonian Institution, Washington, D.C.
Gift of Charles Lang Freer, F1911.405

Fine-grained buff clay. Body and lid thrown and trimmed on the potter's wheel. Spout thrown on potter's wheel, hand trimmed, and luted to vessel. Bail handle and lugs hand modeled and luted to body. Overall application of transparent stoneware glaze, with base and lid contact area in reserve. High-temperature firing. Red and green overglaze enamel decoration includes diaper pattern on handle, peony vine scroll on lid and median, medallion band with lattice surround on rim, and simplified lotus-petal pattern around base. Inscription-signature "Genroku jūgo no toshi Fusō Yōshū Kenzan Tōin sei" (Made in the fifteenth year of Genroku [1702] by Kenzan, Hermit Potter of Fusō [Japan], Yōshū [Kyoto area]) in red enamel, followed by painted relief-style seals "Shōko" and "Tōin," also in red enamel. Low-temperature firing to fuse the enamels.

In the course of ceremonial tea drinking, the kettle, the source of hot water, requires occasional refilling. This is accomplished with a ewer called *mizutsugi*. In addition to ceramic types, *mizutsugi* may be made from wood or metal. Arita porcelain ewers dated between 1680 and 1710 are similar in shape to the Freer piece;[79] these ultimately hark back to a Ming dynasty porcelain prototype.

Despite the date on this piece (quite believable in terms of Japanese ceramics morphology and Kenzan's own stylistic development), the handwriting and seals are not from Kenzan's own hand; the manufacture is a little too skillful for Kenzan's workshop, especially in the period designated. A more likely candidate for authenticity is a ewer that recently came to light in the Myōhōji Temple in Suginami Ward, Tokyo.[80]

This piece may represent an attempt at duplicating a specific original (such an endeavor by Kyoto potter Okumura Shōzan is mentioned in cat. no. 13), an endeavor which may be associated with the Meiji era art market. In an environment where many traditional props of association had been torn away, works had to express value through a kind of self-narration. Potters conceived pieces with exact dates, long inscriptions, and detailed decor. We might also consider this type of copying as an act of preservation, given urgency in an age of international exchange and spoliation.

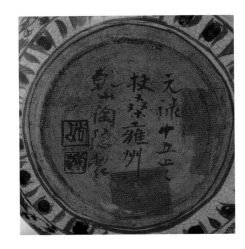

KYOTO WORKSHOP, IMITATION

Japan, Meiji era, late 19th century

Acquired from Matsuki Bunkio ($100); original

attribution: "Kenzan."

Morse attribution: "One of the latest Kenzans—brand-new."

8.1 x 10.6

Freer Gallery of Art, Smithsonian Institution, Washington, D.C.

Gift of Charles Lang Freer, F1900.74

Fine-grained reddish clay. Thrown on potter's wheel with foot ring trimmed by spatula. White slip applied as ground for edge bands, cavetto patch, and blossoms. Bands and dots, diaper pattern, and plum decoration in underglaze iron. Signature "Kenzan Tōin Sei" (made by Kenzan Tōin) and inscription, "Pure fragrance, hidden beauty," in underglaze iron. Total application of transparent lead glaze. Low-temperature firing.

The shape takes after the so-called *undō-de* bowl which was imported from Ming dynasty China in the early seventeenth century. The edge bands and scattered blossom motif also occur in a similar import genre, the so-called *kosometsuke* type.[81]

Part of the first Kenzan's interest in these late-Ming products was the material itself: porcelain. But this is earthenware, which is much easier to form and fire. A copyist decided that the graphic elements alone could sufficiently (and efficiently) convey "Kenzan."

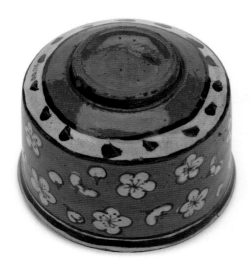
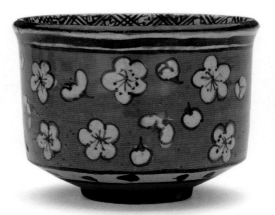
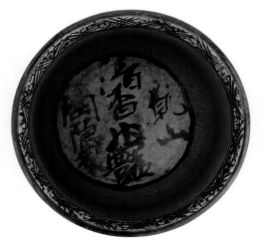

KYOTO WORKSHOP, IMITATION

Japan, Meiji era, late 19th century

Acquired from Yamanaka and Company ($40); original
attribution: "Kenzan."

Morse attribution: "Tokyo all right—but a very remarkable piece.
No slouch of a potter made that."

18.1 x 18.7

Freer Gallery of Art, Smithsonian Institution, Washington, D.C.
Gift of Charles Lang Freer, F1900.30

Fine-grained buff clay. Lid and body thrown and trimmed on potter's
wheel. Spout and lugs luted to body. White slip applied to exterior.
Underglaze cobalt decoration of diaper patterns, plum blossoms,
inscription, and signature, the latter reading "Kenzan Tōin sho."
Underglaze iron details on blossoms. Overall application of transparent
stoneware glaze. High-temperature firing. Green and red overglaze
enamel washes to interstitial areas; overglaze blue and red enamel
accents; "Shōko" and "Tōin" seals painted in overglaze red. Low-
temperature firing to fuse the enamels. Wooden handle, with
red-lacquer inscription "Zenshin" and cipher added. Repaired with
metal strips and gold lacquer.

As made evident by the shape of the piece and its paraphernalia, this
pot was originally intended as a *mizutsugi*, a kettle used in the tea
ceremony to replenish the water in the iron kettle used in the tearoom
proper. The decoration of plum blossoms suggests a wintry mood,
which is also echoed in the inscription:

In the teakettle, the snow boils fragrantly,
Vapors warmly rise from the inkstone and ink;
As guests depart, we open the door and laugh,
The mossy steps are written with bird tracks.

A box lid has been preserved with this vessel, and its inscription,
together with the lacquer inscription and cipher on the handle,
associate it with masters of the Omotesenke school of tea.[82] Such
ciphers, which first appear on tea equipment in the early seventeenth
century, constitute a form of authentication and seal of approval by tea
practitioners, especially grand masters of tea schools. At the highest
level of aspiration this was a creative exercise, but it was also performed
for remuneration, since pedigree added value to the vessel. Ciphers
were of course forged as well.

This piece certainly was based on an early Kenzan-ware prototype,
although the more reliable specimens have vine scrolls rather than
scattered plums. There is catalogue number 33, probably a copy of a
Genroku era original, and we have already mentioned a similar one in
the Myōhōji Temple in Suginami Ward, Tokyo. The hybrid decorative
scheme and the calligraphy and signature are suspicious. Since there
are no closely related imitations, this may have been a one-of-a-kind
product by a skilled Kyoto potter, commissioned for the antique
market. The handle is presumably a mode of value-adding, but it is
conceivable that the handle is genuine, with the ceramic body
replacing a Kenzan (or some other) original.

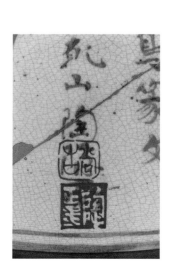
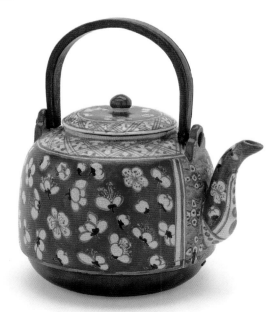
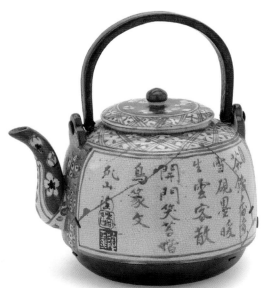

SETO-AFFILIATED WORKSHOP, KENZAN STYLE
Japan, late Edo period or Meiji era, 19th century
Acquired from Sato, Nagasaki ($12.50); original attribution: "Kenzan."
Morse attribution: "May be Kenzan—but Tokyo Kenzan."
8.7 x 10.2
Freer Gallery of Art, Smithsonian Institution, Washington, D.C.
Gift of Charles Lang Freer, F1911.404

Medium-grained buff clay, flecked with iron. Thrown and trimmed on
the potter's wheel. Overall coating of transparent stoneware glaze, with
foot ring in reserve. "Kenzan" signature in underglaze cobalt. High-
temperature firing. Decoration of panels, vine scrolls, and generic
flowers in red, green, and blue overglaze enamels.

The bounded panels of contrasting floral decor is a late-Ming scheme.
It was pursued by Kenzan's adoptive son, Ihachi (see cat. no. 29), and
his direct or indirect pupil, Nunami Rōzan (1718–1777), who would
become the founder of the Banko kiln in Kuwana, Mie Prefecture,
favored it as well. In the nineteenth century many kilns under the
influence of the great stoneware center of Seto, such as Inuyama (Aichi
Prefecture) and Etchū-Seto (Toyama Prefecture), also specialized in this
treatment. The heavy potting and flecked clay in this piece signal a
non-Kyoto provenance.

Two box labels are associated with this piece, one reading "Ikeda
Senmei kaisha honten no insho" (Seal of the main store of the Ikeda
Senmei company"). This may have been part of the inventory of
Kyoto dealer Ikeda Seisuke (1840–1900). Other Kenzan wares from
the Ikeda collection, all purchased through Matsuki, include catalogue
numbers 15, 18, 24, 44, and 67. A second label reads "Aka-ga Kenzan
kōrō futa" (Red-enameled Kenzan incense burner lid), but the piece is
presently without the lid.

KYOTO WORKSHOP, IMITATION
Japan, Meiji era, 19th century
Acquired in Tokyo, spring of 1907 ($500); original
attribution: "Kenzan."
Morse attribution: "Satsuma glaze—Old Satsuma jar redecorated and
signed Kenzan. Done in Tokyo."
32.3 x 18.1
Freer Gallery of Art, Smithsonian Institution, Washington, D.C.
Gift of Charles Lang Freer, F1907.83

Fine-grained, gray-buff clay. Thrown and trimmed on potter's wheel. White slip applied to exterior and inside neck. Decor zones defined by horizontal bands in underglaze iron. Overall application of transparent stoneware glaze, with foot ring in reserve. "Kenzan" signature in single-line frame in underglaze iron. High-temperature firing. Decorative fill, top to bottom, in red, green, yellow, and blue overglaze enamels: character medallions reading *fuku, ju, an, nei* (happiness, long life, ease, comfort) backed by crosshatched lines; stylized vine scrolls; center zone with fish, lotus petals, constellations, and water; and lotus petals on bottom. Low-temperature firing to fuse the enamels. Broken and reassembled.

Such jars are not part of the standard large-ware repertory of Kenzan's day. The shape, derived from Qing dynasty (1644–1912) jars, is seen in export wares made in Satsuma in the first decade of the Meiji era, prompting Morse's comment. The decor is yet another matter, based on late-Ming, common-ware porcelains originating from either Jingdezhen in Jiangxi Province or Zhangzhou in Fujian Province.

The signature style on this vase occurs principally on serving bowls with a broad array of decor;[83] most of them are in foreign collections, suggesting a Kenzan "export" ware.

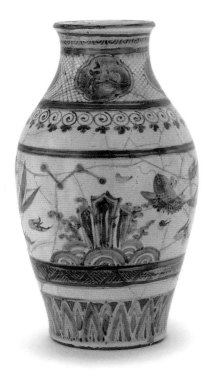
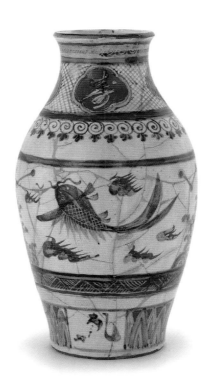

KYOTO WORKSHOP, IMITATION
Japan, Meiji era, late 19th century
Acquired from Matsuki Bunkio ($120); formerly in the collection of
Funahashi, Kyoto; original attribution: "Kenzan."
Morse attribution: "Tokyo—Kenzan—a good piece—a very good
piece. Unusual signature, 'Zan' made in Tenjo [*sic*] style."
2.9 x 7.2
Freer Gallery of Art, Smithsonian Institution, Washington, D.C.
Gift of Charles Lang Freer, F1903.279

Fine-grained buff clay. Base and cover thrown on potter's wheel. Total coating of white slip. Decoration of stylized pampas grass and maple leaves in underglaze cobalt on top and lozenge patterns on sides. Framed "Kenzan" mark on inside of cover, hand painted but contoured to resemble a stenciled mark. Application of transparent stoneware glaze with base and rim contacts in reserve. High-temperature firing.

The shape is that of a container to hold pellets of incense. Pampas grass and maple leaves evoke an autumnal theme. The gridlike structure recalls the design of paper stencils used for printing textiles, where the individual design elements must interconnect to hold the stencil together.

The original Kenzan made incense containers with pictorial covers and patterned sides, but with much greater formal and thematic coherence. When pampas grasses arc over a circular or crescent ground, they are associated with the fields of Musashi (Musashino), the western part of present-day Tokyo. But maple leaves, while profoundly autumnal, are not part of the Musashino scheme.

The use of underglaze cobalt alone is also unusual—the overall impression is a conflation of blue-and-white porcelain style with a Kenzan one. The style of the mark relates this piece to a rather large group of late imitations, probably from Kyoto. See also catalogue numbers 9, 27, and 55.

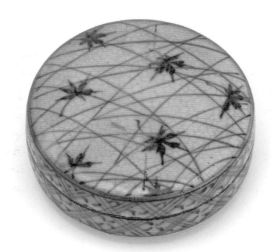

BY OGATA KENZAN (1663–1743) (NARUTAKI WORKSHOP, 1699–1712)
Japan, Edo period, early 18th century
Acquired from Samuel Colman Collection sale ($25); original
attribution: "Kenzan."
Morse attribution: "Tokyo Kenzan—would never have dared to make
that in Kyoto."
9.3 x 13.3
Freer Gallery of Art, Smithsonian Institution, Washington, D.C.
Gift of Charles Lang Freer, F1902.80

Fine-grained white clay. Thrown and trimmed on the potter's wheel.
White slip application to exterior and upper part of interior. Bands of
decoration, including leafy vine, dots, floral medallions, and diagonal
lines in underglaze iron and cobalt, and red, yellow, and blue overglaze
enamels. Lead glaze application to exterior and part of interior.
Signature reading "Nippon Kenzan sei" (Made by Kenzan of Japan)
and facsimile seal reading "Shōko" in overglaze blue enamel. Low-
temperature firing. Stained, either by secondary fire or antiquation.
Extensive surface loss.

Unglazed interior and size suggest use as an ember pot. The body
shape, basically a cylinder with inverted median and flattened rim,
is inspired by the late-Ming porcelain ware called *undō-de*.[84] The
decoration is intended to evoke a Western style, ostensibly Delft ware,
which was imported into Japan from the early seventeenth century.
The feathery motif, called aigrette, appears on a German dish in the
National Museum of American History, Smithsonian Institution,
Washington, D.C. (71.20), and it also appears on Delft tiles.[85] The dots
can be found on Delft ware and also on late-Ming porcelains brought
into Japan in the early seventeenth century.

Kenzan was not the first Japanese potter to copy Delft ware; these
imitations appear among seventeenth-century shards from the midden
of the Shimo-Shirakawa kiln in Arita. Regarding comparative pieces
with a Kenzan signature, the floral medallions and diagonal lines occur
on a set of food dishes in the Idemitsu Museum of Art, Tokyo; its box
is marked "in imitation of a Dutch product."[86] The signature on the
Freer piece is not that of Kenzan himself, but similar marks appear on
the Idemitsu set and other pieces reliably associated with the Narutaki
workshop, such as a set of covered bowls in the Nezu Institute of Fine
Arts, Tokyo.[87] In August 2000 a small shard with dots and bands similar
to this one was discovered among specimens (as yet unpublished)
collected on the site of Kenzan's Narutaki kiln.

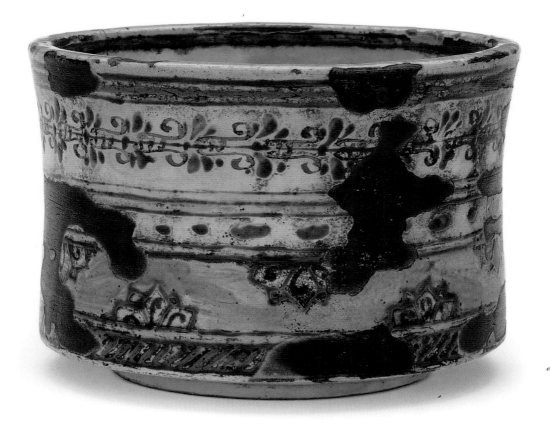

日本
亀山
製

02.80

BY OGATA KENZAN (1663–1743)
(EDO-IRIYA WORKSHOP, CA. 1731–1743)
Japan, Edo period, 18th century
Acquired from Michael Tomkinson, Kidderminster, England (gift);
original attribution: "Kenzan."
Morse attribution: "Tokyo—Kenzan."
14.2 x 15.9
Freer Gallery of Art, Smithsonian Institution, Washington, D.C.
Gift of Charles Lang Freer, F1904.358

Fine-grained buff clay. Wheel thrown and trimmed. White slip coating on exterior. Mouth painted with band of underglaze iron. Transparent stoneware glaze coating on entire vessel, with foot rim in reserve. High-temperature firing. Paper cutouts in the shape of maple leaves applied to sides, and green enamel painted around them. Leaves painted through stencils on white reserve areas in red, black, green, blue, and gold overglaze enamels. "Kenzan" signature in overglaze black enamel on the base. Low-temperature firing to fuse the enamels. The green enamel has coagulated and "crawled" away from the body. Outfitted with a lacquer lid. Later additions include a coat of red lacquer over the red enamel, gold lacquer outlines around the leaves, and a dot in the center of the leaves, which reveals that the restorer understood them as bellflowers rather than maple leaves.

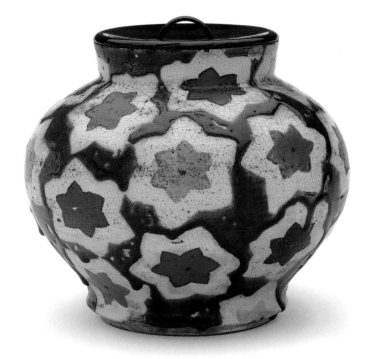

The lacquer lid suggests a water jar for the tea ceremony, although similar pieces, fitted with metal lids, were used as incense burners. The shape is exotic, recalling something nonindigenous such as Delft or even more so Italian Majolica ware. The decoration is in the Kenzan tradition, recalling camellia designs depicted in white against a green ground; this was a stock Kenzan-ware item in the second quarter of the eighteenth century.

The pot seems to have been made by someone not used to working in that shape. It is heavy, and the neck and rim are unresolved. The indented base recalls certain nonimperial blue-and-white wares from early-Qing dynasty China. The clumsy shape and the late-signature style hint that it might have been made in Edo, where the first Kenzan lacked access to good artisans and also used a very colorful palette. Black enamel is rare for Kenzan, but even rarer in imitations. I suspect they are part of his later work.

Two similar pieces exist, another in the Freer collection (cat. no. 41) and one in the collection of the Idemitsu Museum of Art, Tokyo.

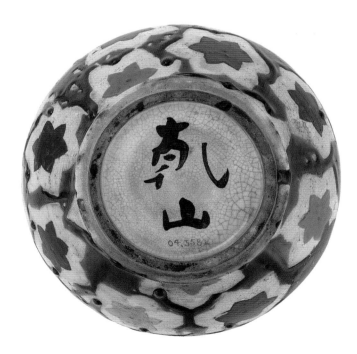

OGATA KENZAN (1663–1743) (EDO-IRIYA WORKSHOP, CA. 1731–1743)
Japan, Edo period, 18th century

Acquired from K. Suzuki ($80); original attribution: "Kenzan."

Morse attribution: "Tokyo—Kenzan."

13.9 x 16.1

Freer Gallery of Art, Smithsonian Institution, Washington, D.C.

Gift of Charles Lang Freer, F1905.24

See notes for catalogue number 40. This piece has a bronze cover with
a reticulated design of cherry blossoms. The cover in effect turns the
exotic vessel form into an incense burner. There is also a clumsily
executed overglaze enamel leaf design in the bottom of the jar.

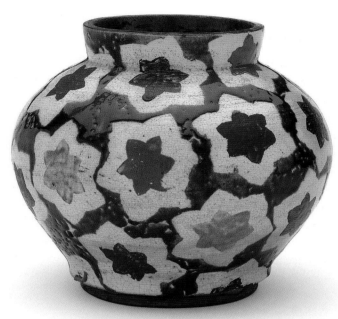

BY OGATA IHACHI (KYOTO KENZAN II, ACT. CA. 1720–1760)

Japan, Edo period, mid–18th century

Acquired from Y. Fujita, Kyoto ($30); original attribution: "Kenzan."

Morse attribution: "Tokyo. Pretty rotten. Edge like Kenzan—Tokyo—Kenzan."

7.2 x 28.2

Freer Gallery of Art, Smithsonian Institution, Washington, D.C.

Gift of Charles Lang Freer, F1911.407

Fine-grained buff clay. Thrown and trimmed on the potter's wheel. White slip applied to entire vessel. Underglaze enamel decoration of bands, diaper panels, and central floral medallion in yellow, blue, green, and purple underglaze enamels. "Kenzan" signature and "ji"-shaped cipher in underglaze iron on base. Overall application of transparent lead glaze. Low-temperature firing; three stacking spur marks on base and cavetto.

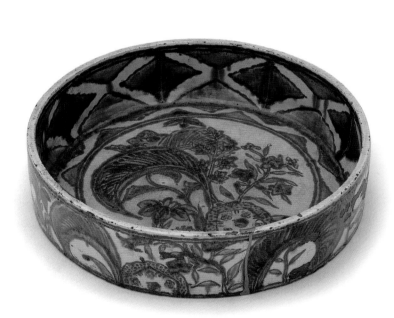

The shape of the piece has a distant referent in Chinese three-color basins *(ban)* said to be made in the Fujian region from as early as the Yuan dynasty (1279–1368); pieces have been excavated in Kamakura and also passed down in temples.[88] The domestic deployment would be in the tearoom, as a *hira-mizusashi,* a water jar used in summer tea ceremonies. The piece would have been fitted with a black lacquer lid.

The floral and geometric motifs are intended to evoke "Dutch" wares, as one of the genre of Dutch copies *(Oranda utsushi).* The first Kenzan

is justifiably credited with introducing Dutch-inspired decoration into the Kyoto-ware repertory, but it was really his adopted son and heir, Ihachi, who developed the idiom. Numerous works by Ihachi remain to testify to this interest, bearing exotic shapes such as the apothecary jar (albarello) and decorations such as Delft-style flowers, scroll patterns, diamond panels, and stripes.[89] The decoration and signature/cipher style of this piece fall squarely into this Ihachi production.

KYOTO WORKSHOP, IMITATION
Japan, Meiji era, late 19th century
Acquired from Matuski Bunkio ($95); original attribution: "Kenzan."
Morse attribution: "Old Korean bowl brought up in the bay of
Chi-mul-po [Chemulp'o], decorated in Tokyo. Signed Kenzan."
7.0 x 19.8
Freer Gallery of Art, Smithsonian Institution, Washington, D.C.
Gift of Charles Lang Freer, F1901.113

Fine-grained, gray-buff clay. Wheel thrown and trimmed. White slip in
cavetto, with resist ring (janome) carved out, ostensibly for stacking.
"Kenzan" mark in iron pigment on base. Transparent stoneware
glaze applied to interior and exterior, with base in reserve. High-
temperature firing. Decoration of exotic figures and flowers in six
bounded panels around cavetto in black, green, blue, purple, and
yellow enamels; overglaze enamel bands on verso. Low-temperature
firing to fuse the enamels. Glaze chips on rim.

The symmetrical panels recall a style of decorated porcelain known in
Japan as *fuyō-de.*[90] The figures and flowers here are intentionally exotic.

This is a nineteenth-century enamel decoration on top of a late-
seventeenth- or early-eighteenth-century stoneware dish. Dishes of
this size with resist rings were produced around Kenzan's time in
the Uchinoyama kilns in Ureshino-chō, Saga Prefecture.[91] Such
Uchinoyama bowls were never painted. Morse was right in consid-
ering the decoration as an afterthought. It is unclear why he attributed

the bowl to Chemulp'o, a fishing village near Seoul that became a
treaty port in the 1880s.

Freer's comment, preserved in the object record, that the piece was
"said to have been made during Kenzan's sojourn to Nagasaki," is
probably a dealer's value-adding to the exotic flavor of the piece.
Nagasaki was the conduit for Dutch goods during Kenzan's time.
Catalogue number 65 has a similar signature.

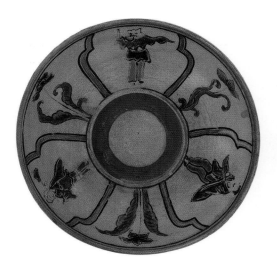
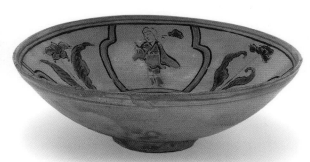

KYOTO WORKSHOP, KENZAN STYLE
Japan, Edo period, 18th century
Acquired from Matsuki Bunkio ($36); formerly in the collection of
Ikeda Seisuke, Kyoto; original attribution: "Kenzan-Oribe style."
Morse attribution: "Tokyo—Kenzan—a beauty—fair age."
3.5 x 8.9
Freer Gallery of Art, Smithsonian Institution, Washington, D.C.
Gift of Charles Lang Freer, F1900.70

Medium-grained buff clay. Cover and base thrown and trimmed on
potter's wheel; base trimming is concave. White slip applied to all
surfaces except base, underside of cover, and rim contact points.
Decoration of kudzu, edge band, and stripes on side in underglaze iron;
underglaze copper accent on cover. "Kenzan" mark on inside of cover
in underglaze iron. Transparent stoneware glaze applied to exterior and
interior of base. High-temperature firing. Glaze losses in cavetto.

The kudzu *(kuzu; Pueraria lobata)* is a vining plant that grows all over
the Japanese islands; it has spread also to the southern United States.
Poetically, the *kuzu* is celebrated as one of the seven grasses of autumn,
and hence carries the associations of evanescence and melancholy that
the season evokes. Pictured in Japanese art from at least the sixteenth
century, it was a popular motif on a type of patterned textile called
tsujigahana. The *kuzu* was also a favorite among Rimpa artists of the
early modern period, and Kenzan's brother Kōrin included *kuzu* in
his paintings of flowers and grasses of the four seasons. Hence the
attribution, originally on the box that accompanied this piece, to
"painting by Kōrin."

The accent of green glaze, together with the pattern of stripes on the
side, signal an imitation of Oribe ware, a product manufactured in
the Mino area (Gifu Prefecture) in the early decades of the seven-
teenth century. There is some evidence that Kenzan took an interest
in Oribe ware, especially its bold and asymmetrical design approach.[92]
Yet further comparative material for this incense box is lacking.
The signature style is closest to that found on later works from the
Chōjiyamachi period, and by that time other Kyoto ateliers were using
Kenzan's designs and signature. This piece is attributable to such
a workshop.

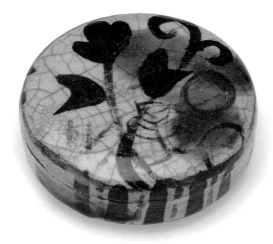
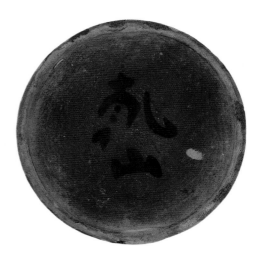

UNIDENTIFIED WORKSHOP, POSSIBLY TOKYO, IMITATION
Japan, Meiji era, 19th century
Acquired from Rufus E. Moore ($12); original attribution: "Kutani."
Morse attribution: "It may be Kutani. I never saw anything like it
before."
15.0 X 41.7
Freer Gallery of Art, Smithsonian Institution, Washington, D.C.
Gift of Charles Lang Freer, F1894.5

Medium-grained buff clay. Thrown and trimmed on potter's wheel.
White slip application to cavetto; auspicious decorations in white slip,
underglaze iron, red, green, light red, and blue overglaze enamels.
Cloud decor in silver enamel. Application of stoneware glaze to all
parts save the foot rim and the area it encloses. "Kenzan" signature and
rectangular enclosure in underglaze iron, coated over with green
enamel. Vessel shows breakage and repair.

This is a bowl full of good luck. The various decor panels are chiefly
wish-granting symbols, and the interior motifs include tortoise
(longevity) and cash (wealth; auspicious tidings) patterns and
auspicious characters such as *kotobuki* (felicitations; longevity) and
daibutsu (Great Buddha).

The shape has no referent in early modern Japanese ceramics; it is a
Meiji era showcase for pictorial design. The decor, furthermore, is
unconnected to any Kenzan mode. It, too, is part of the ebullient
modern imagination, where names and styles were mixed indiscrim-
inately. The style can be dated via comparison to a bowl from the

Azuma kiln in Tokyo, which was inaugurated, interestingly enough, by
German technical advisor Gottfried Wagener (1831–1892) in 1884.[93]
Several potters of the Edo-Kenzan line frequented Wagener's circle.

This was the first piece with a Kenzan mark purchased by Freer,
and among the very first Japanese ceramics he acquired. According to
an early list it was "used in the hall [of Freer's Detroit home] for
greeting cards."

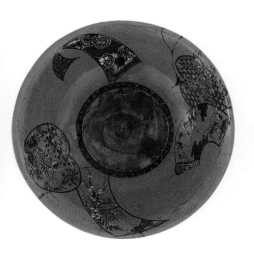
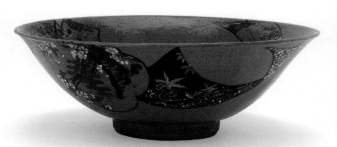

KYOTO WORKSHOP, IMITATION
Japan, Meiji era, late 19th century
Acquired from Matsuki Bunkio ($130); original attribution: "Kenzan."
Morse attribution: "Don't believe Kenzan every [*sic*] made that in the
world. Rotten signature—fresh out of the furnace."
18.8 x 21.4
Freer Gallery of Art, Smithsonian Institution, Washington, D.C.
Gift of Charles Lang Freer, F1898.52

Medium-grained buff clay. Body coil made, lid patted out, both
trimmed by spatula. Rough trimming facets on median. Transparent
lead glaze applied to interior and base, ochre-colored lead glaze applied
to exterior and upper third of interior. Motifs of drying fishnets and
cranes built up in white slip, with details in underglaze iron. Kenzan
signature in underglaze iron on base. Transparent lead glaze applied to
decoration area and base. Overall application of transparent lead glaze.
Low-temperature firing. Later application of overglaze red enamel to
interior bottom and base to conceal crack in latter.

The shape and finish take after so-called Namban jars, unglazed and
largely undecorated earthenwares and stonewares imported into Japan
from mainland Southeast Asia and the Ryukyu archipelago from
the sixteenth century (Namban, literally "southern barbarian," is a
premodern term referring to persons and goods of non-East Asian
origin arriving in Japan via the southern maritime route). An earlier
Japanese Namban imitation in this particular shape was produced in
the 1630s at the Agano kilns in present-day Fukuoka Prefecture,
Kyushu.[94] The decoration, on the other hand, speaks of Chinese and
Japanese painting traditions. According to research by Hisamatsu
Yumiko, the drying fishnet *(aboshi)* motif was based mainly on the
popular painting series "Eight Views of the Xiao and Xiang Rivers,"
particularly the view "Sunset over a Fishing Village."[95] Motifs like this

one circulated in pattern manuals such as the 1757 *Makie daizen*
(Encyclopedia of gold lacquer), published by Harukawa Hōsei.[96]

The combination of raised decoration *(moriage)* and Namban style also
finds a parallel or possibly a model in work by Yokohama potter
Makuzu Kōzan (1842–1916), who is known to have included such
ware in his output from no later than 1888.[97]

Although covering up cracks with enamel is not without precedent,
here the incongruous red base on an otherwise monochromatic piece
speaks of deceptive intent.

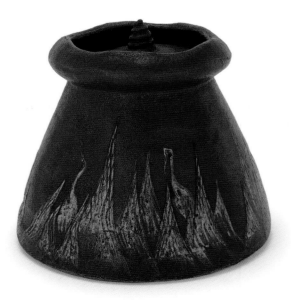

BY MIURA KENYA (1821–1889)

Japan, Meiji era, late 19th century

Acquired from Honma Kosa (gift); original attribution: "Kenya."

Morse attribution: see catalogue no. 60

4.3 x 7.8

Freer Gallery of Art, Smithsonian Institution, Washington, D.C.

Gift of Charles Lang Freer, F1904.429.3–8

Set of six. Fine-grained brown clay. Thrown and trimmed on potter's wheel. Brush application of white slip to outside wall. Inscriptions in underglaze iron on inside and incised outside of foot ring. "Kenya" signature inside foot ring in underglaze iron. Overall application of transparent lead glaze with base in reserve. Low-temperature firing.

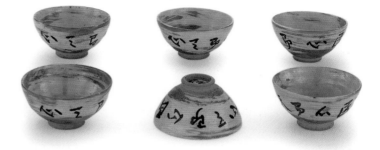

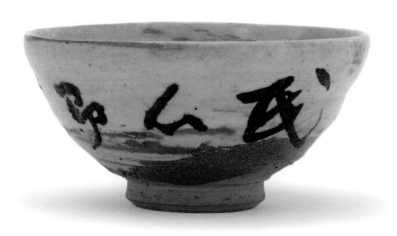

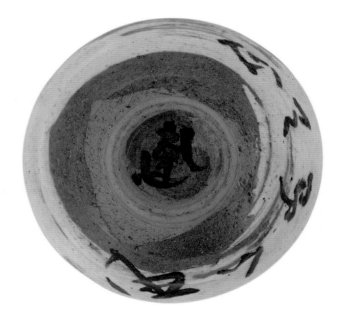

The vessel shape and bold brush application are intended to evoke Korean bowls roughly brushed with white slip—the so-called *hakeme* effect. Such bowls found favor among devotees of *matcha*, the whipped green tea consumed in the tea ceremony. But in this set, the diminutive size points to another form of tea drinking: *sencha*, the steeped tea which became widely popular at the beginning of the Meiji era. The aphorism inscribed on the sides of each piece, "The will of the people is the will of Heaven," has just the kind of scholarly flavor that devotees of *sencha* admired. Such a style is unique for Kenya, since most of his decorations feature stereotypical Kenzan flowers and grasses.

Characters incised on the lower median read "Tenrokudō," which Kenya used as a studio name. There is also an additional illegible inscription, which might allude to the name of a tea shop.

THE KŌRIN MODE

Kenzan's older brother Kōrin (1658–1716) is now remembered as a painter who took the century-old decorative style of Tawaraya Sōtatsu and infused it with greater simplicity, sharpness of line and contour, and heightened color. His painting and designs for lacquer work, textiles, and ceramics were cheerfully free from the didacticism of official art and exuded the chic of the pleasure-loving urban bourgeoisie. Much of this fashionableness seems to have been imbibed from the pleasure quarters, where Kōrin was a habitué (fig. 32). Thus he is seen to embody the spirit of the Genroku era (1688–1704), a period associated with a newly risen and spendthrift urban elite. Unusually good documentation of Kōrin's affairs may place him in an unflattering light—doubtless other wealthy merchants were similarly indulgent—but from an artistic and marketing point of view, Kōrin's proximity to the world of urban fashion would prove to be a boon for Kenzan ware.

The first hints of Kōrin's artistic interests appear in the diary of court noble Nijō Tsunahira (1672–1732), with whom the Ogata brothers enjoyed a close relationship for nearly three decades. In that document Kōrin is cited as having decorated boxes and fans. An archive of Kōrin sketches and documents passed down in the Konishi family shows a wide variety of painting experiments: they include copies of *yamato-e* picture scrolls, Buddhist painting, and Kano-style landscapes and figural subjects. By 1700, Kōrin appears to have matured as a painter: attributed to that time is a pair of six-fold screens entitled *Irises* (collection of the Nezu Institute of Fine Arts, Tokyo), where eight clumps of irises are rhythmically organized on an otherwise vacant gold ground. A number of versions followed, both in large-scale painting and craft formats (fig. 33). Kōrin's years in Edo, spanning 1705 to 1709, were funded by employment with a daimyo household. There, as the result of requirements to reproduce Muromachi era masters Sesshū (1420–1506) and possibly Sesson (1504–1589?), his brushwork is assumed to have become quicker and sharper. In 1709, Kōrin was back in Kyoto. In 1711 he built a spacious house on Nijō Street in the city center, and the following year Kenzan came down from the outskirts of the city to take up residence in Chōjiyamachi several blocks to the east. This is the setting for their collaboration in ceramics. Kōrin's painting activities continued until his death in 1716; shortly before that he is thought to have executed another well-known masterpiece, *Red and White Plum Blossoms* (collection of the MOA Museum, Atami).

In 1737, when Kenzan recounted the history of his ceramics workshop in a manual called *Tōji seihō*, he wrote that "all of the

Fig. 32. Preliminary drawing for a genre scene (detail), by Ogata Kōrin (1658–1716), late 17th–early 18th century. Ink on paper, 62.8 x 38.6. Agency for Cultural Affairs, Tokyo.

Fig. 33. Iris, probably a sketch for a folding fan, by Ogata Kōrin (1658–1716), late 17th–early 18th century. Ink and colors on paper, 21.6 x 28.2. Agency for Cultural Affairs, Tokyo.

Fig. 34. Sketches for Kenzan-ware tea bowls, with signature of Ogata Kōrin (1658–1716), 19th century. Ink on paper, 28.2 x 54.0. Freer Gallery of Art, Smithsonian Institution, Washington, D.C., gift of Charles Lang Freer, F1898.55.

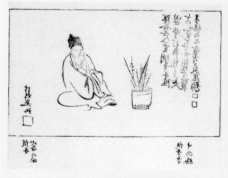

Fig. 35. Zhou Maoshu admiring orchids, after a work by Ogata Kōrin (1658–1716), from Sakai Hōitsu (1761–1828), *Kōrin hyakuzu-jō* (A hundred Kōrin pictures, vol. 1) (Publisher and place of publication unknown, 1815). Freer Gallery of Art and Arthur M. Sackler Gallery Library, Smithsonian Institution, Washington, D.C.

early painting was from the hand of Kōrin; later I used Kōrin's designs, and gradually began to add my own innovations." Their best-known joint work is a set of ten square dishes with assorted designs of flowers, trees, and figures; this is now preserved in the Fujita Museum, Osaka.[98] The sharp, abbreviated brushwork relates to a "quick-stroke" style employed by Kōrin after his return from Edo. A post-1709 dating is also suggested in the use of "Jakumyō" and "Seisei" signatures and a cipher resembling the character "kotobuki" on these pieces; such marks are also found in datable documents. Kōrin additionally provided sketches expressly for Kenzan-ware decoration; the Idemitsu Museum of Art, Tokyo, preserves a handscroll of such designs labeled in Kōrin's hand, "models for Shinsei's [Kenzan's] tea bowls." A painting based on this manual has been preserved in the Freer collection (fig. 34).

Catalogues of Kōrin-inspired textile designs, *Kōrin hiinagata* (Kōrin pattern books), appeared as early as 1706 and continued to be published several decades after his death. While the contents cannot be attributed to Kōrin himself, they do hint at a "Kōrin" boom in craft decoration, and provide an instance of apotheosis, where a public, posthumous reputation was manufactured in word and object. This aura added to the value of Kenzan ware and undoubtedly encouraged various types of unauthorized reproduction.

The image of Kōrin in Freer's time—and today—derives from the revival activities of Edo painter Sakai Hōitsu (1761–1828), a descendant of the same daimyo family that had sponsored Kōrin during his years in Edo. Hōitsu was nothing less than the self-designated custodian of the Kōrin legacy: he restored Kōrin's grave; collected, exhibited, and published his works; and took up the brush to perpetuate the Kōrin style himself. Hōitsu's printed books such as *Kōrin hyakuzu* (A hundred Kōrin pictures; fig. 35) fueled a new Kōrin boom, and much of the Kenzan reproduction of the late-Edo period and Meiji era is informed by *Hyakuzu* imagery.

Hōitsu's connoisseurship activities, carried on by his pupils into the Meiji era, formed a foundation for the modern reception of Kōrin and Kenzan. Kōrin's popularity is demonstrated in the dozens of related articles on him in the new national art magazine *Kokka*, and from the 1880s he was favorably received in Europe, figuring prominently in Louis Gonse's (1846–1921) *L'Art japonais* and Siegfried Bing's (1838–1905) *Le Japon artistique*. As we can see in the Freer collection, such appreciation was frequently detached from any regime of historical style: the mark "Kōrin ga" (painting by Kōrin) occurs on many "Kenzan" wares in an incongruous blend of decor and technique.

POSSIBLY OGATA KENZAN (1663–1743) AND OGATA KŌRIN (1658–1716)
(CHŌJIYAMACHI OR A CONTEMPORARY KYOTO WORKSHOP,
CA. 1710–1725)
Japan, Edo period, early 18th century
Acquired from Matsuki Bunkio ($38); original attribution: "Kenzan."
Morse attribution: "A good Kenzan. Tokyo Kenzan, all right."
2.8 x 21.7 x 21.7
Freer Gallery of Art, Smithsonian Institution, Washington, D.C.
Gift of Charles Lang Freer, F1902.220

Fine-grained buff clay. Slab, formed over a drape mold. Decoration of bridge and two clusters of iris in underglaze iron; edges feature decoration of cloud scrolls and floral panel on outside and cloud scrolls alone on the inside in underglaze iron. High magnification shows the pigment to have a very fine grain. "Jakumyō Kōrin" signature on front, "Kenzan" mark on lower right-hand corner of verso, both in underglaze iron. Vessel coated with transparent lead glaze; brush marks from the glaze application remain. Low-temperature firing. Gold lacquer repairs.

The shape and size suggest the dish was used as a tray for sweets or other light foods. The decoration refers to the popular "Kakitsubata" episode in chapter nine of the classical *Tales of Ise*. The hero, based on the real-life Kyoto courtier Ariwara no Narihira, is in exile; he pauses near a bridge over an iris bog in Mikawa, today's Aichi Prefecture, and composes a poem reflecting his estrangement:

Someone glanced at the clumps of irises that were blooming luxuriantly in the swamp. "Compose a poem on the subject, 'A Traveler's Sentiments,' beginning each line with a syllable from the word 'iris' *[kakitsubata],*" he said. The man recited:

Karagoromo	*I have a beloved wife,*
Kitsusu nareneshi	*Familiar as the skirt*
Tsuma shi areba	*Of a well-worn robe.*
Harubaru kinuru	*And so this distant journeying*
Tabi o shi zo omou	*Fills my heart with grief.*[99]

Kōrin's interpretation, possibly inspired by the recondite Nō-drama version of the theme, refuses to narrate, giving us only a bridge and irises, or irises only. Such reductive vignettes must have captivated audiences, for they appear in much of his work, ranging from folding screens and hanging scrolls to fans and lacquer ware. The Freer composition is closest to one painted on round fans: one is attached to a stationery box preserved in the Yamato Bunkakan, Nara, and the other is in the collection of the Hatakeyama Museum, Tokyo. Later Kenzans used a similar scheme; see catalogue numbers 49 and 50.

Ceramic collaborations of the Ogata brothers, among the most prized of all Kenzan wares, are now thought to have been made between 1709, when Kōrin returned to Kyoto from Edo, and 1716, the year of Kōrin's death. Interestingly, Freer's original notes for this piece provide a date of 1710. Several dozen of these collaborations remain. A strict division, based on minor variation in the decorative scheme, especially in the edge pattern, exposes two major groups, which we provisionally designate A and B.

Group A includes the aforementioned set in the Fujita Museum, Osaka, and two other pieces, one in the Idemitsu Museum of Art, Tokyo, and one in the Nezu Institute of Fine Arts, Tokyo.[100] This group displays crisp painting, confident signatures, and clear facsimile seals; the edge patterns are lattice and floral panels on the outside and stylized loquat patterns on the inside. A minor but significant point is that there is a bounding line around the painting.

Group B, represented by examples scattered throughout Japan and the United States, is also generally accepted as authentic.[101] It is characterized by a painting manner that is somewhat less decisive; in some cases the painted subjects seem too large for the format; and the Kenzan seals are usually blurred. The handwriting of the poetic inscriptions is formulaic. The most obvious difference is the edge patterns, which feature cloud scrolls on the inside and clouds and floral panels on the outside. There is no bounding line around the painting as in A.

A subgroup of group B, different only in the sense that the subjects are not those one would find in Chinese-derived ink painting but come from indigenous styles, is represented by three pieces: a dish with design of waves and plovers, now in the Cleveland Museum of Art; a dish with design of Mt. Fuji, now in the Suntory Museum of Art, Tokyo, and the Freer piece.[102]

That major differences divide these groups, and that qualitatively Group A would generally be accepted as the finest group is not in dispute. The question is whether the difference in quality represents the variation that may exist within a single workshop production, or the differences between workshops. I tend to think the latter, although the dish can't be too far removed, temporally or spatially, from the first Kenzan's Chōjiyamachi workshop.

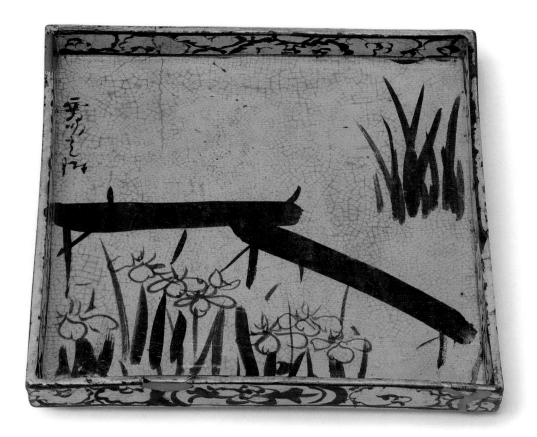

BY OGATA IHACHI (KYOTO KENZAN II, ACT. CA. 1720–1760)

Japan, Edo period, mid–18th century

Acquired from Matsuki Bunkio ($65); original attribution: "Kenzan."

Morse attribution: "Kenzan—Tokyo—modern—anybody can write that Kenzan."

42.5 x 8.2 x 2.4

Freer Gallery of Art, Smithsonian Institution, Washington, D.C.

Gift of Charles Lang Freer, F1896.56

Fine-grained white clay, assembled from slabs; spatula marks visible inside and out. Iris blossoms and leaves in blue and green underglaze enamels on front and side; inscription/signature reading "Kōrin ga [o] mosha [suru], Kenzan" (copying a Kōrin painting, [signed] Kenzan), in underglaze iron. "Ji"-shaped cipher in underglaze iron. Overall application of transparent lead glaze. Low-temperature firing. Position of stacking spur marks on one end and on verso, plus the direction of the glaze flow, show the piece was fired in an upright position.

The analogue for the shape is a paper strip called *tanzaku*, used for inscribing poems. "Tanzaku dishes" were made by the first Kenzan throughout his career. Those, however, are inscribed with poetry while this piece is painted. The theme, like catalogue number 48, is the "eight bridges" from *Tales of Ise*.

The signature and cipher style is that of Ihachi, who acknowledges this as a copy from a Kōrin design. Such florid iris vignettes remain in Kōrin's sketchbooks (see fig. 33). Ihachi's mention of Kōrin is not so

much citation as cachet: the Kōrin boom continued well into Ihachi's heyday in the mid–eighteenth century.

Judging from the extraordinarily fine clay, the piece was part of a custom order. An identical piece, with the same inscription, is in the collection of the Montreal Museum of Fine Arts, and a set of three pieces, slightly larger in size, exists in the Idemitsu Museum of Art, Tokyo.[103] The execution clearly relates to catalogue number 50, and they are probably part of the same batch.

BY OGATA IHACHI (KYOTO KENZAN II, ACT. CA. 1720–1760)

Japan, Edo period, mid–18th century

Acquired from Matsuki Bunkio ($38); original attribution: "Kenzan."

Morse attribution: "Good piece."

8.8 x 13.3

Freer Gallery of Art, Smithsonian Institution, Washington, D.C.

Gift of Charles Lang Freer, F1899.46

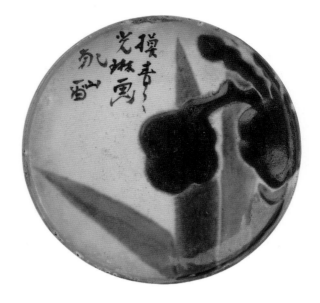

Fine-grained white clay. Lid and vessel thrown on potter's wheel. Painted decoration of iris detail on the exterior median, outside and inside of lid in blue and two tones of green underglaze enamels; inscription/signature reading "Kōrin ga [o] mosha [suru], Kenzan" (copying a Kōrin painting, [signed] Kenzan), with "ji"-shaped cipher, in underglaze iron. Additional underglaze iron "Kenzan" signature on exterior median. Overall application of lead glaze; low-temperature firing. Chip on rim of lid, repaired.

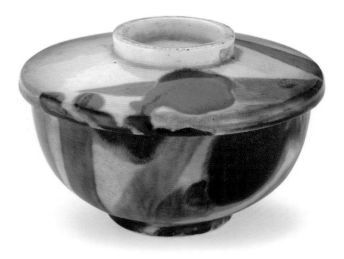

This is a lidded bowl for serving steamed food; the lid is designed so that steam condensing on its underside drips out of the vessel rather than into it. True to the inscription, the decoration is based on a Kōrin design, once again his interpretation of the popular "eight bridges" episode in the ninth chapter of the classical *Tales of Ise*. Like that of catalogue number 49, the Kōrin prototype was probably a fan design (see fig. 33).

In 1997 I discovered an identical piece in the Fitzwilliam Museum, Cambridge, which had been acquired from the collection of British artist Frank Brangwyn (1867–1956). A number of other similar works remain.[104] Misalignment between body and lid design in both the Freer and Brangwyn pieces suggests the components were switched when the set was still together.

The signature is in the style of Kenzan's adopted son, Ihachi, and the attribution of the design is also in keeping with a comment made in *Tōki mippōsho,* a pottery manual thought to be from Ihachi's hand: "One may paint from the models *(tehon)* left by Kōrin and Watanabe. . . ." The signature—widely agreed to be from the hand of Ihachi—has an unusual location on the median is also similar to a bowl in the collection of the Shōgoin Temple, Kyoto.[105]

The broad circulation of the design is revealed in a stoneware plaque made by French potter Auguste Delaherche (1857–1940) between 1894 and 1904.[106]

KYOTO WORKSHOP, KENZAN STYLE

Japan, Edo period, 19th century

Acquired from Matsuki Bunkio ($50); original attribution: "Kenzan."

Morse attribution: "A good Tokyo Kenzan."

10.6 x 11.4 x 11.6

Freer Gallery of Art, Smithsonian Institution, Washington, D.C.

Gift of Charles Lang Freer, F1902.217

Fine-grained, gray-buff clay. Assembled from five slabs, with foot rim hand carved. White slip applied to exterior, upper part of interior, and signature patch on base. Edge bands on outside and inside of rim, around base, all in underglaze iron; incised lines drawn through bands with a pointed instrument. Signature "Hokkyō Kōrin ga" (painted by Hokkyō Kōrin) in underglaze iron on side; "Kenzan" mark in patch of white slip, with double frame, in underglaze iron. Transparent stoneware glaze applied to exterior; base in reserve. High-temperature firing. Considerable discoloration of pigment and scaling of glaze, probably caused by over-firing or repeated use of the vessel.

An absence of glaze on the inside suggests this piece was intended to hold live embers for lighting pipes. The theme is "The Four Admirers" (Shiai), an ensemble created by Yuan dynasty poet Yu Ji (1272–1348). Four beloved Chinese poets are paired with flora and fauna they are thought to have admired: Tao Yuanming (365–427) admiring chrysanthemums; Zhou Maoshu (1017–1073) admiring lotuses; Lin Hejing (Lin Bu; 967–1028) admiring plums; and Huang Shangu (1045–1105) admiring geese.[107] Several "Kōrin" scrolls featuring individual Admirers survive, but more influential on craft production were the sketches in mass-printed books such as *Kōrin hyakuzu* (1815), part of the commemorative activities of Sakai Hōitsu (see fig 35).

Despite the lineage, the brushwork and composition in this piece lack the confidence associated with Kōrin's best ceramic designs, notably the set of square dishes in the Fujita Museum, Osaka, mentioned earlier. The existence of similar *hiire* with decoration signed "Kōrin" point to a later atelier, probably in Kyoto, which produced a large number of similar pieces. One vessel in this group features paintings of individual "lucky gods" on each panel.[108] The Freer pot has a nearly identical signature and the same problems with size management of the figures. While none of the pieces in this later workshop bears a date, the overall style points to the printed books that issued from the Kōrin revival in the early nineteenth century.

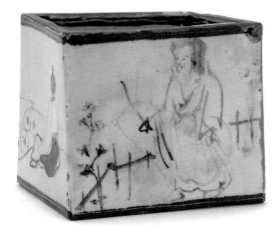 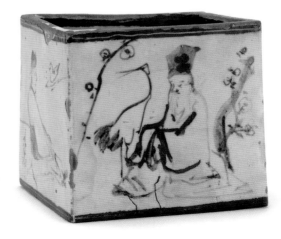

KYOTO WORKSHOP, KENZAN STYLE

Japan, Edo period, 19th century

Acquired from Kobayashi Bunshichi ($50); original attribution:
"Kenzan."

Morse attribution: "Typical Tokyo Kenzan—but which generation
can't tell."

9.2 x 12.5

Freer Gallery of Art, Smithsonian Institution, Washington, D.C.

Gift of Charles Lang Freer, F1902.232

Fine-grained buff clay. Assembled from slabs. Scraping marks on
interior surfaces. Five edge bands and painting of plum branches in
underglaze iron. Side signature reading "Hokkyō Kōrin ga" [painted
by Hokkyō Kōrin] and double-framed signature on base reading
"Kenzan," both in underglaze iron. Exterior and part of interior
covered with transparent stoneware glaze. High-temperature firing.
Base crack developed in firing.

The spiky new shoots of the spring plum were a favorite subject for
Kenzan's older brother Kōrin, who used an abbreviated "quick brush"
style, developed from a study of earlier Japanese monochrome ink
painting. Kōrin also created a manual for ceramic designs that included
plum painting, as suggested by a short scroll in the Idemitsu Museum
of Art, Tokyo.

True to the Kenzan manner, the composition is wrapped around the
vessel, but the brushwork is best called Kōrinesque. Other ember pots,
one in the Burke Collection, New York, and one in the British
Museum, London, are identical in nearly every detail to the Freer piece:
Kōrin's name and trademark design become a colorless denominator.

Many other pots with comparable decor and/or signature styles
survive.[109] The standardized production must postdate the early-
nineteenth-century Kōrin revival; the flat, static plum silhouette
hints at a source in printed matter.

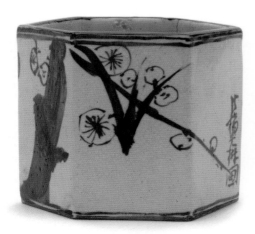

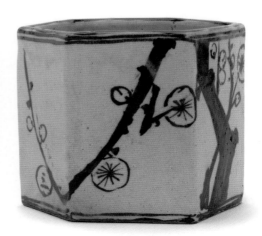

KYOTO WORKSHOP, IMITATION
Japan, Meiji era, late 19th century
Acquired from Y. Fujita, Kyoto ($75); original attribution: "Kenzan."
Morse attribution: "Fairly good—not Kyoto—modern."
13.9 x 17.1
Freer Gallery of Art, Smithsonian Institution, Washington, D.C.
Gift of Charles Lang Freer, F1911.406

Fine-grained buff clay. Thrown and trimmed on the potter's wheel. Rim carved to match contours of painted design; some incised details on median. Rim band in underglaze iron. Decoration of herons, pines, and flowering water in underglaze iron. "Kenzan" signature on base in iron pigment. Overall application of transparent stoneware glaze, with base in reserve. High-temperature firing. Blue and gold overglaze enamel accents. Low-temperature firing to fuse the enamel.

The shape and size suggest use as a bowl for sweets or grilled fish. The notion of a contoured rim that corresponds with painted decoration was developed by the first Kenzan in a series of openwork bowls *(sukashibachi)* decorated with floral themes.[110] In those original Kenzan-ware bowls, however, the decoration continues into the vessel and viewers are presented with two picture planes as they peek through or over the perforations. The Freer piece, on the other hand, simply appears sawed-off, with no interior decoration.

Heron subjects have a long history in East Asian art, becoming a popular subject for Japanese ink painters in the medieval period. The theme was employed by Kenzan's Rimpa predecessor, Sōtatsu, and

Kōrin experimented with the motif as well. A related vignette appears in a posthumous design manual entitled *Kōrin edehon michi shirube* (Manual of Kōrin painting designs; 1732).[111] Other wares with this large-scale, flaccid signature derive from that source too. Pieces from this workshop in the Freer collection include catalogue numbers 7, 65, 67, 79, and 80. As a rule these pots are one-of-a-kind products made to pass as "art"—they are quite absent in the Morse collection, but appear frequently in post-1890 collections in Europe. Many can be found in Japan too, but not easily: they are hidden away like unwanted family secrets.

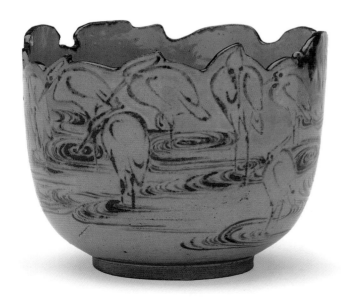

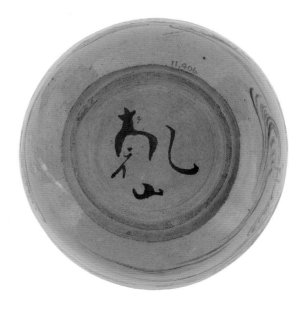

KYOTO WORKSHOP, IMITATION

Japan, Meiji era, late 19th century

Acquired from Samuel Colman Collection sale, American Art
Association ($66); original attribution: "Kenzan and Kōrin."

Morse attribution: "New. Too glassy to be any of the Kenzans."

9.7 x 11.7

Freer Gallery of Art, Smithsonian Institution, Washington, D.C.
Gift of Charles Lang Freer, F1902.74

Medium-grained reddish clay. Hand carved; spatula marks visible.
Overall application of white slip. Decoration of geese in underglaze
iron on inside and outside median. Signature "Kōrin ga" (painted by
Kōrin) and "Kenzan" in underglaze iron on base, outside of foot ring.
Application of lead glaze to all surfaces. Low-temperature firing, with
discoloration. Black (tarnished silver) moon on the rim is a later
addition to cover a repair.

The decoration is intended to convey ascending geese, an autumnal
theme derived from Chinese poetry and painting, and one much-
quoted in Japan. A geese vignette in the hallowed poem-picture
ensemble "Eight Views of the Xiao and Xiang Rivers" mentions a
night sky so cloudless it appears to have been swept. Startled by notes
of a flute on the evening breeze, geese take to the air, their airborne
contours resembling cursive script by the great calligrapher Wang Xizhi.

Such avian imagery is pleasant to contemplate, but the Raku-style
forming together with a faltering design—with Kōrin signature no
less—belongs to one of the historicized "cult" pieces. These are a
contrived response to the late-nineteenth-century enthusiasm for
Kōrin as the acme of a Japanese decorative tradition.

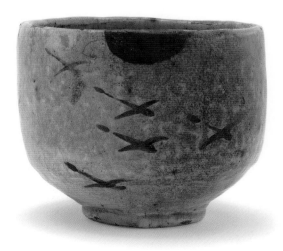

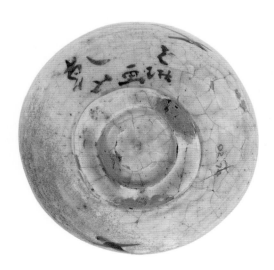

KYOTO WORKSHOP, IMITATION

Japan, Meiji era, late 19th century

Acquired from Yamanaka and Company ($5); original
attribution: "Shōko."

Morse attribution: "Shouldn't know anything about it. Mark probably
Sho-ko. Don't know where it came from."

8.2 x 6.0

Freer Gallery of Art, Smithsonian Institution, Washington, D.C.

Gift of Charles Lang Freer, F1898.468

Fine-grained buff clay. Thrown on potter's wheel, cut off at base with cord, leaving characteristic spiral-shaped cord mark *(ito-gire)*. Decoration of three "standing" cranes *(tachizuru)* in white slip and underglaze iron. Stenciled mark "Shōko" in seal script, in underglaze iron. Overall application of transparent stoneware glaze, with base and mouth rim in reserve. High-temperature firing. Areas of pinkish discoloration from post-firing reoxidation.

The shape and size of the vessel, together with the ivory cover, indicate use as a *chaki*, a container for powdered tea. The unglazed mouth rim suggests that an original ceramic cover was fired with the body. The crane decor and surface coloration have distant referents in Korean tea bowls called *gohon tachizuru*, characterized by inlaid designs of clouds and cranes and pinkish, buff-colored surfaces. The standing crane decoration assumed authority in Japan when daimyo tea master Kobori Enshū (1579–1647) allegedly ordered a tea bowl with the standing crane *(tachizuru)* design from Korea in 1639 at the original behest *(gohon)* of his patron, the third Tokugawa shogun, Iemitsu (1604–1651). That piece is still preserved in the Nezu Institute of Fine Arts, Tokyo.

The ceramic association is here mapped onto a facetious-looking group of cranes in the Kōrin mode; some of these appear in late-Edo period and Meiji era publications.

We have observed that the "Shōko" mark, connoting "veneration of antiquity," is one of Kenzan's pseudonyms. A similar stenciled mark appears on at least three other pieces: a bowl in the Freer collection (cat. no. 9), a handled dish formerly in the collection of Kushi Takushin, and an incense container in the Montreal Museum of Fine Arts. These pieces relate in turn to a larger group of rather uniformly produced stonewares.[112] Since pieces of this type do not appear in the Morse collection, but figure prominently in collections formed after 1890, it is assumed that they were made in the mid- to late-Meiji era.

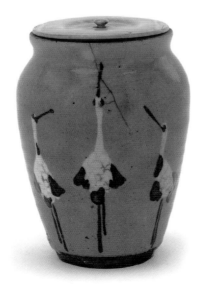
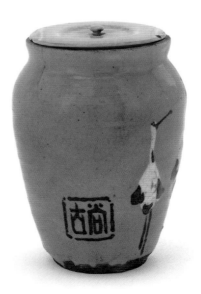

KYOTO WORKSHOP, IMITATION
Japan, Meiji era, late 19th century
Acquired from Siegfried Bing, Paris ($100); original attribution:
"Kenzan."
Morse attribution: "Imitation—all Kenzans dead when that
was made."
9.5 x 10.9
Freer Gallery of Art, Smithsonian Institution, Washington, D.C.
Gift of Charles Lang Freer, F1901.71

Coarse- to medium-grained buff clay. Formed by pinching and
trimming with spatula. Overall application of black lead glaze.
Decoration of three cranes in white overglaze enamel. "Kenzan" and
"Kōrin ga" (painted by Kōrin) signature on base, outside of foot ring,
also in white overglaze enamel. Black lacquer repairs to median and
rim. Tea stains in the interior.

The shape is inspired by a type of Korean Choson dynasty tea bowl
called *gohon-de* (made-to-order type) in Japan. Some of the *gohon-de*
bowls had crane decorations called "standing" crane, or *tachizuru* (see
previous entry). The typical *gohon-de* crane in profile has been replaced
here with a flattened crane design, of a type seen in late-Edo period
and Meiji era books of Rimpa designs.

The juxtaposition of Black Raku, exotic shapes, and a design with
Kōrin mark signals the work of what we have called the "Rimpa cult"
workshop, which burgeoned in domestic and foreign antique markets

in the late 1880s or early 1890s. The "Kenzan" signature on this piece
resembles the mark used by potters of the Edo Kenzan school, but
more evidence is needed to determine the provenance.

The Black Raku glaze in these late cult pieces lacks the pitted "citron"
texture of earlier Raku works; it may be pigmented with refined
materials, which would also obviate the difficult high-temperature
extraction that gives traditional Black Raku its characteristic color
and texture.

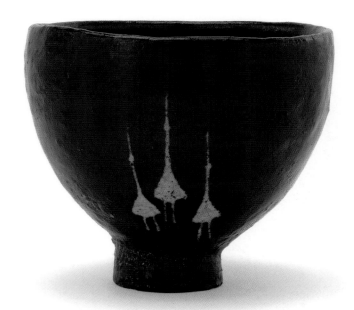

KYOTO WORKSHOP, IMITATION
Japan, Meiji era, late 19th century
Acquired from Rufus E. Moore ($40); original attribution: "Kenzan."
Morse attribution: "Brand new—right from the oven—not more than two years old."
16.1 x 12.5
Freer Gallery of Art, Smithsonian Institution, Washington, D.C.
Gift of Charles Lang Freer, F1896.45
Coarse brown-buff clay. Body coil made and trimmed; lid patted out and trimmed. Overall application of black lead glaze to exterior, with transparent lead glaze applied inside. Decoration of cranes and "dew-laden" pampas grass in white overglaze enamel. Signatures "Hokkyō Kōrin ga" (painted by Hokkyō Kōrin) and "Kenzan" in same. Low-temperature firing. Lacquer repairs to lid.

The shape and size suggest a water jar for the tea ceremony, and the tall shape is considered suitable for autumn. The decoration, while clearly a pastiche, also has an autumnal theme. Moore's receipt to Freer calls this a "Japanese Jar. Mirror-black, by Kenzan, brother of famous artist Kōrin. 1730."[113] Edward S. Morse's estimate, quoted above, is far more credible.

Mirror-black is a description applicable to Qing dynasty Chinese ceramics. Freer's original pottery list noted that this piece came with two covers and a stand. If this was a carved Chinese-style stand with a corresponding carved cover, this may indicate the "Chinese" presentation confected for many Japanese ceramics by dealers in the late nineteenth century.[114]

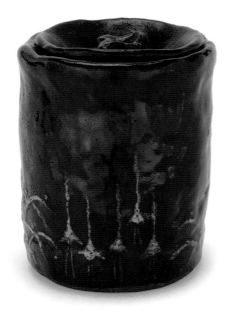
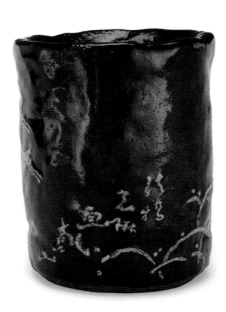

THE KENZAN MODE

Flowers and grasses are the common denominators of Kenzan-ware decor. These are not just any species, but those that carry, or once carried, poetic potency, among them plum, bamboo, chrysanthemum, pampas grass, bush clover, camellia, and iris. The painting manner is marked by flatness, frontality—great abbreviation. This approach is what we now associate with Rimpa, a school variously linked with masters Hon'ami Kōetsu, Tawaraya Sōtatsu, Ogata Kōrin, and, of course, Kenzan. Kenzan potters, beginning with the historic founder, harmonized these elements with clay, slip, and pigments to create simple but eye-catching arrangements that stood out from the more ornate and academic schemes in other contemporary ceramics. This was attractive but moreover efficient, and it formed the basis for mass-produced Kenzan ware over the years.

Such a design strategy has multiple beginnings, and one may be located in decorated poem cards, poem scrolls, and book pages designed by Kenzan's Rimpa forebears. The *Saga-bon* (Saga books), editions of classical novels, poetry anthologies, and Nō drama libretti published between about 1605 and 1615, was a project carried out under the supervision of Kōetsu, Sōtatsu, and a wealthy merchant named Suminokura Sōan (1571–1632). The pages of these Saga books (figs. 36 and 37) fused a decorated paper tradition from Japan's classical age with the bolder sensibilities of the early Edo; the explosion of printed papers in late-Ming dynasty urban culture may have been an influence as well.

Origins aside, the Saga books serve as a primer for subject and composition, in effect creating a modularized system of design. This has been explored by museum curator Nakabe Yoshitaka, whose analysis of a Saga book entitled *Ōhara miyuki* (Visitation to Ōhara) shows how only nine motifs—variously comprising geometric patterns, flora, and fauna—are arranged into a total of twenty-two different compositions.[115] Individual elements are depicted in large scale, without outline, in the so-called "boneless" manner. Printed in mica pigments on tastefully colored paper, these are simple but sumptuous silhouettes.

A 1710 volume entitled *Bengi sho-mokuroku* (Catalogue of doubt-dispensing books) mentions that the Saga books enjoyed generations of fame and had become display items in their own right. It is unthinkable that the Ogata family, with their Hon'ami ancestry and recorded interest in Nō, did not own numbers of them. Preserved sketches from Kōrin's hand show his study of the Saga books, and certain pieces of Kenzan ware quote them as well.[116] The mention of the books as display items is a good instance of the interstitial zone that had opened between reading and viewing in Kenzan's day.

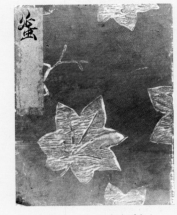

Fig. 36. Cover with maple-leaf design from Nō libretto *Ama* (The woman diver). Author unknown. (Kyoto: publication attributed to Suminokura Sōan [1571–1632], early 17th century.) Freer Gallery of Art and Arthur M. Sackler Gallery Library, Smithsonian Institution, Washington, D.C.

Fig. 37. Cover with ivy design from Nō libretto *Ominaeshi* (Maidenflower). Author unknown. (Kyoto: publication attributed to Suminokura Sōan [1571–1632], early 17th century.) Freer Gallery of Art and Arthur M. Sackler Gallery Library, Smithsonian Institution, Washington, D.C.

Fig. 38. Designing with slip. A new painting ground is created by a partial application of white slip over a darker clay body.

Fig. 39. Set of eight *kawarake*-type food dishes, by Ogata Kenzan (1663–1743), or related workshop, with individual designs, early to mid–18th century. Stoneware with decoration in underglaze iron and cobalt. 1.5 x 11.2. Peggy and Richard M. Danziger, New York. Photograph by Schecter Lee.

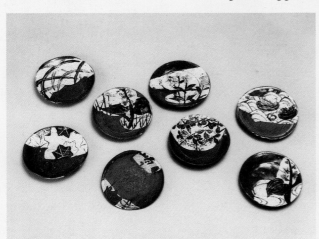

The first Kenzan's kiln site at Narutaki (1699–1712) has yielded shards with such bold flowers-and-grasses decoration, but accumulated evidence points to the consolidation of a "Kenzan mode" at a second workshop, at Chōjiyamachi in downtown Kyoto (1712–ca. 1731). In response to growing popularity, Kenzan changed his workshop organization from horizontal (encompassing all facets of the potter's work) to vertical (decoration only). Shapes were standardized and the decoration, painted now on prefired blanks, settled into the limited repertory just outlined. Kiln space for high-temperature firing was rented from commercial kilns in Awataguchi and Gojōzaka in the eastern hills of the city. The flowers-and-grasses images of Rimpa had become contained in a line of popular vessels.

Mass production is usually synonymous with monotony, but these wares show a number of innovations. One is the creation of a decor zone that breaks the symmetry of globular and cylindrical surfaces; this was accomplished by brushing patches of white slip onto the darker colored blanks prior to decoration (fig. 38). These patches could suggest snow-covered hills, mist, or the moon; or they could simply create a formal contrast. A second new strategy—called *egawari*—featured an assortment of subjects within a single set (fig. 39). This Kenzan mode was continued faithfully by Kenzan's adopted son and workshop heir, Ihachi, and subject-by-subject analysis reveals how Ihachi developed his own versions of the stock images.

Datable artifacts—and even vendor's advertisements—show the enduring popularity of the Kenzan-style floral vocabulary into the second half of the eighteenth century, although there is considerable license and diminished power. Then, in an early nineteenth-century revival, led by Kyoto potters such as Nin'ami Dōhachi, the designs were invigorated with larger scale and great masses of color. So exaggerated are some of the elements that one is tempted to call them kitsch. Certain designs possess a Western-inspired kineticism that insinuates itself into Japanese art in the late-Edo period. New species appear as well, reflecting a burgeoning field of horticulture or even the mischievous pleasure that later Edo urbanites took in the noncanonical. Ironically, it was probably this carnivalesque Kenzan style that earned Kenzan his impressionist laurels in nineteenth-century Europe; it is also one of the types that was repeatedly featured in glossy blowups in the post-1950s Japanese media.

The relative ease of appropriation, together with an unaffected vigor, guarantees the "Kenzan mode" a long life as merchandise. One can visit any pottery shop or department store today and find them in force, a counterpoint to the high-collar academic styles adopted from China and Europe.

BY OGATA KENZAN (1663–1743)

(CHŌJIYAMACHI WORKSHOP, 1712–CA. 1731)

Japan, Edo period, early 18th century

Acquired from Y. Fujita, Kyoto ($20); original attribution: "Kenzan."

Morse attribution: "Imitation Kenzan—not genuine."

6.9 x 11.1

Freer Gallery of Art, Smithsonian Institution, Washington, D.C.

Gift of Charles Lang Freer, F1911.402

Fine- to medium-grained buff clay, exposed parts discolored. Thrown and trimmed on the potter's wheel. Interior modeling with spatula. Patch of white slip applied to median by brush. Painting of pampas grass leaves in underglaze cobalt and iron, in that order. Rim line in underglaze iron. "Kenzan" signature in iron pigment, in oval frame inside foot rim. Application of transparent stoneware glaze, with base in reserve. High-temperature firing. Gold lacquer repairs and interior staining, presumably from extensive tea drinking.

The pampas grass *(susuki; Miscanthus sinensis)* is renowned as one of the seven grasses of autumn, and is so designated in Japan's oldest native verse collection, the eighth-century anthology *Manyōshū* (Collection of myriad leaves). As a ritual offering, *susuki* appears in the full-moon festival (*jūgoya*—the fifteenth day of the eighth lunar month), where celebrants arrange an offering of fruit, rice dumplings, and pampas grass to the moon-spirit. Pampas grass rose to prominence as a motif in the late sixteenth century, when it was employed as a lacquer decoration in the Toyotomi family mortuary temple, Kōdaiji. By Kenzan's time, it had become a general autumnal symbol as in this poem:

Pampas grass in the wind—
Waves farewell, farewell
To the departing autumn. [117]

The pampas-grass motif on Kenzan ware was probably inspired by a Saga book design, for a covered dish in the Suntory Museum of Art, Tokyo, bears a combination of pampas grass and lozenge motifs very close to those in the printed books. The arrangement seen here, characterized by broadly brushed wavy stalks, is a further distillation and appears on numerous tea bowls, covered bowls, and sauce pots. [118] Many of them have a signature in an oval panel similar to the Freer piece. These are part of the large production of the Kenzan workshop in the second and third decades of the eighteenth century. A nearly identical tea bowl, with a poetic inscription added, came to light in a Kyoto collection about a decade ago. [119]

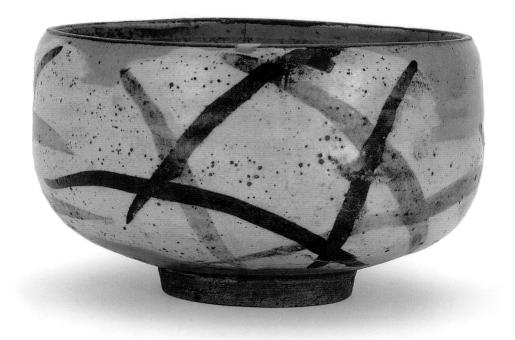

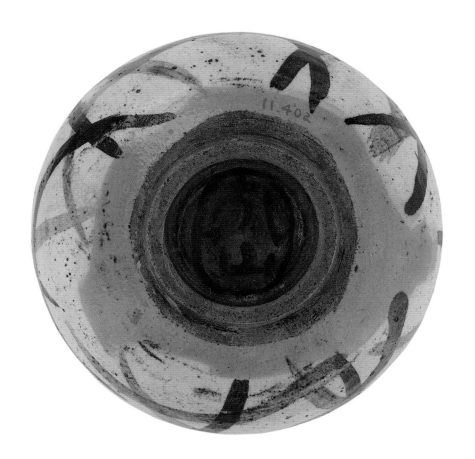

BY OGATA IHACHI (KYOTO KENZAN II, ACT. CA. 1720–1760)
Japan, Edo period, mid–18th century
Acquired from H. R. Yamamoto ($120); original
attribution: "Kenzan."
Morse attribution: "Tokyo—Kenzan. Kōrin style. A handwarmer—
damn new."
26.6 x 22.7
Freer Gallery of Art, Smithsonian Institution, Washington, D.C.
Gift of Charles Lang Freer, F1905.290

Fine- to medium-grained pink-red clay. Thrown on the potter's wheel. Feet created by indenting three sections of the base. Large ogival window and smoke hole carved into upper section. White slip application to exterior and upper half of interior. Application of black lead glaze to left side of body, with blossom and leaf areas left in reserve. Painting of water and chrysanthemums in blue, purple, green, and yellow underglaze enamels. Lines incised through the dark blossoms, sgraffito style. "Kenzan" signature in iron on base. Application of transparent lead glaze to exterior and upper half of interior of vessel. Low-temperature firing. Window fitted with brass rim. Later repairs around the base and extensive scaling of glaze and slip in interior.

The shape of the piece indicates use as a handwarmer, or *te-aburi;* the vessel would be filled with ash as a bed for live charcoal embers. The decoration of chrysanthemums and water is intended to evoke a Chinese legend: long life awaits one who drinks from a stream fed by chrysanthemum dew. This was celebrated on the ninth day of the ninth month in a ceremony called *chōyō,* when guests admired chrysanthemums, exchanged cups of wine, and composed poetry.

The first Kenzan's mass-produced designs used this divided field concept, called *kakiwake,* but always with some natural congruence. In this theme one should therefore expect to find flowers on the bank and ripples in the stream, but here that notion has given way to simply dividing the ground and scattering the design elements throughout. This design slippage, the earthenware manufacture, and the signature style of Kenzan's successor, Ihachi, all point to a movement away from first-generation precepts.

There is another issue here, for Ihachi was a Kyoto potter but the piece is made in a red clay more typical of Edo manufacture. Furthermore, a number of handwarmers with this general design are preserved, all of them belonging to the Edo Kenzan school: two pieces by Minzan, who may have been an early Edo Kenzan successor, one piece by Edo Kenzan III, and two pieces by Ida Kichiroku, who received instruction in the Kenzan style from Edo Kenzan V, Nishimura Myakuan.[120] It is tempting to see the chrysanthemum handwarmer as a succession piece, commemorating the transmission of the Edo title. Indeed the simplified broken field design became and Edo Kenzan staple (see cat. no. 60). But the place of Ihachi, a Kyoto potter, in this scheme is quite uncertain.

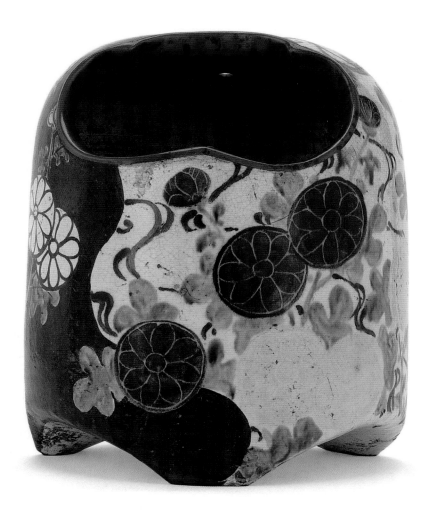

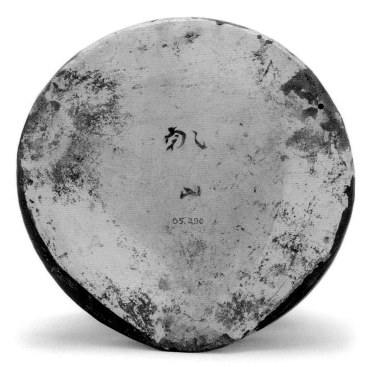

BY MIURA KENYA (1821–1889)

Japan, Meiji era, late 19th century

Acquired from Honma Kosa (gift); original attribution: "Kenya."

Morse attribution: "Probably all right. Yes, I think that may be a set
made by Kenya—for some special occasion."

5.5 x 12.6

Freer Gallery of Art, Smithsonian Institution, Washington, D.C.

Gift of Charles Lang Freer, F1904.429.1

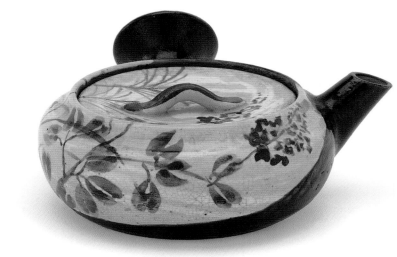

Fine-grained buff-white clay. Handle, lid, spout, and body thrown and
trimmed on potter's wheel; strainer holes drilled into body, spout and
handle luted to body, and lid handle luted to lid. Partial application of
iron glaze; underglaze painting of bush clover and pampas grass in
reserve area with underglaze iron. "Kenya" mark in underglaze iron,
on base. Overall application of transparent lead glaze, with base in
reserve; patch of glaze applied over signature. Low-temperature firing.

The painted decoration of bush clover and pampas grass, both of
which are included among a poetic "seven grasses of autumn," provides
seasonal nuance. It could be argued that the curving contour of the
reserved white surface suggests the full moon, in which case the theme
would be Musashino, a plain in the western Kanto region. This was a
reedy hinterland in the poetic imagination, but irreverent critics
maintain that it was really a mixed hardwood forest managed by locals
as a charcoal supply.

The use of a divided ground, or *kakiwake,* is a device that the original
Kenzan learned from Oribe ware and textile design. Kenzan added
more allusive decoration and this became a staple of his Chōjiyamachi
workshop. As mentioned above, a simplistic *kakiwake* effect was a
trademark of the Edo Kenzan-school potters, who used it more than
later Kyoto potters. The Edo potters, however, worked in lead-glazed
earthenware and used black glaze to create the contrast. (Kyoto potters
relied on the clay body to provide the dark color.)

The signature reads "Kenya" (see also cat. no. 22), although the style of
the mark itself is a little different from those on the commonly
accepted pieces from the hand of Miura Kenya. Several disciples
worked with Kenya at his last studio at Chōmeiji, Tokyo.[121] Side-
handled teapots, used in preparation of the steeped tea called *sencha,*
are conspicuous in urban archaeology assemblages from about 1870.

BY MIURA KENYA (1821–1889)

Japan, Meiji era, late 19th century

Acquired from Honma Kosa (gift); original attribution: "Kenya."

Morse attribution: see catalogue no. 60

4.2 x 11.4 x 16.5

Freer Gallery of Art, Smithsonian Institution, Washington, D.C.

Gift of Charles Lang Freer, F1904.429.2

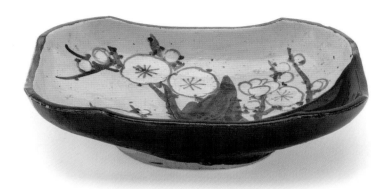

Medium-grained buff clay. Slab, made over drape mold. Foot ring carved out. Painting of plum in underglaze iron pigment and blue, purple, and yellow underglaze enamels. Underglaze iron band on rim. Painted area covered with transparent lead glaze. Lower right half of vessel dipped in black lead glaze, which laboratory tests showed to be high in manganese. "Kenya" signature on base. Low-temperature firing. Branch of plum is painted to cover a crack in the body that runs through to the base.

The shape and size suggest a dish for an individual food portion, a *mukōzuke*. The boat-shape contour, called *funagata,* was a popular item in the Kyoto ceramics repertory. The diagonal surface division is the aforementioned scheme known as *kakiwake*. Here, Kenya has executed a plum painting in a Rimpa style, and it shows a comic distention typical of the nineteenth century.

The peripatetic Kenya was active in a number of locations. The main workshops are: Asakusa-Fukagawa (Edo; 1832–53), Hatano (Odawara; 1869–71), and Chōmeiji (Mukōjima, Tokyo; 1875–79). In his final years at Chōmeiji, Kenya is reported to have been surrounded by a large group of disciples who turned out a rather uninspired group of earthenware vessels and figurines. Other workers beside Kenya may have used his signature. Many of these divided-ground vessels remain,[122] a good number of them in the collection of the Ishii family, into which Kenya was adopted.

KYOTO WORKSHOP, KENZAN STYLE

Japan, Edo period, late 18th to early 19th century

Acquired from Sato, Nagasaki ($6); original attribution: "Kenzan."

Morse attribution: "Tokyo Kenzan—well worn."

1.9 x 19.1

Freer Gallery of Art, Smithsonian Institution, Washington, D.C.

Gift of Charles Lang Freer, F1911.403

Fine-grained buff clay. Slab, formed over drape mold. Front trimmed with broad, deliberate spatula marks in horizontal and diagonal directions. Decoration of bamboo grass *(sasa)* in underglaze iron and green underglaze enamel; "Kenzan" mark in underglaze iron on verso. Totally covered with transparent lead glaze. Low-temperature firing. Stacking spur marks remain. Several gold lacquer repairs and chip on rim.

The size suggests a dish for an individual food portion. Similar pieces exist in sets of five and ten with individual designs—the so-called *egawari* concept championed by Kenzan.

The design is called *kanname zara*—dishes with potter's carving tool *(kanna)* marks *(me)*. It is based on a lacquer-ware prototype, where the lacquer coating would be applied to a planed wooden core. *Kanname* lacquer-ware trays are said to reflect the preference of the famous tea master Sen Rikyū (1522–1591).

Numerous fragments of *kanname zara* have been unearthed from Kenzan's kiln site at Narutaki; many pieces by later followers and imitators also remain. The only group that might be reasonably attributed to the first Kenzan is a set in the Sekisui Museum, Tsu City,

Mie Prefecture.[123] The design and signature of the Freer piece relate to a large group of wares made by an unnamed Kenzan-style workshop, probably in Kyoto. *Kanname zara* are especially prominent in this group.[124]

In 1994, fragments of two square dishes, both with "Kenzan" signatures, were found at the Minami Yamabushi-chō site, Shinjuku Ward, Tokyo, a residence of a direct retainer of the shogun *(hatamoto)*.[125] The signature on those two dishes was identical to the signature on the group just mentioned and to the Freer piece. The accompanying artifacts at the site were datable to the very end of the eighteenth century through the second quarter of the nineteenth century, providing a date for this piece and the related workshop activity.

KYOTO WORKSHOP, KENZAN STYLE
Japan, Edo period, late 18th to early 19th century
Acquired from H. R. Yamamoto (gift); original attribution: "Kenzan."
Morse attribution: "Tokyo—Kenzan."
5.0 x 13.2
Freer Gallery of Art, Smithsonian Institution, Washington, D.C.
Gift of Charles Lang Freer, F1905.320–324

Medium-grained buff clay. Set of five. Thrown and trimmed on the potter's wheel. Thin application of white slip to entire vessel. Underglaze iron band on rim. Underglaze decoration of flowering plants in underglaze iron and in green, blue, purple, red, and yellow underglaze enamels. "Kenzan" mark in underglaze iron on base. Overall application of transparent lead glaze. Low-temperature firing.

Low bowls with straight sides and broad bases were popular in the eighteenth century in porcelain as well as stoneware. This work exploits the concept of assorted subjects in a single set, the afore-mentioned *egawari*. This became a trademark of Kenzan design, not only for its visual interest but also for its allusive potential. This set includes plum, bamboo grass, paulownia, chrysanthemum, and a hydrangea-like flower called *gakusō*. But this ensemble is no longer a coherent poetic enumeration; instead it is a collection of Kenzan-style designs, as interpreted by a later workshop. The rim band is a convention for tea bowls with designs confined to the outside median, but it is discordant in this case since the painted designs "spill over" the edge.

As in the case of catalogue number 62, this set belongs to the production of a large, late-eighteenth- to early-nineteenth-century workshop. Both works share the single bamboo-leaf mannerism. Identical shapes[126] and similar subject treatment[127] are known in Japanese and overseas collections.

Freer's original notes attribute this to "Iriya Kenzan."[128] Influential Meiji era connoisseurs such as Ninagawa Noritane believed painted earthenwares like these were made in Kenzan's late workshop, located in the Iriya section of Edo

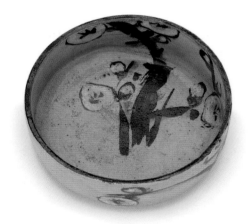

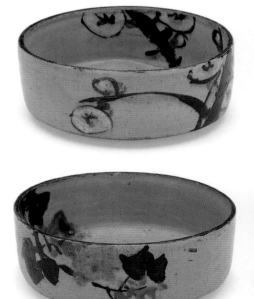

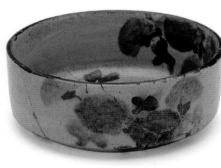

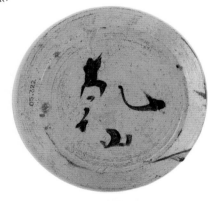

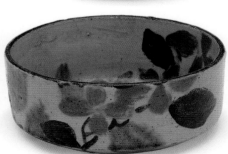

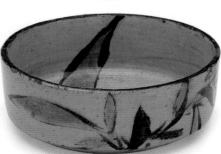

KYOTO WORKSHOP, KENZAN STYLE

Japan, Edo period, late 18th to early 19th century

Acquired from H. R. Yamamoto ($35); original attribution: "Kenzan."

Morse attribution: "Kyoto. Kenzan—a good one."

7.1 x 11.6

Freer Gallery of Art, Smithsonian Institution, Washington, D.C.

Gift of Charles Lang Freer, F1905.216

Medium to coarse-grained, buff-brown clay. Thrown and trimmed on potter's wheel. Partial application of white slip to median. Rim band, decoration of pampas grass in underglaze iron and cobalt. "Kenzan" mark in iron pigment on base. Application of transparent stoneware glaze, with base in reserve. High-temperature firing.

Judging from the rather broad base, this piece may have been made as a lidded bowl for food service rather than as a tea bowl. Tea bowls conventionally fetch higher prices so there is a profit to be made in separating the body from its cover; the latter is also easily broken or lost.

Pampas grass, a motif long associated with autumn, was a perennial subject in Kenzan ware. This is a rather modest interpretation of a prototype developed in Kenzan's urban workshop at Chōjiyamachi, but its coarse clay, diffuse design, and poorly executed signature belongs to a later but unnamed Kyoto atelier that produced these for mass consumption.

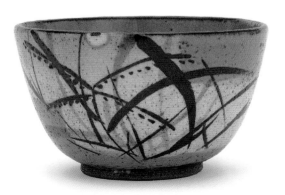

KYOTO WORKSHOP, IMITATION

Japan, Meiji era, late 19th century

Acquired from Matsuki Bunkio ($18); original attribution:"Kenzan."

Morse attribution:"Don't see why Kenzan should have used that

rough clay. Looks like a freak—rotten signature."

7.5 x 12.0

Freer Gallery of Art, Smithsonian Institution,Washington, D.C.

Gift of Charles Lang Freer, F1901.122

Coarse buff clay. Wheel thrown and trimmed, with foot ring fashioned to resemble a crescent-moon shape *(mikazuki kōdai)*. Decoration of bamboo and poem on outer median, and "Kenzan" signature inside foot ring in underglaze iron. Thin application of transparent stoneware glaze. High-temperature firing.

Information in the Freer Gallery of Art object record, presumably based on box and dealer information, relates that this bowl was "By Kenzan, after Irabo style." Irabo refers to a type of Korean bowl made in the fifteenth or sixteenth century, many of which are preserved in Japan as prize tea-ceremony wares. It is said that the name Irabo comes from colloquial terms *ira-ira* and *ibo-ibo,* which suggest the coarse texture of the clay body and glaze. The rough surface of this bowl, produced by a sandy body in concert with a very thin glaze application, is probably intended to suggest the Irabo effect.

Owing to its tea ceremony pedigree Irabo was widely imitated in Japan; Kenzan's predecessor Ninsei made numerous facsimiles, and among the notes that Kenzan inherited from the Ninsei workshop are recipes for Irabo clay and glazes.[129] But Kenzan seldom if ever experimented with textured clays and colored glazes, for his overwhelming artistic concern was with smooth surfaces for decorating and transparent glazes to show the painting to its best effect.

The original notes compiled by Freer from the vendor date this piece to 1725. This was a period when the Kenzan workshop would have been producing, among other things, cylindrical bowls and rectangular dishes with abbreviated paintings and poems. The verse on this piece, reading "Strong and upright, the virtue of a true gentleman" can be found on such pieces. However, the Irabo effect and the painting are mutually negating, and the signature on the piece places it with the recombinant styles of the late nineteenth century. The same workshop produced catalogue numbers 7, 43, 53, 67, and 79.

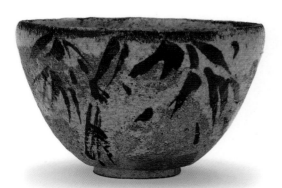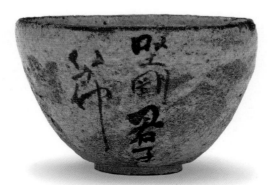

KYOTO WORKSHOP, KENZAN STYLE

Japan, Edo period, late 18th to early 19th century

Acquired from Kobayashi Bunshichi ($50); original
attribution:"Kenzan."

Morse attribution:"Looks like Kenzan to me—Kyoto Kenzan—that
gray glaze."

7.7 x 10.9

Freer Gallery of Art, Smithsonian Institution, Washington, D.C.

Gift of Charles Lang Freer, F1905.222

Medium- to coarse-grained buff clay. Thrown and trimmed on the
potter's wheel. Camellia motif painted in white slip and underglaze
iron and cobalt. Rim band in underglaze iron. "Kenzan" mark in
underglaze iron on base. Application of transparent stoneware glaze
with base and lower part of interior in reserve. High-temperature
firing. Fitted bronze cover with decorative cutouts.

The shape is called *efugo,* derived from a fisherman's bait-pail. It
appears most commonly in bronze wastewater jars *(kensui)* for the tea
ceremony; ceramic equivalents are known as well.

Early nuances of the camellia in Japanese literature suggest magical
properties, a role also mentioned in Chinese Song dynasty poetry.
The flower appears as a motif in Muromachi era (1333–1573) lacquer
ware, and in the Momoyama period (1568–1615) it was broadly used
in painting and textiles. Its ceramic debut occurs in Kutani-style
porcelains from the mid–seventeenth century. The first Kenzan used
the camellia as a motif in a memorable series of cylindrical food vessels
in which bold white blossoms are depicted against a green ground. [130]

This piece, by virtue of its sandy clay and distinctive signature,
is identifiable as part of a large workshop production from the late
eighteenth to early nineteenth century. The designs are characterized
by single flowers, isolated on plain ground. Items from the same
workshop in the Freer collection include catalogue numbers 62 and
63. The dating is prompted by the discovery of items with the
same signature in early nineteenth-century disposals at the Minami
Yamabushi-chō site in Shinjuku Ward, Tokyo, excavated in 1994. [131]

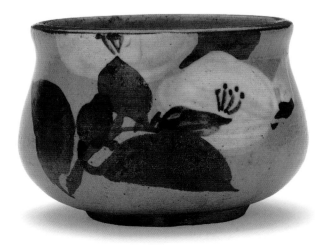

KYOTO WORKSHOP, IMITATION
Japan, Meiji era, late 19th century
Acquired from Matsuki Bunkio ($60); formerly in the collection of
Ikeda Seisuke, Kyoto; original attribution: "Kenzan."
Morse attribution: "Probably one of the very latest Kenzans."
6.4 x 8.5
Freer Gallery of Art, Smithsonian Institution, Washington, D.C.
Gift of Charles Lang Freer, F1900.71

Fine-grained brown clay. Thrown on the potter's wheel, with hand
trimming on base and lower median. White slip applied to upper half
of exterior and inside of rim. Painting and "Kenzan" signature in under-
glaze iron, on opposite sides. Overall application of transparent
stoneware glaze, with base in reserve. High-temperature firing.
Application of green, red, and black enamels, fused in an additional
low-temperature firing. Ivory cover fitted to piece.

The distinctive cover, plus the vessel's shape and size, are that of a
container to hold powdered tea for the tea ceremony (chaki). Tea-
container shapes as a rule follow well-defined historical precedents;
this one, however, is outside the canon. The decoration of violets
(sumire) is part of an early-modern poetic family of plants that appear
in spring fields, such as horsetails, dandelions, azaleas, bracken, ferns,
beach peas, and primrose.

Although a very important part of early-modern ceramics production,
the tea container was never a part of the Kenzan repertory. Tea
containers were conventionally monochromatic, and that failed to
engage Kenzan's interest. Any tea container with the Kenzan mark
is suspect. In this piece, the application of glaze to areas where slip
has accidentally scaled off is an abrogation of standard quality control.
The signature and clay correspond to a large group of late-Meiji era
imitations, including catalogue numbers 7, 53, and 65.

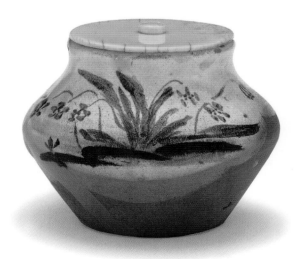

KYOTO WORKSHOP, KENZAN STYLE

Japan, Edo period, mid–19th century

Acquired from Matsuki Bunkio ($25); original attribution: "Kenzan."

Morse attribution: "Kenzan."

6.7 x 13.4

Freer Gallery of Art, Smithsonian Institution, Washington, D.C.

Gift of Charles Lang Freer, F1899.36

Fine-grained buff clay. Thrown on potter's wheel, with unusual counterclockwise trimming. Partial white-slip application. Band on lip in underglaze iron. Decoration of pines in iron and cobalt pigment on outside and inside surfaces. "Kenzan" signature in iron pigment inside foot ring. Transparent stoneware glaze applied to interior and exterior, with base reserved. High-temperature firing; some of the iron pigment has dissolved. Gold lacquer repairs.

This was originally a lidded bowl for serving steamed food. The type, called *futajawan*, seems to have been sold in sets—ten is the most common number among surviving Kenzan-ware sets. These large sets were frequently broken apart into groups of five, and in the case of this shape they were also marketed as one-of-a-kind bowls for the tea ceremony. The decorative scheme is intended to suggest pines against a bank and derives from the "beach pine" composition, called *hamamatsu* or *suhama*. The beach-pine motif dates from the Heian period, when miniature landscapes of rocks, trees, birds, and various auspicious objects were constructed in footed trays for use in offerings on festive occasions such as New Year. Such bowls would have been appropriate for special-occasion cuisine. Beach pines could also suggest the Sumiyoshi shrine or the pines of the Ōyodo Bay, mentioned in the classic *Tales of Ise:*

The pine of Ōyodo
Is not inaccessible;
The resentful waves are themselves to blame,
For they come no closer than the beach
And then go back again.[132]

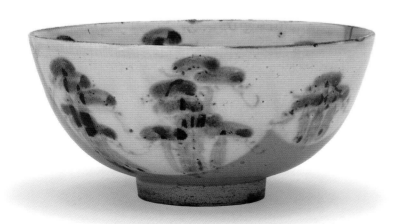

KYOTO WORKSHOP, KENZAN STYLE

Japan, Edo period, mid–19th century

Acquired from Howard Hollis, Cleveland

6.6 x 13.3

Freer Gallery of Art, Smithsonian Institution, Washington, D.C.

Purchase, F1961.28

These bowls are identical in every aspect to catalogue number 68—from the same workshop if not from the same set. It is remarkable that these bowls were reunited after at least sixty years of separation.

Kenzan's Chōjiyamachi workshop manufactured bowls in this design; one remains in the collection of the Miho Museum in Shiga Prefecture.[133] The latter is small in comparison to the Freer piece. In addition to its larger size, the Freer piece is thinly and mechanically thrown and possesses a rather florid signature. Similar marks can be seen on other pieces with the partial slip application and underglaze cobalt and iron pigment combination.[134] Taken as a whole, the style seems to fall between the modest workshop products of the eighteenth century and the more fanciful stylization of later periods.

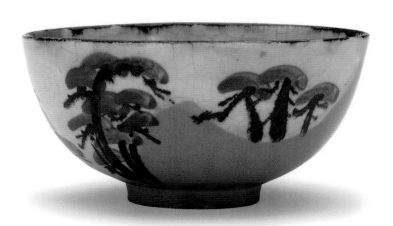

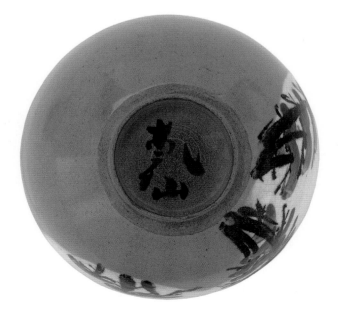

KYOTO WORKSHOP, IMITATION

Japan, Meiji era, late 19th century

Acquired in Japan, spring 1907 ($100); original attribution: "Kenzan."

Morse attribution: "Tokyo, all right."

3.0 x 18.8

Freer Gallery of Art, Smithsonian Institution, Washington, D.C.

Gift of Charles Lang Freer, F1907.86

Set of five. Coarse-grained red clay. Thrown and trimmed on potter's wheel. Application of white slip, in different contours for each piece. Iron band on rim. Decoration of flowers and grasses in underglaze iron and blue, yellow, and green underglaze enamels. "Kenzan" signature in underglaze iron on bottom. Overall application of transparent lead glaze; low-temperature firing.

The size and shape suggests a dish for individual food portions. The design concept can be traced back to a Kenzan favorite, a decorated earthenware dish called *kawarake*. Kenzan appropriated these normally unpainted and unglazed dishes and filled them with dynamic designs. The decor scheme for this set, where the vessel ground is divided irregularly by white slip with painting on the white area, is exactly what early Kenzan potters used on *kawarake*. Waves, bamboo grass, chrysanthemums, and pine seedlings are the subjects here.

The first Kenzan utilized handmade, brown-colored *kawarake* from Hataeda, a major earthenware workshop in north Kyoto. During his late years in Edo, however, Kenzan shifted over to local products made along the banks of the Sumida River; these were wheel thrown and fired to a red color. The Freer pieces generally resemble the latter, but belong to a much later and quite disconnected production episode: the deliberately textured clay, arbitrarily assembled subjects, and saturated pigments reveal the difference. A very similar but larger set (eleven pieces) is preserved in the Idemitsu Museum of Art, Tokyo.

In the absence of other clues, I have seen similar designs on dishes by the first generation Miyanaga Tōzan (1868–1941).[135] From 1885, Tōzan was associated with the circle of German technician and government advisor Gottfried Wagener, where he learned not only about ceramics but also about the antiquities and curio trade. Also in the Wagener milieu were two potters with some claim to the Edo Kenzan line, Miura Kenya (1821–1899) and Urano Shigekichi (1851–1923).

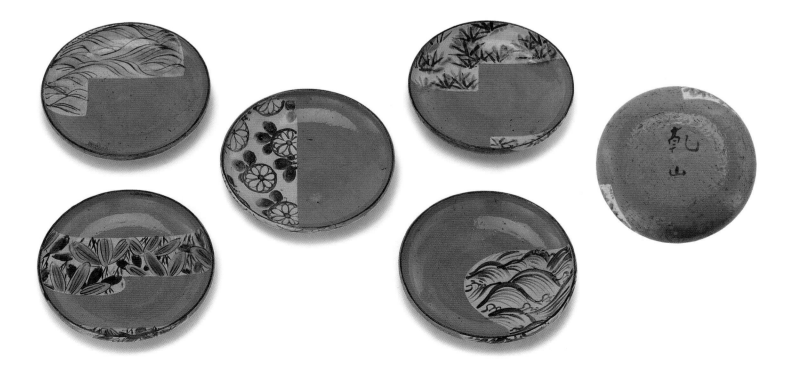

KYOTO WORKSHOP, KENZAN STYLE
Japan, Showa period, 20th century
4.5 x 10.7
Freer Gallery of Art, Smithsonian Institution, Washington, D.C.
Gift of Mrs. John A. Pope, 1986, FSC-P-2243

Fine-grained, gray-buff clay. Lid, base, and spout thrown and trimmed
on the potter's wheel. Pieces luted together. White-slip patch applied
to median and section of lid. Painting in underglaze iron and cobalt.
"Kenzan" signature in underglaze iron on base. Overall application of
transparent stoneware glaze; base in reserve. High-temperature firing.

The shape suggests a sauce pitcher, or *shirutsugi*. The decoration is
spring grasses, which may include violets, horsetails, dandelions,
azaleas, beach peas, and primrose. This is a popular theme in Kenzan
ware. Many small sauce servers were made by either Kenzan's
Chōjiyamachi workshop or related workshops in the middle of the
eighteenth century, but they are softer and more sensitively made. This
piece resembles a type of Kenzan imitation made by master Kyoto
potters for the city's fine *kaiseki* restaurants in the twentieth century.

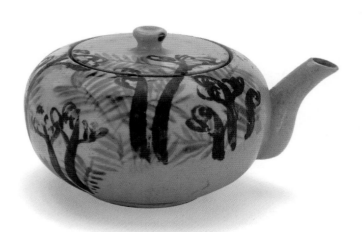

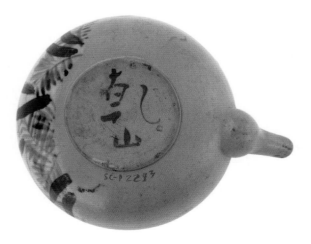

KYOTO WORKSHOP, KENZAN STYLE

Japan, late Edo period or Meiji era, mid to late 19th century

Acquired in Japan, spring 1907 ($200); original attribution: "Kenzan."

Morse attribution: "Spick-span new thing. Tokyo—Kenzan."

6.6 x 26.3

Freer Gallery of Art, Smithsonian Institution, Washington, D.C.

Gift of Charles Lang Freer, F1907.85

Fine-grained buff clay. Thrown and trimmed on the potter's wheel. Foliate rim trimmed with a spatula. Four holes bored through rim and foot ring, respectively. White slip applied to blossom area, cloud surfaces on back, and signature area on base. Underglaze decoration of flower stems and outlines in underglaze iron; "Kenzan" mark in single frame, on base, also in underglaze iron. Overall coat of transparent stoneware glaze. High-temperature firing. Overglaze decoration in red, blue, green, and gold, with a second firing to fuse the enamels. Outfitted with a vine handle, probably wisteria, attached through rim holes.

The Asian lily was popular in early Japanese poetry, but since it was such a lush flower it was not widely employed in early craft decoration. In the Edo period, however, as horticulturists produced many new varieties, there was a surge of enthusiasm for the flower. The type of lily pictured here became a theme in the first Kenzan's late ceramics and painting.

The shape is an unusual one for Kenzan ware—it has a distant referent in Chinese porcelain dishes. The lily probably became linked with Kenzan in the popular imagination after Sakai Hōitsu attributed paintings of the subject to Kenzan in his 1823 book *Kenzan iboku* (Ink traces of Kenzan). The signature displays a manner associated with the overstated nineteenth-century Kenzan revival; a bowl with a similar signature was excavated with wares from the third quarter of the nineteenth century at the Dōshisha University site in Kyoto.[136]

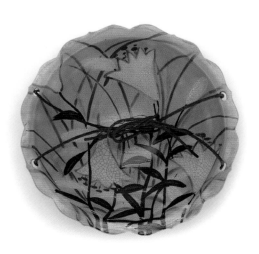
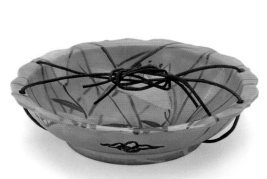
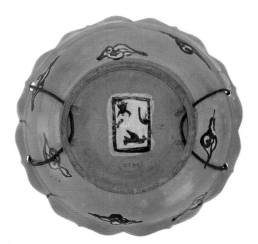

THE RAKU MODE

In his pottery manual *Tōji seihō*, Ogata Kenzan wrote:

> Since this [the manufacture of the Raku style] is [the Raku] family trade, I feel it improper to copy their work, and thus I will not write anything about the Black Raku glaze. I have been on good terms with the Raku family since the time of Ichinyū, the fourth-generation head of the family, so I don't want to inconvenience them. If someone orders Black Raku ceramics from me I will refer them directly to the Raku family, since they have been in the business since the time of Rikyū.[137]

The first Kenzan clearly distanced himself from Raku-style production. Why, then, are there dozens, possibly hundreds, of Raku tea bowls and other Raku-like vessels bearing the Kenzan signature—some of them represented in the Freer collection?

"Raku," like "Kenzan," is polysemic, variously connoting technique, style, and a genealogy of makers. These elements combine and recombine in the representations of potters, tea masters, and antiquarians. In today's popular imagination, Raku as a technique stands for hand making, lead glazing, and small-kiln firing. A Black Raku glaze is especially prized, a result of sudden extraction from the kiln at peak temperature.[138] Stylistically, Raku conjures up sculpted bowls made for drinking *matcha*, the beverage central to the tea ceremony. As a family and workshop name, Raku is proprietary to a household in north-central Kyoto that traces fifteen generations of descent from a sixteenth-century founder named Chōjirō (fig. 40). This is particularly important, for tea ceremony devotees view Chōjirō as the potter-collaborator of Sen Rikyū (1522–1591), the master believed to have devised that severe but ever-so-tasteful form of tea called *wabicha*. ("Raku" also has been incorporated into non-Japanese practice, but that is another story.)

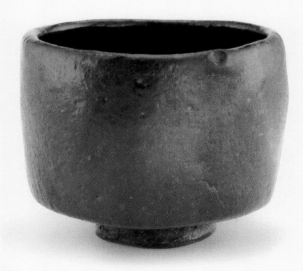

Fig. 40. Black Raku tea bowl in the style of Chōjirō (d. 1596), 19th century. Glazed earthenware, 8.5 x 10.8. Freer Gallery of Art, Smithsonian Institution, Washington, D.C., gift of Charles Lang Freer, F1902.52.

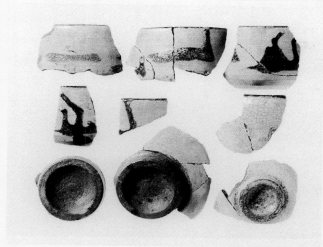

Fig. 41. Fragments of polychrome tea bowls excavated in Kyoto, early 17th century. Glazed earthenware. Kyoto City Archaeology Research Center.

Why the name of Kenzan commingled with that of Raku requires a reassessment of the Raku tradition itself.[139] Kenzan's notes, as well as other early documents, reveal that besides Raku there were other lead-glaze workshops such as Oshikōji. This hints at diversity in the glazed-earthenware industry in Kyoto, which emerged in the late sixteenth century after a glazing hiatus of five hundred years. Urban archaeology of the past two decades has provided corroboration for this diversity: a growing number of consumer sites in Kyoto and Osaka have yielded an array of lead-glazed earthenwares from late-sixteenth- and early-seventeenth-century soil layers and artifact assemblages; shapes include tea bowls, incense burners, and tea caddies, in a broad palette (fig. 41). The Raku workshop proper was a part of this world, although it had opportunities to serve military patrons and collaborate with Kenzan's great-uncle Hon'ami Kōetsu (1558–1637; fig. 42). These associations, however, were no more than occasional—third-generation master Dōnyū (Nonkō; 1599–1656) is mentioned in the annals of the Hon'ami family as being talented but poor. In recent years a broader variety of works impressed with the Raku seal has been found in Kyoto, including hearth tiles and household lighting equipment; this may represent a "vernacular" Raku production from those lean times. Contrary to popular representations, then, the earliest Raku workshop potters had little mooring to any regime of style or patronage.

In the second half of the seventeenth century, the Raku workshop faced competition from a new local stoneware industry as well as splinter workshops. Here the connection with the Ogata family began. Instead of ceding the family headship to

Fig. 42. Black Raku tea bowl, attributed to Hon'ami Kōetsu (1558–1637), early 17th century. Glazed earthenware, 8.7 x 12.5. Freer Gallery of Art, Smithsonian Institution, Washington, D.C., gift of Charles Lang Freer, F1899.34.

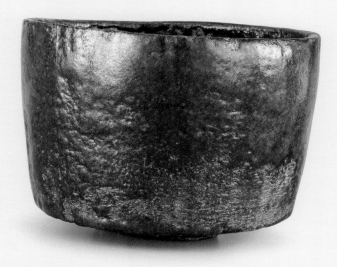

his natural son Yahei, fourth-generation Raku master Ichinyū (1640–1696) adopted Kenzan's cousin Heishirō (later Raku Sōnyū; 1664–1716), and the latter moved the family to new quarters at Aburakōji Nijō Agaru. Yahei relocated to Tamamizu where he made a reputation for himself under the name Ichigen. According to a nineteenth-century document entitled *Raku daidai* (Generations of the Raku), the Aburakōji property had been in the possession of Sōnyū's natural father (and Kenzan's uncle), Ogata San'emon. *Sōnyū monjo* (Archive of Sōnyū), a 1688 lineage document preserved in the Raku family collection, naturalizes Sōnyū's headship and foregrounds the family ancestry. The link with the Ogata provided a much-needed infusion of cash, or at least the potential backing of an established wealthy family. Kenzan's deference to the Raku clan, now led by his own blood relative, is thus understandable.

Fig. 43. *Rakuyaki hinō* (Collected Raku ceramic secrets; 1736), by Nakata Senryūshi (dates unknown). Private collection, United States.

Why, then, the Raku-Kenzan fusion in ceramic products? The following catalogue entry (cat. no. 73) explains that it was not Ogata Kenzan himself but his heir, adopted son Ogata Ihachi, who brought Raku into the Kenzan suitcase. In *Tōki mippōsho* (Secret book of ceramic techniques), a pottery manual attributable to Ihachi, considerable attention is devoted to Raku techniques, although they are made to fit into the Kenzan manner: Ihachi devised a way of making a "picture window" in the Black Raku glaze, into which painted Kenzan-style elements were inserted. Viewed metaphorically, Raku becomes an artisanal "body" for a "cerebral" Kenzan mode.

Ihachi's encroachments also reflect a broadening of interest in Raku, which took place as Ihachi came of age in the second quarter of the eighteenth century. Historian Morgan Pitelka has assembled evidence for that acceleration. Personal letters between Raku potters and tea masters show intimate collaboration, diaries of teaists indicate broad dissemination of the Raku product, and woodblock-printed pottery manuals such as the *Rakuyaki hinō* (Collected Raku ceramic secrets; 1736) brought Raku technique into the range of amateurs and regional workshops (fig. 43).[140] And just as Ihachi appropriated Raku, tea enthusiasts were appropriating Kenzan: from the mid–eighteenth century Kenzan and his brother Kōrin were claimed as members of the Omotesenke school of tea in popular genealogies such as *Chajin kaō sō* (Thicket of teamen's ciphers; 1746).

A new Kenzan-Raku permutation appears in early-nineteenth-century printed sources. In 1823, when painter and antiquarian Sakai Hōitsu published his catalogue of Kenzan works called *Kenzan iboku* (Ink traces of Kenzan), among the more standard painted pieces he illustrated a Black Raku incense container with a design of a deer in

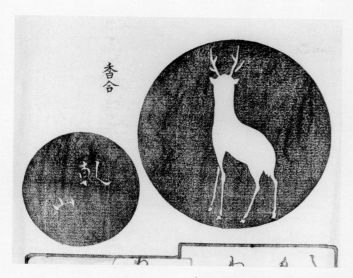

Fig. 44. Illustration of a Black Raku incense box, in Sakai Hōitsu (1761–1828), *Kenzan iboku* (Ink traces of Kenzan; 1823). Freer Gallery of Art and Arthur M. Sackler Gallery Library, Smithsonian Institution, Washington, D.C.

resist (fig. 44). Ihachi's picture window technique apparently was abandoned in favor of incising pictures through the glaze, a manner common to many late Kenzan-Raku works. The technique derives from the Raku themselves, who used this effect, called *kihage*, from the time of third-generation family head, Dōnyū.

Kenzan motifs also appear in the second quarter of the nineteenth century in Black Raku pieces from the hand of "name" potters like Nin'ami Dōhachi on Raku products from *oniwayaki*, small "garden" kilns operated by artisans for the amusement of powerful patrons. From this time names like Raku, Kōetsu, and Kenzan become floating names in a late-Edo historicism. *Rakuyaki hiden* (Raku ware secret tradition), a late-Edo clay and glaze recipe book for amateur potters, lists "Oribe," "Kōetsu," and "Kenzan" glazes along with standard Raku items.[141] This sets the stage for the most recent Kenzan-Raku inclusions in the Freer and other late-nineteenth-century Western collections. Here, all pretense of technical or stylistic congruity is dropped. Instead the object simply functions as the bearer of a name—for a market that has learned these names in a vacuum. The techniques change too: modern oxides replace the old stone colorants; incising through the glaze is frequently abandoned and instead the decoration is painted in an opaque feldspathic pigment on top of a slick glaze. "Kenzan" becomes a kind of art-market graffiti.

Kenzan-Raku, then, is a compound that reflects the popularization and stylistic dispersal of once-exclusive products. But in retrospect, it is not an arbitrary bond: both Kenzan and Raku, in the widest sense of those terms, are built upon the blurring if not downright obfuscation of the boundaries between amateurism and professionalism. That is a legacy of *wabi* chanoyu, Kenzan's literati inclinations, and a marketplace with a great capacity for imagination.

BY OGATA IHACHI (KYOTO KENZAN II, ACT. CA. 1720–1760)
Japan, Edo period, mid–18th century
Acquired from Matsuki Bunkio ($45); original attribution:"Kenzan."
Morse attribution:"Don't know what that is—don't believe
it's genuine."
7.2 x 9.0
Freer Gallery of Art, Smithsonian Institution, Washington, D.C.
Gift of Charles Lang Freer, F1902.53

Clay cannot be observed. Hand carved, with a spiral-shaped depression (called *chadamari*—tea "pool"—by enthusiasts) in the cavetto. Black lead glaze first applied to entire surface, then scraped away in areas intended for brushwork. White slip applied inside the scraped areas; mountain hermitage design painted in underglaze iron and cobalt; and a "Kenzan" mark and surrounding double frame painted in underglaze iron. Painting and signature area covered with transparent lead glaze. Fired to a temperature of about 1,000 degrees Centigrade. Fired glaze exhibits the "citron skin" texture characteristic of the Black Raku style. Three stacking spur marks visible on foot ring; tong marks, required for the high-temperature extraction that is the defining moment in the Black Raku process, visible on median, over the signature area.

The mountain hermitage motif, a staple of Kenzan-ware design, is here combined with the Raku technique, a staple of tea ceremony ceramics. The small size and adherence to tea-ware conventions suggest use in a *chabako*, or portable tea set.

As we have seen, the first Kenzan declared unilaterally that in his workshop manufacture of Black Raku was off-limits. On the other hand, Kenzan's adopted son, Ihachi, pursued Black Raku vigorously, and Ihachi's pottery manual, of which various copies exist, dedicated a section to resist designs with Raku ware:

Putting a White [-Ground] Painting on Black Raku:

Don't ever divulge this. Even though I write this down, it is
best discussed in person. [Apply various base coatings] and on
that surface you may paint [motifs] in blue or black . . .
[directions follow].[142]

A number of pieces with the Ihachi-style signature use this technique, most notably a Black Raku tea bowl with a reserve-panel design of flaming jewels preserved at the Kyoto Shōgoin Temple, where Ihachi is known to have had his kiln.[143] Such evidence, coupled with the characteristic Ihachi-style signature on this piece, makes for a solid attribution and, moreover, anchors the development of Kenzan-Raku in the second generation.

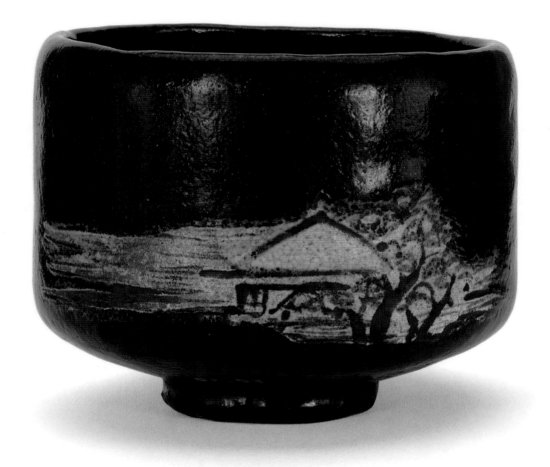

KYOTO WORKSHOP, IMITATION

Japan, late Edo period or Meiji era, 19th century

Acquired from Yamanaka and Company ($75); original attribution: "Kenzan."

Morse attribution: "Not genuine Raku."

8.6 x 14.4

Freer Gallery of Art, Smithsonian Institution, Washington, D.C.

Gift of Charles Lang Freer, F1899.96

Medium- to coarse-grained buff clay. Hand formed and carved with spatula. Overall application of black lead glaze applied to entire body. Maple-leaf design on exterior and interior median; in one type of leaf the leaf surface is scraped away; in another type the leaf outlines and veins are incised. Transparent lead glaze painted over scraped/incised areas. "Kenzan" signature in resist on base, outside of foot ring. Fired to medium temperature. Gold lacquer repairs.

The orthodox style of Black Raku ware, from the time of its alleged development by tea master Sen Rikyū and potter Chōjirō in the late sixteenth century, is chiefly undecorated. In keeping with demands for a more diverting tea ceremony in the early seventeenth century, however, the third-generation master, Dōnyū, developed a pictorial Raku ware: designs would be carved though the opaque unfired glaze; the design part would then be covered by a transparent glaze. This approach, known as *kihage*, became a staple of the Raku family from that time.

In this work, the potter has used a "positive-negative" autumn leaf design; this is a popular Rimpa-style device, appearing frequently in the block-printed designs for the books called *Saga-bon*. It can be found in Kōrin's sketchbook as well.[144]

Here the design is scraped through the glaze. This work, therefore, eschews the "window" decoration of Ihachi in favor of the *kihage* approach. Its date is not certain, but comparable works from the hand of Kyoto Kenzan III (Gosuke) and Nin'ami Dōhachi were using such a technique in the opening decades of the nineteenth century.[145] The extraordinarily large size of this bowl suggests some distance from traditional Raku production.

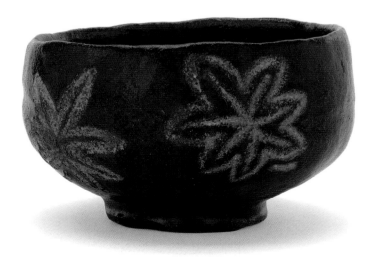

KYOTO WORKSHOP, IMITATION

Japan, Edo period, 19th century

Acquired from Ōshima Kanō ($100); original attribution: "Kenzan."

Morse attribution: "Tokyo Kenzan—genuine."

8.1 x 12.0

Freer Gallery of Art, Smithsonian Institution, Washington, D.C.

Gift of Charles Lang Freer, F1900.103

Clay color and texture not visible. Carved by hand. Undulating rim characteristic of Raku tea-bowl style. Overall application of black lead glaze. Pines depicted in white overglaze enamel, with pale-green glaze foliage accents. "Kenzan" signature on base, outside of foot ring, also in white overglaze enamel. Three spur marks on foot ring; tong marks visible. Low-middle temperature firing. Black glaze has areas of pebbly "citron skin" effect characteristic of the Black Raku finish. Poor bonding of enamel with body.

The pine decoration lacks any particular allusive function save the conventional auspicious intimation of heartiness and longevity, deriving from the upright, evergreen characteristics perceived in the species.

This is an example of a Kenzan design simply painted over the Raku glaze. The small and sparsely placed foliage clusters have a Kōrin ancestry, although the genetic dilution is great. Why Morse assigned this bowl to Tokyo is unclear, but late-nineteenth-century dealers' lore maintained that Kenzan earthenwares were made during the master's years in Tokyo.

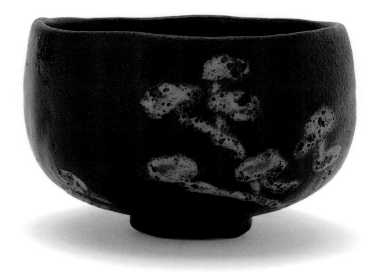

POSSIBLY MIURA KENYA (1821–1889)
Japan, Edo period, mid–19th century
Acquired from Matsuki Bunkio ($30); original attribution: "Kenzan."
Morse attribution: "Mark badly written, but a good, genuine piece."
3.2 x 6.6 x 5.0
Freer Gallery of Art, Smithsonian Institution, Washington, D.C.
Gift of Charles Lang Freer, F1901.118

Medium-grained white clay. Base and cover hand carved. Facets around base. Basted with a red (ochre) slip. Decoration of plum in white slip, underglaze iron, and underglaze yellow enamel. Mark on base, partially obscured by repair: "Keichō Kenzan … Hizaki ni oite…." (in Hizaki [Nagasaki of Hizen Province], Keichō Kenzan). Exterior and interior covered with a transparent lead glaze, with contact points in reserve. Low-temperature firing.

The use of the long axis of the box as the design ground is unusual and suggests a source in lacquer-ware boxes, specifically Rimpa-style inkstone cases in which the decoration runs up from the side onto the cover. The rusticated faceting and frothy glaze evoke Red Raku ware.

The box lid for this piece has been preserved, and the cover is inscribed "Shodai Kenzan kōgō" (First-generation Kenzan incense container); the reverse is inscribed "Keichō Kenzan sei/Hizaki ni oite seisu owannu/monji ari/I" (Made by Keichō Kenzan Sei, while in Hizaki, with "bird" script; [signed] I).

Since it is stated that this piece was made in "Hizaki" (Nagasaki, Hizen), this work invites comparison with catalogue number 28.

But this box is specific about the manufacture in Nagasaki, Kyushu. The inscriptions on catalogue number 28 state only "Nagasaki," not Hizaki. Also, the writing style and ceramic technique are different. If this box was made in Nagasaki, it may well have been made by one of two later Kenzans who are recorded as having visited Nagasaki: Miura Kenya, who visited there in 1854, and Ida Kichiroku, who sojourned in the port city in 1856. The piece has the flavor of being made as part of an amusement rather than a large production, so it is conceivable that Kenya or Kichiroku, acting in a "Kenzan" capacity, created the piece for a patron in Nagasaki.

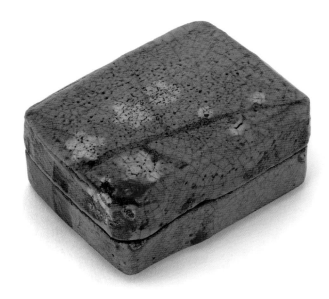

EDO KENZAN SCHOOL
Japan, Edo period, early to mid–19th century
Acquired from H. R. Yamamoto ($95); original attribution: "Kenzan."
Morse attribution: "Bully little box—Tokyo, for all that."
3.3 x 5.3 x 3.9
Freer Gallery of Art, Smithsonian Institution, Washington, D.C.
Gift of Charles Lang Freer, F1905.217

Fine- to medium-grained buff clay. Lid and base carved out; spatula
marks visible. Four feet luted to bottom. Decoration of plum shoots in
white slip, underglaze iron, and yellow and purple underglaze enamels.
"Kenzan" mark on base in underglaze purple enamel. Overall coating
of transparent lead glaze, including glaze over a chipped area. Low-
temperature firing.

The shape and size for this piece suggest it was used for holding pellets
of incense, either for an incense guessing contest or a tea ceremony.
The shape may be inspired by a *chabitsu*, a wooden chest used for
storing tea leaves.

Rough forming, amateurish painting, and frothy glaze suggest the
activity of a hobbyist, but the signature and the distinctive purple-
black enamel are peculiar to the Edo Kenzan school, early to
mid–nineteenth century.

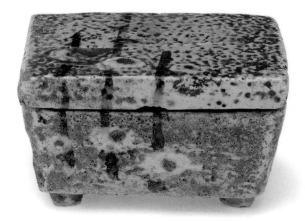

KYOTO WORKSHOP, IMITATION
Japan, Meiji era, late 19th century
Acquired from Yamanaka and Company ($8); original attribution:
"Kenzan."
Morse attribution: "Imitation Kenzan."
8.0 x 13.5
Freer Gallery of Art, Smithsonian Institution, Washington, D.C.
Gift of Charles Lang Freer, F1896.100

Red clay, grain size unclear. Hand carved with applied foot ring. Carving marks in the median, and undulating, "mountain path" mouth rim. Decoration of cranes and flowing water in white slip, with outlines and details in iron pigment. "Kenzan" signature in iron pigment on base, outside of foot ring. Overall application of transparent lead glaze. Low-temperature firing.

The irregular shape of the bowl, while generally consistent with Raku tradition, is not a type pursued by the original Kenzan workshop. The decoration is an adaptation of a design first developed by Kenzan's older brother Kōrin; this became a stock motif for Kōrin-school decorators, although the water pattern here is the so-called "Kanze" type, so named after a prominent family of Nō actors.

Of the two cranes, the head of one disappears over the mouth rim into the interior of the bowl. Such humorous dockings of motif and shape gained popularity in the late-Edo period.

Freer himself seems to have had some doubt about this piece as his margin notes in a later pottery inventory rank this piece as "School of Kenzan," "Rejected," and finally "Reserved."

The emphasis on "name" artists plus the use of the "personalized" Raku idiom underline the demand for individual masterpieces by new market players in the 1890s. The technique and signature style are similar to a number of works in Western collections formed from the 1890s; they include pots with the signatures of Kenzan and Kōrin but also nearly identical ones with the names of Chōjirō, Kōetsu, and Kūchū. These have been associated with the "cult of Rimpa" that developed among collectors at the end of the century. Crane decoration was part of the profile.

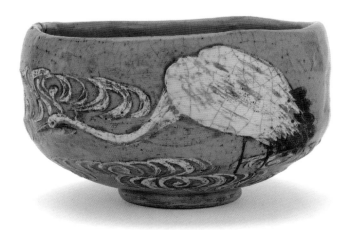

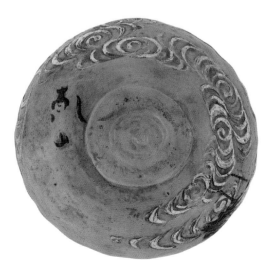

KYOTO WORKSHOP, IMITATION

Japan, Meiji era, late 19th century

Acquired from Matsuki Bunkio ($50); original attribution: "Kenzan."

Morse attribution: "Modern imitation—glassy."

7.9 x 9.6

Freer Gallery of Art, Smithsonian Institution, Washington, D.C.

Gift of Charles Lang Freer, F1902.211

Fine white clay. Hand carved. Vertical facets around wall. Overall application of transparent lead glaze. "Kenzan" signature painted on median in underglaze iron. Thin white slip application on median. Low-temperature firing.

Careful inspection reveals that white slip was applied as a ground for painting, which was never carried out. What remains is the rough facets, a bow to amateurism or the amateuresque, but this is a thin disguise for the mechanical manufacture visible on the inside.

The signature style is well represented in certain Japanese collections and in Western collections formed after 1890. Freer pieces with the same mark include catalogue numbers 7, 43, 53, 65, 67, and 80. The wide stylistic variety mirrors the new—and naive—consumers in the antiquities market.

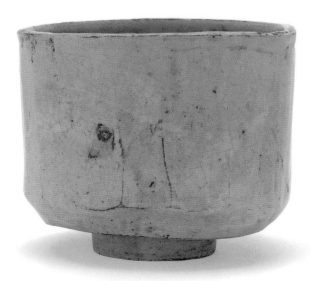
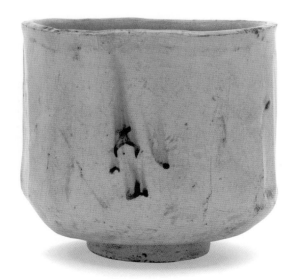

KYOTO WORKSHOP, IMITATION
Japan, Meiji era, 19th century
Acquired from Kita Toranosuke, Kyoto ($6); original attribution:
"Kenzan School."
Morse attribution: "Modern imitation Kenzan."
9.7 x 9.7
Freer Gallery of Art, Smithsonian Institution, Washington, D.C.
Gift of Charles Lang Freer, F1907.524

Medium-grained buff clay. Body thrown and trimmed on the potter's wheel; corners intended with spatula. Lid pinched out by hand, perforated, and bird finial luted to center. Body and lid coated with black lead glaze. Motif of melon leaves and "Kenzan" mark carved out of glaze. Copper-red glaze accent applied to side. Middle-temperature firing.

The concept of an incense burner with a zoomorphic finial on the lid comes from China, specifically Longquan celadon wares with "lion-dog" lids. These were imported into Japan from the medieval period, and heirlooms have been excavated from early modern warlord residences. The splash of red glaze quotes a totally different text, a technical innovation attributed to fourth-generation Raku master Ichinyū. Such a pastiche is typical of "Raku" and other wares made for the fin-de-siècle marketplace.

Lead glazes are used on all traditional Raku products, but preliminary x-ray florescence testing conducted in spring 2000 by conservation scientist Blythe McCarthy at the Freer and Sackler galleries' Department of Conservation and Scientific Research revealed a complete absence of lead in this one. Since a similar signature appears on a wide variety of stonewares and earthenwares, it may be assumed that this black glaze was not true to Raku tradition but was a standard workshop glaze (probably feldspathic) pigmented by minerals such as iron, cobalt, and manganese. Thus glazed, these "Raku" pieces could be fired in a climbing kiln along with other stoneware products.

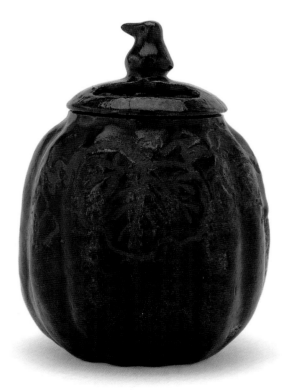

KYOTO WORKSHOP, IMITATION

Japan, Meiji era, late 19th century

Acquired from Siegfried Bing, Paris ($250); original
attribution: "Kenzan."

Morse attribution: "Absolutely brand-new—an imitation."

23.3 x 13.3

Freer Gallery of Art, Smithsonian Institution, Washington, D.C.

Gift of Charles Lang Freer, F1901.61

Clay color and texture not visible. Coil built; surface irregularities
smoothed with spatula. Overall application of black lead glaze, with
design of gibbons and bamboo painted on median in an opaque white
enamel. "Kenzan" signature painted on bottom in same. Middle-
temperature firing. Three stacking spur marks visible on base. Fitted
with a black-lacquer lid. Broken around median and repaired.

Fig. 45. Gibbons and bamboo,
after a work by Kaihō Yūshō
(1533–1615), in Ōoka Shunboku
(1680–1763), *Soga benran*
(Manual for rough painting;
1761). Freer Gallery of Art and
Arthur M. Sackler Gallery
Library, Smithsonian Institution,
Washington, D.C.

The shape is taken from jars belonging to a broader family of ware
popularly called Namban (see cat. no. 46); these were in demand as
flower vases and water containers. Tall water jars are favored in the
tearoom in autumn.

The decoration, on the other hand, is entirely unrelated to Namban. It
is rooted—long roots, to be sure—in ink-painting subjects imported
from China by Japanese warriors and their emissaries in the Zen sect
of Buddhism. Thirteenth-century Chinese monk and painter Mu Qi
was accorded special favor, and his depictions of gibbons were quoted
widely. Versions by Momoyama master Hasegawa Tōhaku (1539–1610),

notably a composition preserved in the subtemple Konchi-in of
Nanzenji, Kyoto, provided a basis for numerous later interpretations in
Japan. The motif here is derived from the printed book *Soga benran*
(Manual for rough painting; 1761), a copy of which is preserved in the
Freer Gallery of Art and Arthur M. Sackler Gallery Library (fig. 45).
That book attributes the composition to Tōhaku's contemporary,
Kaihō Yūshō (1533–1615).

The uninhibited blending of genres—Raku, Namban, the Mu Qi
manner, and Kenzan—is the hallmark of late-Meiji era production,
responding to the diverse but uninformed expectations of a new
art market.

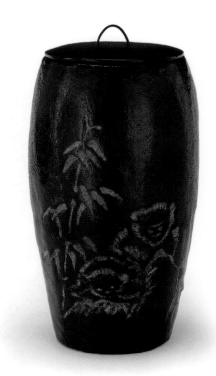

KYOTO WORKSHOP, IMITATION
Japan, Meiji era, late 19th century
Acquired from Iida Shinshichi ($20); original attribution:
"Kenzan."
Morse attribution: "New—Kenzan imitation."
22.6 x 14.1
Freer Gallery of Art, Smithsonian Institution, Washington, D.C.
Gift of Charles Lang Freer, F1899.100

Clay body barely visible but appears to be a medium-grained buff. Lid and body formed from coils and trimmed with spatula. Lid pinched out by hand, with handle attached. Overall application of black lead glaze, with decoration of maple tree and poetic inscription applied in an opaque white enamel. Black and blue enamel accents on tree area. "Kenzan" signature similarly applied. Low-temperature firing; spur marks on bottom of lid show it was stacked separately.

The shape and size suggest a water jar for the tea ceremony, and the tall cylindrical shape is considered appropriate for autumn. The decoration of maple leaves underlines the seasonal theme. The poem reads:

A thousand miles flash across this foot of silk,
That has purloined the very craft of the Creator;
The endless mountains and the flowing streams,
Are rendered altogether in the Mi-family style.

The formal reference to a tree trunk reminds one of similar nineteenth-century efforts to repack natural form—and often grotesque detail—into vessel shapes. Here the reference is not to form in nature but to experiences of those forms as stereotypes in other pots.[146] As for the poem, it is obviously intended not for a maple tree but for a landscape in the manner of the celebrated Chinese painter and calligrapher Mi Fu (1051–1107). Such a gross mismatch cannot be observed in Edo period pieces, and here underlines the almost casual incongruity of the late-nineteenth-century imitation.

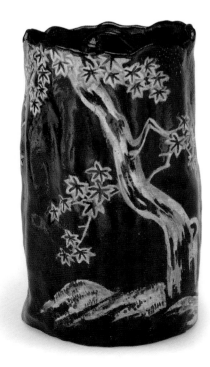
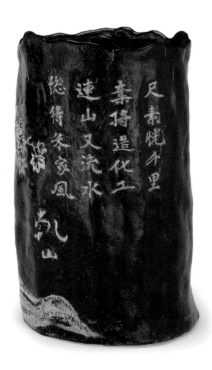

KYOTO WORKSHOP, IMITATION
Japan, Meiji era, late 19th century
Acquired from Yamanaka and Company ($12); original
attribution: "Kenzan."
Morse attribution: "Rotten."
19.0 x 23.3
Freer Gallery of Art, Smithsonian Institution, Washington, D.C.
Gift of Charles Lang Freer, F1900.118

Medium-grained red clay. Thrown on the potter's wheel and hand trimmed. Vertical "pleats" on lower median made by spatula. Two leaf-shaped lugs luted to shoulder. Decoration of maple leaves, water patterns, and gabions in white slip and underglaze iron. Overall application of transparent lead glaze, with base left in reserve. Low-temperature firing. Signature on base reads "Hokkyō Kōrin" with cipher *(kao),* and "Kenzan Shinsei utsusu" (copied by Kenzan Shinsei). Kōrin's cipher is a version called *makugata,* found on a few of his late letters and designs.

The shape and size suggest a water jar for the tea ceremony. The vertical indentations and ripples on the rim provide an association with a purse or moneybag *(kinchaku),* which had auspicious connotations. The painted decoration mixes two popular themes. Maple leaves in water refers to the Tatsuta River in Nara, whose autumn waters were poetically choked with scarlet leaves; gabions *(jakago),* pebble-filled baskets protecting riverbanks, conventionally refer to the Uji River south of Kyoto, site of numerous classical episodes.

The sculpturesque approach to forming and red-colored surface signify the Raku manner, and the decoration, albeit mixed, is taken from Rimpa design sources. These exuberant appropriations, coupled with the spurious signatures, reflect the demands of what has been called the "Rimpa cult" that flourished in the 1890s.

Another one of these large red water jars is preserved in the Museum für Kunst und Gewerbe, Hamburg.[147] It entered that collection in 1906, having been obtained from Urano Shigekichi (1851–1923), remembered as Edo Kenzan VI and the teacher of British potter Bernard Leach (1887–1979). Urano himself had a far less flamboyant style, but he or a member of his circle may have been willing to produce in this manner on call. Freer also had another jar like this in his collection, purchased for a much higher price ($135) from Matsuki Bunkio, who told Freer that the Kyoto owner, Ikeda Seisuke, had brought it in 1892 from the "lord of Okayama." Freer eventually returned it.[148]

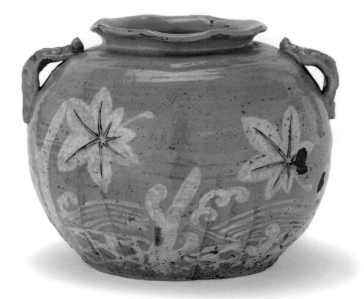

EDO WORKSHOP, IMITATION
Japan, Meiji era, late 19th century
Acquired from Y. Fujita, Kyoto ($15); original
attribution: "Kenzan (?)"
Morse attribution: "Supremely rotten."
7.6 x 10.6
Freer Gallery of Art, Smithsonian Institution, Washington, D.C.
Gift of Charles Lang Freer, F1911.509

Fine-grained red clay. Hand carved and pressed into a four-sided shape. Painting of snow-laden pines in underglaze iron, underglaze cobalt, and white slip. "Kenzan" mark in underglaze iron over white slip patch. Covered with transparent lead glaze. Low-temperature firing. Extensively soiled inside.

Snow-laden pines evoke the heart that remains ever fresh despite the burdens of age. This is a favorite motif of late-nineteenth-century Kenzan potters in Edo; the comparatively low firing attests to Edo as well.

Here we cannot gainsay the carping Edward S. Morse, for in the late nineteenth century these pines had not yet encountered their burdens of age. Noteworthy is the soiling in this and other Raku bowls in the collection. They appear to be tea stains, but the location of the stains is unusual, suggesting some of them were applied artificially. In the Kyoto potter's quarter where I once lived there circulated a story about a dealer who not only performed this service, but even asked his customers which particular century was desired. This was called *jidai o tsukeru,* the "application of time."

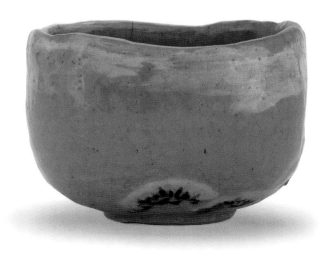
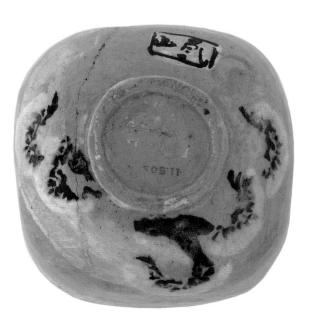

NOTES

1 See Richard L. Wilson, "Simulation in Early Modern Kyoto Ceramics: Modes and Motives," in *Proceedings of the 1994 Asian Ceramics Research Organization Conference* (Chicago: Asian Ceramics Research Organization, forthcoming).

2 The Sadanobu milieu is portrayed in Timon Screech, *The Shogun's Painted Culture: Fear and Creativity in the Japan States, 1760–1829* (London: Reaktion Books, 2000).

3 The "Kenzan" signature recorded in the painting manual *Koga bikō* (Notes on old painting; published in Edo ca. 1854) relates more to nineteenth-century Kyoto potter Nin'ami Dōhachi than to the first Kenzan, suggesting that Dōhachi's imitations passed as Kenzan ware in mid-nineteenth-century Edo; connoisseur Yasuda Kenji also mentions that an early-twentieth-century vernacular Kenzan ware "popular with Kyoto housewives because they were brightly decorated and thickly potted, not easily broken" was boxed and sold as art in the Tokyo market. See Yasuda Kenji, "Kenzan nisemono kō (2)" (Thoughts on Kenzan ware fakes, part 2), *Tōsetsu* 72 (1959): 44–50.

4 H. D. Harootunian, "Late Tokugawa Culture and Thought," in *The Nineteenth Century*, vol. 5 of *The Cambridge History of Japan*, ed. Marius B. Jansen (Cambridge: Cambridge University Press, 1989), 168.

THE SCHOLAR-RECLUSE (pp. 56–77)

5 Interestingly, the same name was used in China to describe literatus potter Hao Shiju. See James C. Y. Watt, "The Literary Environment," *The Chinese Scholar's Retreat* (New York: Asia Society Galleries, 1997), 4.

6 The earliest mention of *Zhang wu zhi* I can trace in Japan is post-1720, although by Kenzan's time there were already tea-ceremony manuals in the same mode such as *Chadō zensho*. The Kenzan descriptions I am referring to are "Shūseidōki" and Kenzan's own description of Jōzan's retreat, "Ōtotsuka o yogiru no ki," both discussed in the "First and Last Kenzan" chapter of this volume.

7 Craig Clunas, *Pictures and Visuality in Early Modern China* (Princeton: Princeton University Press, 1997), 57.

8 Ibid., 45.

9 For example, in the travel guide *Tōkaidō meisho ki* (Record of famous places on the Tōkaidō; 1664), Su Dongpo and Heian poet Ariwara no Narihira are held out as historical exemplars in a discussion of pederasty. *Tōkaidō meisho ki,* unpaginated manuscript, National Diet Library, Tokyo.

10 One would like to say that the new archaeological information has been successfully incorporated into an all-inclusive ceramic history, but in traditional art-history circles, a focus on "name" potters like Kenzan still serves to overwhelm and effectively erase other types of production. The collective "Kenzan" portrayed in this book is an attempt to show the interdependence of elite and vernacular production.

11 Kenzan's version may have been inspired by a poem written in 767 by the celebrated master Du Fu (712–770) and printed in Japan in 1656 in a book called *To Shōryō Sensei shi bunrui shū chū* (Classified and annotated anthology of the poetry of Master To Shōryō); see Nagasawa Kikuya, ed., *Wakodu bon kanshi shūsei—Toshi 3* (Collections of Chinese poetry published in Japan—Tang, vol. 3) (Tokyo: Kyūko Shoin, 1981), 506.

12 According to Hata Masataka and Ōta Kiyoshi, students of the Shino school of incense (Freer Gallery of Art object record, 22 September 1992).

13 There has been some debate as to whether Soshin, whose name appears on several Kenzan wares, was the same person as Rimpa-style painter Watanabe Shikō, but in a recent exhibition dedicated to the work of Shikō, curator Nakabe Yoshitaka pointed out similarities in brushwork and composition between Shikō's painting and the brushwork on several Kenzan wares. See Nakabe Yoshitaka, "Watanabe Shikō o megutte" (Around Watababe Shikō), in *Watanabe Shikō ten* (Nara: Yamato Bunkakan, 2000), 7–12.

14 Richard L. Wilson and Saeko Ogasawara, *Kenzan yaki nyūmon* (Introduction to Kenzan ware) (Tokyo: Yūzankaku, 1999), 61, figs. 4, 5.

15 Seventeenth-century painter Kanō Tanyū (1602–1674) noted a similar inscription in his sketchbook of earlier painting models, so it may be inferred that the phrase was familiar to connoisseurs. See Nakano Genzō, ed., *Tan'yū shukuzu—ge* (Tan'yū sketches, part 2) (Kyoto: Kyoto Kokuritsu Hakubutsukan, 1981), 150.

16 Kawahara Masahiko, *Kosometsuke* (Kyoto: Kyoto Shoin, 1977), 115, no. 438.

17 Richard L. Wilson and Ogasawara Saeko, *Ogata Kenzan: Zen sakuhin to sono keifu* (Ogata Kenzan: His complete work and lineage), vol. 2 (Tokyo: Yūzankaku, 1992), 96–98. This book is hereafter referred to as OKZS II. Salvage archaeology in Edo has demonstrated an immense market for Kenzan-style cylindrical bowls in the mid–eighteenth century. Kenzan's adopted son Ogata Ihachi was a participant in if not the actual instigator of this boom.

18 See Hayashibara Bijutsukan, ed., *Oribe to Kosometsuke* (Okayama: Hayashibara Bijutsukan, 1991), catalogue numbers 57 and 58.

19 Nagetake Takeshi, ed., *Kakiemon*, vol. 20 of *Tōji taikei* (Tokyo: Heibonsha, 1973), fig. 30.

20 A note dated 1914 by Charles Freer, quoted in the Freer Gallery's object record, mentions the piece "was sent to New York for exhibition of the Japan Society, in February, 1914, and Professor Morse, who passed on all the specimens in the exhibition decided to exclude this specimen, as he also did a certain specimen now in the collection of Mr. Howard Mansfield."

21 I once had an opportunity to work with Takahashi Eiichi, a Kyoto master of *kaiseki*, or traditional Japanese cuisine. My job was to select Kenzan-style dishes in Takahashi's pantry and then he would arrange food on them. At one point I asked the chef if he thought the piling of food on dishes such as this one disturbed the visual integrity of the design. He replied to the effect that such placement turned the act of eating into a kind of revelation, where the user had the added pleasure of wondering about and gradually recognizing the scene underneath.

22 OKZS II, figs. 837–858.

23 For the Ming prototype, see Colin Sheaf and Richard Kilburn, *The Hatcher Cargoes* (Oxford: Phaidon-Christie's, 1998), 65.

24 Freer to Moore, 12 March 1901. Also discussed in chapter one, p. 34.

25 OKZS II, fig. 964.

26 OKZS II, figs. 922–943.

27 Ch'en Shou-yi, *Chinese Literature: A Historical Introduction* (New York: Ronald Press Company, 1961), 510, 516.

28 According to an inventory marked "Art Inventories: Pottery, Chinese and Japanese," in the Freer Gallery of Art and Arthur M. Sackler Gallery Archives, this reads:

A precipice so high
I see below the perennial green
Just a spot of dark shady foliage
Where 'tis chilly mid-summer's day.

29 OKZS II, figs. 520, 570, 575, 577, 580-3, 598-4, 1039.

30 The Freer Gallery object record for this piece contains the following translation by Matsuki Bunkio, with the added note that Kenzan used only one verse out of four stanzas on the camellia:

White powder (for face of Japanese lady)
Used by court ladies
Is clear as snow and blossom enclosed.

31 See Kyushu Kinsei Tōji Gakkai Jimu Kyoku, ed., *Kyushu tōji no hennen* (Chronology of Kyushu ceramics) (Arita: Kyushu Kinsei Tōji Gakkai, 2000), 182.

32 OKZS II, fig. 604.

33 See Oda Eiichi et al, *Kōetsu Kai*, 60.

34 Katō Tōkurō, *Genshoku tōji daijiten* (Ceramic dictionary in color) (Kyoto: Tankōsha, 1972), 137. Brinkley's much older account contains similar information, with the added note that Shōzan's given name was Yasutarō, and that he lived in the Kadowaki-chō section of Gojōzaka. Frank Brinkley, *Japan: Its History Arts and Literature*, vol. 8, *Keramic Art* (Boston: J. Millet Company, 1901), 228.

35 Maggie Bickford, *Ink Plum* (Cambridge: Cambridge University Press, 1996), 23.

36 Lin Bu's classic reads:

Its sparse shadows are horizontal and slanted—
The water is clear and shallow;
Its hidden fragrance wafts and moves—
The moon is hazy and dim.

Translation by Hans Frankel, "Poems About the Flowering Plum," in Bickford et al., *Bones of Jade, Soul of Ice: The Flowering Plum in Chinese Art* (New Haven: Yale University Art Gallery, 1985), 165, quoted in ibid., 23. Other extant Kenzan wares show that the pine inscription is part of a couplet that reads:

Strong boughs, remaining unwithered for a thousand years,
Through all four seasons, it casts a cooling shade.

37 OKZS II, figs. 607–608.

38 OKZS II, fig. 1223.

39 See Mitsuoka Chūsei et al., eds., *Nihon yakimono shūsei* (Collected Japanese ceramics), vol. 1 (Tokyo: Heibonsha, 1981), fig. 458.

NATIVE POETICS (pp. 78–97)

40 Laurel Rasplica Rodd with Mary Catherine Henkenius, *Kokinshū: A Collection of Poems Ancient and Modern* (Princeton: Princeton University Press, 1984), 165.

41 Events recorded in the Nijō family diary pertinent to the Ogata family are published in Jintsu Setsuko, *"Nijō-ke nainai gobansho hinamiki" ni okeru Kōrin shiryō"* (Kōrin materials in the *Nijō-ke nainai gobansho hinamiki*), *Yamato Bunka* 33 (1960): 44–69.

42 Edward Kamens, "The Past in the Present: Fujiwara Teika and the Traditions of Japanese Poetry," in *Word in Flower*, ed. Carolyn Wheelwright (New Haven: Yale University Art Gallery, 1989), 31.

43 The theme receives extensive English-language treatment in ibid.

44 Nakabe attributes the brushwork in the dish in the MOA collection to Watanabe Shikō (see note 13), not unreasonable considering the similarity to certain passages in Shikō's painting. Shikō's manner is also rooted in the Edo Kanō style.

45 See Asahi Shinbunsha, ed., *Genroku-Kansei: Shirarezaru "goyō eshi" no sekai* (The unknown world of official painters from Genroku through Kansei eras) (Tokyo: Asahi Shinbunsha, 1998).

46 OKZS II, figs. 95–100; there is also an unpublished set in the Seikadō Bunko, Tokyo.

47 The brushwork is all Kanō style, except for half of the pieces of a set in the Idemitsu Museum, Tokyo, which are in a Rimpa style. The painting palette for all pieces is standard underglaze enamel colors, although the colors on the Freer piece, especially the green and purple, have exceptional consistency and rich hue. The compositions are similar in all except for the stylistic variations in the aforementioned Idemitsu set. There are three variations of edge patterns, including hand-painted diapers, stenciled wisteria patterns, and a stenciled scroll consisting chiefly of camellia and pomegranate motifs. The Freer piece has the latter as does half the set in the Idemitsu. The calligraphy style is generally inspired by the calligraphy manner associated with Fujiwara Teika, although there are subtle differences, based mainly on choice of *manyōgana* (Chinese characters employed phonetically). The writing style on the Freer piece is closest to the Idemitsu set (for the Teika script tradition, see Nagoya Akira et al., eds., *Teika-yō* [Teika style] [Tokyo: Gotoh Museum, 1987]). The signature style is slightly different on each piece, and each employs a different combination of pseudonyms, but the Freer version is stylistically closest to the Idemitsu set.

48 OKZS II, fig. 100.

49 Recent exhibitions and publications have featured similar small boxes with poetic themes made in other materials. The National Museum of Denmark owns a seventeenth-century, shell-shaped, papier-mâché box with an irregular contour like this one. See Maureen Cassidy-Geiger, "The Japanese Palace Collections and Their Impact at Meissen," in the program for The International Ceramics Fair and Seminar (London: Park Lane Hotel, June 1995). A group of forty-five paperboard incense boxes attributed to Empress Tōfukumon-in (1607–1678), now preserved in the Daishōji Monzeki temple in Kyoto, was illustrated in Barbara Ruch et al., eds., *Days of Discipline and Grace: Treasures from the Imperial Convents of Kyoto* (New York: Institute for Medieval Japanese Studies, 1998). My thanks to Louise Cort for calling this to my attention.

50 Translated in Kamens, "The Past in the Present," 31.

51 Pieces in the "set" include:
First month: private collection, Tokyo
Fourth month: private collection, Kyoto
Seventh month: Freer Gallery (cat. no. 17)
Eighth month: Museum für Kunst und Gewerbe, Hamburg
Tenth month: Freer Gallery (cat. no. 18)

52 See Miyazaki Hiroshi et al., *Tameike iseki* (Tameike site), vol. 2 (Tokyo: Tonai Iseki Chōsakai, 1996), 225.

53 The pottery inventory in Box 8 of the Freer papers mentions Matsuki's comment, "One of the most costly specimens of Kenzan in Japan."

54 Translated in Kamens, "The Past in the Present," 31.

55 Helen Craig McCullough, *Tales of Ise: Lyrical Episodes from Tenth-Century Japan* (Stanford: Stanford University Press, 1968), 75.

56 See Yamane, ed., *Konishi-ke kyūzō Kōrin kankei shiryō to sono kenkyū* (Kōrin-related materials formerly in the Konishi collection and their research) (Tokyo: Chūō Kōron Bijutsu Shuppan, 1962), 239, fig. 25-4.

57 See Ōhashi Kōji, ed., *Iro-e kenran* (The gorgeousness of overglaze enamel), Kottō o tanoshimu Series, vol. 10, *Taiyō bessatsu* (1996), 121.

58 These include: The Tama River at Ide (Kyoto Prefecture); The Tama River at Yaji (Shiga Prefecture; see entry for cat. no. 27); The Tama River at Noda (Miyagi Prefecture); Tamagawa no Sato (Osaka and Hyogo Prefectures); The Tama River of Musashino (Greater Tokyo); and The Tama River at Mt. Koya (Wakayama Prefecture).

59 Scott Spears, researcher, National Institute for Japanese Literature, Tokyo, kindly provided the translation.

60 OKZS II, 176–177. The "Kōetsu School" chapter of *Koga bikō*, a mid-nineteenth-century history of Japanese painting, mentions that a person named Miyazaki Tominosuke inherited a "third-generation Kenzan" title in Edo in 1766. It is commonly assumed that Tominosuke was the maker of these pieces, but the long span, from 1766 through the 1830s, suggests that the producer of these "Sandai" pieces and Tominosuke are different people.

61 Kenya never adopted or transmitted the full title, and strictly speaking it died out with him (the Kenzan title documents he left behind were later discovered in a pawn shop).

62 Rodd, *Kokinshū*, 65.

63 Ibid., 109.

64 Nagoya Akira et al., eds., *Uno Sōson korekushon* (Uno Sōson collection) (Tokyo: Gotoh Museum, 1998), 39.

65 Translation in Rodd, *Kokinshū*, 150. It is also conceivable that the decor subject is the "Miotsukushi" (Channel buoys) chapter of the *Tale of Genji*.

66 OKZS II, figs. 103–107.

67 Inukai Kiyoshi et al., eds., *Waka daijiten* (Great waka dictionary) (Tokyo: Meiji Shoin, 1996), 637–38. I am grateful to Scott Spears for helping me with this translation.

68 OKZS II, figs. 922–943.

UTSUSHI: COPIES WITH
A DIFFERENCE (pp. 98–123)

69 Wilson, *The Art of Ogata Kenzan*, 99.

70 Tetsuo Najita, "History and Nature in Eighteenth-Century Tokugawa Thought," in *Early Modern Japan*, vol. 8 of *The Cambridge History of Japan* (Cambridge: Cambridge University Press, 1991), 602.

71 Terashima Kyōichi, "Donburi mondai: Waribashi shian—I" (Brief thoughts on donburi and disposable chopsticks, part I) *Edo Iseki Kenkyūkai kaihō* (Report of the Edo Site Research Association), no. 75 (2000): 13. The price for the Kenzan *donburi* was seventy *momme*, cheaper than the Chinese models but enough to pay a yearly salary for a chambermaid.

72 See, for example, Nezu Bijutsukan, ed., *Kōgō* (Incense containers) (Tokyo: Nezu Institute of Fine Arts, 1972), cat. no. 130.

73 Mitsuoka Chūsei, *Kenzan*, Tōji taikei Series, no. 24 (Tokyo: Heibonsha, 1973), 102. The piece is said to be in the Mitsui collection, but I have not been able to locate it.

74 OKZS II, figs. 469, 471, 479.

75 Schuyler Cammann, "Types of Symbols in Chinese Art," in *Studies in Chinese Thought*, ed. Arthur F. Wright (Chicago: University of Chicago Press, 1953), 208.

76 See Fujian Prefectural Museum, *Zhangzhou yao* (Zhangzhou kilns) (Fuzhou: Fujian People's Press, 1997). The use of auspicious characters in Chinese craft design extends back as far as Zhou dynasty (1027–221 B.C.) China, and it was an especially popular practice in the Han (206 B.C.–A.D. 221), when roof tiles, mirrors, and utensils were so adorned. The practice lapsed until the Song dynasty (960–1127), from which many pots with auspicious characters such as *fu* (good fortune) and *shou* (longevity) are known.

77 OKZS II, fig. 481.

78 Ibid., fig. 780.

79 Kyushu Kinsei Tōji Gakkai jimu kyoku, *Kyushu tōji*, 201.

80 OKZS II, fig. 139.

81 Kawahara Masahiko, *Kosometsuke*, fig. 219.

82 This lid seems to be a replacement, based on a label kept in the object record indicating "the old box." The present lid is inscribed, "Kenzan ware teapot, handle by Sōzen, with inscription by Kakukakusai, said to have been owned by [Sō]zen, [signed] Rokuroku ō [the old man Rokuroku]." The people referred to here are three tea masters of the Omotesenke school of tea ceremony: Hisada Sōzen (1647–1707), a professional tea man highly placed in the school and known for his bamboo and wood tea utensils; Kakukakusai (1678–1730), sixth-generation grandmaster; and Rokurokusai (1836–1909), eleventh-generation grandmaster, head between 1857 and 1892. According to later tea genealogies, Kenzan and his brother Kōrin studied tea under fifth-generation Omotesenke grandmaster Ryōkyū Sōsa (1660–1701), and Hisada Sōzen is listed as one of their fellow students. The mark in question, located on the surface of the handle, reads "Zenshin" (heart of [Sō]zen), and is accompanied by the cipher *(kao)* in the style of Kakukakusai.

83 OKZS II, figs. 1111–1114.

84 An identical shape is illustrated in Katō Tōkurō, *Genshoku tōji daijiten*, 104.

85 See the comparative illustration in Richard L. Wilson and Ogasawara Saeko, "Kenzan yaki no genryū to shiryū" (Sources and tributaries of Kenzan-ware development), in *Kenzan no yakimono* (The ceramics of Kenzan), ed. Takeuchi Jun'ichi et al. (Tokyo: Gotoh Museum, 1987), 148.

86 OKZS II, fig. 152.

87 OKZS II, fig. 153.

88 Hasebe Gakuji and Imai Atsushi, *Nihon shutsudo no Chūgoku tōji* (Chinese ceramics excavated in Japan), Chūgoku no tōji Series, no. 12 (Tokyo: Heibonsha, 1995), fig. 35.

89 OKZS II, figs. 679–696.

90 *Fuyō-de* means "hibiscus-style" in reference to the petal-like configuration. It takes after late-Ming dynasty Jingdezhen and other southern Chinese cobalt-decorated porcelains, most typically the so-called *kraak* wares, which were shipped to Europe in great quantities. In Japan, Arita workshops began to make *kraak* imitations, chiefly for export, in the mid–seventeenth century. The style was also taken up by Delft potters and shipped back to Japan as exotica.

91 From an unpublished report of the third annual meeting of the Kyushu Kinsei Tōji Kenkyūkai, 1993. See also Richard L. Wilson, "Hizen stoneware excavated at Iidamachi," *Iidamachi iseki* (The Iidamachi site) (Tokyo: Iidamachi Iseki Chōsakai, 1995), 258–64.

92 In a section entitled "Recipe for green glaze applied to Seto-style vessels" in Kenzan's *Tōji seihō* pottery manual, a sketch of a plate with a partial application of a contrasting glaze is accompanied by the note: "Black [iron pigment] is painted on top of the white [areas], and green glaze is applied to the red clay [areas left undecorated]." Several Oribe-style experiments also remain among the shards excavated from Kenzan's kiln site at Narutaki.

93 See Mitsuoka Chūsei et al., *Nihon yakimono shūsei* (Collected ceramics of Japan), vol. 1 (Tokyo: Heibonsha, 1981), 85, no. 480.

94 See Ozaki Naoto et al., eds., *Maboroshi no bi—ko Agano yaki ten* (Phantasmal beauty: Exhibition of old Agano ware) (Fukuoka: Fukuoka Kenritsu Bijutsukan, 1987), no. 48.

95 Hisamatsu Yumiko, "Gyobutsu Kaihō Yūshō hitsu aboshizu byōbu" (On Kaihō Yūshō's *Aboshizu* on the folding screen in the Imperial Household Collection), *Bijutsushi* (Art history) 37:1 (1988): 1–33.

96 Karinsha, ed., *Nihon no monyō zuten* (Pictorial development of Japanese motifs) (Kyoto: Shikōsha, 1996), 144.

97 See Katherine Emerson Dell, *Bridging East and West: Japanese Ceramics from the Kōzan Studio* (Baltimore: Walters Art Gallery, 1994), 12 and examples, 52–57.

THE KŌRIN MODE (pp. 124–137)

98 OKZS II, figs. 260–270.

99 Translated in McCullough, *Tales of Ise*, 75. The *ba* syllable in *kakitsubata* is the same as the *ha* in the poem: its position in the word causes it to be aspirated.

100 OKZS II, figs. 260–271.

101 OKZS II, figs. 273–282.

102 OKZS II, figs. 284–286.

103 OKZS II, figs. 640–641.

104 OKZS II, figs. 639–642.

105 OKZS II, fig. 628.

106 See Weisberg, *Japonisme*, no. 176.

107 The "Four Admirers" theme was highly esteemed in Japan, and painted versions (the Chinese source appears to be only literary) from the hand of various Momoyama era masters are known. Kendall Brown locates the admirers in painted "dreamscapes," where they are associated with their beloved plants, the four seasons, and a domesticated environment replete with tearoom-like huts. See Kendall Brown, *The Politics of Reclusion: Painting and Power in Momoyama Japan* (Honolulu: University of Hawai'i Press, 1997), 98–99.

108 OKZS II, fig. 802.

109 OKZS II, figs. 801–814.

110 OKZS II, figs. 450–460.

111 OKZS II, fig. 818.

112 OKZS II, figs. 922–943.

113 Moore to Freer, September 28, 1896.

114 Louise Cort, note in the Freer Gallery object record for catalogue no. 57.

THE KENZAN MODE (pp. 138–157)

115 Nakabe Yoshitaka, "Mokuhan kin-gin dorozuri ryōshi sōshoku ni tsuite" (Concerning the paper decoration of woodblock-printed gold and silver), *Yamato bunka* 81 (1989): 30–59.

116 The best examples are two covered dishes, one with a pine and wave motif in the Idemitsu Museum of Art, Tokyo, and one with a pampas grass motif in the Suntory Museum of Art, Tokyo. See OKZS II, figs. 188–189.

117 Henry Mittwer, *The Art of Chabana* (Rutland and Tokyo: Charles E. Tuttle, 1974), 94.

118 OKZS II, figs. 359–364, 379.

119 See Wilson and Ogasawara, *Kenzan yaki nyūmon,* 81.

120 For Minzan, see OKZS II, figs. 1187-8; for Edo Kenzan III, see OKZS II, fig. 1198; for Nishimura Myakuan, see OKZS II, fig. 1257-8.

121 One such follower, and possibly the maker of such a piece, was Kenba, originally Tsukamoto Torakichi (act. late 19th to early 20th century). He joined Kenya at his workshop in Yokosuka in 1871 and remained with him until his death in 1889. The *ba* character of his name was written as Kenya's *ya,* but with one stroke removed—allegedly because Kenba's ability at decorating was one level inferior to his master. Kenba also signed some of his work with his master's name. Kenba's work was occasionally decorated by the Meiji Rimpa artist Nozawa Teiu (1837–1917).

122 OKZS II, figs. 1299, 1300, 1309, 1310.

123 OKZS II, fig. 115.

124 OKZS II, figs. 724–729.

125 See Ōyagi Kenji, "Shinjuku-ku Minami Yamabushi-chō iseki no chōsa gaiyo" (Outline of the Minami Yamabushi-chō site in Shinjuku Ward), *Edo Iseki Kenkyūkai kaihō* (Report of the Edo Site Research Association), no. 54 (Nov. 1995): 9–20.

126 OKZS II, fig. 742.

127 OKZS II, figs. 721, 723.

128 See Box 8, Pottery Inventory, 323 in the Freer Gallery of Art Archives.

129 See Wilson, *Art of Ogata Kenzan,* 219, 223.

130 OKZS II, figs. 414–418.

131 See Richard L. Wilson and Ogasawara Saeko, "Yōseki to iseki ni okeru Kenzan yaki" (Kenzan wares found in kiln sites and consumer sites), *Hikage-chō III* (Tokyo: Excavation Group for Metropolitan Schools, 2000), 268, 269.

132 In McCullough, *Tales of Ise,* 119.

133 OKZS II, fig. 347.

134 OKZS II, figs. 876–880.

135 See Tōzan Sandai Ten Jikkō Iinkai, ed., *Tōzan sandai ten* (Exhibition of three generations of Tōzan) (Kyoto: Tōzan Sandai Ten Jikkō Iinkai, 1999), 14.

136 Wilson and Ogasawara, "Yōseki to iseki," 274.

THE RAKU MODE (pp. 158–175)

137 Ogata Kenzan, *Tōji seihō,* 1737; unpaginated typeset transcription in Kawahara Masahiko, *Ogata Kenzan,* Nihon no bijutsu Series, vol. 154 (Tokyo: Shibundō, 1979).

138 Kilns for Black Raku conventionally fired at a higher temperature than the other varieties; the temperature rises to about 1,100 to 1,150 degrees Centigrade. It is not totally accurate to call Black Raku an earthenware.

139 It is difficult to discuss Raku outside the seamless genealogy perpetuated by the Raku clan in concert with the Sen family tea schools and the postwar art/publishing industry; like the popular Kenzan, it is a vastly oversimplified account that replaces historical tensions with a charismatic founder, unbroken tradition, and distinctively Japanese artistic excellence.

140 Morgan Pitelka, "Kinsei ni okeru Rakuyaki dentō no kōzō" (The structure of tradition in early modern Raku ceramics), *Nomura Bijutsukan kenkyū kiyō* 9 (2000): 22–24.

141 National Diet Library collection. I am grateful to Morgan Pitelka for bringing this to my attention.

142 The Ihachi manual versions include *Tōki mippōsho* (Secret manual of ceramic techniques) and *Kenzan Raku yaki hisho* (Secret Kenzan Raku ware manual) both in the National Diet Library; another *Kenzan yaki hisho* (Secret Kenzan ware manual) is in the possession of potter Hariu Kenba in Sendai. The secret had gotten out.

143 Wilson, *The Art of Ogata Kenzan,* fig. 117.

144 Yamane, *Konishi-ke,* 266, no. 75.

145 OKZS II, figs. 1147, 1170.

146 Phillip Rawson, *Ceramics* (London: Oxford University Press, 1982), 112.

147 OKZS II, fig. 955.

148 Item no. 773 in Pottery Reserve List, Freer Gallery of Art Archives.

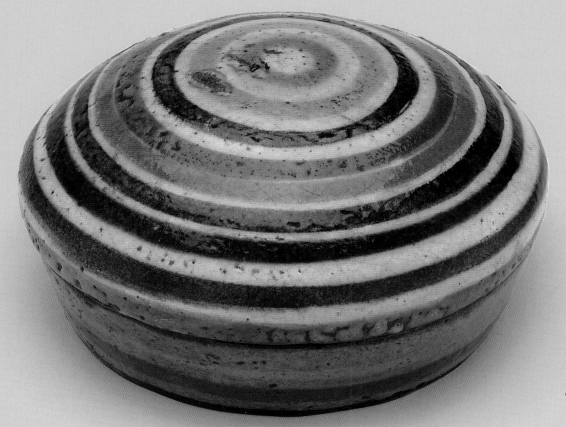

catalogue no. 28

THE
FIRST
AND
LAST
KENZAN

THE FIRST AND LAST KENZAN

A legacy of Freer's generation was the notion that Kenzan was an individual artist rather than a mere producer or brand of pottery. From 1915, when the Ogata family papers were published, researchers sought to provide content to Kenzan's life, a project that culminated in the romantic Kobayashi biography of 1949, *Kyoto Kenzan*. From there it was but a short step to the postwar ceramic boom and the 1962 Sano affair, which worked those assumptions into bogus documents and pots. The modern Kenzan biography—materialized in a broad spectrum of wares and informed more by journalism than by research—has fed imaginations and reputations for a half-century. It is now a pillar of popular ceramics discourse. This party line may be displaced, but one suspects it will never be totally replaced.

For those interested in returning to genuine history, however, the documentary evidence for Ogata Kenzan's (the first Kenzan's) life can be productively reviewed. In doing so we learn, not surprisingly, that there are loose ends. Kenzan had both amateur and professional instincts, and he did not work alone. We see, too, that the records themselves are often fragmentary and seldom innocent: various agendas lay behind their making, interpretation, and ownership. This is not to deny that Kenzan was a remarkable human being and great ceramics producer. Rather, like the lives of all human beings, including the remarkable ones, Kenzan's resists packing into a seamless biography.

Our review of the first Kenzan's life also demonstrates the allure of the last word— that is, the pronouncements of Kenzan's modern fans, followers, and apologists. For many readers, both in Japan and overseas, the authoritative last word on Kenzan has been that of British potter Bernard Leach (1887–1979). According to his own story, Leach studied with a sixth-generation Kenzan in Tokyo and was designated as a successor. In other words, Leach was Kenzan VII. This became a pulpit from which to speak out on behalf of his Kenzan cause célèbre: the controversial "Sano Kenzan" pots and diaries that were introduced at the beginning of this book. The endorsement of Leach, coupled with the rhetoric of the "Sano Kenzan" supporters in Japan, was sufficient to temporarily authorize these spurious objects. That seal of approval, while infrequently mentioned at this particular moment, will surely be reinvoked in the periodic suspensions of disbelief that shore up the popular ceramics world.

The political status of the Tokugawa family upon their ascent to national power at the turn of the seventeenth century is frequently characterized as hegemonic. And not without good reason: in 1615 the Tokugawa had crushed the rival Toyotomi faction, completing a project of national unification and bringing an end to more than a century of civil unrest. Historical accounts place importance on the ensuing polarization between the new military authority and disenfranchised players, particularly the Kyoto court and mercantile class. But the need for the symbolic trappings of authority— which ranged from compulsory marriage alliances with the court to the creation of a system of etiquette—required the new regime to consult and intermingle with those they sought to rule. This start-up phase continued through the first half-century of Tokugawa rule. In addition to the mix of military usurpers, resentful but opportunistic courtiers, and upwardly mobile merchants, a large, heterogeneous population of disinherited samurai and other déclassé persons rose to positions of importance.

The ascent of Kenzan's forebears is a textbook case of the new economic and social possibilities. It is substantiated in a large group of papers passed down in the Konishi family, Kōrin's heirs, and collectively known as the Konishi archive *(Konishi-ke monjo)*.[1] The earliest datable document in the collection is a "Dyed goods ledger" from 1602. It lists the shop name, Kariganeya[2] and the names of five patrons well known to Japanese history: Hideyoshi, Ieyasu, Yodogimi, Oeyo, and Ohatsu. National power indeed had passed from the Toyotomi clan to Tokugawa Ieyasu at the turn of the seventeenth century, but it was three women—Yodogimi, Oeyo, and Ohatsu, the daughters of feudal warlord Asai Nagamasa (1545–1573)—whose patronage brought the Ogata to fortune and eventually to fame.

The Konishi papers are justifiably central to the Ogata story, but they are not uncompromised. From as early as 1819, Edo painter and self-designated Rimpa custodian Sakai Hōitsu (1761–1828) had discovered the collection and looted it, taking some three hundred Kōrin sketches to Edo. In 1894, long before the "first" scholarly explication of the collection by Fukui Rikichirō (1886–1972) in 1915, Tosa-style painter Kawasaki Chitora (1835–1902) published parts of it in an article in the new painting journal *Kokka*.[3] The 1915 explication of the documents took place against the background of a 250-year commemoration of Kōrin's death, promoted by the Mitsukoshi department store for the sake of selling Kōrin-style dry goods.[4] Part of the archive was lost in 1934 after the murder of its prospective buyer, the politically prominent businessman Mutō Yamaji. After that, certain sections could be checked only through earlier notes compiled by Fukui. The bulk of the remaining material currently is divided between the Osaka Municipal Museum and the Agency for Cultural Affairs.

In terms of reliability, the family history can be divided into two parts. The pre-sixteenth-century genealogy is likely a fabrication. The clan created an early lineage by finding an Ogata name in the fourteenth-century war chronicle *Genpei jōsuiki* (Rise and fall of the Genji and Heike clans). A Kyushu samurai named Ogata Saburō Koreyoshi had supported the heroic but disinherited general Minamoto Yoshitsune (1159–1189). For this Koreyoshi was exiled from his home in Bungo Province to Saeki in nearby Bushū Province. There he became retainer to the powerful Ōtomo clan. The record gains specificity—and credulity—in the mid–sixteenth century, from which a historical lineage of Ogata masters can be understood.

Five generations before Kenzan, Ogata Ishun (1502-1573) left the Ōtomo family for Kyoto and became a retainer of the nominally ruling Ashikaga shogunate for a salary of five thousand rice shares. Ishun's heir, Dōhaku (died 1604), married Hōshu (died 1616), sister of Hon'ami Kōetsu (1558–1637). Kōetsu, a sword polisher, calligrapher, and gifted amateur potter, was well connected to warrior clients, and was surely instrumental in the cultural ascent of the Ogata. The Hon'ami family annals *(Gyojōki)* mention Dōhaku as having been "descended from retainers of the Asai family." The Asai clan, whose patriarch's three daughters were introduced above, had conspired with the Ashikaga shogun Yoshiaki (1537–1597) in opposing the rising warlord Oda Nobunaga, but was decimated by Nobunaga's forces at Odani Castle in today's Shiga Prefecture. The three daughters of Asai Nagamasa were spared the Odani carnage and went on to great liaisons. Yodogimi became the favorite concubine of the general who assumed national hegemony after Nobunaga, Toyotomi Hideyoshi; she also bore Hideyoshi a son and short-lived successor, Hideyori. Oeyo, the second daughter, was married to second Tokugawa shogun Hidetada (1579–1632). The two women were to provide generous patronage to the Kariganeya from Dōhaku's time: the latter is referred to in the Konishi archive as head of the "garments office."

As Dōhaku's son and heir to the garments office, Sōhaku (1570–1631) attended Oeyo in her 1595 marriage to Hidetada, who ultimately succeeded Ieyasu to become second-generation Tokugawa shogun. Sōhaku's other patrons included wives of shogunal officials and daimyo, but it was through the political marriage of Oeyo's daughter Masako (1607–1678) to Emperor Gomizuno'o that the family business, now established as the Kariganeya, made its mark. In her capacity as Empress Tōfukumon-in, Masako spent much of her lavish allowance on goods from the Kariganeya, located just a block west of the palace. This placed the shop at the center of Kyoto fashion in an era when the palace doubled as a salon. The finest materials, designs, and techniques in the realm were on display, and many of them came from the Ogata. Sōhaku thus became wealthy, but he was far more than a successful clothier: in this age one could still be part of the milieu that one exploited commercially. He studied calligraphy under Kōetsu and

owned a parcel of land at Takagamine, a community in the hills north of Kyoto where Kōetsu, surrounded by men of similar temperament, had lived in productive retirement. Sōhaku is named in a seventeenth-century document as one of the four great Kōetsu-school calligraphers. He and his first wife, Myōsen, had produced three children who were influential in medicine and Confucian studies in the city.

Sōhaku's second marriage, with a woman called Akiba Ichijūin, split the family into two branches. Akiba's second son, Sōken (1621–1687), assumed control of the collateral house and fathered Kōrin and Kenzan. This new family, then, was to make a mark in the plastic arts, producing not one but two of Japan's greatest artists. (A third son San'emon, eventually fathered Heishirō [1664–1716], who was adopted into the Raku family to become Sōnyū.) The Konishi archive shows that Sōken became head of the Kariganeya in 1660. In addition to receiving the continuing patronage of Tōfukumon-in, he came to be on intimate terms with the noble Nijō family and was involved with daimyo and rich merchants. Like other wealthy townsmen, Sōken made extensive loans to the perpetually underfunded daimyo, but seems to have kept the business on an even keel. Also like many of his Kyoto peers he excelled in the arts, especially calligraphy, painting, and Nō drama. He practiced Kōetsu-style calligraphy under his father, and in a later document called *Ogata-ryū ryaku inpu* (Abbreviated Ogata-school genealogy) he is listed as a student of another Kōetsu-style master, Kojima Sōshin (born 1580). His painting teacher is identified as Yamamoto Soken (died 1706), who is thought in turn to have been the tutor of Kōrin.

Sōken was married to a woman described as the daughter of "Sano Shōetsu, a retainer of Kinoshita Kunai." She is referred to in a letter in the Konishi archive as "Katsu." Katsu died in 1676, and the five daughters she bore with Sōken all died in their youth. The three male children, Tōzaburō, Ichinojō (Kōrin [1658–1716]), and Gonpei (Kenzan [1663–1743]), all lived into adulthood. Tōzaburō (ca. 1650–after 1714) inherited the Kariganeya business, but in 1714 he moved to Edo and, under the name Sukemon, took service with a retainer to the shogun named Kawaguchi Genzaburō. The Kariganeya presumably went out of business, and it is not known when Tōzaburō died. His Kōetsu-style writing can be seen in three letters preserved in the Konishi archive, and he is also recorded as a visitor to the noble Nijō family in the latter's diary, *Nainai gobansho hinamiki*.

Kenzan, named Ogata Gonpei Koremitsu at birth, is first recorded in a visit to the Kogidō, the Confucian academy of his relative by marriage, the prominent Confucian teacher Itō Jinsai (1627–1705).[5] This discovery was made by historian Ishida Ichirō, whose reading of Jinsai's diary disclosed that on the second day in the first month, 1683, one "Ogata Gonpei" had paid a call.[6] He may have come with another Ogata, Shinzaburō, recorded in that day's record as well (Shinzaburō was probably Kenzan's second cousin, a grandson and heir of Kenzan's deceased uncle, Sōho). The visit has become standard evidence for Kenzan's intellectual leanings and social network. Without a doubt, the Itō family was close to the Ogata. Scions of the main Ogata line, doctors and philosophers all, appear repeatedly in the collected poems and essays of Jinsai and his son Tōgai, assembled by the latter after Jinsai's death.[7] Those entries are conventionally prefaced with the occasion for their writing, permitting a reconstruction of the social and physical spaces in which these men moved. Jinsai's school, in contrast to the Confucian academies arrayed around the warrior center at Nijō Castle, was nearer to the homes of wealthy commoners and the imperial court.[8] Visits to men of title and means was an occasion for Jinsai to compose poetry about the surrounding environment, a host's garden, or his scholarly accoutrements; Jinsai inscribed paintings and wrote out model inscriptions for others to use. The record exposes a material dimension of early-Edo period amateurism.

But examination of the actual diary page, preserved with other Kogidō documents in the Tenri University Library, shows Gonpei-Kenzan as but one scribbled name in a long list of New Year's well-wishers (sixty-four visitors in all), and aside from this and another similar mention in the Jinsai diary, there is no other reference to Kenzan in writings by Jinsai or his heir and far more prolific scribe Tōgai. Rather than validating Kenzan's scholarly intentions, the record leaves us to wonder why Kenzan did not figure more prominently in the Jinsai circle. Jinsai was known for his righteousness, and he may have objected to the circumstances under which the branch Ogata house was created. Sōhaku's second wife apparently maneuvered her favorite son (Kenzan's father, Sōken) into the Kariganeya over the rightful heir Sōho, splintering the family. There was also a behavioral problem in the collateral house—Sōken's two eldest sons were either prodigal or debauched. Tōzaburō was temporarily expelled from the family for some unspeakable transgression, and Kōrin had an unconventional love life. With such disreputable siblings, there may have been a subtle limit as to how far Kenzan could penetrate the top tier of Kyoto intellectuals.

In the sixth month of 1687, Ogata Sōken died at the age of sixty-seven. Letters acknowledging the receipt of his legacy remain in the Konishi papers, and these can be located. To his first-born, Tōzaburō, now back in the fold, Sōken left the family business (the monopoly over garment services to Tofukumon-in was mentioned specifically) and an undisclosed sum of cash. Second son, Ichinojō (Kōrin), was provided with cash, equipment that included costumes and utensils for the Nō drama, and two houses. Kenzan was given cash, three houses, miscellaneous utensils, an important scroll, and the family library. It is a generous settlement for the latter two brothers given the practices of the time, which customarily excluded younger siblings. In his will Sōken admonished his heirs, "Do not quarrel amongst yourselves, revere our gods and the Buddha, and practice frugality with an honest heart." However, after Sōken's death the Kariganeya collapsed, and Kōrin squandered his dream speculating in daimyo loans and the copper market, finally becoming a self-employed "town" painter.

Called Ichinojō Koretomi at birth, Kōrin appears to have had ample opportunities to pursue the arts and letters in a manner particular to the second half of the seventeenth century. In Kōrin's youth, the Kariganeya was still prosperous, enjoying the patronage of an empress fairly obsessed with tailored goods. The fluid social intermingling that marked earlier decades had passed, and thus we find the later Ogata supporting commoner schools in performing arts such as Nō. Ogata Sōken was interested enough in Nō to have assembled a collection of costumes and props, and he retained Shibuya Shichirōemon, from one of the two leading town academies, to guide him. At the age of fifteen Kōrin copied out the Nō treatise *Kadensho* and three years later was given a certificate of proficiency by Shichirōemon. The records of the noble Nijō house, which the Ogata brothers frequented, show Kōrin in the occasional role of entertainer. Nō-inspired elements would become manifest in the subjects and style of his mature painting.

After his father's death, Kōrin immersed himself in the life of the pleasure quarters, with consequence that from the early twentieth century, when his affairs came to light, he was understood through the prism of Yonosuke, the debauched hero of the celebrated novel *Kōshoku ichidai otoko* (The life of an amorous man; 1682) by Saikaku (1642–1693). In the same year that his father died, it is recorded that Kōrin had to put his first but illegitimate son Jirōsaburō up for adoption. In 1689 another son, Gennosuke, was born, whereupon Kōrin surrendered a house, art objects, and cash to the mother. By this time Kōrin was making speculative loans to daimyo, a practice that bankrupted many merchant houses in Kyoto. Kōrin was forced to sell his spacious residence in Yamazato-chō, and Kenzan signed a promissory note on his behalf. Kōrin began

pawning his property and borrowing money on interest. In 1692 he changed his name from Ichinojō to Kōrin, apparently at the advice of a diviner friend who said the new name would bring him better luck. After that Kōrin fathered a son named Bunzaburō and a daughter, Sone.

A few years later Kōrin was formally married, to a woman named Tayo. The couple had no children but adopted yet another child of Kōrin, Tatsujirō, who was born

Fig. 46. Kenzan-related sites in Kyoto, with reconstructions based on period documents and site surveys.

A 1688: Establishes Shūseidō retreat

B 1699: Opens Narutaki workshop

C 1712: Moves workshop to Chōjiyamachi

in 1700. When Tatsujirō was eight, through the mediation of a friend, an official of the Kyoto silver mint named Nakamura Kuranosuke (1669–1730), he was formally adopted by Kuranosuke's colleague Konishi Hikokurō. Tatsujirō would later take the name Konishi Hikoemon, and in this capacity he preserved the various papers and Kōrin-related objects that constitute the family archive. Kōrin's marriage and the birth of Tatsujirō coincide with Kōrin's emergence as a painter, backed by the receipt, in 1701, of the court honorific *hokkyō*. Kōrin's mint connections seem to have been instrumental in his 1704 move to Edo, where he secured employment with the Sakai family. It is now thought that Kōrin's contributions to Kenzan ware took place after the former's return to Kyoto in 1709.

THE RECORD OF SHŪSEIDŌ

Inheritance receipts among the Konishi papers demonstrate that Kenzan received the family book collection and a prized calligraphy by Yuan dynasty monk Yin Yuejiang (1267–ca. 1350). Speculation that the youngest Ogata enjoyed reading, poetry, and practice in calligraphy cannot be far from the mark. Such proclivity, as we have seen, constitutes a foundation for much of the Kenzan style. Upon his father's death the youth changed his name from Gonpei to Shinsei (Deep reflection) and left the city for Omuro, located at the foot of two picturesque hills called Narabigaoka, where he began his life as a recluse. The village of Omuro was also called Omuro Gosho (Omuro palace), for the Heian period emperor Uda (867–931) had his headquarters there, and thereafter the place acquired pedigree as an aristocratic resort. The Shingon-sect temple Ninnaji was built there in 888, to be revived in 1647 as a salon for tonsured sons of the imperial family. In the *Onki*, an official record maintained by the Ninnaji Temple, Shinsei's name appears on the seventh day of the third month of 1689. Presumably he had used up his cash inheritance to create "Shūseidō" (Hall for learning tranquility), a secluded environment complete with teahouse, meditation hall, and flower beds (for Kenzan's Kyoto locations, see fig. 46).

What we know of Kenzan's life at the villa comes from "Shūseidō ki," a description of a visit by two monks of the Ōbaku sect of Zen Buddhism, Dokushō Shōen (1617–1694) and Gettan Dōchō (1636–1713). The record was discovered by Tanaka Kisaku in 1937. Kenzan seems to have been interested in Ōbaku Zen from his youthful days in the Kariganeya, and presumably one of the reasons for his moving to west Kyoto was a yearning to be closer to Dokushō; when Kenzan received the lay name "Reikai" from the old monk in about 1690, he was among a privileged few. Kenzan's retreat is described as a pleasant space, outfitted with poetic props right down to the eastern

hedge of chrysanthemums associated with Chinese poet-paragon Tao Yuanming (365–427). Perhaps this was a little too scripted, for in "Shūseidō ki," Kenzan is taken to task by his visitors for adopting the trappings of the recluse. Real tranquility was internal:

> If one is going to search for life's treasure the waves of life must be quieted; when the water is turbulent it is impossible to see into it. If the water is calm, clean, and pure, the radiance of a jewel-like heart will naturally appear. If you do not devote yourself wholeheartedly to the way of Zen through meditation, every purpose will become confused, your relationships with others will lose direction, and the three evil passions of greed, anger and foolishness will obscure your heart. The six senses will blur and mix in your mind. For you to arrive at the stillness of heart which is at the root of all things is still difficult, is it not? Please, young master, try hard to study this; always strive to learn *(shū)* tranquility *(sei)*. Study quietly, widely, and tacitly, and after a long period of maturation enlightenment will occur naturally. When that happens, for the first time you will be really worthy of being called a wise man who has abandoned the world to learn the way of the Buddha.

But Gettan's moving admonition, like Kenzan's lifestyle, was cribbed from Chinese sources. In this case, Gettan was quoting Song literatus Ouyang Xiu (1007–1072).[9] By this time, the life of the recluse was a well-polished—and published—act of consumption. Gettan was a producer, and he circulated his impressions in woodblock-printed journals, *Gazankō* (High mountain record), *Gankyokō* (Cave-dweller record), and *Jikishi Dokushō Zenji kōroku* (Record of Zen priest Jikishi Dokushō), all released in 1704. Shūseidō impressions appear in the former two.

In the *Kōroku*, two other lay students' names are recorded beside Kenzan's Reikai: "Gizan" and "Kohō." Gizan was none other than the wealthy merchant Naba Kurōzaemon Sōjun (1633–1697), and Kohō was his eldest son, Yūei (1652–1699). The Naba were in the top tier of Kyoto merchants, grown wealthy through the money-lending trade. Kawasaki Hiroshi discovered the name of Kenzan in two Naba documents, *Gizan sōkō* (Gizan's grass record) and *Shōsō yōgin* (Continued recitations of Shōsō).[10] For example, the latter includes a 1692 reference to "Shinsei, the recluse of Ninnaji," and a 1697 mention of "Shūseidō Shinsei, the recluse of the western hills." In 1698, Shinsei was identified as the "recluse of Narutaki Mountain." Kenzan met Naba scion Yūei for an afternoon of mushroom hunting and impromptu music making, and Kenzan's poem for the occasion, borrowing on a trope identified with Chinese landscape poet Xie Lingyun (A.D. 397–433) is recorded in *Shōsō yōgin*:

Leaving my hut in mindless haste
For a mountain temple, barren with fallen leaves.
Beyond worldly concerns, with high-minded amusements not yet exhausted,
Why must the evening bell echo over this wilderness? [11]

THE NARUTAKI KILN

In 1694, Kenzan purchased from court noble Nijō Tsunahira, with whom the Ogata had been on familiar terms from the time of Sōken, a tract of land in Fukuōji village, Narutaki Izumidani, about a half-hour's walk further into the mountains from Ninnaji. According to a late-Heian period record called *Fusō ryakki* (Abbreviated record of Japan), Narutaki had been selected in 902 as a place of purification rites for the Heian court. Today the Narutaki River is known as the Omuro River, and its headwaters are found in a valley northwest of Kōetsu's Takagamine. Narutaki appears in native poetry as an *utamakura* (place of poetic association), and in the area were built numerous temples and resort houses. In 2000, while examining a road cut on land adjacent to Kenzan's kiln site, I found a deposit of fifteenth-century earthenware dishes in association with Chinese porcelains, testifying to elite consumption in the neighborhood. The Nijō family was one of these noble residents. The deed transferring this tract from the Nijō to Kenzan is preserved in the Hōzōji Temple, which has occupied the site since 1736. The total area was 1,190 *tsubo* (about 1.6 acres), and the documents preserved in the temple show, in addition to a house, satellite buildings such as woodsheds, wells, and outhouses. It is not known whether Kenzan had totally abandoned his Shūseidō villa for this new location; since Narutaki is a short walk from Shūseidō, he may have been a commuter.

Circumstances leading up to the workshop are detailed in the Ninnaji Temple document *Onki*, introduced by antiquities dealer Ninagawa Teiichi in 1936.[12] This temple diary is key testimony for the study of the Ninsei workshop and the start-up activities of the Kenzan kiln, for in addition to noting visits to the prince-abbot, the document records administrative affairs (many of these temples doubled as headquarters for local bailiffs). Between the third and eleventh month of 1699, Kenzan is recorded at the temple seven times, requesting permission to build a kiln, asking for firewood, and notifying the authorities of his first firing schedule. It is no coincidence that the same record mentions the heirs of Nonomura Ninsei. They have various audiences with the Ninnaji officials right up to the time of Kenzan's firing—and then simply disappear from the record. It is hard not to associate the opening of Kenzan's kiln with the collapse of the Ninsei workshop. This will be discussed further in the "Potters' Perspective" chapter.

The physical environment of the Narutaki workshop can be reconstructed by walking the site and examining documents. The kiln itself was located just behind the present-day temple, on a slope alongside the path leading to the cemetery. Until recently, shards were scattered everywhere. Pieces of kiln wall with accretions of ash glaze have been discovered, and in 1986 I excavated a layer of ash, charcoal, and various artifacts stretching three meters across the site. According to Kenzan's 1737 pottery manual *Tōkō hitsuyō,* the name "Kenzan" was conceived because Narutaki Mountain was situated to the northwest of the capital. This was the seat of the "heaven" trigram elucidated in the Chinese classic *Book of Changes:* the source of strength and creativity. Kenzan also adopted the pseudonym Recluse-Potter, or "Tōin," and this is seen as a wish to extend his reclusive activities into the realm of pottery. It is intriguing that at least one late-Ming gentlemen-potter had used the same name; "taking refuge" in a secular pursuit was a convention used by Chinese literati,[13] and the notion was presumably accessible to a bibliophile like Kenzan.

Testimony for Kenzan's patronage comes in the form of notes in the diaries of the nobility. Kenzan appeared before the tonsured prince of Ninnaji Temple and at the Nijō family household, where he "presented" various pots, presumably at the conclusion of successful firings. But considering the range of styles in shards from the kiln site together with his later popularity, the idea of all-noble patronage strains credibility. The presentation was strategic. In the tradition of older Kyoto kilns, which had exploited courtly links as a way of projecting a materialized "Kyoto" to regional customers, Kenzan was distributing his flagship wares to the local nobility—and a far greater quantity of ordinary wares to urban merchants.

MUNICIPAL RECORDS AND MASS LITERATURE

Production at the Narutaki site continued for a dozen years, until 1712, when Kenzan moved to Nijō Street in the center of the city. The formal name of the place is Teramachi Nishi Chōjiyamachi, and according to the city guide *Kyō habutae,* the street was occupied by makers of texts for Nō chanting, core makers for lacquer ware, and ivory carvers. This was an urban workshop, not unlike those depicted by Kyoto painters in the late nineteenth century.[14] The Chōjiyamachi workshop was also strategically located near the wharves of the Takase River, the main conduit to Osaka and beyond. The move itself is mentioned in a magistrate's document called *Oyakusho muki taigai oboegaki* (General record of the [Kyoto] government office):

> Kenzan Shinsei of Nijō, west of Teramachi on the north side
> [Chōjiyamachi]: Regarding the matter of Kenzan ware, to the west of

Omuro, in a forested mountain within the precincts of bailiff Kobori Jin'emon, Ogata Shinsei owned a house; with the intention of building a kiln and making a living there, he successfully petitioned Takigawa Yamashiro-no-Kami and Andō Suruga-no-Kami of this office in 1699. Since the place was located northwest of the capital, he called the pottery Kenzan, and that is where he operated his ceramics business. In 1712, stating that this place was inconvenient, he dismantled his kiln, granted the land to another person, and came to live in Kyoto, where he now operates a ceramics business. Regarding his kiln, since there are many in the area of Awataguchi and Gojōzaka, he is renting them for his work.[15]

This reference—especially the part about "ceramics business" and "borrowed kilns" is often quoted as evidence that Kenzan had lost his artistic compass and was drifting in the mass ceramics industry. It should be considered more carefully. The *Oboegaki* is structured chronologically, beginning with Raku and its links to late-Momoyama warlord Hideyoshi, then on to Awataguchi (thirteen workshops) and an implied connection to the tonsured prince of the Shōren-in Temple, then Kiyomizu (three workshops), and Kenzan, in that order. There is no mention whatsoever of Ninsei: these are active potteries. Considering the citations of Kenzan ware in popular literature of the day, namely the encyclopedia *Wakan sansai zue* (1713) and the Chikamatsu (1653–1724) puppet play *Ikutama shinjū* (1715), the picture is not one of a potter adrift, but rather of a highly successful potter, now integrated into the local industry. The accelerated production of Kenzan ware must also be connected to Kōrin's return to the city in 1709. Three years later the older brother opened a spacious new house in Shinmachi, several blocks west of Kenzan's quarters in Chōjiyamachi.

In his pottery manual *Tōji seihō*, written in 1737, Kenzan reported that his adopted son, Ihachi, was making pottery in the precincts of the Shōgoin Temple in east Kyoto. Since it is unlikely that Ihachi could establish such a place himself (Shōgoin, like Ninnaji, was a prestigious imperial cloister), I assume that this was arranged by Kenzan before he departed for Edo around 1731. References in *Tōki mippōsho*, a manual attributable to Ihachi, suggest that this workshop, too, relied on rented space in high-temperature kilns. At this time, judging by the proliferation of pattern books for textiles and other items, production of many different goods in a Kōrin style was booming: Ihachi had inherited a thriving brand. As for Kenzan, he was in his early sixties. In 1729, his longtime friend and patron Nijō Tsunahira had taken the tonsure. This may have closed an era for Kenzan, and indirect evidence suggests that shortly afterward he departed for Edo.

The founding architectural premise of the city of Edo was defense but even more so replication, and the model was Kyoto. Edo would not begin to develop its own urban identity until well after Kenzan's death. Kyoto emulation reached fever pitch with the ascendancy of fifth-generation Tokugawa shogun Tsunayoshi (1646–1709), whose powerful mother, the Kyoto-born Keishōin (1627–1705), contrived to transplant people, customs, and things of the ancient capital. The word *kudaranai,* which now means worthless or nonsensical, originally meant "not descended (from Kyoto)." In other words, if a thing was not from Kyoto, it had no value. With his move to the new capital around 1731, Kenzan became, in short, "something from Kyoto," and he was noted for it. A story in the late-Edo period painting manual *Koga bikō* inserts him into a local fable: Kenzan brought a gift of Kyoto warblers for his princely patron in Edo, and the birds escaped to flourish in an area now called Uguisudani (Warbler Valley). The conventional history of the area attributes the warblers to the prince himself.

In the Konishi archive there are two Kenzan letters written from Edo to nephew Konishi Hikoemon (Tatsujirō; 1700–1753). One of them demonstrates that in Edo Kenzan was closely associated with Kōkan Hōshinnō (1697–1736). Kōkan was sixth in a line of tonsured princes serving Kan'eiji, a Tokugawa religious center built in replication of Kyoto's powerful Enryakuji, whose job it was to protect Kyoto from the inauspicious northeast. Kenzan may have become close to Kōkan through Nijō Tsunahira, for the prince was the younger brother of Tsunahira's wife. Kōkan received the ritual post in 1715, and made periodic returns to Kyoto over the next decade or so; he could have met Kenzan during one of those trips. His last departure for Edo took place in 1731, and it is assumed that Kenzan, having turned over the business to Ihachi, accompanied him. Kōkan appears to have enjoyed art: he pursued painting under the pseudonym Keishō. According to *Koga bikō*, Kenzan's Edo abode was in Iriya, just outside of the Kan'eiji precincts, and he is described in that record as being totally preoccupied with pottery.

Later records show that Iriya was home to a group of potters who manufactured tile and earthenware utensils for Kan'eiji, but there is more to the local topography than princely and ecclesiastical connections. On the other side of Iriya was the famed pleasure quarter of Yoshiwara, and the location must be considered in light of Kenzan's appearance in literature penned by two Yoshiwara habitués. Kikuoka Senryō's *Kindai seji dan* (Present-Day gossip; 1733) celebrates Kenzan's arrival as a cultivated Kyotoite, and Shōji Katsutomi's *Dōbōgoenshū* (Cave-Dweller's verse garden; 1738) carries a haiku verse savoring local sweets arranged on a Kenzan-ware dish. Here is evidence linking Kenzan to popular culture, but perhaps we should resist the temptation to bifurcate

Fig. 47. *Yatsuhashi* (Eight bridges), by Ogata Kenzan (1663–1743), late 1730s–early 1740s. Hanging scroll, ink and color on paper, 28.6 x 36.6. Private collection, Japan.

the power center at Kan'eiji from the pleasure center at Yoshiwara. Genre paintings, such as a screen from the hand of Hishikawa Moronobu (1618–1694) in the Freer Gallery collection (F1906.266–267), picture the two places together, a site more for merrymaking than for religious rites. Kenzan seems to have moved through both without trauma.

According to the nineteenth-century records *Kōrin hyakuzu* and *Koga bikō,* Kenzan was known as "second-generation Kōrin" while living in Edo. This was surely based on sibling connections rather than skill. What Kenzan brought to painting was not a specialist touch, but rather the nonchalance of a literatus and the directness of a craft decorator. In his last years those habits were carried over to paper and silk in the form of small compositions, usually with an addition of poetic inscriptions (fig. 47). These must have been executed in the haiku and teahouse salons around Yoshiwara and Honjō, the city's poetry colony. In addition to these lighthearted pieces, there are a few larger scrolls in a Kōrin style. The seals impressed on the paintings suggest that the world of the scholar-recluse: "Reikai" was the early Zen name acquired from Ōbaku priest Dokushō; "Shinsei"—deep meditation—was Kenzan's first pseudonym; "Furiku," a pseudoynym taken up in these late years, has an ancient Chinese connotation as "tutor to a prince"; and "Tōzen," another alias assumed in old age, connotes "beyond Zen"—a world where Zen as form disappears.

A KENZAN SCHOOL?

Kenzan as incarnate form disappeared with Ogata Shinsei's death in 1743. The language of his pottery manual written late in life hints that the old man considered his place in history, but never intended to create a practice that could be transmitted to another embodied "Kenzan." As we shall see in the next chapter, Kenzan himself personified the very fracture of Japanese artisanal transmission inasmuch as he, a dilettante with no formal training in the craft, managed to obtain a manual of recipes from the Ninsei kiln without any intention at all of using Ninsei's name or style. Kenzan left his Kyoto business to Ihachi, but Ihachi never used the name Kenzan II—for him "Kenzan" was simply a trademark. (We have used it, however, in the attribution section of the catalogue to avoid confusion.) Nor is there any evidence that Ihachi ever received a document of succession.

Even if the first Kenzan had intended to found a school, the later transmission is problematic. There are two so-called lines of succession: the Kyoto Kenzan line and the Edo-Tokyo Kenzan line.[16] The successor to Kenzan in his native Kyoto was, as we have

seen, Ogata Ihachi (active ca. 1720–60), Kenzan's adopted son, who worked very much in the Kenzan manner and like his adoptive father had little idea of a succession proper. He seems not to have left a pottery heir, and, as we mentioned at the beginning of the catalogue section, in the second half of the eighteenth century the Kenzan style essentially dissolved. A Kyoto Kenzan III appeared somewhat later in the person of one Miyata Gosuke (active early 19th century), but his adoption of the title seems to be unilateral.

The Edo-Tokyo line, which leads up to Bernard Leach's teacher Urano Shigekichi (1851–1923), was purportedly begun with a late-in-life transmission from Kenzan to an obscure Edo successor. The title was then passed to an Iriya resident named Miyazaki Tominosuke, from Tominosuke's wife (or possibly widow) Haru to Sakai Hōitsu, and from Hōitsu to brothel owner and amateur scholar Nishimura Myakuan (1754–1853), who charted this course in a document called *Kenzan sedaigaki* (Genealogy of the Kenzan school). It came to an end with one Miura Kenya (1821–1889), who inherited a group of materials associated with the title, but never chose to fully assume it. (The "Ken" in his name was received during study with Myakuan.) Kenya himself was a craftsman of some skill, but his true passion was in exploring new Western technologies. Sustaining himself by making Kenzan-style pottery, Kenya managed to build Japan's first ironclad ship and open factories that produced Western-style brick, glass, and ceramic insulators for electric wiring. During a recent trip to Sendai in northern Japan to search for materials that Kenya had disseminated, I found among his traditional pottery manuals a diagram for a Western-style smelting furnace. Kenya's Sendai pottery heir, himself the recipient of a Kenzan pottery manual, arranged to be buried in a huge vat fitted with an imported sheet-glass window. These were anything but "traditional" craftsmen.

Another of Kenya's numerous pottery disciples was Leach's teacher, Urano Shigekichi (fig. 48). Leach describes him as "Ogata Kenzan, old, kindly and poor, pushed to one side by the new commercialism of the Meiji era."[17] There is neither record nor allegation to the effect that a "Kenzan transmission" occurred between Kenya and Urano. In fact the latter's background was also in part nontraditional, as in 1873 he had studied slip-casting—then a revolutionary Western forming technique—under German chemist Gottfried Wagener (1831–1892), before even meeting Kenya. Urano's family circle was also tied to Western innovations: his father-in-law was pioneering Japanese photographer and Europhile Shimooka Renjō (1823–1914). The Kenzan inheritance was set up in 1901, when Renjō arranged to have Urano adopted by one Ogata Keisuke. Such adult adoptions are not uncommon in households where there is no heir. Art administrator Machida Hisanari (1838–1897), whose work in developing the first national museum took him on a nationwide survey of "imperiled objects," seems also to have had a hand in the dealings.

Fig. 48. Urano Shigekichi (1851–1923), ca. 1900. Photographer unknown. Private collection, Japan.

Ogata Keisuke, Urano's adoptive father, claimed familial descent from an Ogata Kenzan back in Kyoto, but Keisuke's genealogy suggests that his ancestor was not Kenzan the first but Kenzan's adopted son, Ihachi.[18] Regardless of its origins, this was not a potter's title inheritance, but after the adoption Urano used the name "Kenzan VI" and signed his pots "Kenzan." Much in the manner of his teacher, Kenya, Urano's real specialty lay in forming and decorating small accessory items such as medicine cases *(inrō)* and beads; wheel work was hired out to a specialist. By the time he began to tutor Leach, Urano had abandoned his traditional multichamber climbing kiln in favor of a single-domed device with flanking square fireboxes, which some authorities claim was a Western innovation. Shikiba Ryūzaburō, an early biographer of Leach, mentions that Urano was making toys and dolls for sale at the Tokyo department store, Mitsukoshi.[19]

Leach's days with Urano are described briefly in Leach's memoir *Beyond East and West*: "There, sitting on his [Urano's] hard floor, I began to learn my alphabet of clay, turning a potter's wheel with a stick, either making the soft ware with wet hands, or turning the cheese-hard pots. He said very little; in fact my many questions in very limited Japanese bothered him—'Do what I show you, which is how my master taught me.'"[20] Leach was impatient with this manner of teaching, and the record shows that before meeting Urano he had tried out several potters, including one named Horikawa Kōzan. They seem to have been less than forthcoming.[21] The fact that Urano was able to satisfy Leach's expectations indicates that the former was to some extent accustomed to discourse: Urano's writing appears in at least one antique art journal.[22] Contrary to Leach's depiction of a last-of-a-breed artisan, Urano was a nimble survivor of Japan's pell-mell modernization.

In hindsight Leach described the moment of transmission thus: "One evening he [Urano] asked me to come, saying he wanted to give me the *Densho* (recipes) he had inherited. This was the sealed proof of succession, produced at a Master's death."[23] This document presumably was lost when Leach's studio burned in 1919, but the contents can be guessed at through later publications: mainly recipes for pigments painted under or over clear lead glazes. These recipes are close to those used by the first and all later Kenzans in their low-temperature work, but there is nothing secret about them, as similar formulas had been used by both professionals and amateurs for centuries. What was Urano's intention in granting them? The earliest writings about this say that Leach received a "certificate of proficiency";[24] later, as we have just seen, that became for Leach a "certificate of succession."

Despite or in addition to this bond Leach continued to search for other mentors: before his departure for China in 1914 he studied overglaze enamel techniques under Makuzu Kōzan (1842–1916) in Yokohama. Kōzan was a superb technician—far more accomplished than Urano Shigekichi—who mastered both fine decorated porcelains in

export taste and somewhat more traditional stonewares for the domestic market.[25] Some of the latter is in the Kenzan style. The Kōzan relationship, however, does not appear in Leach's own accounts.

THE LAST KENZAN

Leach's decision to essentialize Urano and effectively erase his other early pottery tutors shows how he came to value a Kenzan family tree in his resume. But all this developed later: Leach's writings, his Japan activities, and survivor testimony demonstrate that this "Kenzan consciousness" only became important some forty years after his actual study with Urano Shigekichi.[26] The key developments are narrated in Leach's *Potter in Japan,* a diary of his activities during his 1953 to 1954 stay. An entry for April 15th, 1953, reads, "I spent this day at the Kenzan-Kōrin exhibition at the Mitsukoshi [Tokyo Department Store] Gallery talking to visitors and members of the Kenzan Society. The opening of the exhibition had been set so that I, as one of the two living representatives of the school, the other being Tomimoto Kenkichi (1886–1963), could take part in it."[27] Leach's widow, Janet, told me that the Kenzan title assumption and exhibition were a promotional idea of Leach's friend and folk-craft leader Yanagi Sōetsu (1889–1961), who was very skillful in creating venues that would produce interest in—and revenue for— his pet causes.[28] Yanagi appears to have felt that Leach's appearance in such a context would attract publicity for his extended tour. In the 1950s, art shows—many of them held in department stores—achieved explosive popularity in Japan. Entire genres of traditional art achieved their popular consolidations at this time, and Kenzan's Rimpa school was especially prominent.

Janet also told me that after the Mitsukoshi show, in which Leach's pots were exhibited along with those of the original Kenzan and other masters of the school, the "whole thing went to his head and Bernard really began to believe that he was a descendant of this school." To buttress his role as living heir, Leach had to grasp the Kenzan genealogy, and *A Potter in Japan* tells of Leach's growing engagement with Japanese art history at this time: "The whole exhibition introduced me to fresh pastures in art about which I hope to compile a book whilst I am in Japan."[29] This was to be the gestation of *Kenzan and His Tradition* (1966). Of consequence is that Leach's research seized upon the sweeping art historical survey *Epochs of Chinese and Japanese Art* (1912), by Ernest Fenollosa (1853–1908). Fenollosa had, from the last quarter of the nineteenth century, positioned himself as a rescuer of traditional East Asian art; the authority for this undertaking rested in part with his affiliation with the Kanō school, a line of painters that enjoyed great authority and patronage in the premodern era but declined

Fig. 49. Bernard Leach (1887–1979) looks at Sano Kenzan, 1962. Photographer unknown. Private collection, Japan.

precipitously after the late 1860s. For his interest in the Kanō heritage, Fenollosa was rewarded with a title, Eitan. Could this have been a model for Leach's title pretensions? Fenollosa also mentions in his *Epochs* that Kenzan's Rimpa school "had suffered from possessing no historian who had preserved biographical and other facts striking to the popular imagination."[30] Here is a sanction for Leach's historical investigations. In any case, after 1954 the status of his Kenzan affiliation moved from prescription (Yanagi) to description (Leach).

Because of the very activities just mentioned, it appears that from the early 1950s Leach came to be regarded as a Kenzan expert; during his travels around Japan he would often be shown Kenzan-style works with the expectation that he would vouch for them (fig. 49). This is treacherous ground: as a connoisseur one naturally wants to stake out new territory, but there just aren't that many genuine Kenzans. The other problem is that nobody at that time was really sure what a genuine Kenzan was. Here we have the setting for Leach's involvement in what would become the most sensational Japanese art scandal of the century. From the moment he was shown the Sano pieces at a luncheon in 1962, Leach became a staunch supporter, much to the embarrassment of his friends and fellow potters Hamada Shōji (1894–1978) and Tomimoto Kenkichi and wife Janet, who had spotted them as fakes. But Leach was steadfast to the end, and late in life he maintained that even though his failing eyes could not see Sano Kenzan he could feel their genuineness in his heart. His impassioned plea for these pieces is the central theme of his *Kenzan and His Tradition*. I remember reading the book with awe and complete credulity, as I'm sure many others did. Inasmuch as Leach's erstwhile Japanese assistant, Mizuo Hiroshi, was more or less writing the same thing—with some persuasiveness—back home, there was a moment when Sano Kenzan became the center of the discourse, moving all else to the periphery.

As we have seen in this book's prelude, the Sano pieces were literally exposed, which led to their being exposed figuratively. Serious scholars were relieved. But in the fanciful world of "Kenzan," the return to sobriety is little more than a hiatus. Since the high-growth period of the 1980s, there have been several new attempts to foist a large number of fakes on the market. They have met with some success, and one suspects there is more to come.

1 Discussed and annotated extensively in Richard L. Wilson, "Ogata Kenzan 1663–1743" (Ph.D. diss., University of Kansas 1985), and Wilson, *The Art of Ogata Kenzan*, 1991; most of the documents are published in illustration and typeset transcription in Yamane, *Konishike*, 1973.

2 A verse (no. 211) in the tenth-century poetry anthology *Kokin wakashū* may hold a hint as to the meaning of Kariganeya:

The night is chilly
And I borrow a robe for warmth.
As the wild geese call,
Even the lower boughs of
The bush clover are tinged.

Kari means both "borrow" and "geese," so borrowing a robe and wild geese are poetically linked (Rodd, *Kokinshū*, 108). This is a fitting shop name for the Ogata's textile business.

3 Kawasaki Chitora, "Kōrin-Hōitsu: Kōrin inpu ire Kōrin raijin zu" (Kōrin-Hōitsu: Kōrin-school paintings of the thunder god), *Kokka* 57 (1894): 158–67.

4 Tamamushi Satoko, "Kōrin kan no hensen— 1815–1915" (Transitions in the image of Kōrin—1815–1915), *Bijutsu kenkyū* 371 (1999): 26–31.

5 Jinsai's first wife, Kana, was the younger daughter of physician Ogata Gen'an, an older stepbrother of Kenzan's father.

6 Ishida Ichirō, *Itō Jinsai*, Jinbutsu Sōsho Series, vol. 30 (Tokyo: Yoshikawa Kobunkan, 1960), 202.

7 See Matsushita Tadashi, ed., *Kogaku sensei shishū-Jōju Sensei monshū* (Collected poems of the Kogaku teacher; Collected writings of the Jōju teacher) in *Nihon no kanshi* (Chinese-style poetry of Japan), vol. 2, ed. Fujikawa Yoshirō et al. (Tokyo: Kyūko Shoin, 1985).

8 The warrior-supported academies were those of Yamazaki Ansai (1618–1682) and Matsunaga Seikido (1592–1657). See John Allen Tucker, *Itō Jinsai's Gomō Gigi and the Philosophical Definition of Early Modern Japan* (Leiden: Brill, 1998), 46–47.

9 Joseph D. Parker, *Zen Buddhist Landscape Arts of Early Muromachi Japan* (Albany: State University of New York Press, 1999), 33.

10 Kawasaki Hiroshi, "*Shōsō yōgin* ni arawareru Kōrin to Kenzan—jō" (Kōrin and Kenzan as revealed in the *Shōsō yōgin*, part one), *Kobijutsu* 81 (1987): 58–65.

11 Ibid., 61.

12 Ninagawa Teiichi, "Tōsei Ninsei no Bunken Hōkoku" (Report on a document concerning the potter Ninsei), *Chawan* 69 (1936): 53–65.

13 James C. Y. Watt, "The Literati Environment," in *The Chinese Scholar's Studio*, ed. Chu-tsing Li and James C. Y. Watt (New York: Thames and Hudson, 1988), 4.

14 Painter Kōno Bairei (1844–1895) did so at the behest of Edward S. Morse during Morse's 1882 visit to Kyoto.

15 Quoted in Haga Yoshikiyo, "*Kyoto Oyakusho muki taigai oboegaki* no Rakuyaki, *Kyoyaki*, Kenzan shiryō" (Materials on Raku ware, Kyoto ware, and Kenzan in the Kyoto *Oyakusho muki taigai oboegaki*), *Yakimono shumi* 6:16 (1941): 24–27.

16 For a more complete explanation of the Kenzan tradition, see Wilson, *The Art of Ogata Kenzan*, 162–84.

17 Bernard Leach, *A Potter's Book* (London: Transatlantic Arts, 1970; original edition, 1940), 30.

18 The genealogy appears in Ogata Nami, *Hasu no mi* (The fruit of the lotus) (Kamakura: Kamakura Shunjū Sha, 1981), 135.

19 Shikiba Ryūzaburō, *Baanaado Riichi* (Bernard Leach) (Tokyo: Kensetsu Sha, 1934), 606.

20 Bernard Leach, *Beyond East and West: Portraits, Memoirs and Essays* (London: Faber and Faber, 1978), 57.

21 Shikiba, *Baanaado Riichi,* 576.

22 Rokusei Ogata Kenzan (Urano Shigekichi), "Ogata Kenzan oyobi sono kakei ni tsuite" (Concerning Ogata Kenzan and his lineage), *Shoga kottō zasshi* 87 (1915): 11–15.

23 Leach, *Beyond East and West,* 58.

24 Shikiba, *Baanaado Riichi,* 606.

25 Leach's tutelage under Kōzan is mentioned in Shikiba, *Baanaado Riichi,* 605. For more about Kōzan, see Kathleen Emerson-Dell, *Bridging East and West: Japanese Ceramics from the Kōzan Studio* (Baltimore: Walters Art Gallery, 1994).

26 There is no mention of any Kenzan activities nor do we see any deference to the Kenzan tradition during Leach's 1934–35 visit to Japan. When Ogata Nami, Urano's daughter, asked Leach to take her along on a trip to Korea in 1935, Leach and his friend Yanagi rode in a luxury train car and Nami was left alone in third class. See Ogata Nami, *Hasu no mi,* 73. In the same record and page, it is mentioned that Leach "transmitted" the title to her in a railroad carriage on the train to Korea, but this was not a certificate of succession but a notebook recalling his days with Urano. In a 1950 essay by Nami on the Kenzan succession, Leach's name is not even mentioned. See Ogata Nami, "Ogata Kenzan no daidai" (The Ogata Kenzan succession), in *Kenzan* (Records of the Kenzan Society), vol. 3 (1950): 15–20.

27 Bernard Leach, *A Potter in Japan* (New York: Transatlantic Arts, 1967), 70.

28 Indeed, it is Yanagi who first wrote in 1934 that Leach and Tomimoto "should be regarded as seventh-generation Kenzan." See Shikiba, *Baanaado Riichi,* 604. The same sentence appears in Yanagi's foreword for Leach's *A Potter's Book.* This and subsequent remarks are from an interview with Janet Leach, in Saint Ives, England, November 17, 1985. During this and many later conversations with Janet, I felt that her remarks were inspired chiefly by a desire to separate the New Sano Kenzan episode from the larger achievements of Leach's career.

29 Leach, *A Potter in Japan,* 71.

30 Ernest Fenollosa, *Epochs of Chinese and Japanese Art* (New York: Dover, 1963; original edition 1912), vol. 2, 126.

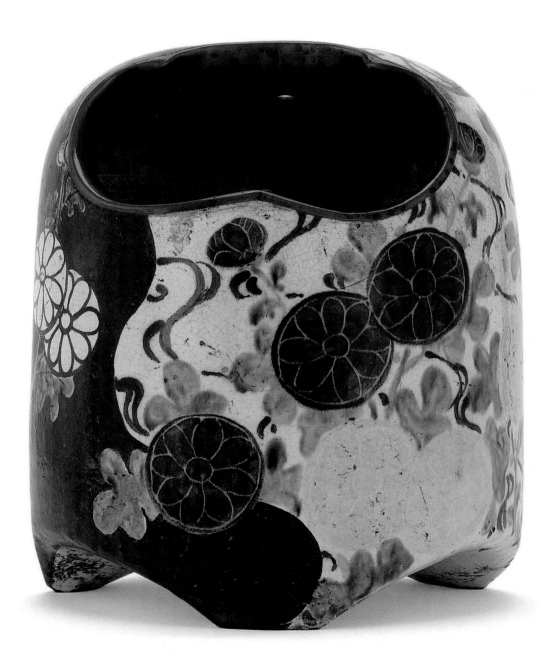

catalogue no. 17

POTTERS'
PERSPECTIVES

POTTERS' PERSPECTIVES

One of the questions frequently asked about Ogata Kenzan is whether or not he made his own pots. The correct answer, "hardly ever," inevitably evokes disappointment. Our image of the potter is based on modern studio practice: it is expected that any potter worthy of the name will handle all the procedures, if not from clay digging at least from forming through unloading the kiln. Even in Kenzan's own work the sense of gesture and spontaneity carries the intimation of solo performance. In the East Asian context, those traits encode an aesthetic and moral critique of the professional workshop and its specialist conceits. And yet we must be cautious. Experience worldwide shows that once potters begin to work outside of households, specialization is precisely what they develop.[1] This was certainly true in Kenzan's Kyoto and elsewhere, where work was carried out in nucleated workshops formed around specific tasks. Kenzan had suppliers for clay, glaze, and pigment; fabricators made his pots and firemen fired them; painters were on hand to paint them.

Consequently one is driven to inquire into what kind of potter Kenzan really was. How did Ogata Kenzan conceive of, represent, and carry out the potter's practice? Empirically speaking, ceramics are clays and stones manipulated. But the organization of these materials in physical and literary form is also a kind of cultural representation, whose assumptions and allusions extend far beyond mechanical procedures. For anthropologist Olivier Gosselain, cultural pressures reveal themselves not only in the selection of potters, pottery sites, or decorative patterns, but also even in raw material selection, clay processing, and firing. It is not a matter of seeing where "function stops and symbol (or style) begins, but to be aware of their remarkable intricacy."[2] This view provides an alternative to antiquarian and popular treatments, where the potter is reduced to a genealogical unit, or the potter's role is described in terms of simple intuition and serendipity. Such generalizations should not be applied to Kenzan. As a pottery workshop owner and designer, he exploited a sophisticated and enfranchised urban ceramics industry; as a cultivated amateur, he had a stake in expressions that developed out of resistance to professional mannerisms. It is no wonder, then, that his notions of potter and pottery are complex and often contradictory. This tension is the very root of the stylistic kaleidoscope that we find in the Freer collection.

Ogata Kenzan's construct of the pottery world emerges in two pottery manuals from his hand, *Tōkō hitsuyō* (Potter's essentials; 1737; fig. 50) and *Tōji seihō* (Ceramic techniques; also 1737).[3] The contents—more than seventy pages of recipes and comments in each book—speak of a keen interest in and knowledge of the potter's craft. But what is not expressly written is equally important: a critique implied in the structure and content of the text. The careful reader will detect an impatience with the manual tasks of the potter— here Kenzan reminds us of Italian potter Cipriano Picolpasso (1524–1579), whose *Three Books of the Potter's Art* (1557) says little about the preparation of clays and the procedures for forming and finishing. Kenzan additionally takes his predecessors to task for relying on transmitted minutiae, suggesting instead that trial and error will yield equally sound results.[4] Behind what appears to be a simple compendium of clay and glaze recipes, then, are conflicting claims for continuity and innovation.

Fig. 50. *Tōkō hitsuyō* (Potter's essentials; 1737), by Ogata Kenzan (1663–1743). Unpublished manuscript. Yamato Bunkakan, Nara.

As for continuity, *Tōkō hitsuyō* is structured as a synthesis of three bodies of ceramic knowledge. The first section is a copy of the recipes for making high-temperature *(hongama)* pots that Kenzan received from the Ninsei workshop in 1699; to this Kenzan added his own observations in red ink. The second section relates the low-temperature *(uchigama)* recipes that Kenzan learned from Magobei, an artisan that he employed from the early years at the Narutaki workshop. Methods that Kenzan considered his own comprise the third section. In the preface Kenzan describes himself as heir to an exclusive and secret body of practice:

The techniques of pottery fabrication, glaze mixing, and clay formulation that were passed down from Nonomura Ninsei, who lived in front of the Ninnaji Temple in northwest Kyoto, to me, Kenzan Ogata Shinsei, are presented here in the form of a book written by Ninsei, signed with the title Harima Daijō, and seal Fujiyoshi, that he was granted. The techniques are copied out in their original form, including even the colloquial terms, as requested. The contents are not to be divulged to anyone. [signed] Kenzan Shinsei [sealed] Shinsei. [then in red:] Ninsei's name was originally Nonomura Seiemon. The name Ninsei came from combining the Nin of Ninnaji and the Sei of Seiemon; this is the name that he commonly used on his ceramics. Almost all the wares in the preference of [tea master] Kanamori Sōwa were made by Ninsei.

Kenzan's inheritance of a second tradition, that of the Oshikōji earthenware techniques, is related midway through the manual:

> In Oshikōji, in the eastern part of Yanagi no Bamba street in Kyoto, there is an
> Oshikōji-ware potter named Ichimonjiya Sukezaemon; using the techniques he
> learned from a Chinese, he is making glazed earthenware. It is said that this
> Oshikōji ware predates Chōjirō, the founder of Raku ware, but I don't know which
> is earlier. From 1699, I lived at Narutaki northwest of the capital; there I began
> making ceramics. Since the location was in the northwest quarter of the city, I
> signed "Kenzan" on the pots that were made there. At that time I employed a
> craftsman, one Magobei, who was related to the Oshikōji family and had trained
> under them. He was a skilled workman and proficient at firing the kiln; he, along
> with Seiemon, the eldest son of Ninsei of Omuro, assisted me. From these two men
> I learned the secret traditions of Oshikōji glazed earthenware as well as those of
> Ninsei ware of Omuro.

Then, in the final section, he explains how he synthesized these two major Kyoto approaches into a unique manner called "Kenzan":

> About forty years have passed since I began making ceramics in the hills northwest
> of Kyoto. At that time, in addition to the glaze techniques passed on to me from
> Ninsei and the Oshikōji workshop, I used just about every kind of method;
> discarding the bad parts of the above and combining them with new methods
> I have invented, I have created a unique Kenzan style (Kenzan ichiryū).

This is grist for the historian. Nonomura Ninsei brought Kyoto ceramics to heights of elegance in the mid–seventeenth century, establishing the local ware as a coveted product nationwide. (Oshikōji, for its part, rivaled the Raku workshop as a principal low-temperature workshop in the city.) Given Ninsei's general prominence and the contents cited above, it is not surprising that in post–World War II Japan, the relationship has been structured hagiographically, with Kenzan as the disciple of Ninsei. Popular ceramics journalism survives through repeating these "genealogical" accounts. Ogata Kenzan himself is not entirely free from complicity in this image making: the acquisition of the Ninsei manual and recruitment of Seiemon do suggest a succession of sorts. Kenzan repaid the debt by later adopting Seiemon's son, Ihachi, setting him up as heir to the Kyoto Kenzan workshop.

In every other respect, this was a takeover. First, the language in the opening of the manual elides the fact that the first Ninsei was dead and his workshop had for all practical purposes failed.[5] Second, Ninsei's heir Seiemon was not Kenzan's teacher but a hired hand, making clay bodies (the forte of the Ninsei kiln) for "painting over" (the

forte of Kenzan). Here the new division of labor becomes a form of erasure. Third, Kenzan literally "writes over" Ninsei in the manual. Having received authorization in the form of these secret recipes, Kenzan proceeded to amend them with red margin notes. The comments range from innocent glosses to innuendo about the limits of the artisanal approach. This was tantamount to rewriting history from within, a device typical of Tokugawa-era textual transmissions.[6]

Transmission then, but to whom, and for what reason? Proliferation of technical manuals is part of the information explosion in early modern East Asia. Citing the case of Ming dynasty China, scholar Craig Clunas mentions manuals in agronomy, military techniques, and even lacquer making as part of a project to "produce the knowing subject, as much as or even more than they do to transmit knowledge conceptualized as something discrete from those who know."[7] For premodern Japan, Nishiyama Matsunosuke has thoroughly documented how a plethora of manuals were circulating in town and country in Kenzan's day.[8] More than vocational tools, they too were cultural currency. Both of Kenzan's manuals were passed into the hands of nonprofessionals. Most of these manuals begin or end by swearing the recipient to secrecy, but when we consider their wide circulation, this kind of proscription ironically enhanced the commodity value of the text.[9] In prying pottery techniques away from their customary guardians, Kenzan helped to make the craft an open secret, all the while reminding the reader that he was the agent in this transformation.

Unstated but unmistakably present was a transformation with regard to the pot itself. The decline of the workshop of Ninsei, which dominated Kyoto ceramics in the generation before Kenzan, paralleled the domestic ascendancy of Arita porcelain. This was no coincidence. Brilliantly white, durable, and divertingly decorated, Arita constituted the new frame of reference for producers and consumers, and one of the consequences was that the Kyoto industry faced an identity crisis at the time of Kenzan's debut at the turn of the eighteenth century. Kenzan's disinterest in fabrication and strong interest in pigments and enamels pointed the way to a new workshop focus. For Kenzan, pottery could be not only diverting but personalized—and that was accomplished via the brush. At the heart of Kenzan's technical sensibility was the painting analogue. Kenzan thought of the pot as a surface, and his orchestration of clays, forms, pigments, and glazes—all accessible though broadly developed commercial networks—reflects that. We summon a battery of information, including Kenzan's manuals, scientific analysis, archaeology, and the pots themselves, as evidence.

Consistent with high-temperature ceramic production worldwide, one may assume that the Kenzan workshop required clays with wet and dry strength, plasticity, and refractoriness. The decorative agenda also mandated fine grain—for fluid brushwork—and whiteness. Such a material was available in Kyoto. Kenzan's notes show a preference for a "clay mined for many years in front of the Shiunzan Kinkai Kōmyōji in Kurodani." Kurodani, located in present-day Sakyō Ward in east Kyoto, was mentioned as a suitable material as early as 1636 in the gazetteer *Kefukigusa*. Today's geologists identify this clay as part of an underground layer of decomposed granite. Traditional manuals show tunneling and excavating as the method of access. The source was exhausted, possibly even in Kenzan's time, but I have found numerous white clays in small deposits throughout Kyoto, and they have similar chemistry to that of Kenzan's kiln shards. In photomicrographs (fig. 51) one can see the range of particle sizes; the dominant mineral "suite," quartz, feldspar, and mica, reinforces the likelihood of granitic origins. In his notes Kenzan hints at the existence of professional clay diggers; these specialists also might have excavated clay for walls *(kabe tsuchi)* and dug the underground storage chambers *(chikagura)* that recent archaeologists have discovered in many urban sites. Similar to today, clay and glaze materials were marketed commercially, and Kenzan mentions wholesalers along the Yodo River bank in Osaka.

Although it was of lesser importance to Kenzan, the Ninsei section of *Tōkō hitsuyō* devotes considerable attention not just to raw clays, but also to clay bodies. As the catalogue has highlighted, from its inception the Kyoto industry established *utsushi*—the making of refined imitations—as a mainstay. Kyoto potters imitated other ceramics—of China, Korea, Southeast Asia, Europe, and earlier Japanese kilns—and other materials, including wood, metal, and lacquer. To approximate these referents it was necessary to juggle materials. Ninsei began with the white Kurodani base, then altered color, texture, and fusibility through the addition of other materials. Kenzan was

0.2 mm

Fig. 51. Micrograph of typical clay body used at Ogata Kenzan's Narutaki kiln. Qz=quartz; Kf=orthoclase feldspar; Gm=mudstone; P=void.

forte of Kenzan). Here the new division of labor becomes a form of erasure. Third, Kenzan literally "writes over" Ninsei in the manual. Having received authorization in the form of these secret recipes, Kenzan proceeded to amend them with red margin notes. The comments range from innocent glosses to innuendo about the limits of the artisanal approach. This was tantamount to rewriting history from within, a device typical of Tokugawa-era textual transmissions.[6]

Transmission then, but to whom, and for what reason? Proliferation of technical manuals is part of the information explosion in early modern East Asia. Citing the case of Ming dynasty China, scholar Craig Clunas mentions manuals in agronomy, military techniques, and even lacquer making as part of a project to "produce the knowing subject, as much as or even more than they do to transmit knowledge conceptualized as something discrete from those who know."[7] For premodern Japan, Nishiyama Matsunosuke has thoroughly documented how a plethora of manuals were circulating in town and country in Kenzan's day.[8] More than vocational tools, they too were cultural currency. Both of Kenzan's manuals were passed into the hands of nonprofessionals. Most of these manuals begin or end by swearing the recipient to secrecy, but when we consider their wide circulation, this kind of proscription ironically enhanced the commodity value of the text.[9] In prying pottery techniques away from their customary guardians, Kenzan helped to make the craft an open secret, all the while reminding the reader that he was the agent in this transformation.

Unstated but unmistakably present was a transformation with regard to the pot itself. The decline of the workshop of Ninsei, which dominated Kyoto ceramics in the generation before Kenzan, paralleled the domestic ascendancy of Arita porcelain. This was no coincidence. Brilliantly white, durable, and divertingly decorated, Arita constituted the new frame of reference for producers and consumers, and one of the consequences was that the Kyoto industry faced an identity crisis at the time of Kenzan's debut at the turn of the eighteenth century. Kenzan's disinterest in fabrication and strong interest in pigments and enamels pointed the way to a new workshop focus. For Kenzan, pottery could be not only diverting but personalized—and that was accomplished via the brush. At the heart of Kenzan's technical sensibility was the painting analogue. Kenzan thought of the pot as a surface, and his orchestration of clays, forms, pigments, and glazes—all accessible though broadly developed commercial networks—reflects that. We summon a battery of information, including Kenzan's manuals, scientific analysis, archaeology, and the pots themselves, as evidence.

Consistent with high-temperature ceramic production worldwide, one may assume that the Kenzan workshop required clays with wet and dry strength, plasticity, and refractoriness. The decorative agenda also mandated fine grain—for fluid brushwork—and whiteness. Such a material was available in Kyoto. Kenzan's notes show a preference for a "clay mined for many years in front of the Shiunzan Kinkai Kōmyōji in Kurodani." Kurodani, located in present-day Sakyō Ward in east Kyoto, was mentioned as a suitable material as early as 1636 in the gazetteer *Kefukigusa*. Today's geologists identify this clay as part of an underground layer of decomposed granite. Traditional manuals show tunneling and excavating as the method of access. The source was exhausted, possibly even in Kenzan's time, but I have found numerous white clays in small deposits throughout Kyoto, and they have similar chemistry to that of Kenzan's kiln shards. In photomicrographs (fig. 51) one can see the range of particle sizes; the dominant mineral "suite," quartz, feldspar, and mica, reinforces the likelihood of granitic origins. In his notes Kenzan hints at the existence of professional clay diggers; these specialists also might have excavated clay for walls *(kabe tsuchi)* and dug the underground storage chambers *(chikagura)* that recent archaeologists have discovered in many urban sites. Similar to today, clay and glaze materials were marketed commercially, and Kenzan mentions wholesalers along the Yodo River bank in Osaka.

Although it was of lesser importance to Kenzan, the Ninsei section of *Tōkō hitsuyō* devotes considerable attention not just to raw clays, but also to clay bodies. As the catalogue has highlighted, from its inception the Kyoto industry established *utsushi*—the making of refined imitations—as a mainstay. Kyoto potters imitated other ceramics—of China, Korea, Southeast Asia, Europe, and earlier Japanese kilns—and other materials, including wood, metal, and lacquer. To approximate these referents it was necessary to juggle materials. Ninsei began with the white Kurodani base, then altered color, texture, and fusibility through the addition of other materials. Kenzan was

0.2 mm

Fig. 51. Micrograph of typical clay body used at Ogata Kenzan's Narutaki kiln. Qz=quartz; Kf=orthoclase feldspar; Gm=mudstone; P=void.

not so concerned with the innards of the fabric, even insinuating that for some types of products one could use any kind of clay. For his basic needs he used two clays: the Kurodani base and another clay, Yūgyō, from the Gojōzaka area some two kilometers to the south of Kurodani. Large amounts of the latter were excavated during road construction in the 1960s, and I managed to obtain a sample. Its chemistry is quite similar to Kurodani, having the same parent rock, although it has a little more iron and a stiffer, noduled quality. I assume Kenzan used the Kurodani white clay for wares with detailed painting, and this Yūgyō clay for off-white wares with contrasting white-slip decorations.

In his manual Kenzan also relates experiments in making porcelain. At that time porcelain production in the Arita area of Hizen Province in Kyushu—which had a near monopoly—was supplying upper-class households nationwide. Porcelain was also great to paint on. Unfortunately, it was not easy to make, even for a synthesizer like Kenzan:

> [Regarding porcelain] . . . clays similar to those of Hizen [Arita] and Nankin [Jingdezhen] wares: White clay from the upper part of Mount Hira in Gōshū has been mined by the villagers and sold to pottery workshops in Kyoto; I bought a considerable amount myself. This clay, however, when used by itself, does not fire to a pure white. The color resembles the unglazed areas of folk porcelain from China and Kyushu. To achieve a pure white, I use a technique which is the most important secret of the Kenzan kiln. That is, I mix the white clay from Bungo Province [Oita Prefecture] with this Hira clay in equal parts.

Kenzan, then, tried to develop a local source for porcelain but found it to be impure. The order to Bungo is intriguing, for this was not the porcelain center in Arita—for strategic reasons they probably would not sell their precious porcelain stone—but a mine that produced white clay for sizing paper.[10] The use of a Kyushu material has been confirmed scientifically. Recently, with the cooperation of Tokyo scientist Ninomiya Shūji, I had the opportunity to study, through neutron activation analysis, the rare-earth chemistry of more than one hundred Kenzan shards excavated from his kiln site and consumer sites nationwide. Although most of the data clustered around a buff-colored Kyoto clay that presumably represents Kurodani/Yūgyō, a small group of shards tested closer to Kyushu porcelain bodies. As for the decoration on these Kenzan kiln porcelain shards, the choice was underglaze blue, overglaze enamel, or both, in styles following *kosometsuke* and *gosu aka-e,* late-Ming porcelains popular in early-Edo period Japan. But this Kenzan porcelain was little more than an experiment—the shards are usually thickly formed and badly warped, and the intractability of the material may explain why it did not become a major product.

Kenzan tempered his clays. He mentions a crushed rock from a place called Fujino'o in Yamashina, east Kyoto. Years ago I visited Fujino'o and found an extensive area of rotten granite that would be commercially exploitable. It was sufficiently decomposed as to not need crushing—that would save the step of pulverizing it with a water-driven crusher as was the custom elsewhere. Kenzan mentions that an addition of this Yamashina stone was necessary when "cracks form in the base of vessels"—in other words, it was a temper used to counteract excessive shrinkage. Petrographic analysis of Kenzan-ware shards shows that the size of the rock filler increases in proportion to the thickness of the walls, i.e., bigger vessel, larger temper grains.

Generally the raw clays were dried, crushed with a mallet, and put into water to slake. Successive decanting left a clay with the desired fineness. After an initial period of dehydration in a holding tank, the soft clay was scooped onto tiles or boards for drying, and was then kneaded by foot and hand.

Kyoto potters have had access to such finely blended bodies for almost three hundred years. When I worked in Kyoto, a truck would come to our workshop every week and one could order, in addition to the "standard" blend, clays such as "Ninsei" (fine white body with delicate glaze crackle), "Shigaraki mountain" (buff body with large nodules of quartz and feldspar), or "Ishihara" (buff body with pink haloes emerging through glaze pinholes after firing). It was a real potter's palette. There was no "Kenzan" clay—understandably he is not associated with a signature clay body. But one shouldn't underestimate the importance of a finely blended and thoroughly predictable clay body in his work.

Kenzan's reliance on fine white clays and his disinterest in blending is also a signal to connoisseurs: when one sees a Kenzan ware with a dark-colored or coarsely textured body, beware.[11] These are later mergers of Kenzan with other famous products, intentional and otherwise.

FORM

The changes in form that characterize early-modern-period ceramics are numerous, and include a greater variety of vessel types and a numerical ascendancy of small wares over the storage jars and kitchen mortars that were the mainstay of the medieval industry. Most conspicuous is the proliferation of bowls and dishes. Edo period ceramics is, in the grossest sense, about tableware (although it should technically be called "tray ware" since most of the vessels were placed on some intermediate surface, usually wooden or lacquer-ware trays set in front of the individual diner). The Kenzan-shape repertory is consistent with this development. What is different is the kind of bowls and dishes that Kenzan preferred. The main types are detailed below in figure 52.

Fig. 52. Vessel forms manufactured by the workshop of the first Ogata Kenzan (not drawn to scale).

Bowls

Flat dishes

"Shaped" dishes
and bowls

Other serving and
condiment vessels

Incense or seal ink
containers

Handwarmers, ember
pots, incense burners

BOWLS: Analysis of shards excavated from Kenzan's Narutaki kiln is under way. The excavated shards show three basic bowl types: idiosyncratic pieces for the tea ceremony, cylindrical bowls, and bowls with rounded bases. The latter two, present in much higher numbers, are characterized by broad surfaces for decorating. The cylindrical tea bowl is of special interest, for it became a Kenzan trademark. It was probably inspired by the *undō-de* bowl imported from late-Ming China and imitated to some extent in early-Arita wares. In Kenzan's workshop the shape was modified into a straight cylinder and the base corners were rounded. The form was widely appropriated in Kyoto and Seto mass production after Kenzan's death in the mid–eighteenth century. In the late eighteenth century the form was "taken back" by Arita potters (becoming a source for the cylindrical *soba* cup popular among modern collectors), whereupon it ceased to be made in Kyoto. The Kenzan bowl repertory at Narutaki also includes lidded bowls: the trademark version, used for steamed dishes, has an overhanging lid that allows condensed steam to drip outside of the vessel rather than into the food.

Handmade Raku-type tea bowls with the Kenzan signature are also numerous, but these begin in a later generation.

FLAT DISHES MADE TO RESEMBLE PAPERS FOR POETRY AND PAINTING: Square, rectangular, and polygonal varieties of these flat dishes exist. Most have upright walls, but there are also pieces with everted edges resembling the framed wooden plaques mounted in temples and shrines. The origin of such rectilinear vessels is multiple. The concept could be inspired by certain late-Ming *kosometsuke* porcelain pieces or late-Ming dynasty to early-Qing dynasty lacquer wares. The box inscriptions (fine ceramics were typically stored in wooden boxes, many of which bear inscriptions) for some of these pieces describe them as *suzuributa*, which means "inkstone cover." Inkstones were equipped with rectilinear lacquer covers and became a part of standard writing equipment from the Heian period (794–1185). At some later point, the name came to be applied to food trays of a similar shape. This is a good example of how a name carries prestige—in this case the prestige of classical letters—into an entirely new deployment. But the main analogue for the rectilinear dish is the paper surface. Kenzan-ware dishes assume the shapes of painting scrolls and cards for inscribing poems, the latter encompassing single sheets *(shikishi)*, overlapping sheets *(kasane shikishi)*, and long narrow sheets *(tanzaku)*. Poetic nuance and cross-media novelty are conveyed at a glance.

DISHES AND BOWLS "SHAPED" BY PAINTED ELEMENTS: Various contours exist among the dishes, but all share a diameter of about sixteen centimeters, which is standard for the *mukōzuke*, a dish arranged with seafood to accompany bowls of rice and soup in the standard meal service. Essentially the contours of the painting and the contours of the pot are coordinated. These could be simple facsimiles—for example, pot as radish—

but the more interesting ones combine a painted composition such as a landscape or flowers with the vessel form. Pot and painting coexist in an entertaining tension. Such irregularly shaped dishes became popular in late-Ming China and form part of the repertory of diverting vessels imported into early-Edo period Japan. They were manufactured domestically in Arita from around the 1630s and continued in favor into the early eighteenth century. Around the time that Kenzan was making them, fine specimens were being produced for the military elite in the Nabeshima kilns, part of the Hizen porcelain context. The Kenzan workshop also made larger bowls, some of which have cut-out sections to suggest gaps between the painted flowers and foliage.

EMBER POTS (HIIRE) AND INCENSE BURNERS (KŌRO): This grouping comprises round and rectilinear shapes, and they have various ceramic referents. Tobacco arrived in Japan around the turn of the seventeenth century; the earliest mention of tobacco is in a 1601 record of gifts presented to Tokugawa Ieyasu (1542–1616) by Spanish missionaries. Pipes, called *kiseru*, were manufactured in Japan thereafter. The smoking habit was an important part of social life in Kenzan's day. A tray called *tabako bon* held, along with smoking pipes, tobacco, the ember pot, and an ashtray. This was standard hospitality equipment (see an example in fig. 32). The ember pot, used for actually lighting the pipes, was filled with ash with a burning stub of charcoal set in the middle. Sometimes the rims of ember pots are battered, for smokers struck them while tapping spent tobacco from their metal-tipped pipes.

The incense burner is usually associated with the fine imported pieces placed in alcove displays, but incense burners, too, had become a vernacular item by the turn of the eighteenth century. Most of them were ash-glazed wares made in Seto and Mino. In Kenzan ware, ember pots and incense burners are frequently indistinguishable except when the latter is accompanied by a perforated metal lid.

INCENSE CASES (KŌGŌ): Small lidded boxes form a significant part of Kenzan-ware production. There are a few wheel-made models, but most are made by carving out a piece of clay, with the final shape based on the same design principle as the irregular dishes, where the contour of the painted decoration is carried over into the vessel shape. The vessels are usually described as containers for pellets of incense that are sprinkled into the hearth during the tea ceremony, but the absence of other "tea" vessels in Kenzan's oeuvre (discussed below), plus the discovery of new evidence, has suggested other possibilities. Cinnabar has been detected scientifically on the inside of catalogue number 17, suggesting this was used as a container for the pastelike red ink used for seals. This, similar to the above-mentioned *suzuributa,* puts some of Kenzan's products more in line with literati equipment than tea ware.

Indeed, with the exception of the tea bowl (itself adaptable to several different uses), other tea wares are conspicuous by their absence. Tea caddies, tea jars, flower vases, fresh-water jars, and water jars were not made by the first Kenzan. A tea ceremony potter he was not. Nor do we see the everyday household ware that the contemporary Seto or Mino kilns routinely produced, such as ewers for oil, kitchen mortars, and sake bottles. Among the few hollow wares produced at the Kenzan kiln are small ewers and sauce pots used with food service.

FORMING

Like a painter for whom the canvas is little more than a point of departure, Kenzan has nothing to say about the actual forming of pots in his manuals. The artifactual evidence shows a repertory of highly skillful forming techniques. For the potter's wheel work, we assume that Kenzan relied on Ninsei's successor, Seiemon. Kenzan also mentions that his assistant, Magobei, from the Kyoto lead-glaze workshops of Oshikōji, was *saiku jōzu*—skillful in hand-forming techniques. Thus work that involved cutting and molding clay slabs was probably carried out by Magobei.

HIGH-TEMPERATURE DECORATION

Early modern Japanese tableware—especially from Kenzan's time—was decorated. This is a manifestation of both technical development and the variety of tastes and interests in a stratified urban culture. From the beginning of the early seventeenth century potters developed stable transparent glazes and built kilns that could fire them to maturity. A prosperous, peaceful, urban society demanded utensils that were entertaining. In early painted stonewares such as those from Karatsu and Mino, visual pleasure came from simply brushed birds, flowers, grasses, hills, and trees. With the development of decorated porcelain at Arita, there is a qualitative escalation, embracing first the great decorative traditions of the continent, and later domestic preferences. A great variety of designs were produced and changed continuously.

SLIP: By Kenzan's time underglaze painting was coded hierarchically, based on rarity and expense of pigment: underglaze cobalt, the painting material for blue-and-white porcelain, was "high," and monochrome iron, relegated chiefly to use on common stoneware, was "low." Kenzan was mindful of the order, and in his early work he seems to have tried making blue-and-white porcelain, but his real contribution was to reinvigorate underglaze-painted stoneware. A preliminary move was to transform the

rather somber surface of stoneware via an imaginative use of slip, a fine-grained liquefied clay:

> The technique for white slip is the greatest secret of the Kenzan kiln, so I will pass it on orally rather than writing it down. . . . Because I found it impossible to achieve a good white with [other mixtures], I attempted to use white clay from Yagi Mountain in Bizen and white clay from Satsuma. In particular, I used material from Akaiwa Village in Kuzu District, Bungo, which is dug by the villagers and used to whiten paper; using this clay I conceived an original way of applying white [slip]. Recently, many kilns in east Kyoto have imitated this technique.

Kenzan was not the inventor of slip; it had been used since medieval times, first as a protoglaze and then in Kyushu and Mino stonewares as either a total covering or an accent over a dark body. Kenzan used slip as a pigment for painting, but also—in a very different and daring way—as a partial covering. In his *Tōji seihō* notes he mentions using it as a partial application, or *kakiwake*. This was an attempt to overcome the confines of the frame imposed by the vessel: by dipping or painting part of a vessel in a contrasting color, the surface could be divided into various fields for painting, which could in turn offset the regularity of the round pot (see catalogue section, "The Kenzan Mode"). This concept, which may have derived from the partial green-glaze applications in Oribe wares of a century earlier, was an all-important breakthrough for Kenzan ware. The most pedestrian vessels could now possess a rich and variegated surface.[12]

IRON/BLACK: This pigment is made from finely ground iron powder. As Kenzan explains, when a blacksmith forges a tool, the iron scales that fly off the ingot can be used for painting pottery. Recent excavations in Edo show that refining of iron scale was a side business for blacksmiths or even low-level samurai. The Hikage-chō site in Bunkyō Ward, Tokyo, for example, yielded dozens of sticks of a fine red material.[13] Analysis by John Winter and Janet Douglas in the Freer and Sackler galleries' Department of Conservation and Scientific Research showed it to be a very pure iron of fine particle size.

Iron will yield rusty flashes under high-calcium ash glazes such as Kenzan's; these are delightful for today's "folk" potters and connoisseurs but would have been undesirable for someone with Kenzan's agenda. He proposed creating a black color by mixing iron with *gosu* (asbolite, an impure cobalt) in 5:5 or 10:4 proportions. His referent is not ceramic pigment at all, but the painter's ink.

BLUE PIGMENT: Kenzan writes that his blue is "the same as in Nankin; this means the ceramics pigment brought by the Chinese to Nagasaki." Kenzan is referring to imported cobalt ore for underglaze blue painting. Use of blue alone occurs in Kenzan's early porcelain experiments and only rarely on stoneware.

OTHER COLORS AND COMBINATIONS: Persimmon (brown) pigment is a blend of ochre and white slip. It represents an effort to expand the high-temperature palette, which is normally limited to the brown-black of iron and the blue of cobalt.

Although the underglaze iron painting on the dishes decorated jointly by Kōrin and Kenzan is better known, most of Kenzan's underglaze work is carried out in a combination of iron and cobalt pigments. Called *sabie sometsuke,* it is a Kyoto decor scheme that begins in the second half of the seventeenth century. It may be a potter's permutation of the blue and green palette favored in indigenous painting from the Heian period. Kenzan, would, of course, very much update this "classical" color scheme with swatches of white slip and boldly painted elements.

Depending on their fluidity and adhesion, pigments were suspended either in a seaweed syrup called *funori* or an animal glue called *nikawa.* The correct use of these materials is critical to the success of the decorator—especially for someone working on bisque ware; accordingly Kenzan wrote in some detail about their use.

STONEWARE GLAZE

The notes that Kenzan received from Ninsei and copied into his own manuals are full of arcane formulas for tea-ware glazes. Especially the glazes for tea caddies, one of Ninsei's specialties, are full of obscure terms and resist replication. Kenzan seems to have tested some of these but in the main used only one stoneware glaze, a transparent one, made of ten parts of a "white stone" and six parts ash:

> White stone is a white sand taken from the mountains at Namase Village, Arima
> District, Settsu Province. There is a wholesaler of this material near the south end of
> the Tenjin bridge in Osaka. Sources are not limited to the white sand from Namase.
> In every place where ceramics are made, suitable white sands exist, so it can hardly
> be said that ceramics cannot be made without Namase stone. Since this is the
> material that has long been used by Kyoto potters, however, I shall leave it at that.
> The above-mentioned ash is wood ash; it is the same material that is used in the
> dyeing of silk cloth. After the ash has been used by the dyers, the waste is used by
> the potter. Generally, if this white glaze turns a greenish blue in the kiln, the heat
> is too strong, and if the surface looks like an eggshell the heat is too weak.

Namase stone is feldspar. The original deposits in Hyogo Prefecture, which served Kyoto potters throughout the Edo period, are now depleted, but a nearby mine in Hiraki has a comparable product. Feldspars were ground in a stone mill before mixing. Kenzan's ash is hardwood (*kashi,* a kind of oak, is recommended as a source for ash in

the *Tōji seihō*). This type of feldspar-ash glaze was used in all glazed stoneware industries in Kenzan's day.

Kenzan, like other Kyoto potters of his day, had no interest in the type of iron-rich, mottled, or otherwise textured glazes that often are seen to epitomize traditional Japanese ceramics. Transparency and smoothness was his aim.

THE STONEWARE KILN

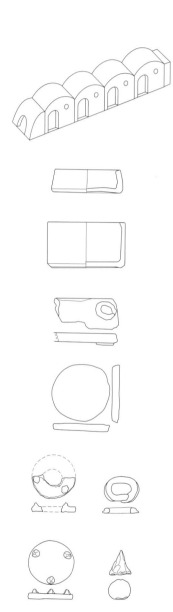

Fig. 53. Speculative drawing of the Kenzan stoneware kiln at Narutaki and measured drawings of stoneware kiln furniture excavated from the site.

As the passage on porcelain shows, Kenzan understood something of high-temperature kiln effects, but he recorded little of it. Reconstructing his kiln apparatus is complicated by the fact that no high-temperature kiln has been excavated in Kyoto—most of the remains lie under densely developed urban land. Kenzan's kiln site was worked over by amateurs in the 1930s and 1940s and extensively disturbed. Fortunately, sections of stoneware and earthenware kilns from Kenzan's time have just been excavated from the Dōjima Kurayashiki site in Osaka, and they provide an unprecedented look at a mid-Edo period high-temperature kiln from the Kansai region.[14] According to excavator Satō Takashi, the proportions of the Dōjima stoneware kiln and the nature of its setting furniture are demonstrably different from those of the two major production (and hence potential technology donor) centers, Arita-Karatsu or Seto and Mino, leaving the nearby Kyoto industry as the likely source. Most of the shards excavated from the site are consistent with Kyoto style, adding credence to Satō's idea.

The foundations of the firebox, first chamber, and part of the second chamber of the Dōjima high-temperature kiln, referred to as kiln number 1 in the site report, were recovered. The first chamber is one meter long and 1.5 meters wide. The absence of steps between the flues points to what kiln specialists call a diagonal flue arrangement. The height and total length of the kiln could not be determined through excavation, but a reference in 1722 to a Kyoto kiln in the *Jōjūin nikki*, a record preserved in Kiyomizu Temple, gives the size of five *shaku* (about 1.5 meters) high and five *ken* (nine meters) long.[15]

The site of Kenzan's Narutaki kiln, in the cemetery of Hōzōji Temple in Ukyō Ward, Kyoto, is well known. Kasuga Junsei, who first informally surveyed the site in 1928, described an area about twelve meters long and two meters wide containing large numbers of shards, kiln fragments, and setting tools.[16] During the installation of a flood-control facility on the site in 1986, a sloping layer of blackened soil about ten meters long was exposed at a depth of about one meter from the present surface. I recovered about one hundred shards from that layer. One is tempted to match this length with the Kiyomizu record and the size of the Dōjima kiln, but the Narutaki site, as mentioned above, is extensively disturbed. The available information hints at a small- to medium-

size climbing kiln with sagger and open-shelf setting (fig. 53), brought up to medium temperature by stoking the main firebox and then finished with side-stoking in each chamber. Further information about Kenzan's kiln and related artifacts is contained in the "Archaeology" chapter.

OVERGLAZE ENAMELS

Overglaze enamels, called *nishiki-de,* or "brocade style," by Kenzan and other period potters, bring bright color to the normally subdued high-temperature palette. Color was central to the Kenzan aesthetic agenda, and hence his inheritance of Ninsei's enamel recipes was a great prize, a body of practice that Kenzan continued to develop throughout his career. East Asian enamels such as Ninsei's were made of two chief ingredients: frit, a prefired glass that gives bulk and stability; and colorants, which were impure oxides or carbonates of iron, cobalt, manganese, and copper. Sometimes the colorants are fired into the frits. Rounding out the enamel recipe is lead (acting as a further flux) and/or silica (a refractory "brake"). Increments of both could be added to synchronize the melting points and color maturation.

With its extensive deployment in Chinese and Arita porcelains, red enamel is given special attention in Kenzan's notes. It was precisely at this time that a lavish, red-decorated porcelain called *kinran-de* (gold brocade style) was being produced domestically. Kenzan replaced Ninsei's clay-based colorant, which was dull, with the iron sulfide-based colorant used by enamelers working in the Kakiemon style at the Arita porcelain kilns.

Black enamel was also a special Kenzan recipe. Ninsei's black enamel was a mixture of iron and cobalt, but Kenzan is quick to note its deficiencies: that it had no gloss by itself and had to be used under another glossy enamel, such as green or blue, and it was therefore limited to linear details, such as the veins of leaves. That, in fact, is the method seen in the black enamel of Arita products, appearing most conspicuously in the variant called Kokutani. Kenzan offers his own completely different formula, adding that it is effective for writing (poetic inscriptions) on a glazed surface.

Ninsei's recipe for gold enamel was a mixture of gold powder and a flux called *hōsha* (the present term for borax, although it may have referred to a different substance). Kenzan criticized this recipe, maintaining that its application in Higashiyama (east Kyoto) workshops produced a gold that rubbed off easily. In the last section of his manual Kenzan proposed a completely different concept, derived from lacquer-ware decoration: the potter could use a specially prepared enamel to "glue" gold or silver leaf to the surface of a vessel.

The characteristic of enamel that was anathema to Kenzan's practice was its glassiness. That beady viscosity, so richly expressed elsewhere in Kyoto enameled ware, was not congenial to the light, painterly look that Kenzan liked. One senses in Ninsei and other early-Kyoto-ware decoration a textured effect analogous to the ornament popular in seventeenth-century elite textiles, which was embroidery and gold appliqué. Is it any coincidence that Kenzan ware came to the fore precisely when this encrusted surface was being supplanted by a new textile aesthetic, that of *yūzen* technique? In *yūzen*, heavy needlework was replaced by resist dyeing, which left a light, sheer effect. For a ceramic equivalent, Kenzan used underglaze colors.

UNDERGLAZE ENAMELS: UCHIGAMA TECHNIQUES

Kenzan referred to painting in colored lead glazes under a clear lead glaze as *uchigama*. The term literally means "inner kiln" or "muffle kiln," referring either to a kiln small enough to be used indoors or the muffle that protected the wares in firing. The general connotation, however, is lead-glazed earthenware. As was mentioned earlier, these techniques were derived from the Kyoto workshop named Oshikōji, which had a lineage rivaling that of the Raku house. Their specialty, as recorded by Kenzan, was making "imitations of the [enamel-on-biscuit] product known as 'Kōchi' [Cochin China] ware, with figures of birds, trees, animals, and the like incised into the surface and painted with green, yellow, and purple colors."[17] For lack of a better term, I refer to these colors as underglaze enamels, although it should be noted that East Asian enamels are conventionally fritted, whereas these recipes contain no frit.

The foundation of the Oshikōji recipes was a transparent base glaze consisting of ten parts lead carbonate to four parts silica. These ingredients were dry-screened to powder grade, suspended in water, and the precipitate was mixed with seaweed syrup. A paint box was created by adding colorants to the above: copper carbonate for green, a cobalt-bearing glass for blue, and antimony oxide for yellow. Red was calcined ochre and black was iron scales mixed with a cobalt-bearing rock; various cobalt- or manganese-bearing ores produced other shades of blue and purple.

The enamels were painted or stenciled onto bisque ware, and a transparent glaze was applied over that. The wares were fired to about eight hundred degrees Centigrade inside the *uchigama* proper. The major disadvantage of the technique is that such colors tend to run on vertical surfaces. But this was not a problem for Kenzan—he used his underglaze enamels chiefly on the horizontal surfaces of dishes. And there, the colors fired with a soft, watery look. In place of the hard, beady enamel surface the effect was like painting on absorbent paper or the filmy *yūzen*.

LOW–TEMPERATURE KILNS

The Kenzan workshop used smaller kilns, or perhaps a single small kiln, for bisque firing, overglaze enameling, and underglaze enameling (fig. 54). There are no remains of Kenzan's low-temperature operation save a few fragments of kiln furniture and parts of the kiln body and interior muffle. Again we turn to evidence from the Dōjima excavation in Osaka, and to a report on the Kyoto kiln industry compiled in 1872.[18] The foundation of kiln number 2 at Dōjima was recovered. Looking at its location in reference to the aforementioned high-temperature kiln, and comparing its plan with a later illustrated Kyoto report that labels a similar kiln as a bisque kiln, one can infer that Dōjima number 2 was used for firing bisque wares prior to the high-temperature glaze firing.

The Dōjima bisque kiln was 1.5 meters in entire length. A square-plan ash pit and rectangular firebox were installed below the surface. The attached kiln body was cylindrical, with the side wall flaring outward at the base, but perpendicular in the upper half. The stacking area inside the kiln body was made by placing a sagger in the middle of the floor as a support post, with pie-slice-shaped clay slabs laid over it, forming a disk-shaped shelf.[19] Such small cylindrical kilns are still in isolated use for firing toys and dolls, for example at the Fushimi doll workshops in Miyoshi, south Kyoto. These kilns, incidentally, differ from the bisque kilns indicated in early pictorial records of Kyushu and Seto and Mino production.

The kiln used for firing enamels was similar to the bisque kiln, but a muffle was inserted to protect the enamel surfaces from ash and debris. Kenzan may also have used a smaller enamel kiln, one in which the fuel, in this instance charcoal, was packed around the muffle instead of being burned in an attached firebox.

KENZAN AND TECHNIQUE

We began this technical journey with the lament for Kenzan's deficiencies as a potter— for all his knowledge, he was certainly was not a clay digger, thrower, or kiln foreman. An all-around potter Kenzan was not; a divinely talented designer and decorator he was. We can understand this in terms of Kenzan's environment. By the early eighteenth century, the potter's basic materials were marketed commercially, and highly skilled fabricators were available for hire. If we view the ceramic arts as a scale of values with physical ecology on one end and a cultural system on the other, Kenzan was free to explore the latter. But Kenzan was not content simply to manage the materials and expertise at hand. His painting analogue demanded new shapes and new types of slips, pigments, and enamels. This may not have constituted a revolution of ceramic

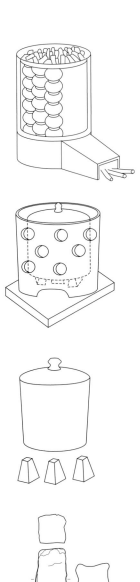

Fig. 54. From top to bottom, speculative drawing of bisque kiln, *uchigama* kiln, and muffle based on period documents, and measured drawing of support brick excavated at Kenzan's Narutaki kiln site.

technology, but it created at least two precedents: first, commercial workshop masters, especially in Kyoto, began to concentrate on decoration, and second, a pathway opened for amateur potters to move beyond what was basically pinch-potting to a world of expressive painted imagery. As the Freer collection shows, these avenues would be followed—and redefined—by numerous practitioners in the decades to come.

NOTES

1 Prudence Rice, *Pottery Analysis* (Chicago: University of Chicago Press, 1987), 184.

2 Olivier P. Gosselain, "In Pots We Trust: The Processing of Clay and Symbols in Sub-Sarahan South Africa," *Material Culture* 4:2 (July 1999): 221.

3 The *Tōkō hitsuyō* is now preserved in the Yamato Bunkakan in Nara. For a typeset transcription, see Mitsuoka Chūsei, ed., *Ogata Kenzan jihitsu* Tōkō hitsuyō *narabini kaisetsu* (Ogata Kenzan's *Tōkō hitsuyō* and annotations) (Kyoto: Benridō, 1963). It is translated in full, with annotations, in Wilson, *The Art of Ogata Kenzan*. The *Tōji seihō* is owned by a private collector outside of Tokyo. It is transcribed and typeset in Kawahara Masahiko, *Kenzan*, Nihon no bijutsu Series, no. 154 (Tokyo: Shibundō, 1979). Unless otherwise mentioned, the references here are to the slightly more comprehensive *Tōkō hitsuyō*.

4 For example, after Ninsei's detailed and precise formulas for clay bodies to match certain classic styles, Kenzan comments, "Clays anywhere in the world can be used for ceramics. One has only to fire them in the kiln and their quality will be apparent. If a clay can only be used in narrowly-defined proportions, good results cannot be obtained."

5 A 1695 reference to the poor quality of "second-generation Ninsei" wares in a document called *Maeda Sadachika oboegaki* (Memoranda of Maeda Sadachika) hints at a qualitative decline. The document is quoted in Suzuki Hancha, "Omuro yaki-Ninsei no bunken kyūmei" (Investigation of documents on Omuro ware and Ninsei), *Tōsetsu* 50 (1957): 38.

6 This comment was inspired by Kramer's analysis of textual transmission in what he calls the "tea cult." Robert Kramer, "The Tea Cult in History" (Ph.D. diss., University of Chicago, 1985), 48–49.

7 Clunas, *Pictures and Visuality*, 156.

8 Nishiyama Matsunosuke, *Edo Culture: Daily Life and Diversions in Urban Japan, 1600–1868*, trans. and ed. Gerald Groemer (Honolulu: University of Hawaii Press, 1997).

9 Kramer, "The Tea Cult," 46–47.

10 Kenzan's notes later mention this place to be "Akaiwa mura in Bungo." Akaiwa, also pronounced Akayuwa, is located in present-day Oita Prefecture, Amagasa-chō, just east of Hita City. It uses rhyolite or trachyte from volcanic rocks bleached by Amagasa hot springs at the same location. This is similar in geologic origin to the Izumiyama porcelain stone used in Arita, in nearby Saga Prefecture.

11 The only exception is Kenzan's signature earthenware dish *(kawarake)*, which was made by a different lineage of potters (in Hataeda, north Kyoto) and purchased by Kenzan as a "blank" for decoration.

12 For more detail see Wilson, *The Art of Ogata Kenzan*, 117–19.

13 Discussed in Richard L. Wilson et al., eds., *Hikage-chō III-2* (Tokyo: Excavation Group for Metropolitan Schools, 2000), 122–23.

14 Osaka Shi Bunkazai Kyōkai, ed., *Dōjima kurayashiki ato* (Dōjima warehouse-residence site) (Osaka: Osaka Shi Bunkazai Kyōkai, 1999).

15 Oka Yoshiko, quoted in ibid., 59.

16 Kasuga Junsei, "Kenzan yaki yōshi hakken ni tsuite" (The discovery of Kenzan's kiln site), *Tōji* 2:5 (1930): 52–55.

17 Ogata Kenzan, *Tōji seihō*.

18 The 1872 Kyoto report, entitled *Tōjiki setsu* (Ceramics explained), is reproduced in full in *Kyoyaki hyakunen no ayumi* (A century's course of Kyoto ware) (Kyoto: Kyoto Tōjiki Kyōkai, 1962).

19 No direct connection is intended, but use of the same pie-sliced-shaped components for a floor can be see in an updraft kiln used by Bernard Leach at St. Ives upon his return from Japan. See Bernard Leach, *A Potter's Book*, 181.

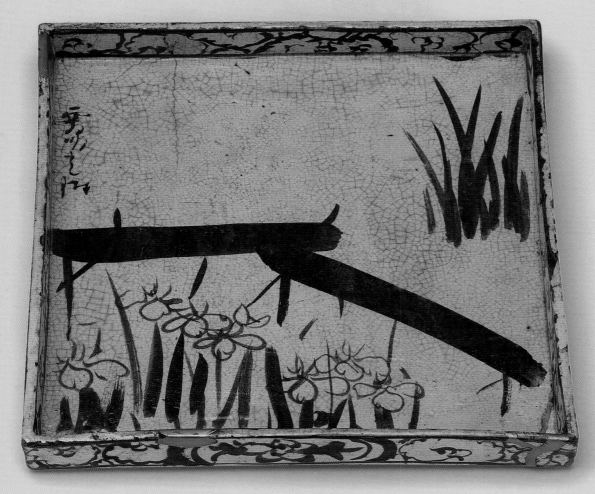

catalogue no. 48

ARCHAEOLOGY

ARCHAEOLOGY

Our survey of Kenzan-ware production has demonstrated how expectations often overshadow truth. Market, media, and scholarly sleuths hunger for more masterpieces—usually with the knowledge that only a small fraction of the wares with Kenzan's name have anything to do with the original master. The search for authenticity, then, will not yield the hoped-for results, but as the Freer collection so effectively demonstrates, the thousands of vessels that bear the Kenzan signature need not be summarily dismissed. All "Kenzans" have a story to tell, and the early modern archaeological record is now part of the telling (fig. 55). In addition to providing basic information on chronology and stylistic change, evidence from kiln and user sites helps to locate ceramics, including Kenzan ware, in a visual, material, and technical environment.

THE NARUTAKI KILN AND KILN FURNITURE

Artifacts, just like works of art, are never innocent; imitations are buried with the "genuine" works. Access to kiln sites, however, opens up the possibility of developing reliable standards for a potter's technology and style. The inhibiting factor in premodern Kyoto ceramics studies is the lack of access to such sites: most of them are covered by urban development. Fortunately, Kenzan's first and only remaining kiln site, at Narutaki Izumidani in north Kyoto, was not buried by concrete; on the other hand, it was extensively disturbed by three amateur digs between the late 1920s and early 1940s. Some of the pot shards and kiln-related artifacts—including fragments of the kiln structure as well as the devices for stacking that we call kiln furniture—have been preserved at Hōzōji, the temple that now occupies the site, but a majority of them have been dispersed and lost. I have been able to track down about five hundred of these shards (this total includes the roughly four hundred pieces at Hōzōji) for stylistic and scientific analysis. Kiln-related artifacts occupy a prominent place among them.[1]

New material is becoming available through a methodical excavation of the Narutaki kiln site, undertaken by our Excavation Group for the Hōzōji Narutaki Kenzan Kiln Site. Between August 17 and September 14, 2000, we excavated seven test pits totaling twenty square meters in areas thought to have been the kiln site proper and the workshop. In situ parts of the kiln have yet to be discovered—we are hoping to find such parts in the main excavation season in the summer of 2001—but the pits in the kiln area yielded hundreds of fragments of kiln structure and setting furniture. As was mentioned in the chapter on pottery techniques, sections of stoneware and earthenware kilns from Kenzan's time have just been excavated from the Dōjima Kurayashiki site in

central Osaka, and they offer useful comparative material. Furthermore, as I write, excavators working within the precincts of the Kyoto National Museum in Higashiyama Ward, east Kyoto, have uncovered a huge dump of kiln fragments and furniture, accompanied by shards from pots typical of the early-Meiji era (1868–1912). The evidence for kiln construction and setting of wares shows a dramatic change (instigated by the manufacture of porcelain) from the comparatively simple methods in evidence at the Dōjima and Narutaki stoneware kilns.

KILN SHARDS AND MATCHING HEIRLOOMS

Vessel fragments excavated from the Narutaki kiln site are not new to Kenzan studies. But until today they have been used only parenthetically, to add fill or decorative accent to lavishly illustrated volumes of heirloom specimens. But in a sense the tables have turned; increasingly, serious studies of Japanese ceramics from every period depend on archaeological material. A serious and systematic consideration of vessel shards from the Kenzan kiln site is now possible. But several problems emerge. One is that the kiln was haphazardly dug by amateurs and a large amount of material carried away. I also have heard anecdotally that in the pre–World War II period the monks tending the temple site became so tired of treasure seekers that they simply gathered all the shards they could find and dumped them into an abandoned well. The other problem is that the shards presently accessible are largely from random digs or even surface collections, which means later material might accompany the Kenzan era shards.

On the other hand, knowledge of Edo period ceramics in general is now sophisticated enough that one can separate, for example, late-eighteenth- or nineteenth-century material from that of the previous era. Furthermore, data from neutron activation analysis of the surface specimens matches well with pieces excavated from the lowest levels of the site. On the whole, then, the material under consideration here may be regarded as part of the first Kenzan's Narutaki production, and therefore important. The shards provide authoritative evidence for early Kenzan design, and they also show what strategies Kenzan chose to discard (he quickly abandoned, for example, close copies of earlier ceramics and a line of small functional wares). Methods of clay selection, forming, decorating, and glazing are accessible to a degree inconceivable in collected specimens. Needless to say, the ongoing excavation at Narutaki will augment our understanding. At the end of the test dig of 2000 we began to find deep pits which, in the next digging season, may yield artifacts associated with the Kenzan workshop.

THE NARUTAKI KILN STRUCTURE AND KILN FURNITURE

It may be inferred from surviving shards and from Kenzan's pottery manuals that his Narutaki workshop (act. 1699–1712) made use of at least two kilns, a high-temperature climbing kiln *(hongama)* and low-temperature cylindrical kiln *(uchigama)*. The structure of the *hongama*, apparently built on the south-facing slope of the site, is accessible to us only in the form of kiln wall fragments (a). The only bricks (b) found at the site are small tapered ones. It is unclear what they were used for, but the considerable spalling on some surfaces suggests they may have been used for hot spots such as flues. Saggers (c) discovered at the Narutaki site include wide, low ones (dishes) and taller, narrower ones (bowls). The sizes are comparable to those excavated from the Dōjima Kurayashiki kiln mentioned in the text. Wads (d) were used to separate the saggers. Wares were also stacked on shelves, and the Narutaki kiln site yielded a round shelf that was probably placed at the top of the sagger stack, and a rectangular shelf (e), stacked using dumbbell-shaped posts. Various kinds of clay supports were used to keep individual pieces from sticking to shelves, including a spur-support with three legs (f).

Low-temperature kiln artifacts, identifiable by their distinctive clay body (blended with a high percentage of sand to reduce thermal shock), include *uchigama* parts, including outer and inner walls (g), lid (h), and stacking tools.

KILN-SITE SHARDS

In studying the shards from the Kenzan kiln site one is immediately struck by the large amount of flat, rectilinear dish fragments. Most of these relate to the trademark Kenzan dish called *kakuzara*. Illustrated here (i) is a fragment with poetic inscription in underglaze iron (the same poem appears on catalogue no. 16), a fragment with a floral design executed by stenciling (j), a fragment whose edge is stenciled with a lozenge pattern characteristic of many Kenzan *kakuzara* (k), and a fragment imitating the Oribe-ware style of a century earlier (l).

In addition to the *kakuzara,* the cylindrical tea bowl is another distinctive Kenzan-ware product, and several shards, including a fragment (m) with Chinese poem ("mountains cluster, obscured in mist") inscribed, have been unearthed at the site. Heirloom specimens with matching poems are known. Covered bowls for serving steamed dishes (n) also appear to have been a stock Kenzan-ware item. The distinctive Kenzan-ware shaped dish is evident in fragments of a dish in the shape of a lily (o) and another with dish fragment with contours following outlines of a plum blossom (p).

Doll fragments (q) excavated from the Kenzan kiln such as the figure of Bodhidharma are all bivalve-molded. They are fired to high temperature.

Painted "Kenzan" marks (r, s) are typically brushed in iron pigment on the vessel base. While it cannot be fully substantiated, the earliest marks seem to be small-sized and generic, implying a workshop name, and later ones larger and personalized, implying a personal signature.

Increasing numbers of shards with a stamp-impressed "Kenzan" mark (t) are found at the site as well. We have analyzed these using a nondestructive replica technique. The impressed area and its immediate surroundings are impregnated with a casting material used in the orthodontic industry and the subsequent casts are photographed with a scanning electron microscope. In addition to identifying different stamps the material of the stamp and specific abrasions are detectable.

CONSUMPTION SITE ARCHAEOLOGY

The Shiodome site, Tokyo, excavated in 1993, was the official Edo headquarters of the Date and Wakisaka clans. A square dish with a floral motif executed in underglaze blue enamel (u) matched with well-known collected specimens. Two foliate dish shards (v) made of porcelain were found by neutron activation analysis to have been manufactured in Arita, corroborating a statement made by Kenzan in his pottery manuals.

The Minami Yamabushi-chō site, Tokyo, excavated in 1993, was the residence of two retainers to the shogunate, the Nakane and Kashiwabara families. A cylindrical tea bowl inscribed with a poem (w) was found in an assemblage of various ceramic products datable to the second decade of the eighteenth century. Fragments of square dishes (x) were found in an assemblage of early-nineteenth-century artifacts.

The Ichigaya site, Tokyo, excavated in 1994, was the official Edo headquarters of the Owari branch of the Tokugawa family. A cylindrical tea bowl with poem (y) was found in an area occupied by shogunal retainers just prior to the construction of the West Pavilion of the Owari residence in 1767.

The Yasue-chō site, Kanazawa, excavated in 1992, was the residence of the Maeda family retainer Nakai Zen'emon. The site yielded a "Kenzan style" tea bowl with design of pines (z). Many such pieces with "degenerate" Kenzan-style decoration and no signature are now known; a similar piece is a dish with floral design and garbled seal (aa) from the Ichigaya Yakuōji-chō site, Tokyo, excavated in 1995–96. In the late nineteenth and twentieth centuries even flower pots bore Kenzan signatures (bb), such as a specimen excavated at the Hikage-chō site, Tokyo, in 1989.

Fig. 55. Archaeological evidence for Kenzan ware: kiln structure and setting furniture, kiln-site shards, and shards excavated from consumption sites.

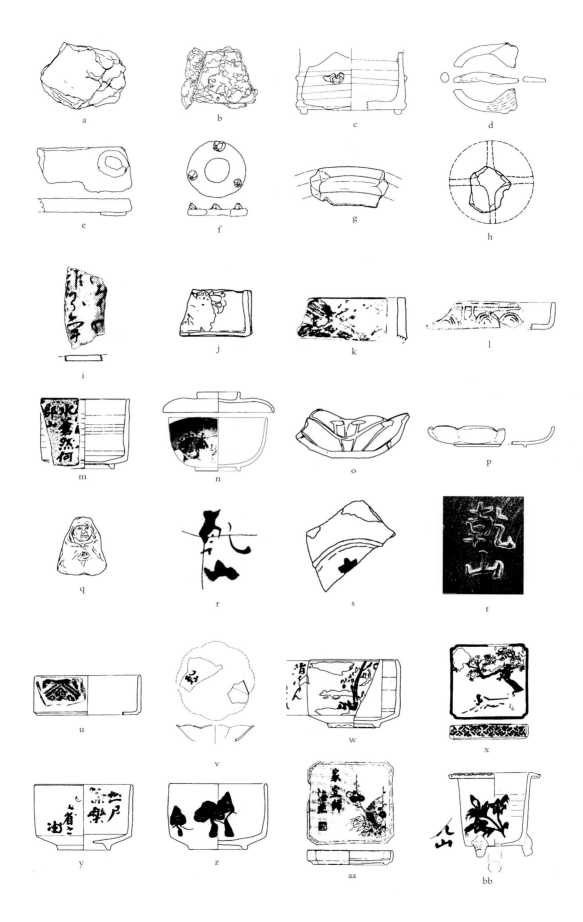

a

b

c

d

e

f

g

h

i

j

k

l

m

n

o

p

q

r

s

t

u

v

w

x

y

z

aa

bb

The confidence generated by the high-growth era of the 1980s led to a general tendency by historians to reexamine the Edo period. Scholars began to posit that the roots of Japanese modernity could be found in pre-Meiji times rather than in the imported Western culture and civilization of the Meiji era. That revisionism, coupled with a strong economy, supported the development of early modern archaeology. Two productive excavations in Tokyo in 1974—the Hitotsubashi High School site in Chiyoda Ward and the Dōsaka site in Bunkyō Ward—paved the way for an explosion of activities citywide. Over four hundred excavations had been conducted as of 1998.[2]

The archaeological explosion was qualitative and quantitative: whereas in prior years Edo period artifacts had been discarded together with the topsoil, suddenly it was decided that they were important, worthy of study and preservation. The number of artifacts recovered was huge, abetted by the disposal patterns of the residents, who usually buried things within the confines of their own property, much of it in discrete soil layers or pits. Also, researchers could draw upon an abundance of collateral information, such as ethnographic collections, books, and illustrations of the period, and art objects. Of considerable appeal was the relationship of sites and artifacts to the socio-cultural differentiation of the day. One could begin to see, in very material terms, the respective environments of tenement dwellers, tradespeople, wealthy merchants, and various levels of warrior society. Aspects of work, play, and public and private lives were exposed and explained.

In Tokyo, where urban redevelopment was extensive, budgets for postexcavation research and reporting were generous, and advances were made in a number of areas, ranging from studies of land use to classification of wooden clogs. Edo period archaeology uncovered literally tons of ceramics, and archaeologists seized the opportunity to create detailed chronologies for Hizen, Seto, and Mino, and other major products. Most of these can now be dated to within a quarter-century. In addition to the stupendous number of generic ceramics unearthed and explicated in these projects, some forty pieces of Kenzan ware (in the widest sense of the term) have now been excavated from over fifteen different sites nationwide.

From this evidence, one can envision that it will be possible to schematize various Kenzan-ware markets. But the evidence is still far from complete, for only when pots are excavated in a tightly sorted and datable assemblage of wares in a distinctive feature (*ikō*) can one begin to treat them as evidence for a given "period style." Owing to the nature of salvage archaeology in general and early modern subsistence patterns in particular, however, such assemblages are the exception rather than the rule. Most of the Kenzan ware so far excavated has been found in rather loosely sorted assemblages and

in many cases outside any discernible archaeological features, such as wells or trenches. The Minami Yamabushi-chō site in Shinjuku Ward, Tokyo is the clear exception, for there Kenzan ware was unearthed from distinct assemblages datable to the early eighteenth and early nineteenth centuries, respectively.

Regardless of the present limitations, archaeology is providing evidence about the purchasers of Kenzan ware. Contrary to the orthodox notion of Rimpa patronage, the excavations show that Kenzan ware attracted not only merchants, but warrior-class patrons. That some Kenzan ware was consumed as special orders or gifts and not regular merchandise was demonstrated, for example, at the Shiodome site in Chiyoda Ward, Tokyo, where Kenzan ware (some of it firmly attributable to the Narutaki kiln) was discovered in association with late-Ming dynasty Chinese porcelains.[3]

The acceleration of Kenzan-ware trade after Kenzan's death is also interesting. This includes not only wares with the Kenzan mark, but also, as was mentioned in the catalogue, a generic "Kenzan-style" ware, chiefly tea bowls datable to the mid to late eighteenth century (see fig. 18 of the catalogue section). This Kenzan dispersal is of considerable interest inasmuch as it marks the rise and fall of a brand. The frequent archaeological occurrence (and hence popularity) of generic Kenzan-style ware also shows how removed premodern users were from today's cherished notions of authenticity: it is doubtful that any of them thought they were using authentic specimens from the hand of a great potter.[4] We look forward to the day when a fiercely independent archaeological model for Kenzan ware can challenge the many complacent notions about Japan's most celebrated master potter.

NOTES

1 See Richard L. Wilson and Ogasawara Saeko, "Kenzan yaki tōhen: Yōseki to shōhichi iseki" (Kenzan ware shards: Kiln site and consumer site), in *Hikage-chō III-2* (Tokyo: Excavation Group for Metropolitan Schools, 2000), 233–92.

2 See Richard L. Wilson, ed., *The Archaeology of Edo, Premodern Tokyo*, Working Papers in Japan Studies Series, vol. 7 (Tokyo: International Christian University), 1997.

3 Richard L. Wilson, "Kenzan Ware Excavated at the Shiodome Site, Tokyo," in *Shiodome iseki* (The Shiodome site) (Tokyo: Shiodome Iseki Chōsa Kai, 1996), 257–78.

4 This reminds me of my fellow denizens in the potters' quarter of Kyoto back in the early 1980s; when I told them I was studying Kenzan they replied, "Oh, Kenzan-san," as if he were just another (living) neighbor.

Clark, Timothy. "The Intuition and the Genius of Decoration: Critical Reactions to Rimpa Art in Europe and the United States during the Late Nineteenth and Early Twentieth Centuries." In *Rimpa Art from the Idemitsu Collection, Tokyo*. London: British Museum, 1998.

Conant, Ellen, in collaboration with Steven D. Owyoung and J. Thomas Rimer. *Nihonga: Transcending the Past*. St. Louis: Saint Louis Art Museum, 1995.

Frelinghuysen, Alice Cooney, et al., eds. *Splendid Legacy: The Havemeyer Collection*. New York: Metropolitan Museum of Art, 1993.

Guth, Christine. *Art, Tea, and Industry: Masuda Takashi and the Mitsui Circle*. Princeton: Princeton University Press, 1993.

Hall, John Whitney, ed. Early Modern Japan. Vol. 4 of *The Cambridge History of Japan*. Cambridge: Cambridge University Press, 1991.

Katō Tōkuro, ed. *Genshoku tōki daijiten* (All-color dictionary of ceramics). Kyoto: Tankōsha, 1972.

Kawahara Masahiko, ed. *Kosometsuke*. Kyoto: Kyoto Shoin, 1977.

Lawton, Thomas, and Linda Merrill. *Freer: A Legacy of Art*. Washington, D.C.: Freer Gallery of Art in association with Harry N. Abrams, 1993.

Oda Eiichi et al. *Kōetsu Kai no ayumi* (The path of the Kōetsu Kai). Kyoto: Kōrin-sha, 1981.

Pitelka, Morgan. "Kinsei ni okeru Rakuyaki dentō no kōzō" (The structure of tradition in early modern raku ceramics). In *Nomura Bijutsukan kenkyū kiyō* 9 (2000).

Scharf, Frederick A., et al. "A Pleasing Novelty: Bunkio Matsuki and the Japan Craze in Victorian Salem." In *Essex Institute Historical Collections* 129:2 (1993).

Tamamushi, Satoko. "Kōrin kan no hensen—1815–1915" (Transitions in the image of Kōrin between 1815 and 1915). In *Bijutsu kenkyū* 371 (1999): 1–70.

Tomlinson, Helen Nebeker. "Charles Lang Freer: Pioneer Collector of Oriental Art." Ph.D. diss., Case Western Reserve University, 1979.

Wilson, Richard L. *The Art of Ogata Kenzan: Persona and Production in Japanese Ceramics*. New York: Weatherhill, 1991.

_____. *Inside Japanese Ceramics: A Primer of Materials, Techniques, and Traditions*. New York: Weatherhill, 1995.

_____. "Kenzan Ware Excavated at the Shiodome Site, Tokyo." In *Shiodome iseki* (The Shiodome site). Tokyo: Shiodome Iseki Chōsa Kai, 1996.

_____. "Excavated Tea Ceremony Wares From Momoyama Period Kyoto." In *Commemorative Essays in Honor of Naoki Katada*. Nara: Tezukayama University, 1997.

_____, ed. *The Archaeology of Edo, Premodern Tokyo*. Working Papers in Japan Studies Series, vol. 7. Tokyo: International Christian University, 1997.

_____. "Bernard Leach and the Kenzan School." In *Studio Potter* 27:2 (1999).

Wilson, Richard L., and Ogasawara Saeko. "Kenzan kenkyū no hensen to kaigai ni okeru Kenzan hyōka" (Evolution of Kenzan research and the reception of Kenzan in the West). *Museum* 481 (1991).

_____. *Ogata Kenzan: Zen sakuhin to sono keifu* (Ogata Kenzan: His complete work and lineage). 3 volumes, with English supplement. Tokyo: Yūzankaku, 1993. Abbreviated in the endnotes as OKZS.

_____. "Kenzan Ware: New Research and Old Taboos." In *Humanities* 26 (1994).

_____. *Kenzan yaki nyūmon* (Introduction to Kenzan ware). Tokyo: Yūzankaku, 1999.

_____. "Kenzan yaki tōhen: Yōseki to shōhichi iseki" (Kenzan ware shards: Kiln site and consumer site). In *Hikage-chō III*. Tokyo: Excavation Group for Metropolitan Schools, 2000.

Yamane Yūzō, ed. *Konishi-ke kyūzō Kōrin kankei shiryō to sono kenkyū* (Kōrin-related materials formerly in the Konishi collection and their research). Tokyo: Chuō Kōron Bijutsu Shuppan, 1962.

Yamato Bunkakan, ed. *Ogata Kenzan jihitsu* Tōkō hitsuyō *narabini kaisetsu* (Ogata Kenzan's *Tōkō hitsuyō* with annotations). Kyoto: Benridō, 1963.

CONCORDANCE

ACCESSION NO.	CAT. NO.	ILLUS. PAGE NO.	DESCRIPTION
F1894.5	45	121	Bowl with design of auspicious motifs
F1896.45	57	136	Black Raku water jar with design of standing cranes and pampas grass
F1896.56	49	128	Rectangular dish with design of iris
F1896.97	9	70	Tea bowl with design of mountain retreat
F1896.99	4	65	Tea bowl with design of mountain retreat
F1896.100	78	168	Red Raku tea bowl with design of cranes and flowing water
F1897.20	10	71	Desk screen with design of mountain retreat
F1898.52	46	122	"Namban-style" water jar with crane and fishnet design
F1898.440	1	61	Incense burner with design of mountain retreat
F1898.445	31	106	Serving bowl with design of lion-dog and peony
F1898.468	55	134	Powdered tea container with design of standing cranes
F1899.36	68	152	Bowl with design of pine trees
F1899.46	50	129	Lidded bowl with design of iris
F1899.96	74	164	Black Raku tea bowl with design of maple leaves
F1899.98	19	87	Tea bowl with design of crane and chrysanthemums
F1899.99	7	68	Tea bowl with design of mountain retreat
F1899.100	82	172	Black Raku water jar with design of maple tree
F1900.30	35	110	Ewer with design of plum blossoms
F1900.50	12	73	Tea bowl with design of narcissus
F1900.70	44	120	"Oribe-style" incense container with design of kudzu
F1900.71	67	151	Powdered tea container with design of violets
F1900.72	18	86	Incense or seal ink container with design of crane and chrysanthemums
F1900.73	15	76	Flower vase with design of bamboo
F1900.74	34	109	Tea bowl with design of plum blossoms
F1900.75	27	96	Incense container with design of Tama River at Yaji
F1900.76	28	103	Incense container in the shape of toy top
F1900.77	24	93	Incense container with design of Mt. Kasuga
F1900.103	75	165	Black Raku tea bowl with design of pines
F1900.118	83	173	Red Raku water jar with design of maple leaves and gabions
F1901.52	3	64	Water jar with design of mountain retreat
F1901.61	81	171	Black Raku water jar with design of gibbons and bamboo
F1901.71	56	135	Black Raku tea bowl with design of standing cranes
F1901.75	30	105	Powdered tea container with design of phoenix and clouds
F1901.76	6	67	Dish with design of mountain retreat
F1901.77	5	66	Desk screen with design of mountain retreat
F1901.113	43	119	Bowl with "Dutch" design
F1901.115	25	94	Incense container with design of Sumiyoshi Shrine
F1901.118	76	166	Red Raku incense container with design of plum
F1901.122	65	149	Tea bowl with design of bamboo
F1901.160	13	74	Ember pot with design of camellia
F1901.194	8	69	Brazier tile with design of winter landscape
F1902.53	73	162	Black Raku tea bowl with design of mountain retreat
F1902.74	54	133	Tea bowl with design of geese

F1902.80	39	115	Ember pot in "Dutch" style
F1902.82	21	90	Six-sided ember pot with design of Tama River of Musashino
F1902.211	79	169	White Raku tea bowl with facets
F1902.217	51	130	Ember pot with design of Four Admirers (Shiai)
F1902.218	11	72	Ember pot with design of pines
F1902.219	26	95	Incense container with design of Cherry River (Sakuragawa)
F1902.220	48	127	Square dish with design of "eight bridges" (Yatsuhashi)
F1902.232	52	131	Six-sided ember pot with design of blossoming plum
F1903.117	17	85	Incense or seal ink container with design of magpie and maidenflower
F1903.279	38	113	Incense container with design of maple leaves and pampas grass
F1904.358	40	116	Water jar with design of maple leaves
F1904.429.1	60	144	Side-handled teapot with design of autumn grasses
F1904.429.2	61	145	Food dish with design of blossoming plum
F1904.429.3–8	47	123	Set of six cups with slip design and inscription
F1905.22	32	107	Food dish with chrysanthemum design, inscribed "longevity"
F1905.24	41	117	Water jar or incense burner with design of maple leaves
F1905.58	16	83	Square dish with design after poems of birds and flowers
F1905.216	64	148	Tea bowl with design of pampas grass
F1905.217	77	167	White Raku incense container with design of plum shoots
F1905.222	66	150	Incense burner with design of camellia
F1905.290	59	143	Handwarmer with design of chrysanthemums and flowing water
F1905.320–324	63	147	Food dishes with assorted designs
F1906.260	2	62	Square dish with design of landscape in the "splashed ink" style
F1906.284	23	92	Tea bowl with design of cherry blossoms
F1907.83	37	112	Flower vase with auspicious decor in overglaze enamels
F1907.84	20	89	Incense container with design of "Narrow Ivy Road"
F1907.85	72	156	Serving dish with design of lilies
F1907.86	70	154	Dishes with assorted designs
F1907.524	80	170	Black Raku incense burner in "melon" shape
F1911.400	29	104	Handwarmer with design of vine scrolls
F1911.401	14	75	Ember pot with relief designs of pine and plum
F1911.402	58	141	Tea bowl with design of pampas grass
F1911.403	62	146	Square dish with bamboo grass design
F1911.404	36	111	Incense burner with design of flowers and vine scrolls
F1911.405	33	108	Ewer with design of floral scrolls
F1911.406	53	132	Serving bowl with design of herons
F1911.407	42	118	Water jar with "Dutch" design
F1911.509	84	174	Red Raku tea bowl with design of snow-laden pines
F1961.28	69	153	Bowl with design of pine trees
F1984.45	22	91	Medicine case with design of "eight bridges" (Yatsuhashi)
FSC-P-2243	71	155	Sauce pot with design of spring grasses